THE QUEEN'S PICTURES

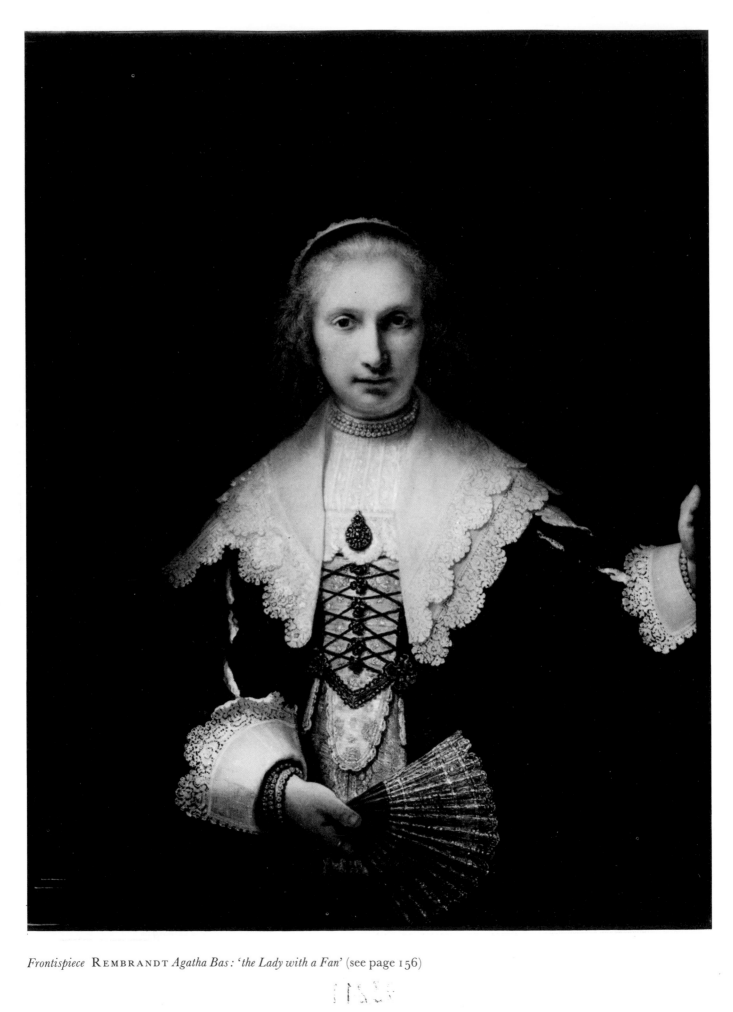

Frontispiece REMBRANDT *Agatha Bas: 'the Lady with a Fan'* (see page 156)

THE QUEEN'S PICTURES

OLIVER MILLAR

MACMILLAN PUBLISHING CO., INC.
New York

To
all my colleagues
in
The Royal Households
1947 to 1977

The pictures, miniatures and drawings
in the royal collection illustrated in
this book are reproduced, and quotations
from material in the Royal Archives
are made, by gracious permission of
Her Majesty The Queen.

Plates 237–243 and L are reproduced
by gracious permission of Her Majesty
Queen Elizabeth The Queen Mother.

Macmillan Publishing Co., Inc.
866 Third Avenue, New York, N.Y. 10022

Library of Congress Cataloging in Publication Data

Millar, Oliver, 1923–
 The Queen's pictures.

 1. Windsor, House of—Art collections.
2. Paintings—England—Catalogs. I. Title.
N5247.W56M54 1977 709'.4 76-30894
ISBN 0-02-584690-6

First American Edition 1977

Printed in Italy by A. Mondadori Editore, Verona

CONTENTS

LIST OF PLATES

BLACK AND WHITE PLATES

112 EUSTACHE LE SUEUR *Nero with the Ashes of Germanicus*
Oil on canvas 63⅝ × 48 in., 160·9 × 121·4 cm.

113 SIR ANTHONY VAN DYCK *St Martin dividing his Cloak*
Oil on canvas 101½ × 95½ in., 257·8 × 242·6 cm.

114 SIR ANTHONY VAN DYCK *Thomas Killigrew and William, Lord Crofts*(?) Signed and dated 1638
Oil on canvas 52¼ × 56½ in., 132·7 × 143·5 cm.

115 DAVID TENIERS THE YOUNGER *Peasants outside a Country Inn*
Oil on panel 13⅜ × 18½ in., 33·9 × 46·8 cm.

116 BARTOLOMÉ ESTEBAN MURILLO *Portrait of the Artist*
National Gallery, London
Oil on canvas 48½ × 42 in., 122 × 107 cm.

117 SIR PETER PAUL RUBENS *The Summer Landscape*
Oil on canvas 56¼ × 87¾ in., 142 × 222 cm.

118 JEAN-ETIENNE LIOTARD *Augusta, Princess of Wales*
Pastel on paper 25½ × 20¼ in., 64·8 × 51·4 cm.

119 ALLAN RAMSAY *George III*
Oil on canvas 98 × 64 in., 248·9 × 162·6 cm.

120 FRANCIS COTES *Princess Louisa and Princess Caroline*
Signed and dated 1767
Oil on canvas 104⅝ × 73½ in., 265·7 × 186·7 cm.

121 NATHANIEL DANCE *Timon of Athens*
Oil on canvas 48 × 54 in., 121·9 × 137·2 cm.

122 JOHANN ZOFFANY *George, Prince of Wales, and Prince Frederick*
Oil on canvas 44 × 50⅜ in., 111·8 × 127·9 cm.

123 JOHANN ZOFFANY *John Cuff* Signed and dated 1772
Oil on canvas 35¼ × 27¼ in., 89·5 × 69·2 cm.

124 JOHANN ZOFFANY *The Academicians of the Royal Academy*
Oil on canvas 39¾ × 58 in., 100·7 × 147·3 cm.

125 OZIAS HUMPHRY *Charlotte, Princess Royal*
Signed and dated 1769
Watercolour on ivory 4½ × 3¾ in., 11·5 × 9·5 cm.

126 JEREMIAH MEYER *Frederick, Duke of York*
Watercolour on ivory 2¼ × 2 in., 5·8 × 5 cm.

127 THOMAS GAINSBOROUGH *The Family of George III*

128 THOMAS GAINSBOROUGH *Queen Charlotte*
Oil on canvas 94 × 62½ in., 238·8 × 158·7 cm.

129 BENJAMIN WEST *George III* Signed and dated 1779
Oil on canvas 100½ × 72 in., 255·3 × 182·9 cm.

130 P. J. DE LOUTHERBOURG *The Mock Attack*
Signed and dated 1779
Oil on canvas 48 × 72½ in., 121·9 × 184·1 cm.

131 BENJAMIN WEST *The Departure of Regulus*
Signed and dated 1769
Oil on canvas 88½ × 120 in., 229·9 × 304·8 cm.

132 BENJAMIN WEST *The Black Prince after the battle of Poitiers* Signed and dated 1788
Oil on canvas 113 × 177 in., 287 × 449·6 cm.

133 C. WILD *The King's Audience Chamber, Windsor Castle*
Watercolour on paper 8 × 9⅞ in., 20 × 24·5 cm.

134 JOHN SINGLETON COPLEY *Princess Mary, Princess Sophia and Princess Amelia* Signed and dated 1785
Oil on canvas 104½ × 73¾ in., 265·4 × 186 cm.

135 ANNIBALE CARRACCI *The Madonna and Sleeping Child with the Infant St John*
Oil on canvas 20 × 27 in., 50·8 × 68·6 cm.

136 GUERCINO *The Libyan Sibyl*
Oil on canvas 45½ × 37¼ in., 115·6 × 94·6 cm.

137 JOHANN ZOFFANY *The Tribuna of the Uffizi*
Oil on canvas 48⅝ × 61 in., 123·5 × 154·9 cm.

138 BERNARDO STROZZI *A Concert*
Oil on canvas 40 × 48⅞ in., 101 × 123 cm.

139 MARCO RICCI *A Ruin Caprice*
Tempera on leather 13 × 18 in., 33 × 45·7 cm.

140 ANTONIO VISENTINI AND FRANCESCO ZUCCARELLI *The Banqueting House* Signed and dated 1746
Oil on canvas 33⅛ × 50¾ in., 84·1 × 128·9 cm.

141 PIETRO LONGHI *Blind Man's Buff*
Signed and dated 174(?)
Oil on panel 19 × 23 in., 48·3 × 58·4 cm.

142 CANALETTO *The Piazzetta towards the Torre dell'Orologio*
Oil on canvas 67 × 52 in., 170·2 × 132·1 cm.

143 CANALETTO *The Interior of St Mark's by Night*
Oil on canvas 11¼ × 7⅜ in., 28·6 × 18·7 cm.

144 J. P. STEPHANOFF *The Crimson Drawing-Room, Buckingham House*
Watercolour on paper 8 × 9⅞ in., 20 × 24·5 cm.

145 SIR JOSHUA REYNOLDS *Portrait of the Artist*
Oil on panel 29⅝ × 24⅞ in., 75·2 × 63·2 cm.

146 THOMAS GAINSBOROUGH *Diana and Actaeon*
Oil on canvas 62¼ × 74 in., 158·1 × 188 cm.

147 RICHARD COSWAY *Princess Sophia*
Signed and dated 1792
Watercolour on ivory 3 × 2½ in., 7·9 × 6·4 cm.

148 SIR JOSHUA REYNOLDS *Thomas, Lord Erskine*
Oil on canvas 50 × 39¾ in., 127 × 101 cm.

149 GEORGE ROMNEY *Lady Hamilton as Calypso*
National Trust, Waddesdon Manor
Oil on canvas 47½ × 58 in., 120·5 × 147·3 cm.

150 SAWREY GILPIN *Cypron with her Brood*
Signed and dated 1764
Oil on canvas 38¼ × 60⅞ in., 97·1 × 157·2 cm.

151 GEORGE STUBBS *Soldiers of the 10th Light Dragoons*
Signed and dated 1793
Oil on canvas 40¼ × 50⅜ in., 102·2 × 127·9 cm.

152 GEORGE STUBBS *William Anderson with two Saddle-Horses*
Signed and dated 1793
Oil on canvas 40¼ × 50⅜ in., 102·2 × 127·9 cm.

153 JACQUES-LAURENT AGASSE *The Nubian Giraffe*
Oil on canvas 50⅛ × 40 in., 127·3 × 102 cm.

154 JAMES WARD *Nonpareil*
Oil on panel 31½ × 43¾ in., 80 × 111·1 cm.

155 MATHER BROWN *George IV*
Oil on canvas 98⅜ × 71½ in., 249·9 × 181·6 cm.

156 JOHN HOPPNER *Horatio, Viscount Nelson*
Oil on canvas 94 × 58¼ in., 238·9 × 147·9 cm.

157 J. M. W. TURNER *The Battle of Trafalgar*
National Maritime Museum, Greenwich Hospital Collection
Oil on canvas 103 × 145 in., 260·5 × 366·8 cm.

158 SIR THOMAS LAWRENCE *George IV*
Oil on canvas 114 × 79 in., 289·6 × 200·7 cm.

159 SIR THOMAS LAWRENCE *Pope Pius VII*
Oil on canvas 106 × 70 in., 269·2 × 177·9 cm.

PREFACE

THE GREAT INVENTORY of Queen Victoria's pictures, compiled by her Surveyor of Pictures, Richard Redgrave, contained nearly five thousand items. He had made sheets for drawings, enamels, pictures on china and the like, which happened to be hanging on the walls as pictures; but, taking into account subsequent additions, the royal collection can by now hardly number less than five thousand pictures, especially if the most recently purchased are to be considered, for the moment, as belonging to it. This huge collection is the property of the Crown, held in trust for the nation by The Queen during her lifetime and administered, as it was when Redgrave's first-recorded predecessor was appointed by Charles I in 1625, under the supervision of the Lord Chamberlain from whom the Surveyor of Pictures still receives his warrant to look after the pictures and help as far as possible those who enquire about them.

One of Redgrave's more recent successors has described the collection as 'a lone and proud survivor'. In the past it was one among many European royal and princely collections; but with the passing of time the great possessions accumulated, for example, by the Valois or the Bourbons, the Habsburgs in Spain and Austria, the House of Orange, the Romanovs, or the Electors and Kings of Saxony have become state property, the foundation of national collections in Paris, Madrid, Vienna, The Hague, Leningrad or Dresden, and have in the process lost something of their identity. The collection formed by the rulers of Britain, from the Tudors to the present time, survives as a collection made by a succession of English Kings, Queens, Consorts and Princes; and it reflects their discernment and prejudice, their bad taste as well as their good, their friendships, diversions, loves, hates, idiosyncrasies and obsessions – and of course a network of dynastic associations – in a uniquely illuminating manner.

The collection was dealt a disastrous blow after the death of Charles I and pictures have disappeared from it for various reasons and at different times since then; but enough survives, even so, to give an impression of what the collection looked like in its early days. Incomparably rich, richer than many public galleries, in certain artists and schools of painting, it also reveals gaps which the director of a national gallery would be compelled to fill. The commonplace that the worst and most extravagant Kings have the best taste is well borne out by the story of the collection. Charles I, as a ruler obstinate, devious and self-deluding; Frederick, Prince of Wales, an irritating,

irresponsible scatterbrain; George III, whom even today one may be allowed to describe as possibly a trifle unsure of his grasp of the world around him; George IV, a self-indulgent and neurotic wastrel: all appear in a favourable light in the ensuing pages. The advisers who stimulated their love of good pictures and their interest in contemporary art, men like Buckingham, Bute or Lord Hertford for instance, have been deservedly detested or despised by their contemporaries and blackened by historians; and the huge sums spent on works of art, by (in particular) Charles I and George IV, contributed to their unpopularity and helped to induce a condition in their lives of almost permanent financial chaos.

The role of the adviser is, of course, particularly significant in the development of royal taste; and it is especially important when, as is almost inevitable, a royal patron or collector may not find it easy to hunt out a promising artist or spend time looking at pictures and so must have them brought to his notice by someone in his circle. In the history of the English royal collection it is worth remembering that only Charles I (on one short visit to the Continent) and the Prince Consort, and to a lesser extent Queen Victoria and Queen Mary, had the opportunity to study works of art in foreign collections. Inevitably the great purchases, in particular those from Mantua and Consul Smith, had to be made on trust, though admittedly on the very best possible advice in both instances.

For many years I have been working on the documentary sources for a history of the collection; so far three sections have been published of a new Catalogue Raisonné of The Queen's pictures, and a companion volume on Raphael's Cartoons, in which many of these sources have been exploited for the first time. There is, however, no up-to-date account of the growth of the collection and I feel that the Silver Jubilee provides an opportunity to present such an account and to include in it an indication of what The Queen and The Duke of Edinburgh have done to make the last twenty-five years the most lively in the history of the collection since the death of the Prince Consort in 1861. Further research in original documents will undoubtedly bring fresh information to light and cause some judgments to be modified. I am particularly conscious that it is very difficult, vast though the quantity of material is, to arrive at a balanced assessment of the attitude to the arts of Queen Victoria and Prince Albert; and there is, I have no doubt, much material to be worked through in the Lord Chamberlain's papers before

the advent of Richard Redgrave. I have incorporated some information at points in the text on the growth of The Queen's collection of miniatures, incomparably the largest of its kind in the world and the one with the longest history. The Queen's collection of Old Master drawings, on the other hand, does not come within the scope of this survey.

I am very grateful to friends who have worked with me on parts of the royal collection: Mr Michael Levey, Dr Lorne Campbell, Professor John Shearman and Mr Christopher White; and I am particularly indebted to those whose entries are not yet published but who have so generously made the result of their researches available to me. Mr Geoffrey de Bellaigue, Surveyor of The Queen's Works of Art, has answered questions on more points than I can enumerate. I am very grateful to the Hon. Mrs Roberts and to Miss Frances Dimond for their help in the Print Room and the photographic section of the Royal Archives at Windsor. Miss Sarah Wilson assembled with patience the plates for this volume. My wife has calendared an immense amount of (mainly) unpublished documentary material on Queen Victoria's collections. One debt, however, I cannot begin to repay. It is more than thirty years since Mrs Gilbert Cousland came, as Miss Margaret Brown, to work with the Surveyors at the time when the exhibition of *The King's Pictures* was being prepared. Since then her experience and judgment have been of incalculable value to us. I would like, in dedicating this book to all my colleagues over the last thirty years, to offer it to them, and to Margaret in particular, with gratitude and affection.

O.N.M.
July 1976

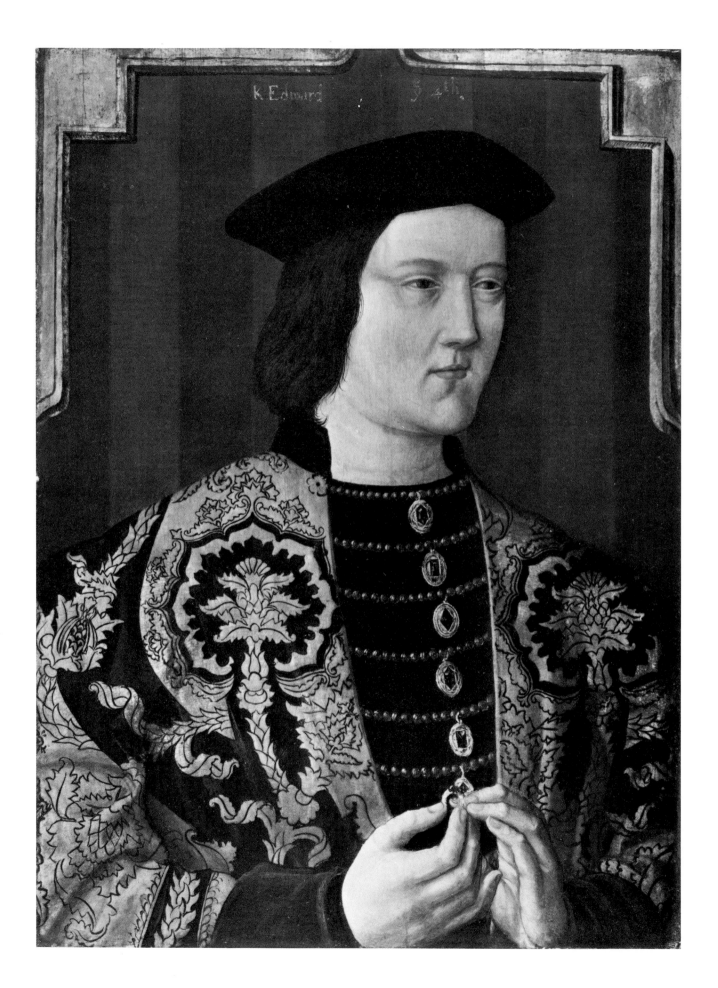

1

THE TUDORS

I N THE SUMMER OF 1414, when negotiations were under way for a marriage between Henry v and a daughter of the Duke of Burgundy, *Maistre Vranque* of Malines was commissioned to paint a portrait of the Princess to accompany the verbal report brought back by the King's envoys.[1] In 1442, portraits of the three daughters of the Count of Armagnac were to be shown to the young Henry vi, so that he might choose one of them for his Queen. Henry v is the earliest English Sovereign of whom a reliable portrait (plate 2) survives in the royal collection, and the nucleus of the collection was formed from portraits of Kings and Queens, Plantagenet and Tudor, and from portraits of foreign Sovereigns, Princes and Princesses whose portraits had been sent over as gestures of friendship or in the course of diplomatic exchanges, sometimes with a marriage or an alliance in view. Almost all the early portraits which had survived in the collection were assembled by Prince Albert in a low passage underneath one of the galleries of Edward Blore's new Private Chapel at Windsor, a little room known for no apparent reason as the Holbein Room. Here they were seen in 1851 by Dr Waagen: 'I remarked five-and-thirty portraits of distinguished personages, which His Royal Highness has had placed together in a small room . . . owing to the badness of the weather, such an Egyptian darkness prevailed in this room that I was obliged to abandon all closer description of them.'[2] There were originally many more such portraits in the royal collection. In the time of Charles i, among the old portraits hanging in the Privy Gallery in Whitehall were 'Nyne old heades being whitehall Pictures Painted uppon Boards' and a further twenty-three 'litle heads most of them Painted without hands uppon Boards';[3] those described as 'Whitehall peeces' were survivors from the Tudor collection, the greater part of them in gilded frames often picked out in red, blue, black or green.

The portraits of Henry v, Henry vi, Edward iv (plate 1) and Richard iii can be reasonably safely identified in the inventories of 1542 and 1547;[4] but recent research has shown that they may not have been painted very much earlier,[5] although they are the earliest surviving examples of popular standard types and were to be much copied. Near them at Windsor still hang Burgundian and Habsburg portraits: Philip the Good, Philip the Handsome, Margaret of Savoy, Joanna of Castile; companion portraits of Ferdinand of Aragon and Isabella of Castile, the parents of Catherine of Aragon; Charles v (plate 3); a portrait of Louis xii of France (colour plate 1); and, the most important in this closely-linked group, Mabuse's *Children of Christian II of Denmark*

1 (left) ARTIST UNKNOWN
Edward IV

2 (below) ARTIST UNKNOWN
Henry V

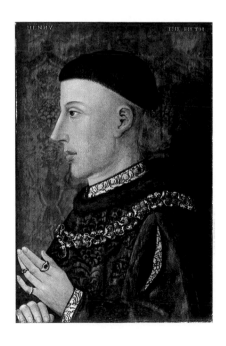

(plate 4).[6] All these can be recognized with some certainty in the inventories of 1542 and 1547. The tradition by which English Sovereigns exchanged their portraits with those of rulers abroad continued through Stuart, Tudor, Georgian and Victorian times and only came to an end in 1914, when enormous state portraits of the Emperor Francis Joseph, William II and Nicholas II were hanging in Buckingham Palace. In England, the first life-size official portrait of a Sovereign is the well-known image of Henry VIII, designed by Holbein (though there is the isolated earlier portrait of Richard II in Westminster Abbey); and thereafter an approved likeness of the new Sovereign was produced at the outset of a reign and then officially copied and distributed. A very large part of their time, and that of the assistants in their studios, was devoted by successful painters such as Kneller, Ramsay, Lawrence or Sir Luke Fildes to supplying copies of the chosen image. There is inevitably a strong dynastic element in the growth of the royal collection. Under the Tudors a masterpiece such as Holbein's full-length of Christina of Denmark, the widowed Duchess of Milan (now in the National Gallery), came into the collection as a portrait of a young woman whom Henry VIII might marry. It was apparently the only portrait by Holbein recorded in the King's collection. And, for an even shorter stay, a portrait by Titian of Philip II was sent over by the Queen of Hungary to Mary I: 'it will serve to tell what he is like, if she will put it in a proper light and look at it from a distance.'[7] Portraits of a prospective bride continued for many years to play an important part in negotiations for a royal marriage.

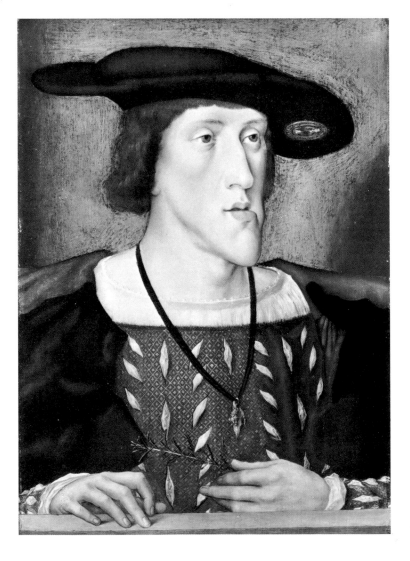

It is impossible to gain an accurate impression of the quality of the Tudor collection, but in quantity it was considerable. The inventories of 1542 and 1547 list a large number of pictures of all kinds at Greenwich, Hampton Court and Oatlands, and many more at Westminster; an inventory of 1549–50 lists pictures, principally portraits, at St James's; but none of these early sources provides the name of an artist. Many of the pictures were protected by curtains of sarsenet, usually of yellow and white 'paned together'. At the end of the Tudor period visitors from abroad were certainly impressed by what they saw in the royal palaces. The Duke of Württemberg said of Hampton Court in 1592 that 'many of the splendid large rooms are embellished with masterly paintings'; and Norden saw at Whitehall in the same year 'manie fayre galleries, stately furnished w^th moste artificiall and dilectable pictures'.[8] Such visitors noticed particularly the portraits and battle-pieces in which the collection has always been so rich; indeed, portraits and warlike scenes are almost the only pictures which we can identify as survivors from the Tudor collection. The archaic panel of *The Meeting of Henry VIII and the Emperor Maximilian I* (plate 5) was listed at St James's in the inventory of 1549–50; but the best-known of such pictures, *The Battle of the Spurs*, *The Embarkation of Henry VIII* and *The Field of the Cloth of Gold*, which record spectacular events in the King's reign, are not mentioned in the surviving earlier Tudor inventories.[9] Perhaps the most significant survival from the Tudor collection is the 'table', recorded in the inventory of 1547, 'of the busshop of Rome and of the foure Evangelists casting stones

4 JAN GOSSAERT, CALLED MABUSE *The Children of Christian II, King of Denmark.*

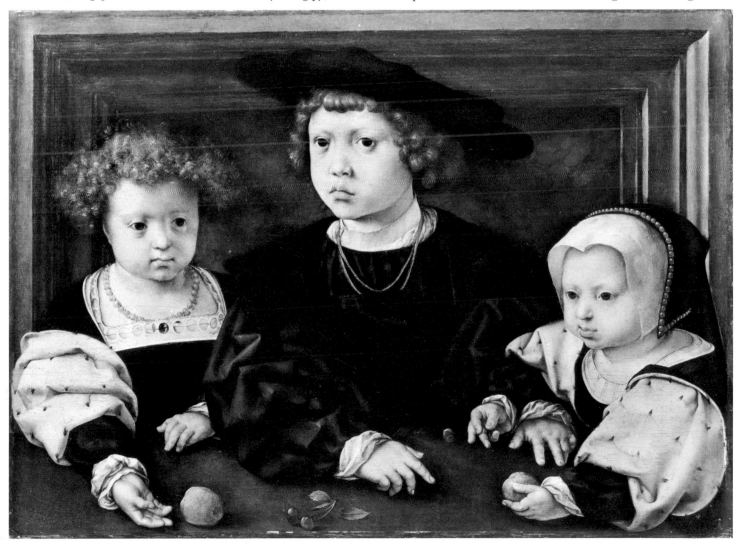

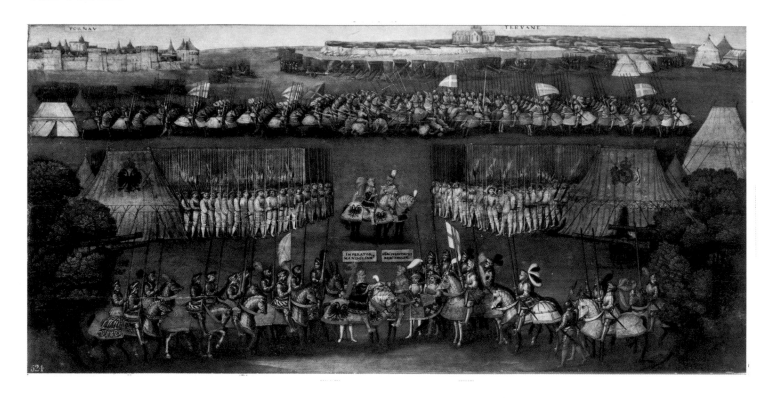

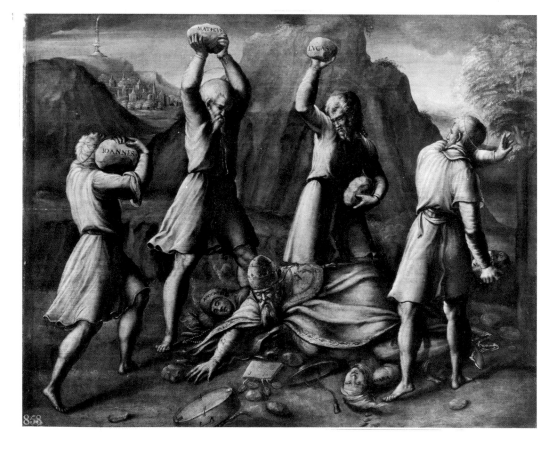

5 (above) ARTIST UNKNOWN
*The Meeting of Henry VIII
and the Emperor Maximilian I*

6 (left) GIROLAMO
DA TREVISO *The Four Evangelists
Stoning the Pope*

7 ATTRIBUTED TO
HANS EWORTH *Elizabeth I and
the Three Goddesses*

upon him' (plate 6): a virulent Protestant lampoon, painted for Henry VIII in London
by Girolamo da Treviso.[10] The most beautiful survivals are the panel of the young
Queen Elizabeth confounding the Goddesses (plate 7), with, in the background, one of
the earliest painted views of Windsor Castle; and the portrait of the great Queen in her
girlhood (plate 11) in which are displayed the famous hands and something of the
'beauty, stature, prudence, and industry' which her tutor praised.[11]

Henry VIII summoned the arts into his service to create a magnificent setting for his
presence and to proclaim the supremacy of the new Tudor *imperium*. Elizabeth I could
talk intelligently about painting to Nicholas Hilliard: 'showing me howe she notied
great difference of shadowing in the works and diversity of drawers of sundry
nations'.[12] She assembled a gallery of portraits of her royal forebears, at least as far back
as Richard II, 'in my house and gallery at Westminster'; and she must have had some
reputation for an interest in pictures. The Calvinist rebels in Ghent intended to offer
her the Ghent altarpiece in 1579; and she was apparently endeavouring later to buy
the great *Lamentation* altar by Quentin Massys.[13] In fact, the most famous Tudor pieces
in the royal collection were all acquired by later collectors: Charles I and Henrietta
Maria; Queen Caroline; Frederick, Prince of Wales; and Queen Victoria. An
assessment of the appearance of the royal houses in the Tudor and early Stuart period
must take into account that so few of the pictures mentioned in the sources can now be
recognized and that so many have been dispersed, and also that so many rooms were
decorated, not mainly with paintings, but with tapestries and hangings. Nevertheless,
it is unlikely that the Tudor collection was in any way superior to the collections being
assembled at the same time by such *magnifici* as Lord Lumley and the Earl of Leicester.

2

THE EARLY STUARTS

JAMES I AND HIS CONSORT, Anne of Denmark, presided over a court which was luxurious, indeed almost luxuriant, compared with 'that strict time of Queen Elizabeth' to which Lord Clarendon looked back. He remembered also with nostalgia 'the uninterrupted pleasures and plenty of twenty-two years peace' under King James, 'That great peacemaker, Britain's peaceful King'.

The image of Peace as protectress of the Arts is a constant theme in the masques and in other courtly literature. The benefits to the Arts from Good Government, Prosperity and Order is a dominant theme in the ceiling by Rubens, commissioned by Charles I as a memorial to his father who had regarded Peace as the first of blessings. Although James I's foreign policy was a failure, his diplomatic envoys and agents took the opportunity of making contact with artists in intervals between their official duties. It also became easier for educated Englishmen to travel, an experience formerly 'not usual', as Clarendon maintained, 'except to merchants, and such gentlemen who resolved to be soldiers'. The period between the early years of James I and the flight from Whitehall of his son on the eve of the Civil War is a golden age in the history of English taste, when a number of collectors and patrons in the court circle set about making magnificent collections of classical, renaissance and contemporary works of art and at the same time encouraged artists and craftsmen from the Continent to try their fortunes in England.

Queen Anne of Denmark was said by Lord Salisbury to prefer pictures to the company of living people; and George Abbot stated that she went into her gallery on the day before her death to look at the pictures.[1] Unfortunately the names of artists never appear in the inventories of her collection. In the Cross Gallery and the Great Gallery at Somerset House there was an inevitable preponderance of portraits – of the royal family, their Tudor predecessors, foreign rulers and a few distinguished English contemporaries – but there were other pictures too: still-lifes, mythological and religious pictures and a number of landscapes, including views of Venice, Highgate, Nonsuch, Windsor, Greenwich and Lewisham. Pictures 'of the smallest sorte' were kept in the Cabinet. The Queen had been for many years a convert to Catholicism and her Great Bedchamber contained four scenes of Christ's Passion and a picture of the Magdalen; and the religious pictures in a little room between the two galleries may have included Hans Vredeman de Vries's *Christ in the House of Martha and Mary* (plate 8)

8 (above) HANS VREDEMAN
DE VRIES *Christ in the House
of Martha and Mary*
9 (below) ATTRIBUTED TO
MARCUS GHEERADTS
THE YOUNGER *Tom Derry*.
The Scottish National
Portrait Gallery

which had been acquired by Henry, Prince of Wales.[2] Many of the pictures still had their protective curtains of taffeta or sarsenet. In the late 1630s the Queen's Gallery at Greenwich still contained the pictures left by Queen Anne: an impressive group of royal portraits and portraits of members of the early Stuart court. Among those that can be identified are Van Somer's portrait of the Countess of Kent (now in the Tate Gallery); a likeness, which can be attributed to Marcus Gheeradts, of the court fool Tom Derry (plate 9)[3]; and, still in the collection, portraits of the Countess of Lennox (James I's grandmother), the Countess of Nassau (by Moreelse) and members of the Brunswick family.

James I had probably brought into the royal collection portraits of his immediate forebears, such as two by Hans Eworth of Lord Darnley: the portrait painted in 1555[4] which escaped from the collection in the eighteenth century, and the little full-length of 1563 with his brother Charles (plate 10). The touching little portrait of King James himself at the age of five, probably by Arnold Bronckorst (plate 11), was given to Charles I by Robert Young.[5]

Queen Anne had a third important group of pictures at Oatlands which had been granted to her in 1611: yet more royal and family portraits; identifiable pictures, such as the *Boy Looking through a Casement* (plate 12) at Hampton Court, which had belonged to Prince Henry; religious pictures in the Gallery[6] and a very large

23

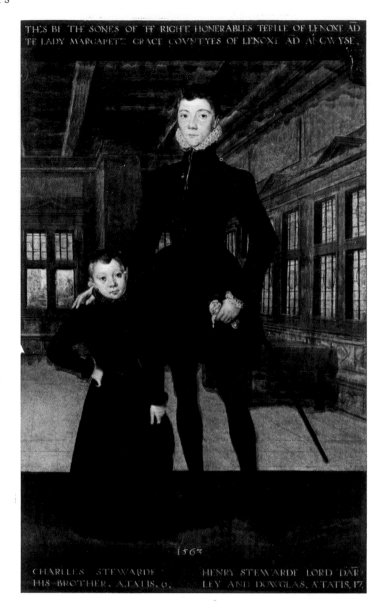

THIS BI THE SONES OF TH RIGHT HONERABLES TERILE OF LENOXE AD
TE LADY MARGARET: GRACE COVNTYES OF LENOXE AD AT GWYSE

1563

CHARLLES STEWARDE
HIS BROTHER. ATATIS. 6.

HENRY STEWARDE LORD DAR
LEY AND DOWGLAS. ATATIS. 17.

10 HANS EWORTH
*Henry, Lord Darnley, and his
Brother Charles, Earl of Lennox*

number of devotional pictures in the Oratory and the adjoining Closet; large pictures (of which one would much like to know the painters) in the Garden Stone Gallery of *Diana and her Nymphs*, a *Market Scene*, the *Entry into the Ark*, the *Feast of the Gods*, *Mammon, Venus and Adonis, Lucretia*, the *Four Evangelists* and the *Angel appearing to the Shepherds*; and, in 'the gallery next y^e vineyard her Ma^{ts} owne picture, w^{th} her horse by her, done at large'. This was Van Somer's well-known portrait *à la chasse* (plate 13) with Oatlands itself in the background. Queen Anne also kept at Oatlands 'Two large leaves of one faire picture to be folded, but now unioynted': the two great *Trinity* panels by Hugo van der Goes, the most magnificent of all early Stuart royal portraits and the most famous Flemish pieces in the royal collection.[7] Thought to have been commissioned by Edward Bonkil (plate III), perhaps on behalf of James III, for the Collegiate Church of the Holy Trinity in Edinburgh, the panels may have been brought south by King James from a visit to Scotland in the summer of 1617.[8] Though the circumstances in which this noble work was commissioned are obscure, it should be seen to some extent as the outcome of close dynastic, cultural, commercial and political links with a foreign country, in this instance between Scotland and Flanders.

James I had a horror of soldiers ('to hear of war was death to him'), but his son,

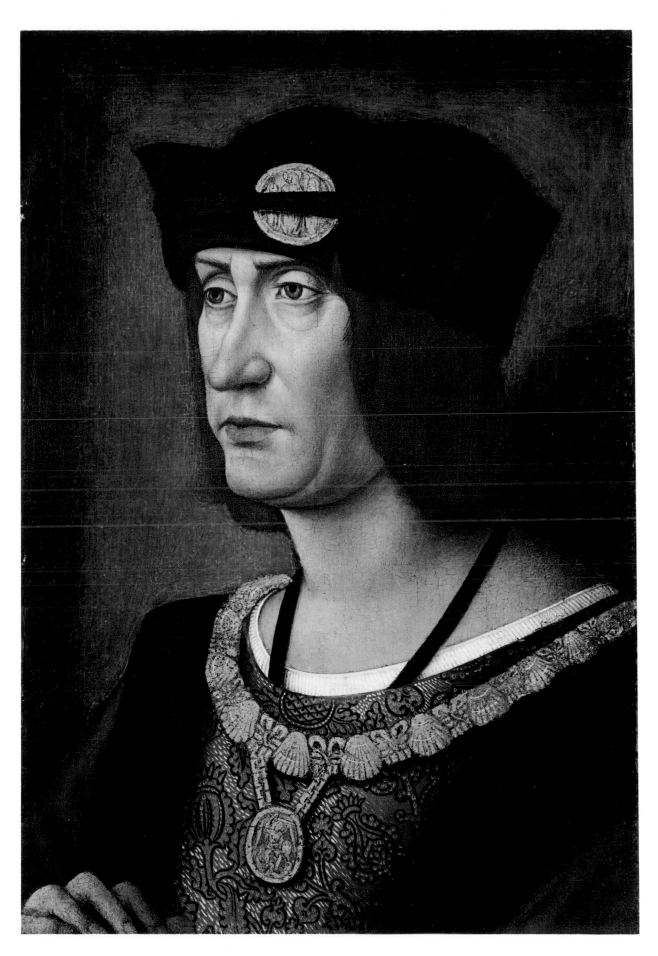

1 ARTIST UNKNOWN *Louis XII, King of France* (see page 17)

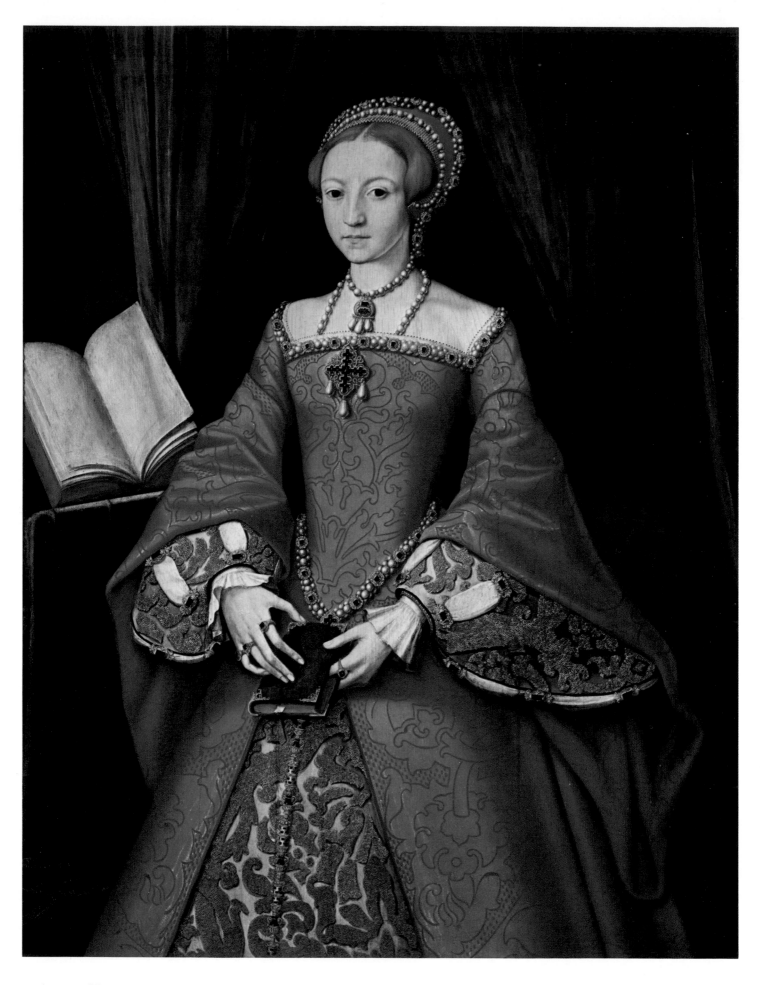

11 ARTIST UNKNOWN *Elizabeth I* (see page 21)

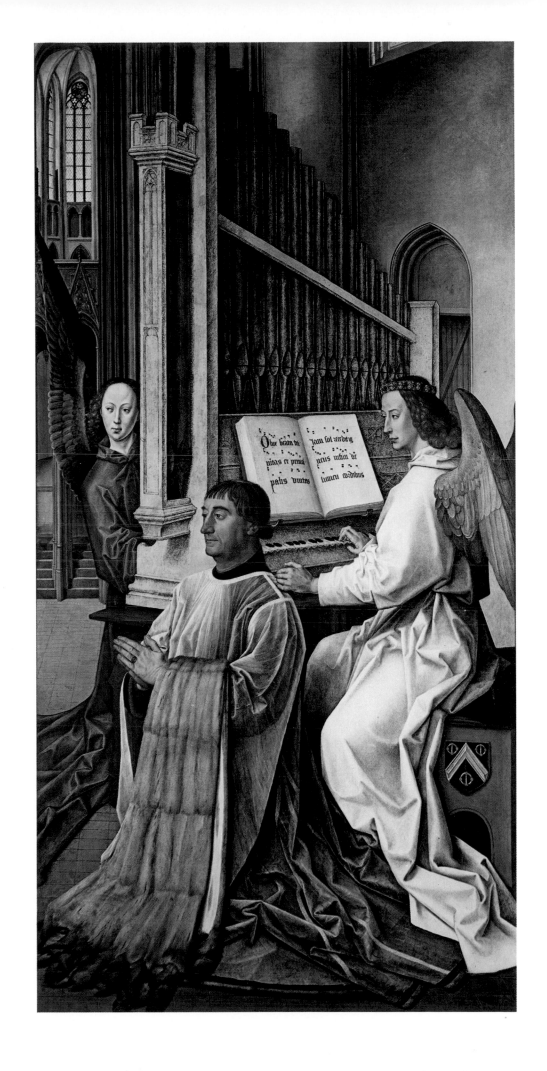

III Hugo van der Goes
Sir Edward Bonkil in Adoration
(see page 24)

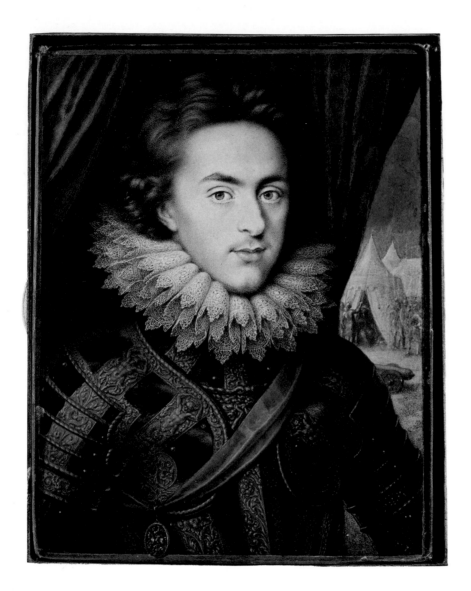

IV ISAAC OLIVER
Henry, Prince of Wales
(see page 25)

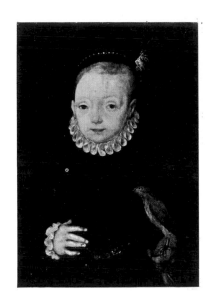

Henry, Prince of Wales, delighted in all manly exercises, in ships, and in arms and armour. As the warrior prince, he is depicted in Isaac Oliver's magnificent miniature (plate IV): 'in a gilded Armor and a Landskip by wherein some Souldiers and Tents are made'.[9] To his contemporaries the hopeful, serious-minded young man seemed the ideal Prince in the Renaissance tradition. He took pains to cultivate 'the exquisite knowledge and understanding' of the arts which Sir Thomas Elyot had thought so important in a gentleman,[10] and 'the cunning in drawing, and the knowledge in the verie arte of painting' which Castiglione enjoined his Courtier not to neglect. The Prince's Treasurer, Sir Charles Cornwallis, wrote that 'He greatly delighted in . . . Building and Gardening; in Music, Sculpture, and Painting, in which last art he brought over several valuable works of great Masters from all countries.'[11] Pictures as well as arms and armour were sent over to the Prince from Holland and in 1611 Sir Edward Conway was hoping to secure the passage to London, on behalf of the Prince, of 'the painter of Delft', who is usually thought to have been Miereveld.[12] An embassy from the States-General to England in the spring of 1610 brought over for the Prince

11 (above) ATTRIBUTED TO ARNOLD BRONCKORST *James VI and I*. The Scottish National Portrait Gallery

12 (right) ARTIST UNKNOWN *A Boy Looking through a Casement*

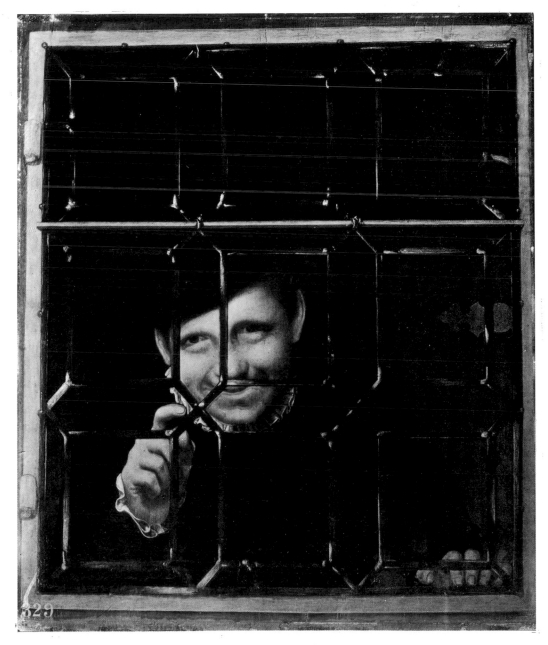

25

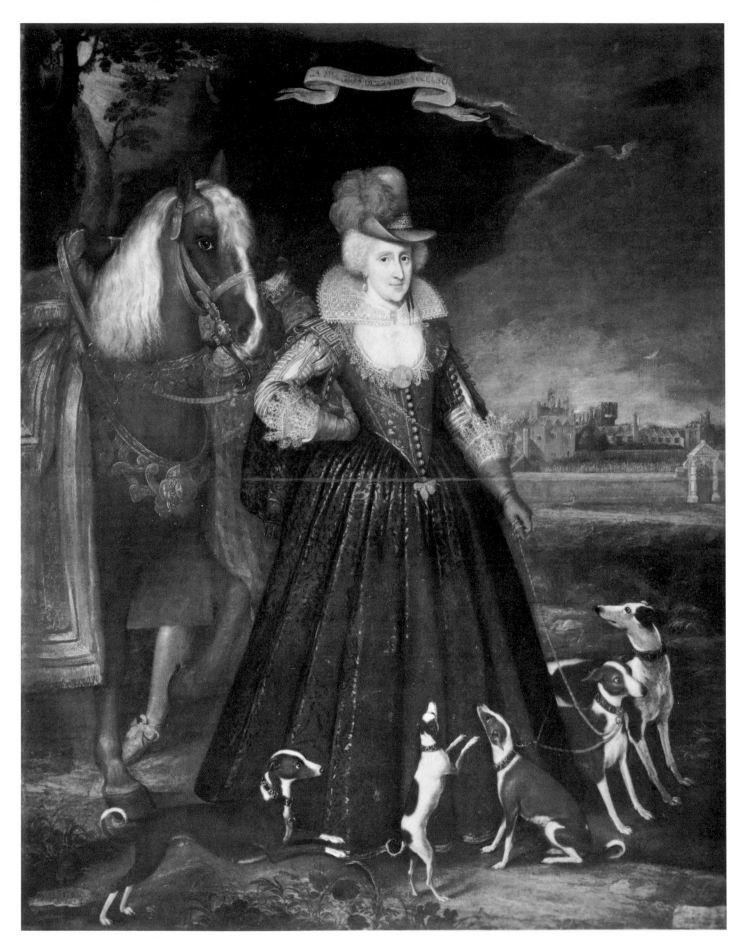

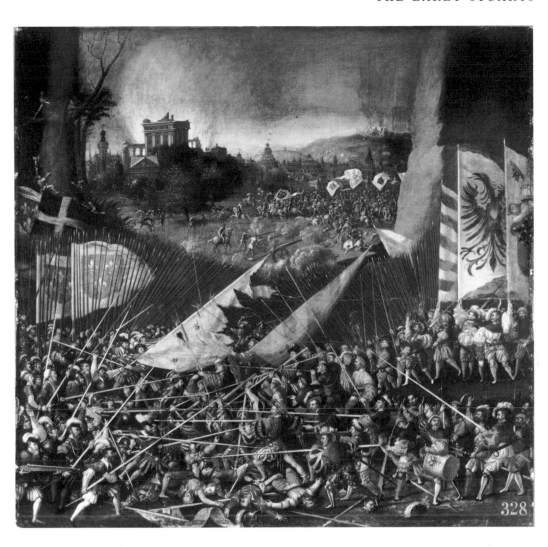

13 (left) PAUL VAN SOMER
Queen Anne of Denmark

14 (right) ARTIST UKNOWN
The Battle of Pavia

'some fine paintings by the best masters' in Holland. This present included 'a certain painting made at Haarlem by Master Vroom of the Sea Battle before Gibraltar' (probably the painting now in the Rijksmuseum) and a *Storm*, which may be the picture by Jan Porcellis which is still in the collection.[13] This panel and a companion *Sea Battle at Night* are the earliest known works by the painter and, like the little panel of the *Battle of Pavia* (plate 14), would have appealed strongly to the Prince.

The Venetian Ambassador, reporting on 14 January 1611, mentions the Prince's enthusiasm for building and gardening: 'he is paying special attention to the adorning of a most beautiful gallery of very fine pictures ancient and modern, the large part brought out of Venice.'[14] This was presumably the gallery at St James's in which the Duke of Saxe-Weimar, visiting England in 1613, saw the pictures which had belonged to the Prince, who had died so untimely on 6 November of the previous year. Work on a library and a gallery at St James's had been carried out by the Officers of the Works, and the rooms may have been fitted up by the Prince's Surveyor, Inigo Jones.[15] In contrast with the parts of the royal collection which the Duke saw at Whitehall, Somerset House and Greenwich, with their old-fashioned preponderance of portraits and battle-pictures, the Prince's gallery contained portraits only of two rulers the Prince had especially admired – Henry IV of France and Prince Maurice of Nassau – and large paintings of *Bacchus, Ceres and Venus*; *Cain and Abel*; *Tityus and the Eagle*; *Holophernes*; the *Tower of Babel*; and the *Sacrifice of Isaac*.[16] The last was presumably the

27

picture which was in Charles I's collection at Whitehall with an attribution to Leonardo Corona: 'This Peece did belong to Prince Henrie'. A *Venus, Bacchus and Ceres* was in Charles I's collection with an attribution to Francesco Albani;[17] a *Prometheus* by Palma Giovane is still in the royal collection; but it is impossible to be certain which of the pictures of *Holophernes* and the *Tower of Babel*, recorded in Charles I's collection, had been inherited from his brother.

Among pictures at Nonsuch in the 1630s were a still-life and a full-length of a seated woman in yellow, 'done by Tintorett', which had belonged to the Prince.[18] A collection of payments made on the Prince's behalf by the Keeper of his Privy Purse, Sir David Murray, includes some tantalizing items: £2 on 29 January 1610 'To my lord of Arundells man with a great picture to his highnes'; £1 on 15 March 1610 to 'my lady Cumberlande's man with two pictures'; and £3 in July of the same year to Lord Exeter's and Sir Noel Eavom's men with pictures 'to his highnes'.[19] Portraits of prospective brides were also sent over to the young Prince: Princess Christine of France or the two Savoy Princesses whose likenesses were despatched to King James by Sir Henry Wotton. During the negotiations for a possible marriage between the Prince and Princess Caterina de' Medici, the Prince asked for pictures among the gifts which were being prepared for him in Florence, as well as for the bronzes which actually arrived.[20] Prince Henry's collection was sufficiently large and carefully looked after to justify the making of a special brand (Fig 1); and it was kept together at Whitehall, at least for a time, as a separate entity. Constantine Huygens, who visited the collection on 3 July 1618, still described it as '*la galerie à peintures du feu prince*'. Then it passed to the Prince's brother, the young Prince Charles, whose Surveyor always specially noted in his catalogue, drawn up some twenty years later, the provenance of those pieces which had come 'by the decease of Prince Henry of famous memory'.

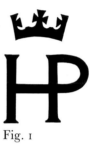

Fig. 1

3

CHARLES I

PRINCE HENRY'S ACCOMPLISHMENTS and bearing must have made a lasting impression on his tongue-tied younger brother who walked as chief mourner in his funeral procession; but Prince Charles's growing love of pictures was also stimulated by the tastes of his father's extravagant and wayward favourites, the Earl of Somerset and his successor, George Villiers, ultimately Duke of Buckingham; by the more scholarly and austere enthusiasms of the Earl of Arundel; and by the expertise of Inigo Jones. Sir Dudley Carleton had bought pictures for the Earl of Somerset in Venice, where Sir Dudley was ambassador, and had sent them to London in the spring of 1615 with others bought for the Earl by Daniel Nys and with twenty-nine cases of antique marble figures and heads. When Somerset, later in the year, was disgraced, the King seized his goods. The recently arrived pictures bore the names of Bassano, Veronese, Tintoretto, Schiavone and Titian. At least one of these pictures seems to have passed into the royal collection: 'The Labyrinth of Tintoretto' can probably be identified with the picture of a maze at Hampton Court.[1] The Duke of Buckingham was an even more enthusiastic collector of Venetian pictures. One can imagine the impact on the Prince of Wales, and indeed on the court as a whole, of such a picture as Titian's *Ecce Homo*, which Balthasar Gerbier secured for Buckingham in Venice in 1621.[2] In a 'character' of the young Prince, written on 21 September 1622, the Venetian ambassador said that 'he loves old paintings, especially those of our province and city'.[3] This particular love was strengthened by his experiences during his visit to Madrid with Buckingham in 1623.

Peace with Spain, signed in 1604, had been celebrated in the traditional way when Philip III sent to London portraits of himself and his Queen (plate 15), painted in 1605 by his court painter, Juan Pantoja de la Cruz. Soon after King James's accession, the rulers of the Spanish Netherlands, the Archduke Albert and the Archduchess Isabella, gave the King portraits of themselves by Otto van Veen.[4] The four portraits were hung in the Cross Gallery at Somerset House. The wily figure of Count Gondomar is still to be seen on the walls of the Haunted Gallery at Hampton Court. He had been primarily responsible for persuading King James to look with favour on an alliance with Spain by marriage. The Prince's ride to Spain in 1623, in an effort to win the hand of the Spanish Infanta, was the unexpected culmination of his efforts. Politically and diplomatically the 'Venture' was a fiasco, but the Prince – and his companions – profited in other ways

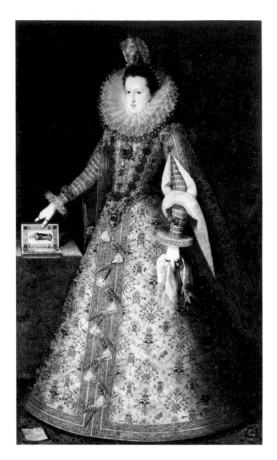

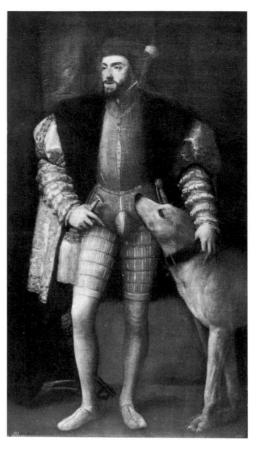

15 (far left)
JUAN PANTOJA DE LA CRUZ
Margaret, Queen of Spain

16 (left) TITIAN
Charles V
Prado, Madrid

from the experience. The Prince and Buckingham laid out considerable sums on works of art. An account book,[5] kept by Sir Frances Cottington during the visit to Spain, records purchases made by the Prince, sometimes through Endymion Porter. A *Last Supper* by Eugenio Caxes, a 'picture of our Ladie' by Dürer and a copy of a *Christ carrying the Cross* by Titian are specifically mentioned; and there are general references to pictures which had been bought for the Prince and to the cases and serecloth in which pictures were packed up for despatch to England. The sight of the magnificent collections formed by Charles V and Philip II must have been overwhelming, and it fired the Prince's growing passion for Venetian painting and for the work of Titian in particular. The pictures he acquired in Spain included such masterpieces as the full-length of Charles V (plate 16), the *D'Avalos Allegory* (plate 17), bought at an auction by the Prince, and *The Girl in a Fur Cloak* (plate 18). Just before the Prince left Spain, the young King Philip IV presented two pictures to him: a Correggio of *The Madonna and Child with St Joseph* (probably the picture in the Musée des Beaux-Arts, Orléans) and one of the most glorious pictures ever to have been in the collection, 'the great Lardge and famous peece called in Spaine the Venus out of Pardo' (plate 19).[6]

In the summer of 1623 the young Velazquez had come to Madrid. At the same time as he was painting his first portrait of Philip IV he made a sketch of the Prince of Wales. On 8 September Endymion Porter paid one hundred *escudos* 'unto a Painter for drawing the Princes Picture'.[7] The return of the fleet bearing the Prince of Wales and his own and Buckingham's new treasures was recorded by Cornelis Vroom in a big canvas which is still in the collection. One more great purchase was made at this period. The Prince wrote from Madrid on 28 March 1623 to ask that money be set aside for the delivery of 'certaine patterns to be brought out of Italy, and sent to us into England for the making thereby a Suite of Tapestry. wch drawings (as we remember) are to cost neir

19 (right) TITIAN
Jupiter and Antiope: the Venus of the Pardo. Louvre, Paris

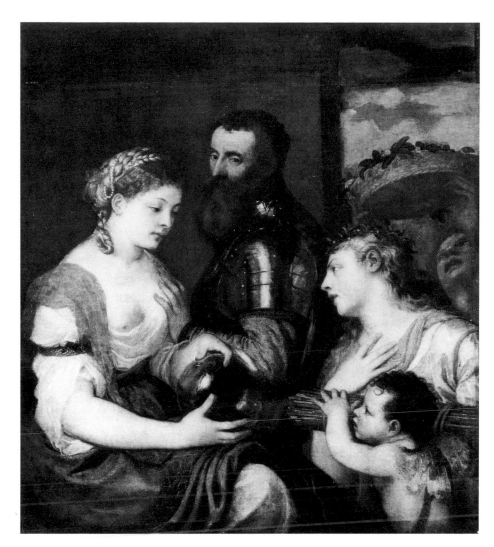

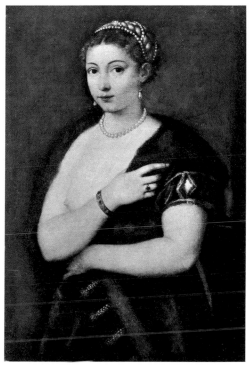

17 (left) TITIAN
The Allegory of Alfonso d'Avalos.
Louvre, Paris

18 (below) TITIAN
The Girl in a Fur Cloak.
Kunsthistorisches Museum, Vienna

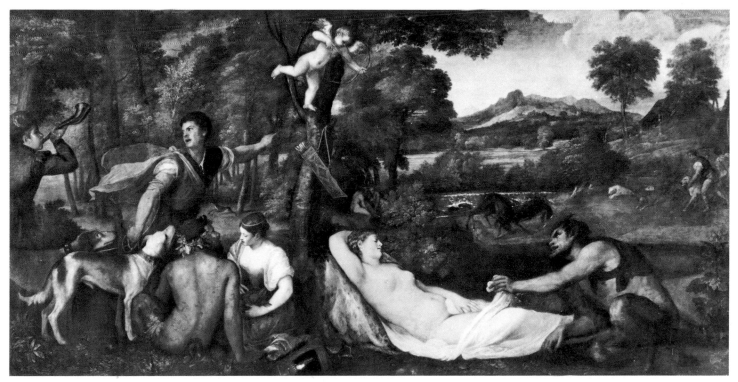

uppon the poynt of Seaven hundred pounds'. These were Raphael's Cartoons (plate 20) which were being bought as 'patterns' for tapestries to be woven at King James's newly-founded factory at Mortlake.[8]

After his return to London Charles I, although he never gained his Spanish bride, remained keenly interested in the works of art that might still be acquired in Spain. His ambassador, Sir Arthur Hopton, acquired pictures for him, including works by 'El Labrador' (e.g., plate 21), and was responsible for helping the young English painter, Michael Cross, who had been sent over by the King to copy famous pictures for him. Hopton reported the arrival in Spain in 1633, as a present to Philip IV from the English King, of Orazio Gentileschi's *Finding of Moses* (now in the Prado). Late in 1639 only the 'lazynesse' of Velazquez (it is presumed to have been he) was holding up the despatch to London, for Queen Henrietta Maria, of portraits of the Spanish King and Queen and their son in return for portraits, for which Van Dyck had been paid, of the King, Queen and Prince of Wales.[9]

Even before his accession, Charles I's collection must have been very impressive, the pictures newly brought from Spain hanging with those which had belonged to his mother and his brother and with such masterpieces as Holbein's *Erasmus* (plate 22), given to him by his brother's tutor, Sir Adam Newton. He had also succeeded in persuading Rubens to paint for him the magnificent *Self-Portrait* (plate 23). It was no mean achievement on the part of a seemingly diffident, but deeply sensitive, young connoisseur to have made contact in his early twenties with two such artists as Velazquez and Rubens. In Rubens's own words: 'The Prince of Wales . . . is the greatest amateur of paintings among the princes of the world.' He had probably exerted himself on the Prince's behalf in painting the *Self-Portrait* because early in 1621 the Prince, who at that point owned only a *Judith and Holofernes* 'w^ch Rewben

20 RAPHAEL
The Sacrifice at Lystra.
Victoria and Albert Museum

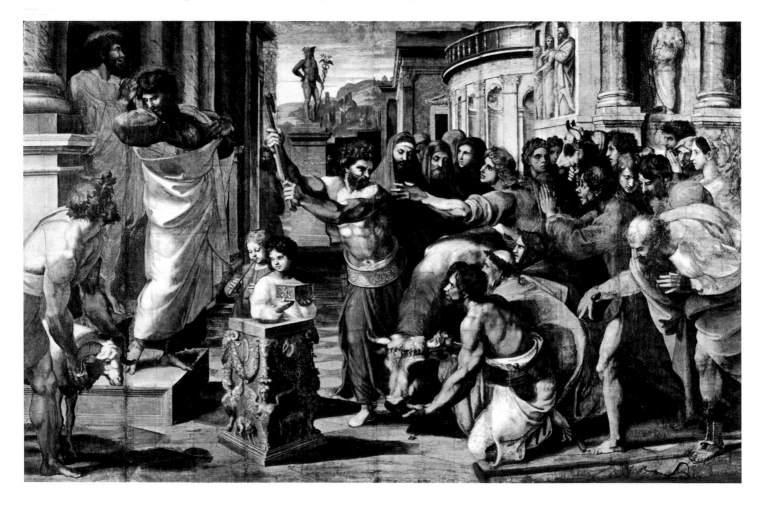

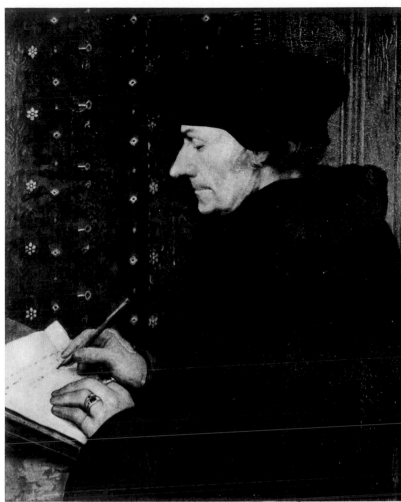

21 (above left)
JUAN FERNÁNDEZ,
'EL LABRADOR' *Still-Life*

22 (above right)
HANS HOLBEIN THE YOUNGER
Erasmus. Louvre, Paris

Fig. 2

disavoweth', had refused to admit into his Gallery at St James's a picture (probably a *Hunt*) which had been sent over by Sir Dudley Carleton: 'in every paynters opinion he hath sent hether a peece scarse touched by his own hand, and the postures so forced . . . I could wishe, thearfore that the famus man would do soum on thinge to register or redeem his reputation in this howse and to stand amongst the many excelent wourkes w^ch ar hear of all the best masters in Christendoum.'[10] In imitation of his brother, the Prince caused a special brand (Fig 2) to be made with which his pictures could be marked.

Between his accession on 27 March 1625 and his flight from London on 10 January 1642, Charles I and Henrietta Maria presided over a civilized court – perhaps the most civilized that this country has ever known – to which the magnificent collections formed by the King and his fellow collectors provided a lustrous background. Sir Henry Wotton, one of the most cultivated and widely-travelled Englishmen of the day, addressed the King: 'the most splendid of all your entertainments, is your love of excellent Artificers, and Works: wherewith in either Art both of Picture and Sculpture you have so adorned your Palaces, that Italy (the greatest Mother of Elegant Arts) or at least (next the Grecians) the principal Nursery may seem by your magnificence to be translated into England.'[11] The King's enemies, however, were to attack him for 'squandering away millions of pounds on old rotten pictures and broken-nosed marbles'. The young Joachim von Sandrart, accompanying Honthorst to London in 1628 and staggered by the riches of the collections he saw, described the King as an outstanding lover of the arts.[12] Rubens was struck by 'the incredible quantity of excellent pictures, statues, and ancient inscriptions which are to be found in

33

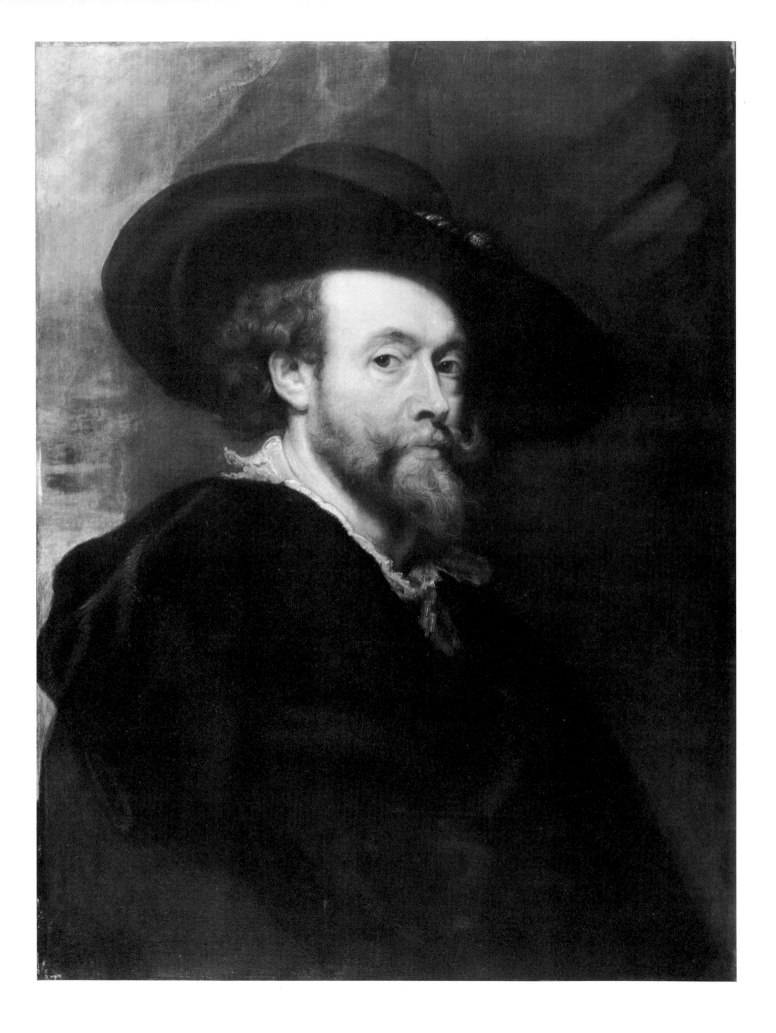

23 (left) SIR PETER PAUL
RUBENS *Portrait of the Artist*

this Court. . . . I have never seen such a large number in one place as in the royal palace and in the gallery of the late Duke of Buckingham.'[13] Van Dyck privately passed a word of warning in 1636 to an agent, acting on behalf of a merchant in Perugia who wanted to sell a collection of pictures in England, not to underestimate the standards of connoisseurship in the King's circle.[14] When Cardinal Barberini was preparing a selection of pictures as a present to the English King, he was informed that it did not matter whether old or modern pictures were chosen, *purche siano buoni*; he too was uneasy that it might not be realized that the King had *buon naso* for pictures. The Puritan Lucy Hutchinson, wife of a regicide Colonel, drew a contrast between the bawdy court of James I with its 'fools and bawds, mimics and catamites' and the court of his son ('temperate, chaste and serious'), where 'men of learning and ingenuity in all arts were in esteem, and received encouragement from the king, who was a most excellent judge and a great lover of paintings, carvings, gravings, and many other ingenuities.'[15]

The achievement of the principal *cognoscenti* at Whitehall, and the quality of the works of art for which they vied, are attested by the exchanges that they made among themselves. The Earl of Holland received a bronze bust of the King in exchange for a *Landscape* with an attribution to Bonifazio; in 1639 a Franciabigio was given by the Fourth Earl of Pembroke, who received miniatures of the King and Queen in return; and on another occasion he was given a version of one of Van Dyck's portraits of the Queen in exchange for a *Self-Portrait* by Pordenone. Among exchanges with the widowed Duchess of Buckingham was a Veronese (?) of *Leda and the Swan* which she gave the King in return for Fetti's *Vision of St Peter* (plate 24). The Third Marquess of Hamilton gave the King a good version of François Clouet's portrait of Mary, Queen of Scots, and received in return Fra Semplice da Verona's huge *Expulsion of the Wedding Guest*; on one occasion, early in 1639, the King handed over to Hamilton a *Holy Family*, now attributed to Luca Penni, 'upon some consideration of a wager which he hath won of the King'.[16] The Third Earl of Pembroke, the Lord Steward, gave the King a female portrait and a painting of the Infants Christ and the Baptist, attributed respectively to Giovanni Bellini and Parmigianino, in exchange for a 'little Judith' (plate 25) which was then said to be by Raphael. His brother, the Fourth Earl, Lord Chamberlain, received from the King the book of Holbein's portrait-drawings (which he at once gave to Arundel) in return for Raphael's little *St George and the Dragon* (plate 26) 'in a black ebbone & speckled woodden frame'. But the most spectacular of such exchanges took place when Roger de Liancourt, a Gentleman of the Bedchamber to Louis XIII, sent over to the King 'for a present' Leonardo da Vinci's *St John the Baptist* (plate 27). For this picture, 'whereof the Arme and the hand hath bin wronged by some washing before it came to your Ma^tie', Charles I ceded his Holbein of Erasmus ('side faced lookeing downwards') and 'our Lady and Christ and St John half figures' by Titian which had belonged to John Donne.[17]

The King's relations sent him pictures from abroad. His sister, the Queen of Bohemia, sent him a portrait of Erasmus by Visscher; and a little *Landscape with Lions* by Savery was given by her son, the Elector Palatine. Many more pictures were presented to the King and Queen by friends, fellow-collectors and courtiers. Arundel and the Earl of Ancrum were especially generous; Sir John Suckling gave the King a little Neefs of *The Woman taken in Adultery*; Sir Robert Killigrew gave him two Holbeins, one of them the *Reskimer* at Windsor; William Murray and Sir David Murray gave, respectively, little pictures by Rottenhammer and Valkenborch; Sir James Palmer's presents included the *Wilton Diptych*[18] (plate 28). Sir Francis Crane, Sir Thomas Roe, and Lady

24 (below) DOMENICO FETTI
The Vision of St Peter. Kunst-
historisches Museum, Vienna

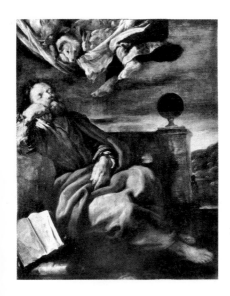

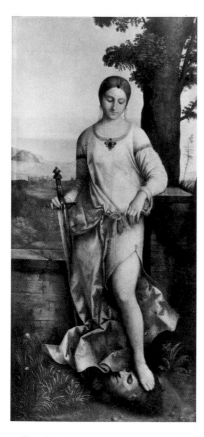

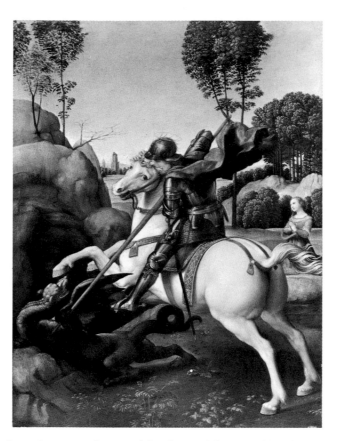

Coningsby were among the other donors, along with the noblemen Hamilton, Newcastle, Feilding, Holland and Danby.

On the Continent the King's ambassadors, special envoys and diplomatic agents were under instructions to look out for works of art on his behalf. When Hamilton was on his abortive expedition to assist Gustavus Adolphus, the King wrote to him on 30 April 1632: 'I hope shortly you will be in a possibility to perform your promise concerning pictures and statues at Muneken [i.e., Munich], therefore now in earnest do not forget it.'[19] The pictures Hamilton brought back from Germany included the *Assumption of the Virgin* by Calvaert; others bore attributions to Guido Reni, Frans Francken II, Pencz, Van Veen, Palma Giovane and Cranach.[20] Sir Robert Anstruther, a professional diplomat, brought back from Germany a family group by Bernhard Strigel.[21] The two portraits of the Cuspinians by Cranach (plates 29, 30) may have been brought to London by Hamilton or Anstruther.[22] Sir Henry Wotton and Sir Dudley Carleton, later Lord Dorchester, were tireless in looking for pictures; Carleton gave the King, with other pictures, the huge Rubens of *Daniel in the Lions' Den*[23] and paintings by Torrentius; Sir Henry Vane secured in Germany Holbein's *Hans of Antwerp* and a double portrait 'done by some good Germaine painter' who is now thought to be Ulrich Apt. Holbein's *Derich Born* (plate 31) also came into the King's possession. Cottington and Hopton were active in Spain. Cottington gave pictures by 'Labrador' and others attributed to Perino del Vaga and Giorgione; Hopton, who gave the King pictures by Elsheimer and Jan Brueghel, also managed to secure for him the fragment cut from the right side of Titian's *Last Supper* in the Escorial: 'A Long black fellow cut of a peece of Tytsian'.[24] Endymion Porter, who had been with the Prince and Buckingham in Spain and was one of the most knowledgeable and well-travelled of the connoisseurs in the King's circle, acquired for the collection some particularly distinguished pictures, among them a grisaille of *Three Soldiers* by Pieter Bruegel (plate 32), a flower-piece by Daniel Seghers, *Friars in a Nunnery* by Aersten (still at Hampton Court), the magnificent Van Dyck of Henrietta of Lorraine (now at Kenwood) and

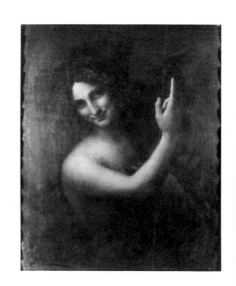

36

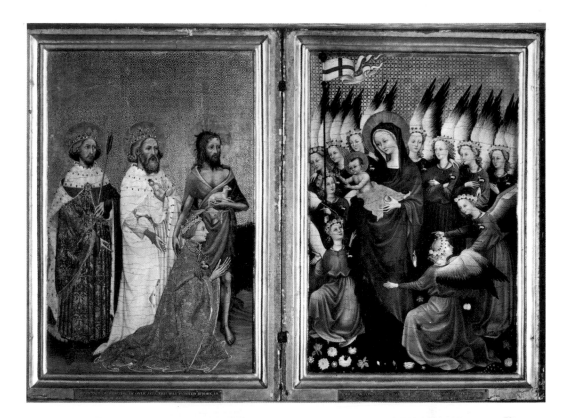

28 (right) FRENCH SCHOOL
The Wilton Diptych.
National Gallery, London

29 (below left)
LUCAS CRANACH THE ELDER
Johann Cuspinian. Oskar
Reinhart Collection, Winterthur

30 (below right)
LUCAS CRANACH THE ELDER
Frau Cuspinian. Oskar
Reinhart Collection, Winterthur

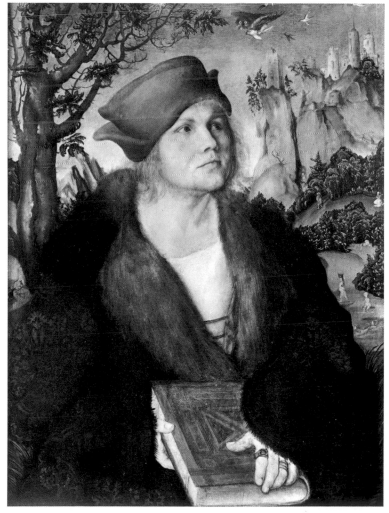

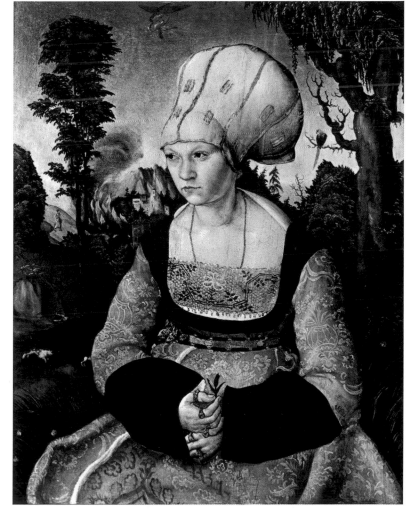

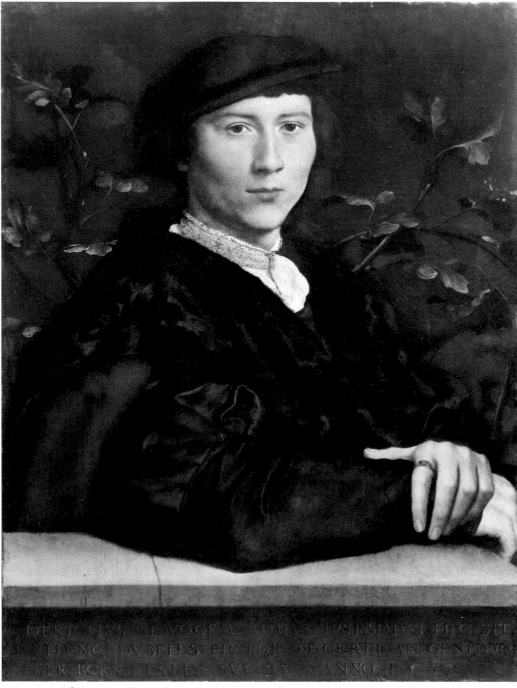

31 HANS HOLBEIN
THE YOUNGER *Derich Born*

'the great S.^t George' by Rubens which is thought to be the famous *Landscape* (plate 33) still in the collection.[25] Returning through Nuremberg in November 1636 from an embassy to the Emperor Ferdinand II, the Earl of Arundel paid a visit to the Stadthaus. There he saw Dürer's portraits of his father and himself (plate 34) which the City Fathers, in a gesture of rare munificence, gave to the Earl for his master[26]. In 1629 Sir Robert Kerr (later Earl of Ancrum) led a mission of condolence to the Queen of Bohemia who was living in exile in The Hague. He returned with two pictures by the young Rembrandt – a *Self-Portrait* (plate 35) and the so-called *Artist's Mother* at Windsor – and one by Jan Lievens, which had probably been given to him for the King by the Prince of Orange through the mediation of Constantine Huygens, who had a keen admiration for the work of the two young men.

In addition to these acquisitions through friendship and diplomacy, much was

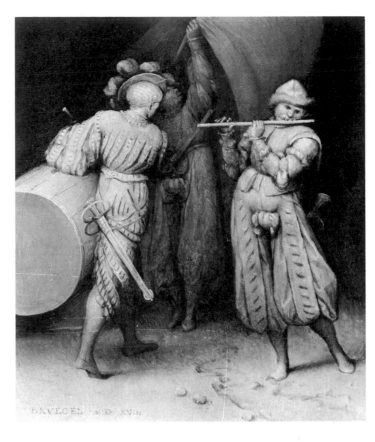

32 (left) Pieter Bruegel
the Elder *Three Soldiers*.
Frick Collection, New York

33 (below) Sir Peter
Paul Rubens *Landscape with
St George and the Dragon*

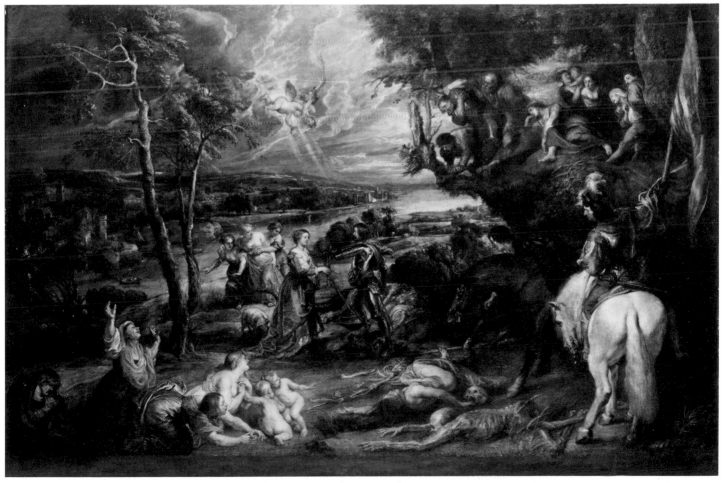

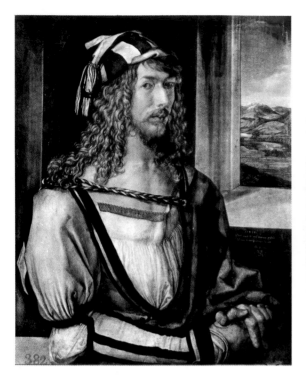

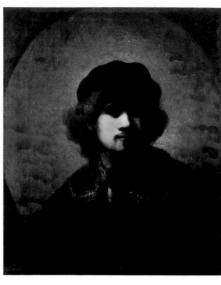

34 (far left) ALBRECHT DÜRER *Portrait of the Artist*. Prado, Madrid

35 (left) REMBRANDT *Portrait of the Artist*. Walker Art Gallery, Liverpool

acquired by direct purchase. A group of pictures bought from William Frizell in 1638, for example, included the series of panels (still at Hampton Court) by Polidoro. The King's agents were busy on his behalf on the Continent, especially in Italy. At the Restoration in 1660 Michael Cross petitioned Charles II for the continuance of an annual stipend of £200 which he had been granted by Charles I, whom he claimed to have served for twenty-eight years in copying the work of famous painters in Spain and Italy and in making new collections[27]. Francesco and Giulio, sons of Orazio Gentileschi, were sent to Genoa in 1627 to buy 'a study of Pictures' for the King.[28] The most effective of the King's agents were Nicholas Lanier and Daniel Nys, who made a spectacular purchase on the King's behalf – one of the most remarkable *coups*, indeed, which has ever been brought off in the entire history of the art trade: the acquisition of a large part of the collections formed by the Gonzaga Dukes of Mantua.

This celebrated collection had been enriched in the early years of the century by Duke Vincenzo I and by his two eldest sons, Francesco IV and Ferdinando I, first cousins of the English Queen. The dynasty was by now in a state of total moral and financial collapse and Ferdinando was prepared to consider selling part of the collection. As early as 1623, before the King's accession, the Duke had made him a 'courteous offer of pictures'. In the summer of 1625 the composer Lanier, Master of the King's Music and fluent in Italian, was in Italy on the King's behalf 'to provide for him some choice Pictures in Italie'. In June he was preparing to export to England a group of pictures which included the two panels of the crucified thieves by Perino del Vaga.[29] Nys, a merchant and picture-dealer with business connections in Venice and Mantua, was almost certainly employed by Lanier, on the King's behalf, to negotiate with the Mantuan court; he described Lanier as possessing *gran gusto delle pitture e disegni*. Duke Vincenzo II, who succeeded his brother in 1626, was willing to sacrifice the greater part of his famous inheritance and welcomed the suggestion that it should be sold to England, as this would help to keep the transaction secret. By the summer of 1627 the list of pictures to be sold had been settled, the price fixed at £15,000 and the pictures prepared for shipment. Nys then began to negotiate for a second instalment, a

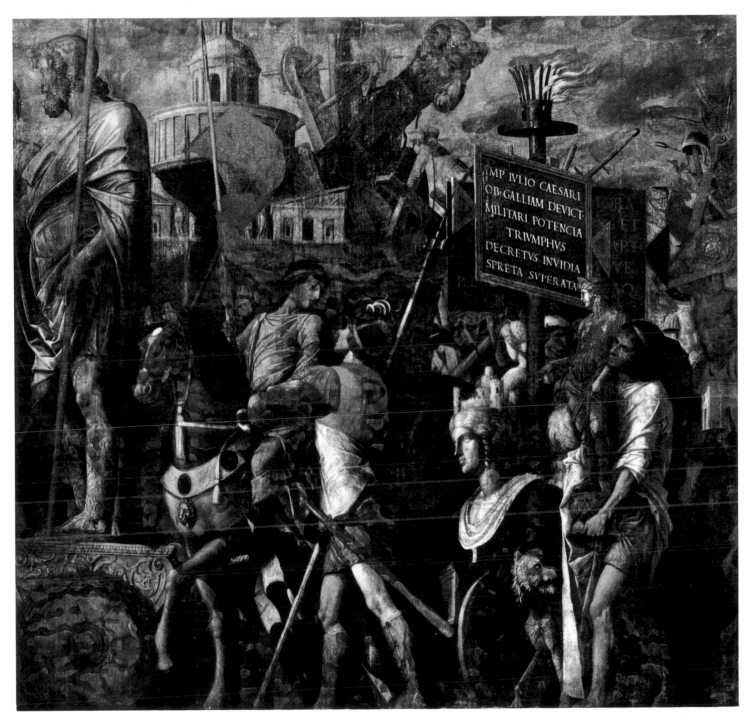

The sign in the image reads:
IMP. IVLIO CAESARI
OB GALLIAM DEVICT
MILITARI POTENCIA
TRIVMPHVS
DECRETVS INVIDIA
SPRETA SVPERATA

36 ANDREA MANTEGNA
*The Triumph of Caesar, II:
The Bearers of Standards and
Siege Equipment*

composite collection of marbles and pictures, to include Mantegna's *Triumph of Caesar* (plate 36) which had hitherto been held back. These negotiations, facilitated by the death of the Duke late in 1627, were completed early in 1628 and the bargain clinched at a further £10,500. Even at this stage, it does not appear to have been generally known that Nys had been acting on behalf of the English King.

Lanier prepared the pictures in the first consignment for shipment in cases on the *Margaret*, which sailed from Malamocco. He himself set off overland with a Raphael and with Correggio's two *Allegories of Virtue* (plate 37) and *Vice*, which, being in tempera, could not be subjected to the sea air: 'the finest pictures in the world, and well worth the money paid for the whole, both on account of their rarity and exquisite beauty'. Nys described his purchase, with justification, as 'so wonderful and glorious a

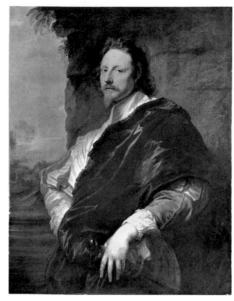

37 (far left) CORREGGIO
Allegory of Virtue. Louvre, Paris

38 (left) SIR ANTHONY
VAN DYCK *Nicholas Lanier*.
Kunsthistorisches Museum, Vienna

collection, that the like will never again be met with; . . . truly worthy of so great a king as his Majesty of Great Britain.' But those who had loved the Mantuan collection must have shared Rubens's distress when he met Lanier, who had arrived in Antwerp in June 1628 on his way back to London: 'this sale displeases me much.'[30] It also deeply disturbed those in the King's circle who actually had to find the money.

It is not surprising that Charles I hung up Van Dyck's portrait of Lanier (plate 38), *quell' Inglese di pelo biondo*, in the Bear Gallery at Whitehall. Lanier had transformed the royal houses with pictures overwhelming in their impact: a huge collection which numbered such masterpieces, for example, as Mantegna's *Dead Christ* (possibly the picture in the Brera) and the *Death of the Virgin* (plate 39) in the Prado; Raphael's *La Perla* (plate 40); a large number of pictures by Giulio Romano, among them the *Nativity* and the *Triumph of Titus and Vespasian* (plate 41), both in the Louvre; Andrea del Sarto's *Madonna della Scala* (plate 42); four Correggios, *Venus, Mercury and Cupid* (National Gallery), *Jupiter and Antiope* (plate 43) and the two *Allegories*, in the Louvre; Dosso's *Holy Family* (plate 65) at Hampton Court; and a group of Titians, including the *Entombment* (plate 44) and *Supper at Emmaus* in the Louvre, the *Twelve Emperors*, the *Allocution of Marshal D'Avalos* and *Venus with the Organ-Player* in the Prado. There was also a fine display of contemporary Italian pictures: works by the Carracci, almost certainly including Annibale's *Butcher's Shop* (plate 45); Fetti (especially well represented); Baglione; Guido Reni's four canvases of the *Labours of Hercules* (plate 46); and the magnificent *Death of the Virgin* by Caravaggio (plate 47).

A collection, growing so fast and assembled from all points of the compass, required

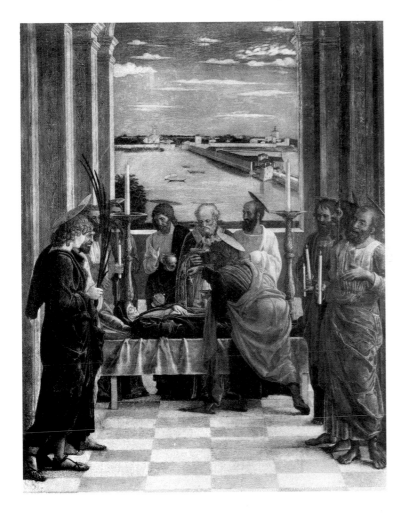

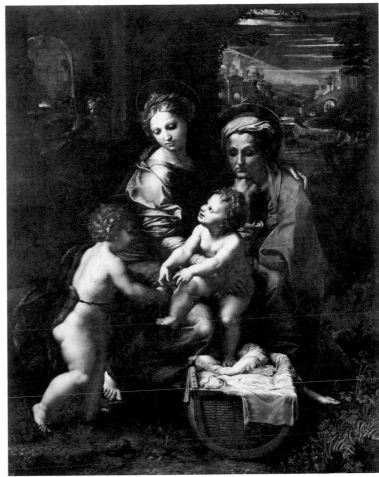

39 (above left) ANDREA
MANTEGNA *The Death of
the Virgin.*
Prado, Madrid

40 (above right) RAPHAEL
The Holy Family: 'La Perla'.
Prado, Madrid

41 (right) GIULIO ROMANO
The Triumph of Titus and Vespasian.
Louvre, Paris

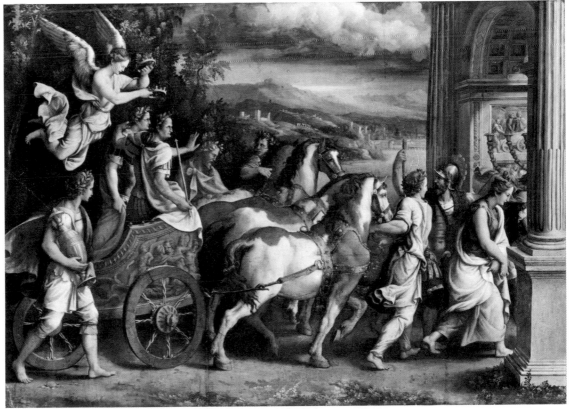

the services of a professional custodian. Before his accession Charles I had appointed as Keeper of the Cabinet Room (then at St James's) Abraham van der Doort, a craftsman of Dutch origin who had worked at the court of the Emperor Rudolf II and, coming to England, had entered the service of Prince Henry. He was a modeller in wax and a specialist in coins and medals; he had been charged with the melancholy task of making the face and hands for the funeral effigy of his master. The appointment to the Cabinet Room (the contents of which were ultimately transferred to Whitehall) was to some extent in fulfilment of a promise made by Prince Henry; but in May 1625 the King appointed Van der Doort to another, probably entirely new, post in the Royal Household: Overseer or Surveyor of 'all our pictures of Us, Our Heires and Successors

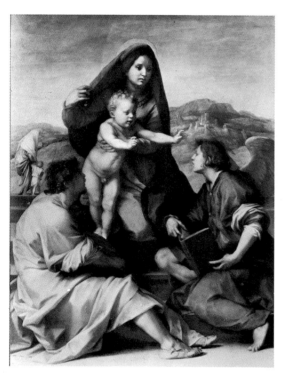

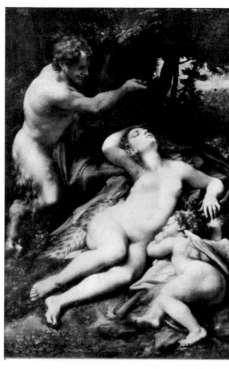

42 (far left) ANDREA DEL SARTO *The Virgin and Child with a Saint and an Angel.* Prado, Madrid

43 (left) CORREGGIO *Jupiter and Antiope.* Louvre, Paris

44 (below) TITIAN *The Entombment.* Louvre, Paris

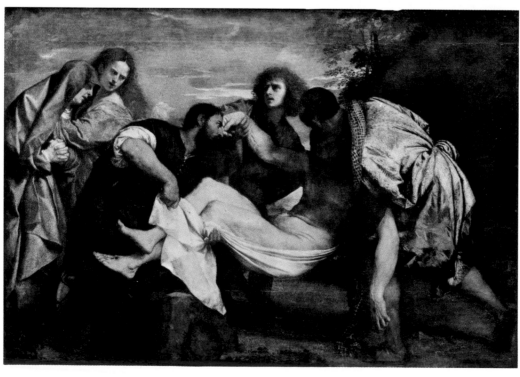

. . . at Whitehall or other our houses of resort'. The appointment was for life and carried an annual salary of £40. The duties of the office have not greatly changed:

. . . to prevent and keepe them (soe much as in him lyeth) from being spoiled or defaced, to order marke and number them, and to keepe a Register of them, to receive and deliver them, and likewise to take order for the makeing and coppying of Pictures as Wee or the Lord Chamberlaine of Our Houshold shall directe, And to this End . . . hee shall have Accesse at convenient Times unto Our Galleries Chambers and other Roomes where Our Pictures are.

Van der Doort's tenure of the new post was not happy. He had a limited knowledge of English and, in carrying out his duties as he saw them, was so frustrated by a group of courtiers who felt they had some kind of long-established responsibility for certain of

45 (right) ANNIBALE CARRACCI *The Butcher's Shop.* Christ Church, Oxford

46 (below left) GUIDO RENI *Nessus and Deianira.* Louvre, Paris

47 (below right) CARAVAGGIO *The Death of the Virgin.* Louvre, Paris

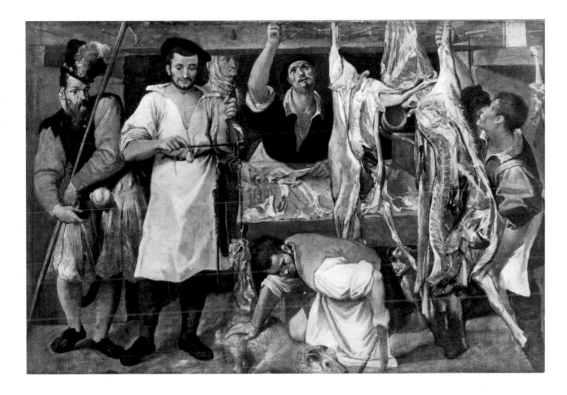

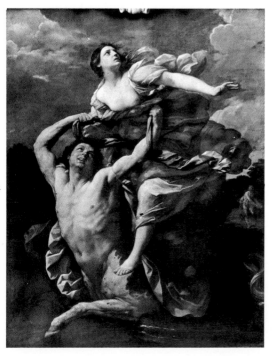

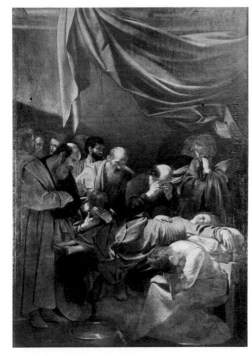

48 Label and brand on the back of Dominico Fetti's *Vision of St Peter* (see plate 24). Kunsthistorisches Museum, Vienna

Prince Henry's goods, that he was driven in the summer of 1640 to suicide: either in despair at the loss of a miniature which the King had asked him to look after with special care or through a jealous fear (apparently unfounded) that the King 'designed some other man to keepe his pictures'. After his death the responsibilities of his post were divided: his underling Jan van Belcamp had charge of pictures on the King's side, Daniel Soreau of those on the Queen's. A new brand (Fig 3) had been designed in Van der Doort's time for the backs of the King's pictures; labels, a number of which survive (e.g., plate 48), were stuck on the back of the pictures; and the 'Register' was begun.

It was never completed. For Whitehall the rough draft seems to be as complete as such a document can ever be; fair copies were made only for two of the rooms. The draft also contains a list of the pictures at Nonsuch and summary notes on pictures at Greenwich. The finished entries in Van der Doort's catalogue are written in greater detail and provide more information on provenance, size, condition and frames than can be found in any known inventory of the royal collection before the great inventory begun, at Prince Albert's instigation, by Richard Redgrave. Some of the attributions are couched in cautious terms that explain the high regard Van Dyck had for the standards of connoisseurship at Whitehall: 'Saide to Be done by Corrigio & by Some esteemed to be a verie good old coppie'; 'Said to be of Leonard de Vincia: or out of his Scoule'; 'an Italian painter as yet unknowen'; 'by one at Room who is an Immetator of Caravagio'. Of the experts in the King's circle, it was Inigo Jones who appeared to the world at large as the most authoritative – *molto intendente di Pitture*. When a long-

Fig. 3

expected group of pictures arrived from Cardinal Barberini, he ostentatiously threw off his coat and, candle and eye-glasses in hand, joined the King in a careful examination of them in front of the Queen and her ladies.[31]

Van der Doort endeavoured to keep the pictures from being 'spoiled or defaced'. His notes on condition and conservation must be among the earliest of their kind. In spite of Lanier's precautions, the pictures from Mantua had suffered damage during their sea voyage: 'quicksilver was gott in among them & made them all black'. Some pages of Van der Doort's register are taken up with a sombre record of pictures 'utterly ruined and Spoyled' by quicksilver and then by unskilful attention. Repairs, often extensive, were carried out where possible. Jerome Lanier, Nicholas's uncle, claimed later to have cleaned the surfaces with aqua-vitae. Richard Greenbury was paid £140 in 1637 for restoring and mending Mantua pictures. John de Critz, the Serjeant Painter, and Daniel Soreau also repaired pictures; De Critz, with Edward Pierce and Matthew Gooderick, did much painting and gilding of frames; Zachary Taylor is recorded as a carver of frames.[32]

From Van der Doort's pages one gains a valuable indication of how the King arranged his pictures. The long galleries at Whitehall or Greenwich, still rather old-fashioned in appearance, were enriched with portraits by Mytens, Van Somer, Honthorst, Miereveld, Bunel and Van Dyck, and by such splendid pieces as Titian's *Charles V* or Rubens's *Peace and War* (now in the National Gallery). Small and highly-prized pictures were placed in the Chair Room and in the newly-erected Cabinet Room. Here Van der Doort's pages read like a key to one of the cluttered cabinets painted by Van Haecht or Francken. Superb pictures are housed with bronzes, small reliefs, carvings and waxes, books, prints, drawings, coins, medals, precious stones, pieces of gold, crystals and engravers' plates – the whole crowned by a sketch by Rubens, set into the ceiling: 'the Moddle or first patterne of the paintinge w^ch is in the Banqueting house Roofe'. Placed in the cupboards, set for the most part in simple turned 'boxes' of ivory, amber, ebony, jet or boxwood, was a collection of nearly eighty miniatures.

Miniatures had for many years served as conveniently small images which, in fine jewelled settings, could be used in courtly or diplomatic exchanges, or as portraits to be privately treasured as symbols of more intimate affection. Elizabeth I had kept in a little cabinet in her bedchamber 'divers little pictures wrapt within paper, and their names written with her own hand upon the papers'. When Buckingham was in Spain with Prince Charles he had been reassured by King James that he wore his 'picture in a blue ribbon under my wash-coat next my heart'.[33] Van der Doort's pages provide the earliest detailed account that we possess of a large collection of miniatures and of the methods of displaying it. There were the highly-prized copies made by Peter Oliver of renaissance masterpieces in the Whitehall collections; fine sixteenth-century miniatures, including examples by Clouet and Holbein (e.g., plate v); and a group of Stuart portraits by Hilliard (plate 49), Isaac (plate vi) and Peter Oliver (plate 50) and Hoskins.

By the mid-1630s the King's most serious rival, the Earl of Arundel, could write that 'His M^tie knowes best what he hath *gusto* in'; in the Privy Lodging Rooms at Whitehall (and in the Queen's rooms at Whitehall and elsewhere) were hung the pictures he most deeply loved: the Giulio Romanos, the Polidoros, the Correggios, the Raphaels and Andreas, and above all the Titians, including, apart from those we have already mentioned, such pictures as *Jacopo Pesaro with Alexander VI before St Peter* (plate 51), *St Margaret*, a *Magdalen*, *Andrea Gritti* (now in Washington) and Lotto's *Triple Portrait* (plate 53), which then bore an attribution to Titian. Perhaps the *gusto* was unlike the

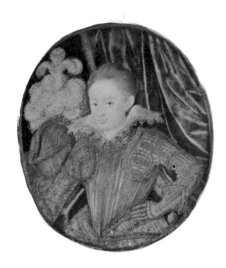

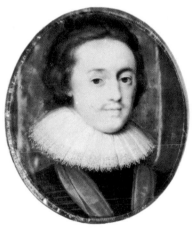

49 (top) NICHOLAS HILLIARD
Henry, Prince of Wales

50 (above) PETER OLIVER
Charles I

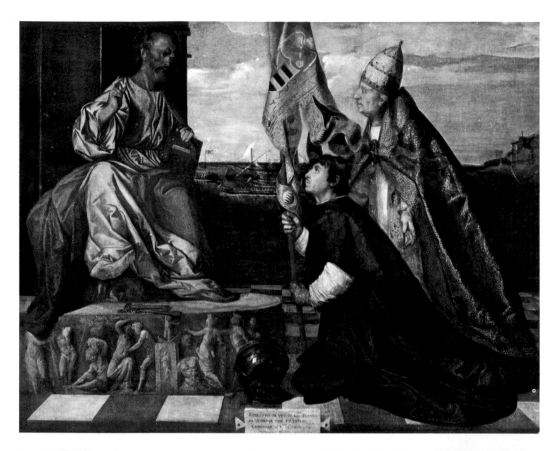

51 (left) TITIAN
*Jacopo Pesaro with Alexander VI
before St Peter.* Musée Royal
des Beaux-Arts, Antwerp

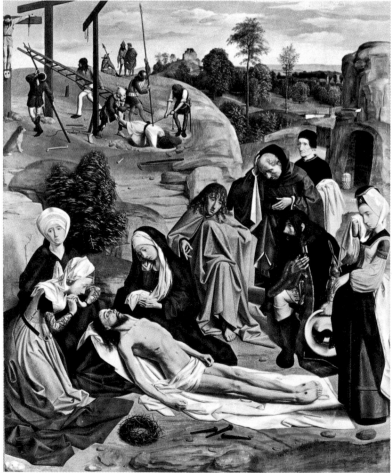

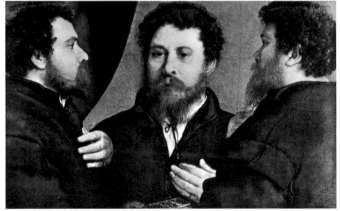

52 (left) GEERTGEN TOT SINT JANS
The Lamentation. Kunsthistorisches Museum, Vienna

53 (above) LORENZO LOTTO
Portrait of a Goldsmith in Three Positions.
Kunsthistorisches Museum, Vienna

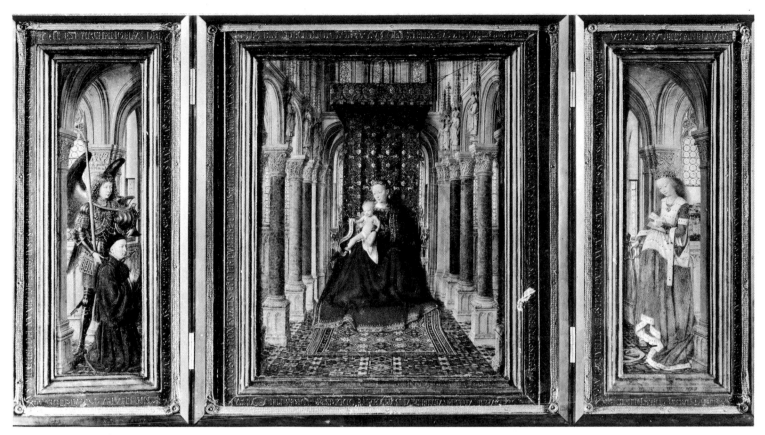

54 JAN VAN EYCK
The Virgin and Child with
SS. Michael and Catherine and
a Donor. Gemäldegalerie, Dresden

Earl's in that it did not so warmly embrace early Netherlandish painting. When the Dutch States-General gave the King in 1636 a group of early pictures, he gave away to Hamilton the two panels by Geertgen tot Sint Jans – the *Lamentation* (plate 52) and the *Legend of the Relics of St. John Baptist* – although he kept Mabuse's *Adam and Eve* (plate VII) at Hampton Court, where he may also have placed such early Flemish masterpieces from the Mantuan collection as the little altarpiece by Van Eyck (plate 54) which Duke Vincenzo I had acquired in 1597.[34]

At St James's Palace a visitor entering the Gallery found himself in the presence of a stupendous display of Italian pictures, among them seven of Titian's *Emperors* and seven little pictures of Emperors on horseback by Giulio Romano; but what struck him most was Van Dyck's 'portrait of the King, armed and on horseback' (plate 55), which hung at the end of the room.[35] This magnificent presentation showed the King in the Imperial and Venetian traditions of which as Sovereign and patron he was the heir. The relationship between the King and his painter was strengthened by their mutual devotion to Titian; Titian's name is constantly coupled with Van Dyck's in the minds of his contemporaries; and the pictures by Titian which Van Dyck encountered in London exercised a profound influence upon him. He understood Titian's technique so well that he was asked to repair one of the Emperors and to paint for the series a wholly new *Vitellius*, as it had proved impossible to repair the original.

Van Dyck had passed some months at the court of James I and had thereafter remained in touch with the English court. On his return in the spring of 1632 he was warmly welcomed and established in the service of the King. He was to perfection the courtier-artist, Apelles to his Alexander, as Titian had been to Charles V; and, like Titian, he invested his patron with an incomparable air of natural kingliness and good breeding. Generous though the King had been, for example, to Daniel Mytens (he had hung his *Self-Portrait* next to those of Rubens and Van Dyck), no contemporary royal

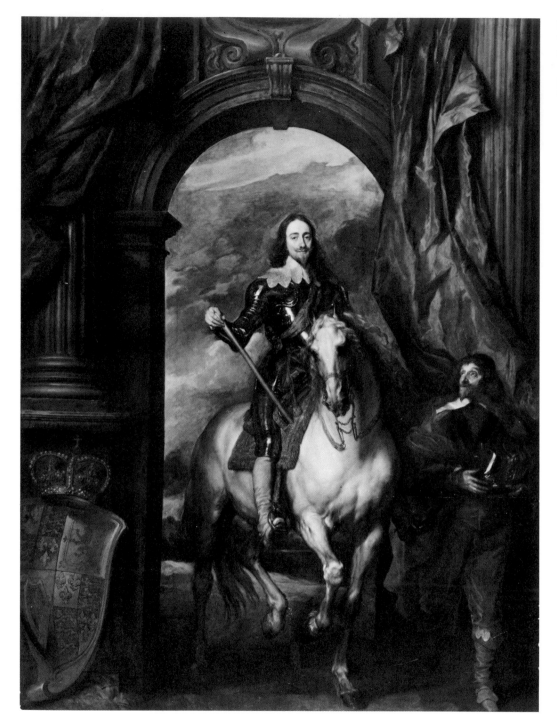

portrait by any other painter than Van Dyck was prominently displayed. Two large
equestrian portraits of the King, enchanting portraits of his Queen (plate 56), their
growing family (e.g., plate 57) and their relations and the beloved Villiers children
were hung in chosen positions. When posthumous portraits of the King's father and
Prince Henry were required for the range of royal full-lengths in the Cross Gallery at
Somerset House, it was Van Dyck who had to concoct them. The ravishing *Cupid and
Psyche* (plate VIII), among the last works painted by Van Dyck for the Crown, conveys
something of the fragile sophistication of the Caroline court – something too, one feels,
of the Queen's liking for 'faces as beautifull as may bee, ye figures gracious and suelta' –
and strikes a note not to be heard again in England before the time of Gainsborough.[36]

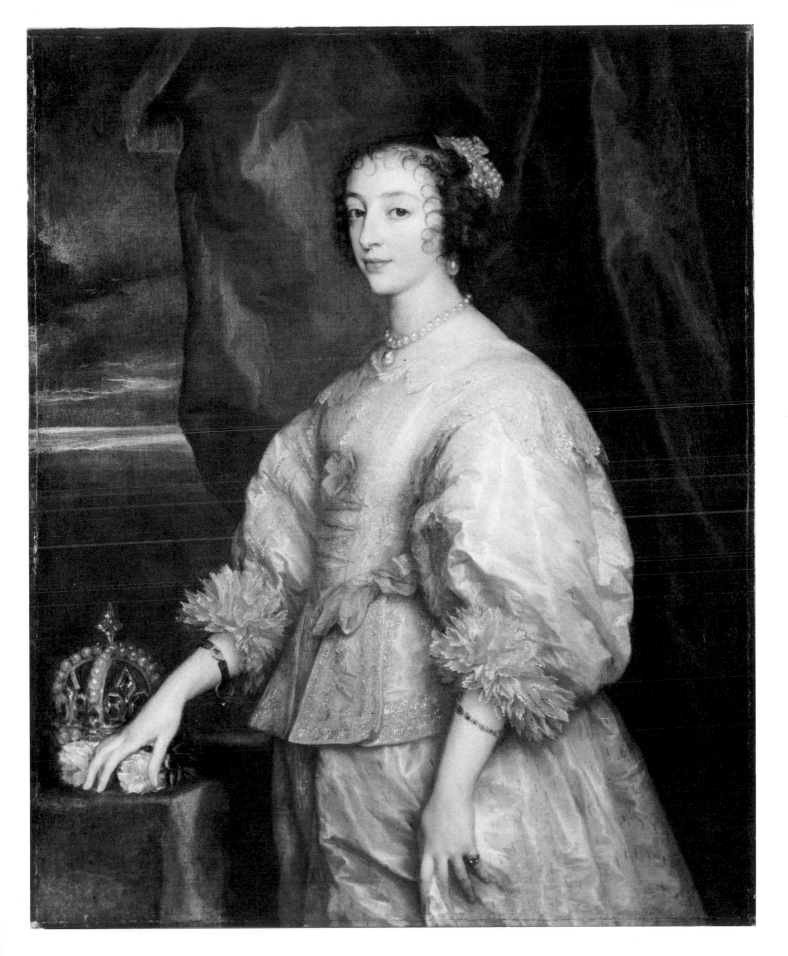

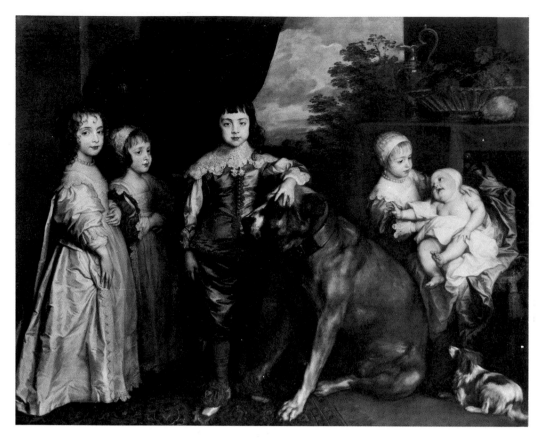

Of course Van Dyck and Rubens were by no means the only foreign painters to work at the court of Charles I. The King had a particular liking for the intricate and ingenious perspectives and night scenes of Hendrick van Steenwyck (e.g., plate 58). He owned a large number of pictures by Cornelis van Poelenburgh and Alexander Keirincx; Moreelse, Houckgeest, Breenbergh and De Heem were represented in the collection; and he acquired a very good Ter Brugghen (plate 59). Hendrick Gerritsz. Pot may have been in his service and both he and the Queen sat to him. Among contemporary Dutch painters the King especially liked the work of Honthorst. The most popular and most courtly of the Dutch followers of Caravaggio and a favourite with the King's sister, Honthorst was in London in 1628, when he worked for Buckingham and the King. His group of the Buckingham family (plate 60) hung over the fireplace in the King's Bedchamber at Whitehall; and he painted for the King, apart from a number of fairly conventional portraits, the vast *Seladon and Astarea*, in which the parts are played by the royal family of Bohemia, and the even larger *Apollo and Diana* (now on the Queen's Staircase at Hampton Court) in which the Duke appears as Mercury introducing the Liberal Arts to the King and Queen in the title parts. In subject-matter and dress both designs could be 'stills' from a masque.

The King's collection of contemporary Italian pictures was less impressive, although it was naturally rich in a painter such as Fetti who had worked for the Gonzagas. He owned works by Guercino and Albani, although he failed to persuade either of them to come to England; the work of Guido Reni was liked by the King and Queen, but a large *Bacchus and Ariadne* which was being painted for the Queen on the eve of the Civil War never arrived in London. Cardinal Barberini, who was involved in the commission, had earlier sent religious pictures to the Queen which she set up in her chapel at Somerset House. It was the Queen also who was partly responsible for the arrival in 1626 of the Florentine Orazio Gentileschi from Paris. He was a pensioner of

the Duke of Buckingham, who can be seen once more encouraging the King's patronage of a Caravaggesque painter whose style had taken on a clumsy, yet refined courtly elegance (plate 61); and of his daughter, whose work (plate IX) is vigorous – almost earthy – by contrast.[37]

At Christmas 1640, Rossetti, the Papal agent, gave to the Queen a large *Nativity* by Titian, with which the King was particularly delighted. When, in 1645, William Prynne published the second part of his *Hidden Workes of Darkenes Brought to Publike Light*, he specifically attacked the Papal Nuncio for his efforts to incline prominent courtiers to the Roman party and 'to seduce the King himself with Pictures, Antiquities, Images & other vanities brought from *Rome*'.[38] The chapel at Somerset House was a prime target for iconoclasts and parliamentary soldiers in the Civil War; in the spring of 1643 it was rifled by troops who hurled into the Thames an altarpiece by Rubens. Grave damage was done in St George's Chapel at Windsor; in 1643 superstitious pictures in the chapel at St James's were defaced; and there was a constant threat of damage at Whitehall; but the pictures in the royal houses seem to have come through the war comparatively unscathed. The Houses of Parliament were aware of the dangers facing the King's collections. The Lords acted responsibly in ordering that nothing which had belonged to the King was to be removed from Whitehall. The despicable Earl of Pembroke, Lord Chamberlain in the halcyon days when he had given the King Raphael's *St George*, was still nominally responsible for the palace and its contents, and Jan van Belcamp remained in London in the 1640s. The Earl of Northumberland was influential in preserving the great Whitehall

58 HENDRICK VAN
STEENWYCK
The Liberation of St Peter

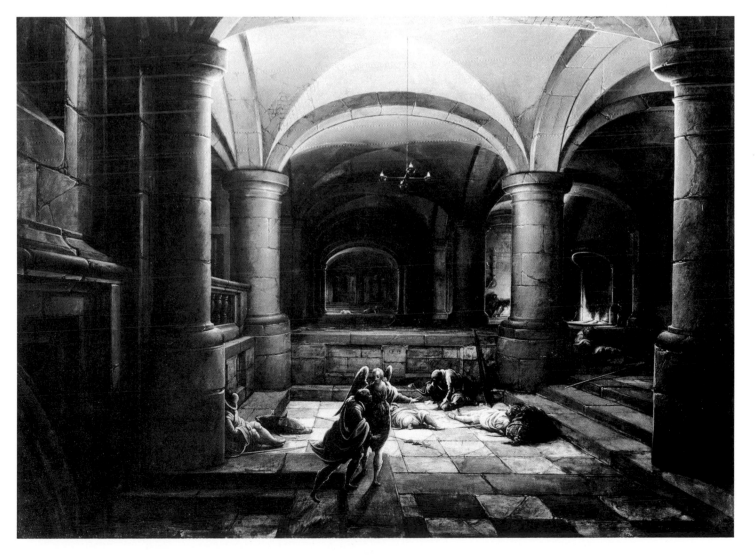

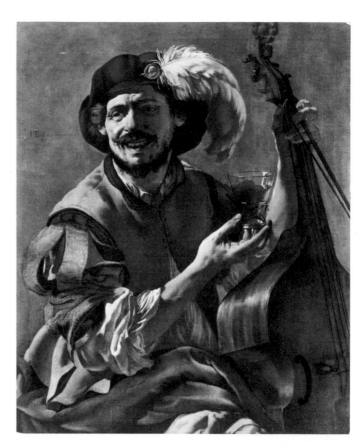

59 (left) HENDRICK
TER BRUGGHEN *A Bass Viol
Player with a Glass*

60 (below) GERRIT
VAN HONTHORST *The Family of
the First Duke of Buckingham*

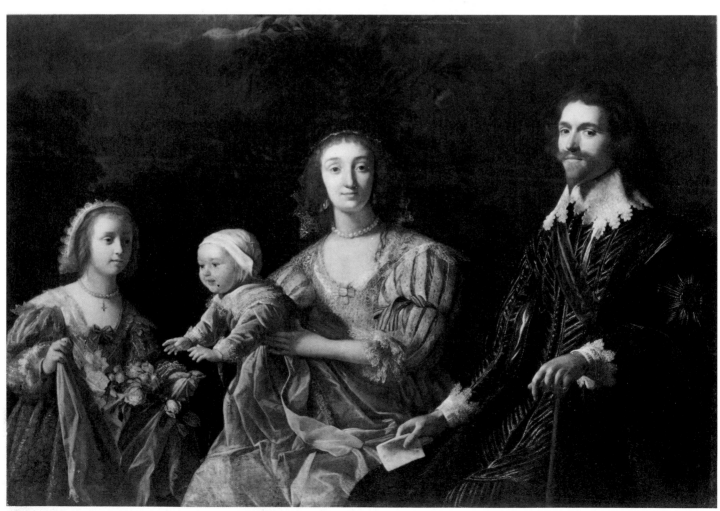

collections. As early as 1645 the Commons were anxious to have an inventory of goods at Whitehall which would help the Whitehall Committee to safeguard them; and a fortnight before the King's execution the Commons gave the first and second readings to an ordinance that provided for the 'Discovery, Inventorying, and Preserving' of the goods in the royal houses.

During the Civil War and its aftermath the King was at many of his houses of resort outside the capital. There is a sad account of him at Hampton Court in 1647, on the eve of his departure for the Isle of Wight, handing over to the Keeper of the Privy Lodgings and Standing Wardrobe certain miniatures and other small objects, concerned about the welfare of 'My Houshold stuffe and moveables of all sorts, which I leave behind Me in this House, that they be neither spoyled nor imbesled'; and anxious that four portraits, which were not his, should be sent back to their rightful owners. Of his pictures at St James's and Whitehall he would only have caught a glimpse in the last days of his life.

Less than three weeks after the King's execution, Oliver Cromwell reported on the risk of the embezzlement of the royal family's goods which now belonged to the State, particularly (at this stage) the library, pictures and statues at St James's. Ultimately, on 23 March 1649, the Commons resolved: that the personal estate of the late King, Queen and the Prince of Wales should be inventoried, appraised and sold, except for such goods as the Council of State, the administrative organ of the usurping régime, should choose for the State's service; that commissioners should be appointed to inventory, secure and value, and thereafter to sell, the goods; and that the money raised should go towards paying off the debts left by the royal family and be used for 'publick Uses of this Commonwealth'. The first £30,000 raised by the sale was to be handed over to the Treasurer of the Navy for the use of the fleet. The Act for the sale was passed on 4 July, and published on 26 July, 1649. Thus was initiated the so-called

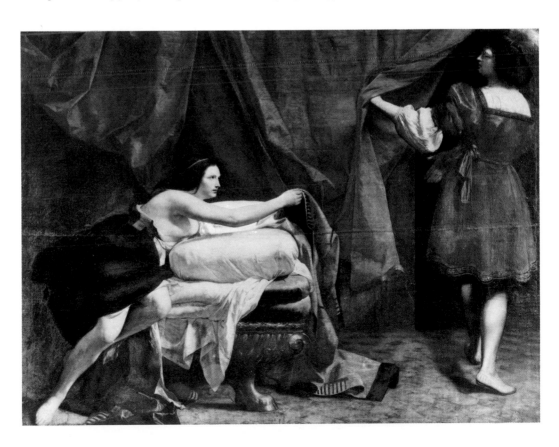

61 (right) ORAZIO GENTILESCHI *Joseph and Potiphar's Wife*

'Commonwealth Sale': a cumbrous process, obscure in much of its detail but undeniably a tragedy in the history of the arts in this country.[39] One must, however, resist the temptation to accuse those who authorized and conducted the sale of wanton pillage or mindless philistinism. Determined to root out the institution of monarchy, they were at the same time anxious to preserve from damage and embezzlement the vast quantity of goods of all kinds, goods they regarded as justly forfeited, that filled the royal houses. The destruction of the regalia was a disaster; but the Council's desire to relieve the royal family's creditors (those, at least, whom they did not regard as Delinquents) was commendable. The leaders of the parliamentarian party had endeavoured to preserve goods from the onslaughts of the iconoclast; and they organized with efficiency, for the good of the State as they saw it, an immensely complicated operation.

To draw up the inventories and valuations of the goods, the essential preliminary to sale, a group of Trustees was appointed of whom Jan van Belcamp was one. He died in December 1651, by which time the inventories had been completed. He and his companions seem to have been especially active in the summer and autumn of 1649. They had full authority to search for royal goods in any quarter; anyone refusing to supply them with information was liable to be imprisoned. Their inventories were handed to the Commissioners, described as gentlemen and citizens of London, who acted as Contractors for the sale; and to the Council, which selected goods to be reserved for the use of the State. The Contractors were appointed to sell the goods to the best of their judgment. Rooms in Somerset House were fitted up in the autumn of 1649 for the display of goods to be sold. One of the Contractors, Daniel Norman, received a special payment of £40 on 26 November 1649 for expenses involved in removing 'the goods from the houses or places where they now are to be brought to Somersett house'. At Somerset House there was a porter, Thomas Greene, on whose 'care and industry' the organizers of the sale relied.

The valuations are an incomparable source. The Trustees drew up inventories in all the royal houses, although the entries for the pictures are invariably brief. If they were compiled by Belcamp, he showed little of Van der Doort's expertise and does not seem to have had by him any of his predecessor's notes. It is fair to add that the lists must have been written under pressure and by an amanuensis, but the entries for other kinds of goods, such as tapestry, furniture, furnishings and plate, are often extremely full. The most important lists of pictures are, of course, those for Greenwich, Whitehall, Somerset House, St James's and Hampton Court. The inventories are particularly useful for houses about whose contents we know less (Wimbledon, Oatlands or Nonsuch) and for those in which only a few unimportant pictures had been left: Richmond, Ludlow, Theobalds and Windsor.

The trustees' inventories list about 1,570 pictures valued at some £37,000. The highest valuation put on a single picture was £2,000 on Raphael's *La Perla*. Titian's (and Van Dyck's) *Emperors* were appraised together at £1,200. One thousand pounds was placed on Mantegna's *Triumph of Caesar* and on each of three of the Correggios: the two *Allegories* and *Jupiter and Antiope*. His *Venus, Mercury and Cupid* was valued at £800; so was a small *Madonna* by Raphael. Titian's *Supper at Emmaus* and *Entombment* were each valued at £600. Five hundred pounds was set on two of the Giulios and on the *Venus of the Pardo*; Guido Reni's four *Labours of Hercules* and Raphael's Cartoons were valued respectively, as sets, at £400 and £300; and £300 was the value of Tintoretto's *Christ washing the Feet of the Apostles*. Titian's *D'Avalos Allegory* and *Allocution of Marshal D'Avalos* were valued at £250 each; among pictures valued at £200 were

v HANS HOLBEIN THE YOUNGER
Charles Brandon, Duke of Suffolk
(see page 47)

VI ISAAC OLIVER
Elizabeth, Queen of Bohemia
(see page 47)

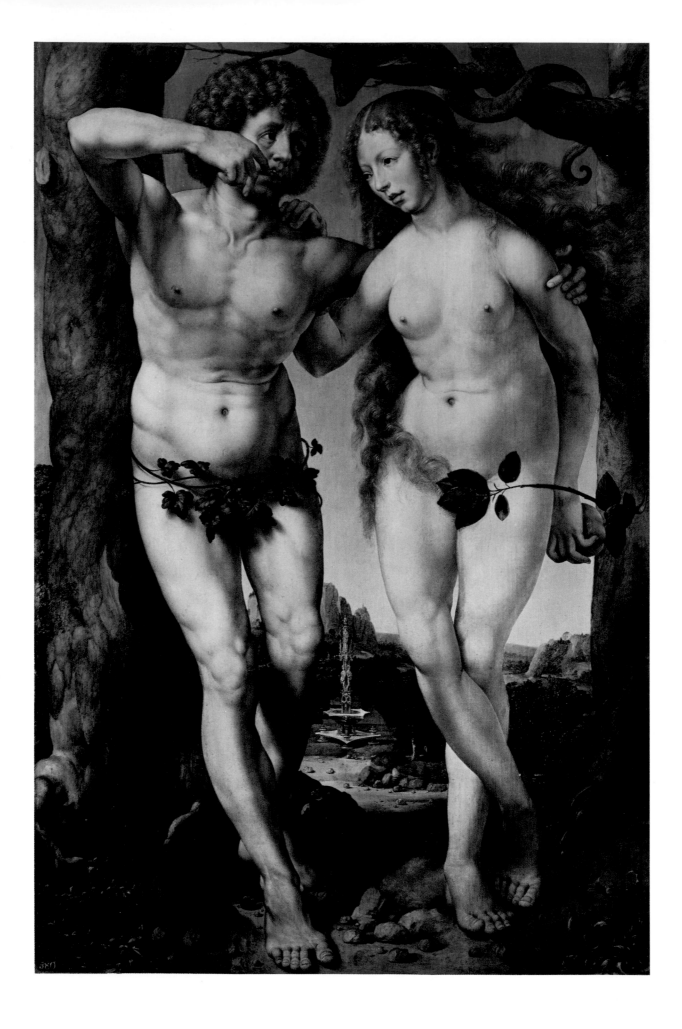

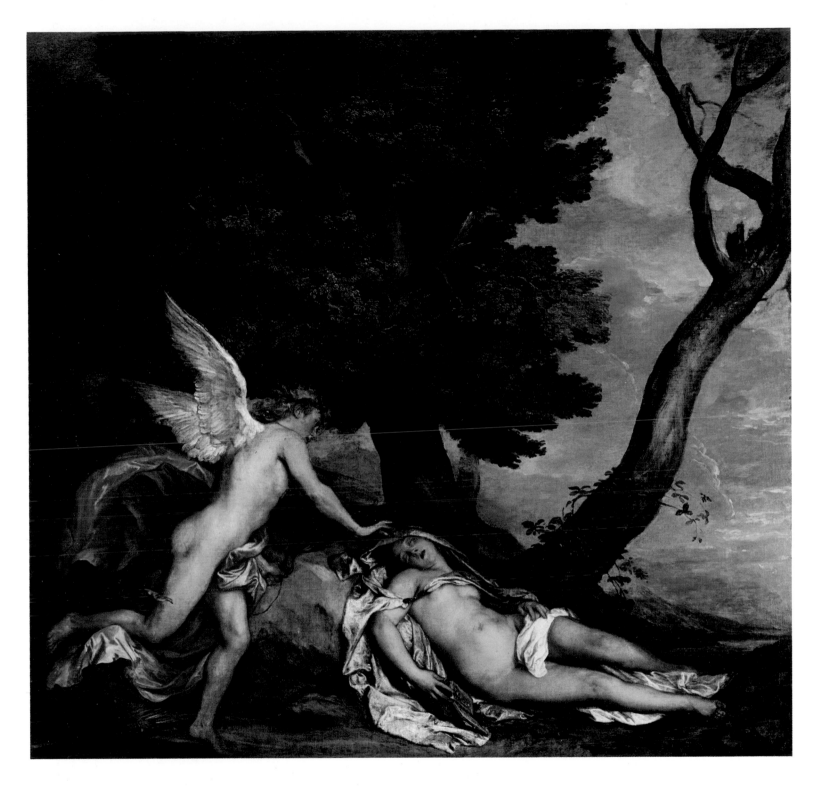

VIII SIR ANTHONY VAN DYCK
Cupid and Psyche (see page 50)

VII (left) JAN GOSSAERT CALLED MABUSE
Adam and Eve (see page 49)

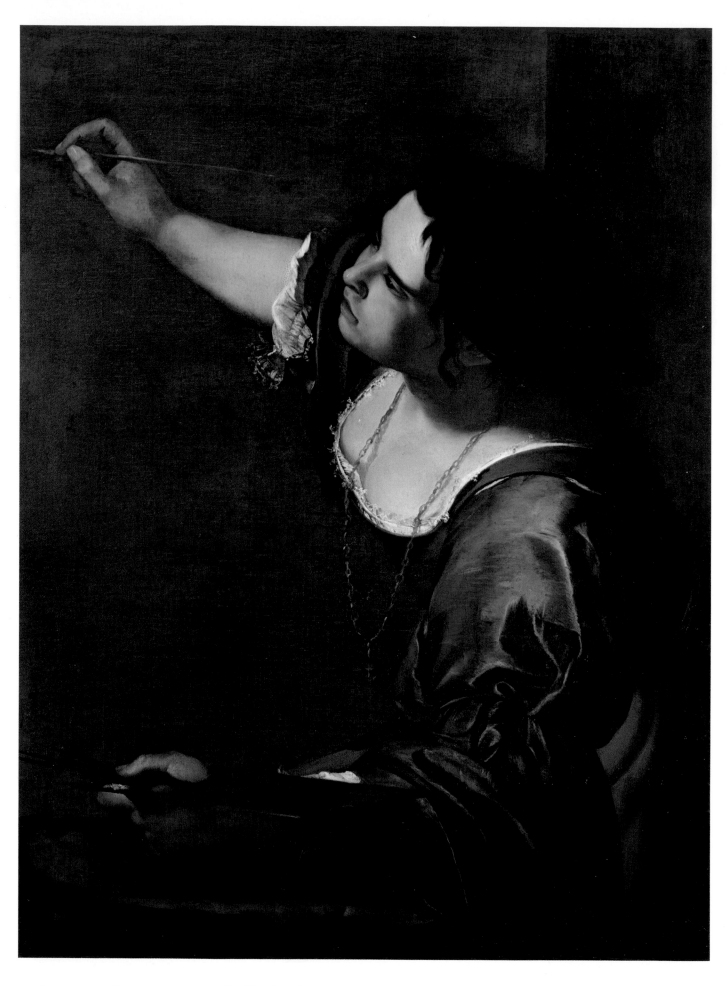

IX Artemisia Gentileschi *Portrait of the Artist* (see page 53)

Andrea del Sarto's *Madonna della Scala* and the series of eight canvases painted by Jordaens for the decoration of the Queen's Cabinet at Greenwich. Caravaggio's *Death of the Virgin* and Raphael's *St George* were among those valued at £150. Leonardo's *St John the Baptist* was valued at £140.

The early Netherlandish pictures and the pictures which had been in the Tudor collection were often valued surprisingly low. Mabuse's *Adam and Eve* was valued at £50, as were both the Dürers from Nuremberg, but such pieces as *Elizabeth I confounding the Goddesses* (£2), the *Battle of the Spurs* (£8), Prince Henry's *Battle of Pavia* (£3), *Tom Derry* (£1) and Eworth's little *Lord Darnley with his Brother* (£6) seem undervalued. Jacobean full-lengths could be bought for as little as £4; full-lengths by Van Somer, Honthorst or Mytens were in the £20–£25 bracket. Peter Oliver's miniature copies of renaissance masterpieces were, on the other hand, valued between £80 and £100; two groups of eight miniatures of the royal family were sold for £100 each. Van Dyck's two great equestrian portraits of the King were valued at £200 and £150, the King's five children at £120, *Cupid and Psyche* at £110, full-lengths between £20 and £40, the half-length of the Queen at £30, the sketch of the *Garter Procession* at £5. Rubens's and Rembrandt's *Self-Portraits* were valued at £16 and £5 respectively. A large number of extremely good pictures were assessed at values between £25 and £120. When items came to be sold, the price was sometimes slightly higher than the figure established by the Trustees.

Progress with the sale was held up by delays on the part of the Council of State in selecting goods to be reserved for the use of the State. Large quantities of hangings and furnishings were needed for the royal apartments which the new administration had taken over and, above all, for the use of the Protector and his family at Whitehall and Hampton Court. In fact, after Cromwell's installation as Protector in December 1653, the sale proceeded far more slowly. Evelyn found Whitehall in 1656 'very glorious & well furnish'd', which gives the lie to the lament, in a famous cavalier song, over 'cobwebs hanging on the wall, Instead of silk and silver brave'. Not many pictures were reserved from sale for the Protector's use. Among them were religious pieces: *St Paul drawn out of the City, Herodias with the Baptist's Head* by Titian (at £150), a *Madonna with Angels*, an *Ascension of the Virgin*, a *Holy Family* by Schiavone, Bathsheba 'w^th other naked figures' by Artemisia Gentileschi; a few miscellaneous portraits; a large sea-piece by Porcellis; pictures of a giant and a German stag; Pordenone's *Family Group* and Andrea del Sarto's *Portrait of a Woman*. The most important reserved pictures were ceiling pictures at Greenwich, Raphael's Cartoons and Mantegna's *Triumph of Caesar*.

Those who actually bought the pictures fall into several classes. The most discerning were the surviving members of the King's circle and one or two younger artists and *cognoscenti*. Sir Balthazar Gerbier, who had helped the Duke of Buckingham to form his collection and had been the friend of Rubens, was recommended to the Trustees by the Council of State as one whose endeavours were for the service of the Commonwealth. He bought at least two very valuable pictures: Titian's *Charles V* for £150 and the more expensive of Van Dyck's two equestrian portraits of the King (now in the National Gallery). Lanier bought pictures by Breenbergh, Giulio Romano, Annibale Carracci and, as by Giorgione, the *Concert* by a follower of Titian now in the National Gallery. He also bought, for £10, his own portrait by Van Dyck. His uncle Jerome also bought good pictures. Peter Lely bought Veronese's *Finding of Moses* for £55 and pictures by Breenbergh and Tintoretto. Such buyers almost certainly resold their purchases fairly quickly. Gerbier's Titian and (probably) Lely's Veronese were bought for the King of Spain; Gerbier's huge Van Dyck was soon in Flanders. The painters

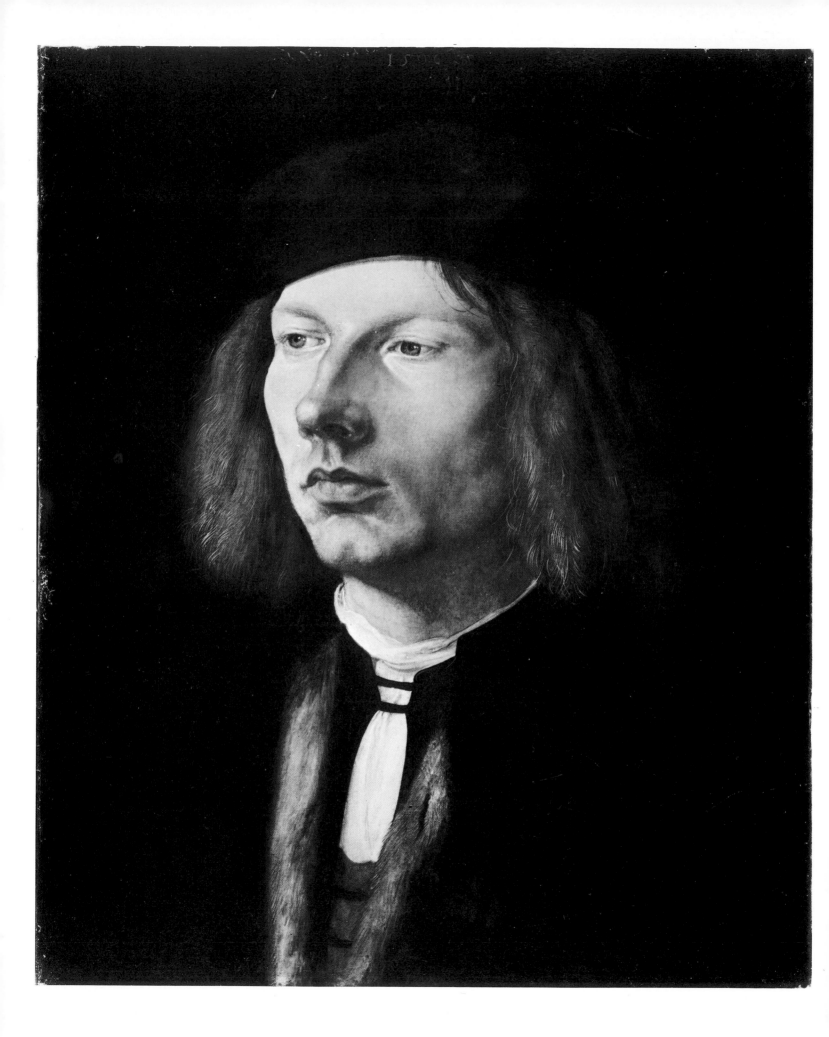

John Baptist Gaspars and Remigius van Leemput bought many pictures; Belcamp's executors acquired Leonardo's *St John*. Jasper Duart, the King's Jeweller, paid £170 for Caravaggio's *Death of the Virgin* and £50 for Van Dyck's double portrait (now in the Louvre) of the King's eldest nephews.

One of the most interesting figures among the buyers is the regicide, Colonel John Hutchinson, who became 'a great virtuoso and patron of ingenuity':

> Loth that the land should be disfurnished of all the rarities that were in it, whereof many were set for sale from the king's . . . collections, he laid out about two thousand pounds in the choicest pieces of painting, most of which were bought out of the king's goods, which had been given to his servants to pay their wages. . . . These he brought down into the country, intending a very neat cabinet for them.

He appears to have spent at the sale just under £1,000 on pictures. He had a special liking for still-lifes, but he owned a full-length by Van Dyck and had paid £600 for the *Venus of the Pardo*.

Apart from dealers and private buyers, the 'necessitous Servants and Creditors to the late King', provided they made good their claims and had not been in arms against Parliament, could receive goods in lieu of the money due to them. Grouped in fourteen 'Dividends', these creditors acquired goods to the value of nearly £66,000, mainly on 23 October 1651. The leader of a Dividend would probably negotiate a purchase, and a later re-sale, on behalf of his colleagues; and it was to the creditors, as to the other buyers, that the agents of foreign collectors would go. The original Act for sale had acknowledged that some of the royal goods, 'by reason of their Rarity or Antiquity', would fetch great prices abroad, 'yet for particular men's use in England they would be accounted little worth' (Colonel Hutchinson does seem to have been a fairly unusual figure); and the Contractors were empowered to treat with foreign merchants for sale at the best rates, to sell to foreign merchants direct or, if they thought best, to export goods for sale overseas. In the early 1650s the houses of the more prominent creditors were full of the King's pictures. Richard Symonds jotted down what he saw in the hands of Edmund Harrison, Embroiderer in the Wardrobe, at a wharf near Somerset House; Thomas Baggley, glazier of the Works; Ralph Grynder, the upholsterer at the Lion in the Poultry; Captain Mallory, 'a doughty painter by the Stocks'; and Emmanuel de Critz, the Serjeant Painter, who had a house stacked with the King's pictures in Austin Friars.

Sales were made to English collectors. Lord Savile had bought from Grynder for £250 Giulio Romano's *Nativity*, but because of its size and weight was unable to move it; to Knightley he had made an unsuccessful offer of four yearly payments of £100 for Correggio's *Jupiter and Antiope*; but it was the foreign agents who were the most energetic buyers. 'In this manner', Clarendon wrote bitterly, 'did the neighbour-princes join to assist Cromwell with very great sums of money . . . whilst they enriched and adorned themselves with the ruins and spoils of the surviving heir.' The Archduke Leopold William had sent David Teniers over to London from the Spanish Netherlands to buy pictures from the dismembered Whitehall collections. The celebrated German collector, Everhard Jabach, who had been in England in the 1630s and had sat to Van Dyck, arrived in London from Paris for the same purpose; and Cardinal Mazarin, who in Clarendon's words sought Cromwell's friendship 'by a lower and a viler application than was suitable to the purple of a cardinal', sent his minister, Antoine de Bordeaux, to traffic in the goods of 'the rifled Crown'. In 1653 and 1654 M. de Bordeaux was dealing with merchants, artists (such as Geldorp) and

62 ALBRECHT DÜRER
Portrait of a Man

63 (left) AGNOLO BRONZINO
Portrait of a Lady in Green

the officials responsible for the sale. He successfully approached Colonel Hutchinson who owned 'la plus belle pièce qui reste icy', which he eventually secured for 7,000 *livres*.[40] His most pertinacious rival was the Spanish ambassador, Alonso de Cardenas, 'who had always a great malignity towards the King'. Symonds states that 'he was the first that bought & layd out for these things of the Kings', tirelessly negotiating with the creditors and dealers, and that the State had actually given him the *Twelve Emperors*. In 1653 he was allowed to export, free of duty, twenty-four chests of pictures, hangings and household stuff. Already, in 1651, goods from the royal collection had begun to arrive in Madrid: 'as many pictures, and other choice and rich furniture, as did load eighteen mules'.

It is perhaps ironical that the great European royal collections, which with the passage of time and in the course of revolutionary change ultimately formed the nucleus of permanent national collections in Paris, Vienna and Madrid, should have been enriched by plundering, with the active encouragement of a revolutionary régime, a collection which had been honestly acquired.[41] The only parallel to this organized holocaust, which in its turn enriched so many collections, was the dispersal of the contents of the French royal palaces after the collapse of the monarchy in 1792. The tragedy of the destruction of Charles I's collection lies in the fall of a Sovereign who was artistically very sensitive but politically incurably obtuse; and who with sustained enthusiasm and considerable knowledge had built up a collection without rival in the history of English taste. In the actual dispersal there flourished in microcosm the art trade of the future: a shadowy host of dealers, creditors, merchants, artists and foreign agents. In spite of their success, there are still in the royal collection many pictures

64 (right) CORREGGIO
The Holy Family

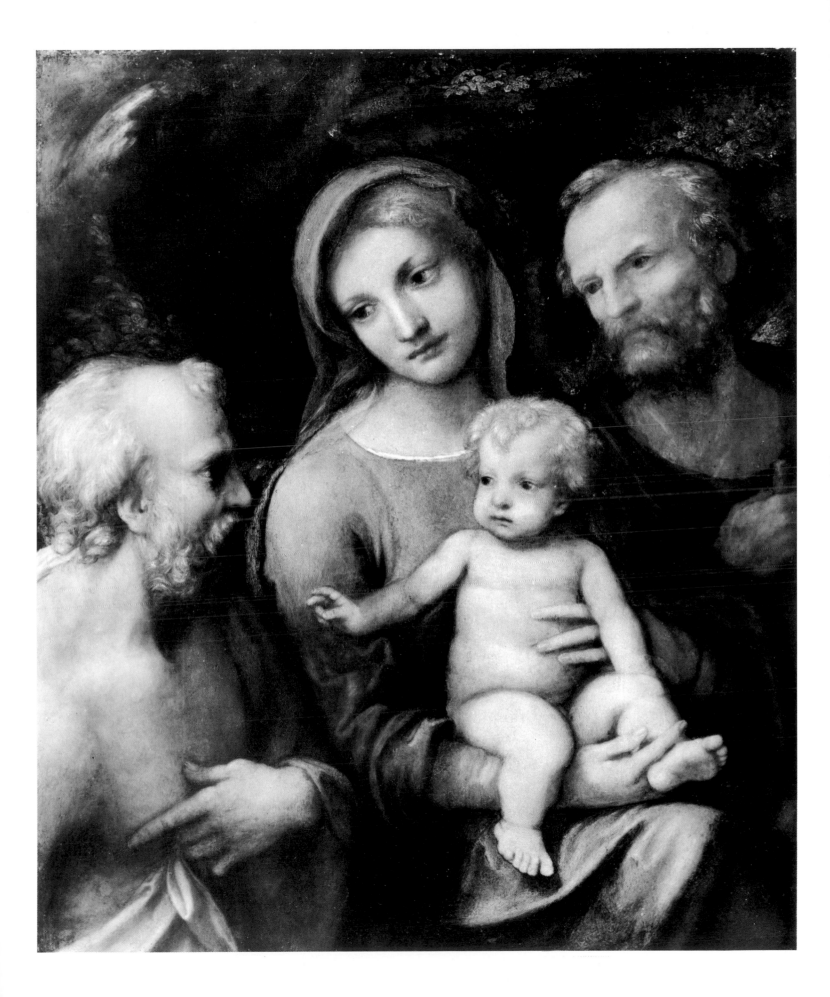

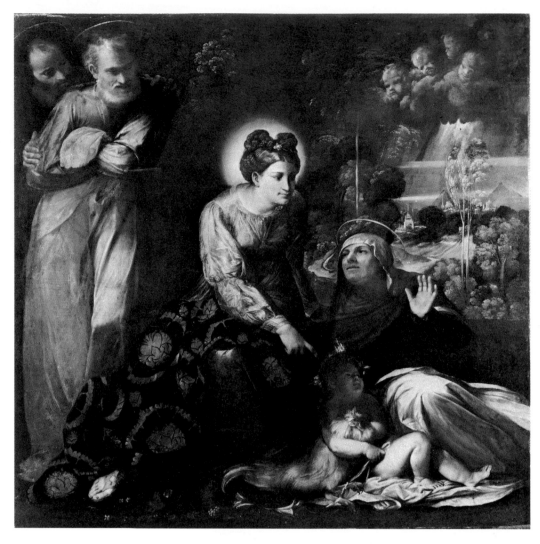

65 (left) Dosso Dossi
The Holy Family

66 (below left) Franciabigio
Jacopo Cennini

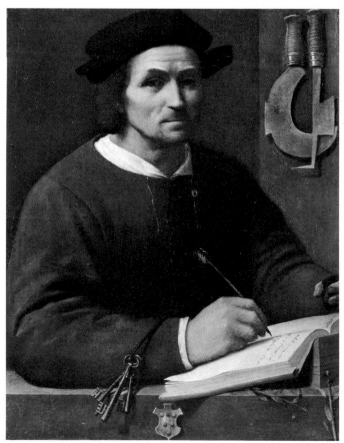

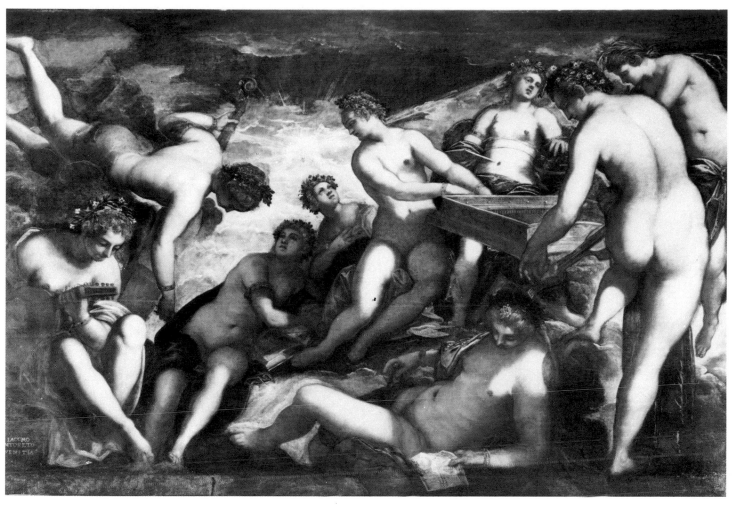

67 TINTORETTO
The Nine Muses

which Charles I had acquired. To those we have already mentioned must be added the Holbeins and the Dürer (plate 62) at Windsor; good Netherlandish pictures at Hampton Court by (for example) Joos van Cleve, Hemessen and Aertgen van Leyden; and some of the finest Italian renaissance paintings in England: the Giorgione, the *Lady in Green* (plate 63), Correggio's *Holy Family* (plate 64), the *Lucretia* and *The Lovers* from Van der Doort's list of Charles I's Titians, the fine Bassanos and Palmas, Dosso's *St William* and *Holy Family* (plate 65), the panels by Polidoro, *Jacopo Cennini*[42] by Franciabigio (plate 66), and the magnificent Tintorettos, *Esther and Ahasuerus* and the *Muses* (plate 67). On this by no means unimpressive foundation the later Stuarts and their advisers began to reconstruct a new royal collection.

4

THE LATER STUARTS

O N 9 MAY 1660 Samuel Pepys and Edward Mountagu were interrupted at
dinner by a messenger from the House of Lords. 'He brought us certain
news that the King was proclaimed yesterday with great pomp ... with
great joy to us all.' On the same day the Lords appointed a Committee 'to
consider and receive Information where any of the King's goods, Jewels, or Pictures
are; and to advise of some Course how the same may be restored to His Majesty'.

The most experienced member of the Committee was Northumberland, whose
collection, alone of all those formed before the Civil War, had come unscathed (if not
enriched) through the intervening revolutionary years. On 12 May the Committee
issued an order that anyone who had in his possession any of the King's goods was to
bring them in to the Committee within a week. Two days later a stop was put on any trans-
portation, from London or any other port, of pictures and statues which belonged to the
King; and all royal goods that came to the notice of the Committee were to be seized.

On 10 May George Geldorp, a portrait painter of German origin who had been
active in artistic circles in London since the time of James I, was summoned to attend
the Lords. He told them he would require eight days to inform the Committee of
pictures and other goods 'sold or surreptitiously conveighed away'. The Trustees of the
sale had to submit all their papers to the Committee. Thomas Beauchamp, who had
been their clerk, was ordered to hand over his inventories and other papers to John
Webb, who had exercised some responsibility in the past for the King's 'Medals, Rings
&c' and who, as Inigo Jones's nephew, now counted on succeeding him as Surveyor of
the King's Works. Discovered goods were to be brought in to his office at Whitehall.
Other officers – Colonel William Hawley, Colonel William Anselm and Colonel
Hercules Lowe – were also employed by the Committee to lay hold of declared and
concealed goods. They delivered them to the Wardrobe Keeper, Clement Kynnersley,
at Whitehall, or handed them over to Geldorp or Webb. During the month of May a
number of declarations had been made to the Committee: by those who had royal
goods in their possession or had been compelled to part with them 'by the power that
was then in being'; or by informers who knew where such goods lay hid. Lely, for
example, came forward on 18 May to declare seven pieces of sculpture, a frame and
eight pictures, which included the Ter Brugghen and two Van Dycks: *Cupid and Psyche*
and the *Three Eldest Children* of the late King. The declarations often throw light on the

difficulties with which the creditors and those involved in the sale had been faced in the 1650s, and seem to show that certain buyers had tried to stop some of the goods leaving the country. Beauchamp himself, for instance, claimed to have been 'only a servant and not an actor' in the sale, and to have bought divers pictures and statues, at a time when so much was being bought for foreign collectors, 'w.^ch he hath refused to transport but hath preserved y^e same & restored and amended y^e breakeings & other defaceinge done therunto by Coll Pride's sould.^rs & others'. A number of declarations were made by men who had bought works of art in good faith from the old Dividends; and the creditors who had received goods in lieu of the money due to them were obliged to declare them.

A royalist such as Emmanuel de Critz presumably rejoiced at the turn of events. He had received goods in part settlement of the debt due to his father, the old Serjeant Painter, which he claimed 'have bine ever since p^rserved by him w^th great care & danger his now Ma^tie haveing had oft notice from him of y^e same'. He was able to distinguish which of the goods he held were his own solely (*Europa* by Giulio Romano, for example), which he owned in partnership and which had been entrusted to his care by others, of which the most important was Tintoretto's *Esther*. He was especially proud to have kept safe Bernini's 'incompareable head in Marble' of the late King; and hoped at least to be reinstated as Serjeant Painter.

Geldorp had made on 21 May a report on the whereabouts of goods. He gave information, for instance, that painters such as Leemput had pictures, that the merchant Francis Trion had, among others, Van Dyck's *Five Eldest Children*; and that the parliamentarians, Lambert and Hutchinson, had 'divers Raerre Pictures'. Trion stated that he had preserved the Van Dyck in hopes of living to present it to the restored King. Some collectors – Northumberland, the Earl of Peterborough and Lord Lisle, for example – claimed that they were uncertain whether pictures in their possession had been in the late King's collection. The two Earls undertook to keep them in safety until the new King returned and then to offer them to him. Lord Lisle, who was Northumberland's nephew, informed the Committee on 10 May that his pictures and statues had been 'bought in many severall places and in severall yeares whereby the matter is in the nature of it incapable of certainty w^ch were the King's'; but that those he believed to have been the King's he would hold in readiness for him.[1] In the end, on 8 and 10 September, he sent in from his house at Sheen an impressive collection of statues and pictures which included works by Bassano, Giulio Romano, Polidoro and Orazio Gentileschi and the magnificent early Rubens, painted in collaboration with Snyders, the *Satyrs with Sleeping Nymphs* (plate 68)[2]. Lucy Hutchinson recorded that all her husband's pictures were taken from him; but the Earl of Sussex, the former Lord Savile, had claimed that he had bought pictures from Somerset House for £2,500 in order to give them to the King when he should be restored.[3]

On 23 May Webb was in a position to ask that pictures suitable for hanging up in the King's lodgings at Whitehall, Somerset House and St James's should be delivered to him and Emmanuel de Critz. When Charles II rode into London on 29 May 1660 the Committee of the Lords had presumably succeeded, at the end of three weeks' hectic activity, in making at least the royal houses in London presentable.

The attempts to recover the King's rightful goods dragged on for many years. The records of the sale were worked over and discovered goods were seized, frequently as the result of reports from informers. The Bill of Pardon, Indemnity and Oblivion,[4] which received the royal assent on 29 August 1660, had excepted 'all offences in detaining, imbezilling or purloining' the royal goods apart from those which had been

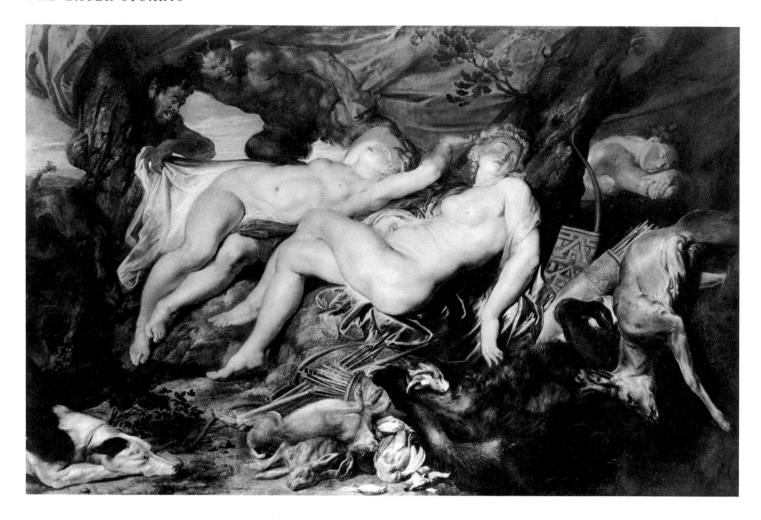

68 SIR PETER PAUL RUBENS
and FRANS SNYDERS
Satyrs with Sleeping Nymphs

sold, or made over, to the creditors. A proclamation had been issued on 14 August reiterating that all possessors of royal goods were to bring them into the Wardrobe before the end of September. One informer reported that some of the King's possessions were lying in houses in Cripplegate and Bishopsgate and were moved about from place to place to evade the official searchers. Antoine de Bordeaux, on his way to France with a set of rich hangings, was to be laid hold of. The authorities were particularly anxious to pursue those who, instead of dealing with the creditors, had extorted goods from the Wardrobe Keepers at the royal houses. Between May 1662 and early in 1672 a Committee for recovery of goods was in being, of which Elias Ashmole was a member, to concentrate on the pursuit of dealers whose activities were not embraced within the Act of Indemnity and to hunt out the works they had acquired. As late as 1672 Ashmole and his colleagues were pursuing Jasper Duart for goods he had acquired which had belonged to the old Queen, including the Van Dyck of the King's nephews and Caravaggio's *Death of the Virgin*. It was eventually found that Duart had compounded with her trustees for the goods and the hunt was called off.[5] In September 1672 Beauchamp was given a final reward of £100 for his efforts in discovering and bringing in the King's goods. Geldorp had been rewarded earlier, in November 1662, with the appointment, under the Lord Chamberlain, of picture-mender and cleaner to the King.[6]

It was presumably under the auspices of De Critz and Webb that an inventory was drawn up, later in the 1660s, of the King's pictures at Whitehall and Hampton Court.[7] Over 450 pictures and limnings had by then been put up at Whitehall and some 177

69 JACOB HUYSMANS
Queen Catherine of Braganza

70 ADRIAEN HANNEMAN
William III when Prince of Orange

additional pictures were in store. At Hampton Court were just over 210 pictures. Assuming that there were pictures hanging once more at Somerset House and at St James's as well, the reconstituted collection may have numbered, soon after the King's return, at least 1,000 pictures. The galleries at Whitehall were hung with good pictures, although the level of quality was inevitably less high than it would have been thirty years before. Van Dyck's *Great Piece*, in which the two-year-old Prince of Wales was standing at his father's knee, was back in its old position at the end of the Long Matted Gallery; 'Twenty eight Kings and Queenes In Small' were once more in the Privy Gallery and the finest Italian pictures in the Second Privy Lodging Room. In the King's Bedchamber was Van Dyck's *Cupid and Psyche*, his portrait of the old Queen, and more recent royal portraits, such as Adriaen Hanneman's of the King's eldest sister and of his young nephew (plate 70). At Hampton Court the Queen's Gallery was hung principally with royal (and other) full-lengths, including Jacob Huysmans's portrait of the new Queen, Catherine of Braganza (plate 69). The King's Gallery contained many smaller pieces and such noble survivors from the old collection as the Trinity altarpiece and Mantegna's *Triumph*. In the King's Bedchamber hung only *Venus with three Cupids*.

Pepys enjoyed being shown the pictures 'in the gallery' at Whitehall by De Critz on 30 June 1660 and, on a later occasion, spending some time with them alone; but Cosimo de' Medici, visiting London in 1669, was less impressed. Visitors were, however, invariably enchanted by what they saw in the King's Closet, a comparatively small room which led off the Privy Gallery and looked out on the Privy Garden. Charles Patin, who had admired the contents of the larger rooms, regarded them

71 Johann Rottenhammer
Diana and Callisto

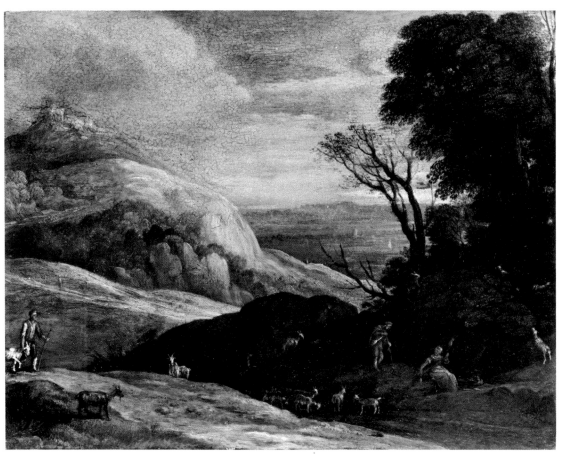

72 Paul Bril
A Landscape with Goatherds

73 HANS HOLBEIN
THE YOUNGER *Robert Cheseman*.
Mauritshuis, The Hague

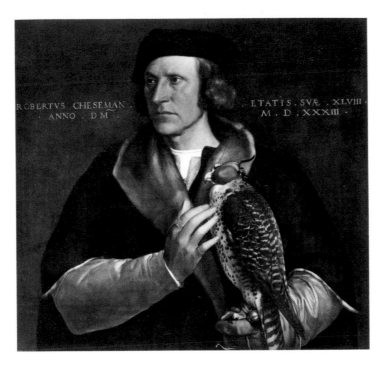

as only a prelude to the delights within the *Cabinet*.[8] Pepys 'could have spent three or four hours there well' on 27 August 1667 and found William Chiffinch, Closet Keeper to the King, a kindly and patient guide to the 'exceeding great variety of brave pictures and the best hands'. In the Closet were the finest small paintings in the collection: the miniatures, among them those which William Smithsby had preserved since Charles I had handed them over to him, including a Hoskins of Henrietta Maria in its 'goulden round enamelled frame'; small masterpieces, still in the collection, by Holbein, Correggio, Palma Vecchio, Titian, Parmigianino, Dosso, Andrea del Sarto, Steenwyck, Clouet, Rottenhammer (plate 71), Bril (plate 72) and Neefs; and others, such as Holbein's *Robert Cheseman* (plate 73), which have since been lost.

Evelyn's descriptions of the Cabinet, early in November and again in December 1660,[9] give a lively impression of its splendour. This 'Closet of rarities' was not looked after by Geldorp, but was the responsibility of Thomas Chiffinch, who had been a page to the King in exile and to his father before him. At the Restoration he was made Keeper of the King's Closet and pictures; at his death he was succeeded, in April 1666, by his younger brother William. The contents of the Closet had probably been arranged in imitation of the former Cabinet Room, which Webb, and perhaps Geldorp too, would have known well. There is a rather sad account by Balthasar de Monconys who, on 14 June 1663, had been taken into the Cabinet and was admiring its treasures when the King came in and addressed him in his usual easy way: 'he said he was delighted that I should see what he had, but that it was not half of what his father had owned.'[10]

The King had probably taken to heart the advice of his old tutor, the Earl of Newcastle: 'for the arts, I would have you know them so far as they are of use;' and he could discuss them knowledgeably. He and his brother James, Duke of York, who succeeded him on the throne in 1685, would have remembered, as well as their father's marvellous pictures, trips down the river to Van Dyck's studio in their twelve-oared barge. The new court was dissolute and cosmopolitan; and the Roman Catholic influence, even stronger than it had been in the days of Henrietta Maria, was to provoke in the Glorious Revolution of 1688 outbreaks of the same savage

iconoclasm as had vented its fury on her chapel at Somerset House in the 1640s. Charles II, James II and their consorts encouraged Roman Catholic painters, such as Huysmans, or those whose Frenchified style of painting brought to Whitehall something of the atmosphere of Versailles: Simon Verelst, Henri Gascars or the brothers Claude and Philippe Vignon. Philippe Vignon's cold and artificial portrait of the Duchess of Portsmouth (plate 74), for example, is, as an essay in the French court style, appropriate to the sitter who had accompanied the King's sister, the Duchess of Orléans, to England and who later, as the King's mistress, was to be a focal point of the French interest at his court. Painters of this type were far less distinguished than Sir Peter Lely, who had officially succeeded to Van Dyck's old post of Principal Painter in 1661. The royal brothers did not take such pains as their father had done to place their likenesses at focal points in the royal houses. Their employment of Lely was fitful and the younger brother patronized him more often than the elder. Lely's portrait of Lady Byron, who may have been one of the King's mistresses in exile, was in store at Whitehall, and so was Honthorst's portrait of the Duke of Monmouth's mother. The well-known series of Windsor Beauties (e.g. plate x) was, however, painted for the Duchess of York. On 21 August 1668 Pepys saw the Duke's 'room of pictures of some Maids of Honour, done by Lilly; good, but not like'. This was perhaps the White Room at St James's, embellished with blue mohair and silk fringes, in which the Beauties hung, with the long, narrow panels by Schiavone below. For the Duke Lely had also painted his other famous set: portraits of the thirteen flag-officers (e.g., plate 75) who had served under him in the battle of Lowestoft. Eight of these were hanging in 1671 in the Great Chamber of the Duke's house at Culford Hall.[11] The Duke had

74 (above left) PHILIPPE VIGNON *Louise de Kéroualle, Duchess of Portsmouth*

75 (above right) SIR PETER LELY *Edward, First Earl of Sandwich.* National Maritime Museum, Greenwich Hospital Collection

commissioned from Lely a number of portraits of his own family, but Charles II owned little by him. The most interesting piece must have been 'Madam Gwynn's Picture naked with a Cupid', for which a 'Slideing Peice' had been painted by Hendrick Danckerts, who painted for the King a number of rather dry classical landscapes for special positions, over a door or a fireplace in the royal apartments. The King also employed Danckerts, in a more practical vein, to paint topographical views of important places in the kingdom: two views of Plymouth (no longer in the collection), a view of Falmouth Harbour, two views of Portsmouth, perhaps to record the remodelling and rebuilding of fortifications and the construction of new docks, and a picture of England's new possession, the fortress and naval base at Tangier.[12] The same practical motive probably led the King to commission from Robert Streeter a record (plate 76) of two separate stages in his dramatic escape after the battle of Worcester, and from Willem van de Velde the Younger a little canvas of the Brightelmstone coal-brig in which he had sailed over to France and which, after the Restoration, was fitted up as a royal yacht (plate XI). Early in 1674 Van de Velde and his father had been awarded an annual pension from the Crown and they collaborated in a fine set of pictures of naval actions for the Duke of York. Among contemporary portraits commissioned by Charles II was Michael Wright's presentation of the actor John Lacy, a comedian who was a special favourite with the King, which he set up in a passage at Windsor between the King's Eating-Room and Withdrawing-Room. The humourless and dogmatic James II put up over the fireplace in the Withdrawing-Room, only a few yards away from the comedian, Kneller's masterly portrait of *The Chinese Convert* (plate 77), 'a young, pale-faced fellow who had travelled from his country and become a papist (his picture being done very well like him in one of the King's lodgings)', and who was seen in the King's entourage at Windsor on 3 July 1687, when the Papal nuncio was received in audience by King James.[13]

With the return of the Stuarts, Cardinal Barberini started again to send pictures over from Rome, concentrating particularly upon the Duke of York.[14] Reviving memories of his former plans to send to Henrietta Maria a Guido Reni of *Bacchus and Ariadne*, he commissioned from Romanelli two large canvases for despatch to England. A visitor to

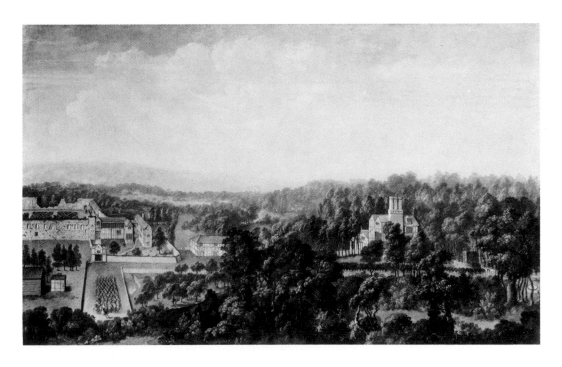

76 ROBERT STREETER
Boscobel House and White Ladies

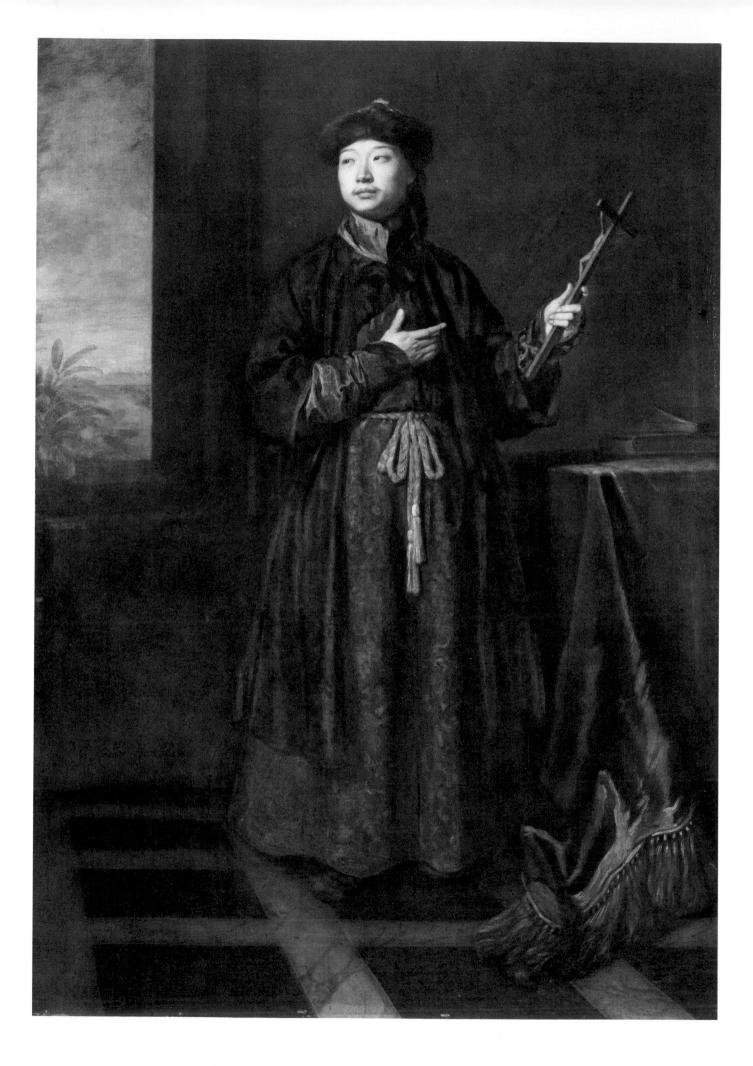

Hampton Court in 1681 saw 'two very large pieces of painting, sent to the King by Cardinal Barberini, of excellent work', but only a fragment of one of them survives. When Monconys had visited London in the summer of 1663 he had seen the *St Agnes* by Domenichino (plate 78). Hanging above the fireplace in the Duke of York's apartments at St James's, apparently in the Bedchamber of State which was later occupied by Mary of Modena, it would have looked down upon the birth of Prince James Francis Edward. As late as 1677 the Cardinal was hoping 'to send a fine peece of painting to o^r present Dutchesse of York'.[15]

Roman Catholic painters were welcomed at the court of the later Stuarts; but Antonio Verrio and Benedetto Gennari, the undistinguished nephew of Guercino, were hardly worthy successors of Rubens, Van Dyck or Gentileschi, and the

77 (left) SIR GODFREY KNELLER *The Chinese Convert*

78 (right) DOMENICHINO *St Agnes*

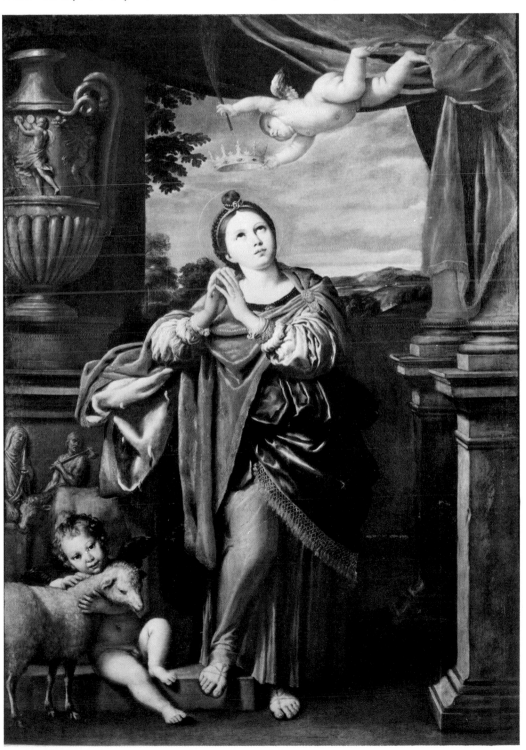

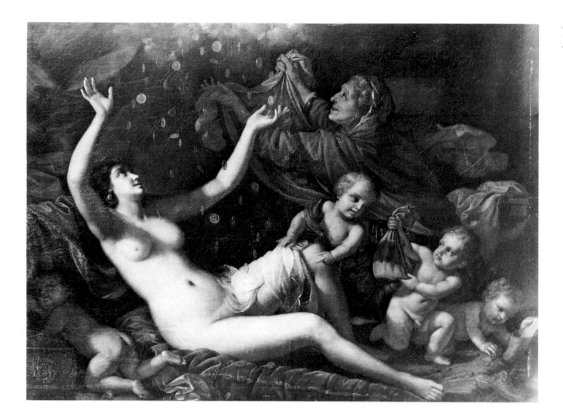

79 BENEDETTO GENNARI
Danaë

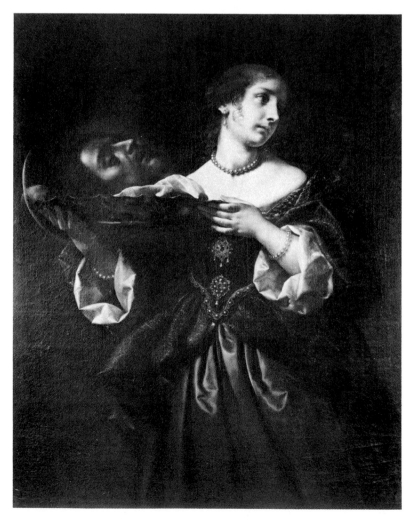

80 CARLO DOLCI
*Salome with the Head of
St John the Baptist*

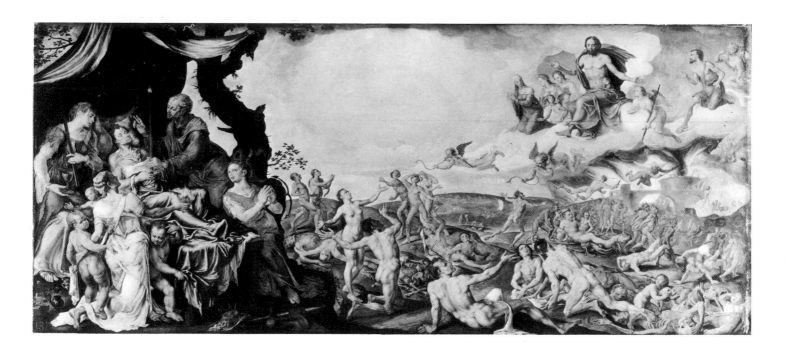

atmosphere of the court of Charles II and James II can be gauged perhaps by comparing Verrio's St George's Hall with the Banqueting House ceiling, or the fragile charm of Van Dyck's *Cupid and Psyche* with the vulgarity of Gennari's court style. Gennari was not exclusively employed by Roman Catholics, but he introduced himself to the Queen, on his arrival from Paris, with a little *Infant Baptist* and to the King with a *Diana and Endymion* which he had painted for the Duc de Richelieu. He painted subsequently a number of religious pictures for Queen Catherine's use at Somerset House and, for the saintly Mary of Modena, pictures for her private chapel at St James's. After the accession of James II he produced a series of pictures for the magnificent new chapel with its 'world of mysterious Ceremony' which King James had inaugurated on Christmas Day 1686: for the high altar, the side-chapels and the sacristy. None of these survive in the collection;[16] but there are a number of heavy-handed mythological canvases, some of them erotic in an unsubtle way, which Gennari had painted for Charles II: among them a set of four which were placed in the King's Dining-Room at Windsor and a *Sleeping Shepherd and two Women* and a *Danaë* (plate 79) for Whitehall. After the flight of James II, Gennari joined the exiled court at St Germains. In Queen Catherine of Braganza's Bedchamber and Closet at Whitehall, Pepys had seen on 24 June 1664 'pretty pious pictures and books of devotion'; Carlo Dolci's *Penitent Magdalen* and *Salome* (plate 80) were appropriate presents from Sir John Finch, for whom they had been painted while he was Resident in Florence.

Many of the pictures commissioned from living artists by the later Stuarts are of mediocre quality, but in his buying of earlier pictures Charles II was not unworthy of his father's memory. In exile he had been in touch, in the Spanish Netherlands, with William Frizell, from whom Charles I had bought a collection of pictures in 1638. At Breda in April 1660, on the eve of the Restoration, the King asked Frizell to keep for him a group of seventy-two pictures until they were sent for; and in 1662 the purchase, at £2,686, was completed and the pictures sent over to London. A number of the pictures are not subsequently recorded in the collection, but some important items in the collection are numbered in this purchase: the *Gentleman in Red* at Hampton Court (described by Frizell as a Holbein of Henry VIII when young); *Jonah under the Gourd* and *The Four Last Things* (plate 81) by Maerten van Heemskerck; the *Rape of the Sabines* by Christoph Schwarz; the *Marriage of Cupid and Psyche* (plate 82) by Bloemaert

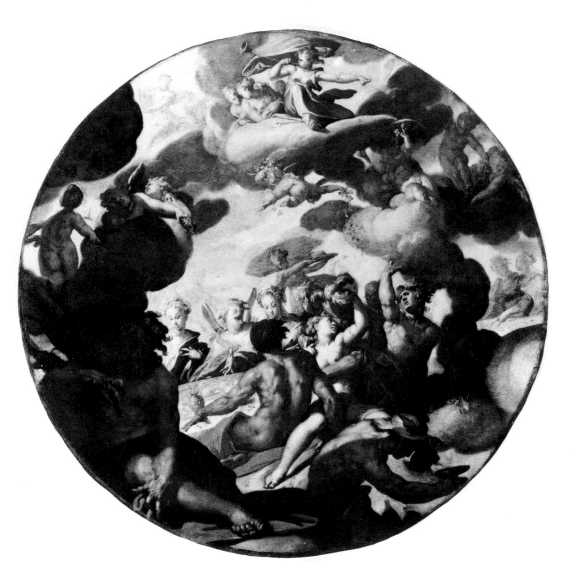

82 ABRAHAM BLOEMAERT
The Marriage of Cupid and Psyche

(confusingly attributed by Frizell to Goltzius); the *Adoration of the Shepherds* attributed to Joos van Cleve; a beautiful small panel, *David and Goliath*, by Veronese, with a companion piece of *Judith and Holofernes*; Georges de la Tour's *St Jerome* (plate 83), described as 'of the manner of Albert Dürer'[17]; pictures by such rare artists as Spierincks and Schönfeld; and, most spectacular survivor of this most interesting group, Pieter Bruegel's *Massacre of the Innocents* (plate 84). The Bruegel, the Schwarz, the Bloemaert and the larger Heemskerck were claimed by Frizell to have been among the pictures carried off from the gallery of the Emperor Rudolf II at Prague by the Swedish forces and to have been acquired from Queen Christina in the Netherlands.

In August 1669 the Queen Mother died at Colombes. Her estate was the subject of a legal wrangle between Charles II and his sister, the Duchess of Orléans. Sir Leoline Jenkins and a group of commissioners successfully argued the case for the King, who apparently secured those works of art to which he had a claim and which were not indigenous to the old Queen's house. Early in 1670 the King instructed the Duke of York to send over a ship to Rouen to fetch the goods. Ralph Montagu, ambassador to the King of France, who had been apprehensive that the goods might have been filched by the Duke of Orléans or by the Earl of St Albans, considered that Jenkins had executed his commission with skill.[18] From the inventory drawn up between 31 October and 5 November 1669, presumably in the course of Jenkins's negotiations, it is clear that Henrietta Maria had taken over to Colombes a number of pictures:[19] likenesses of her children, including Van Dyck's group of the three eldest; a portrait,

76

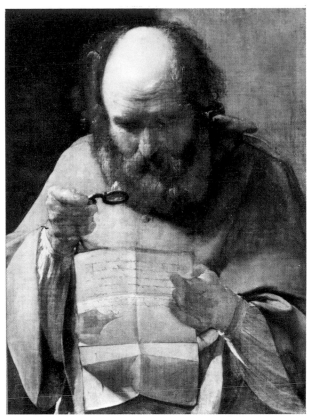

83 (right) Georges
de la Tour *St Jerome*

84 (below) Pieter Bruegel
the Elder *The Massacre of
the Innocents*

dated 1610, of her father, which may be the portrait now at Hampton Court; and
pictures which would have reminded her of happier times: Gentileschi's *Joseph and
Potiphar's Wife* or Baglione's *Virgin and Child with Angels*, which hung in her Bed-
chamber at Colombes. Among the pictures in the Queen's Cabinet next to the
Bedchamber was a 'Noli me Tangere', by which, in the inventory, was the note: 'To be
taken away unknowne to Madame'. If, as seems almost certain, this was the panel
painted by Holbein *c.* 1524 (plate 85), the King had secured one of the most beautiful
pictures in the collection and one which moved Evelyn to ecstasy when he saw it in the
Privy Lodgings at Whitehall on 2 September 1680: 'I never saw so much reverence &
kind of Heavenly astonishment, expressed in Picture.' It is possible, moreover, that a
picture of the *Baptism*, at Colombes in 1669, is the Francia of this subject at Hampton
Court (plate 86).

Clarendon wrote bitterly that of the 'neighbour-princes' who had plundered the
collection in the Interregnum not one had thought to return a single picture to the
restored King. It was left to the States of Holland to assemble a fine group of pictures

85 HANS HOLBEIN
THE YOUNGER
Noli Me Tangere

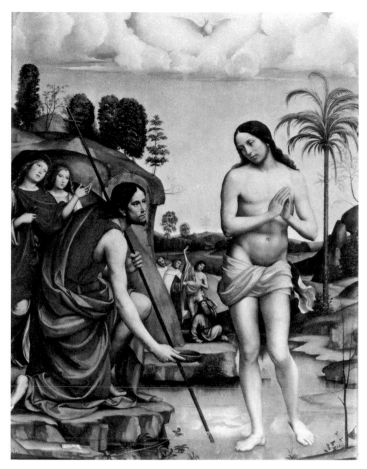 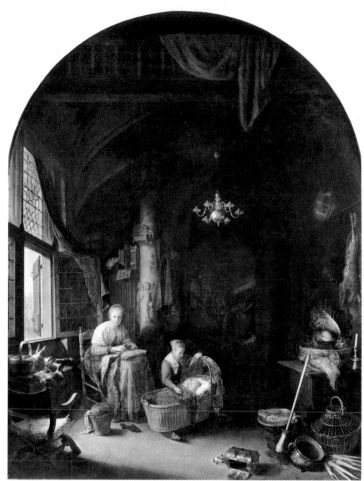

86 (above left) FRANCESCO
FRANCIA *The Baptism of Christ*

87 (above right)
GERRIT DOU *The Young Mother*.
Mauritshuis, The Hague

which were presented to the King in November 1660 in celebration of his return. The
States had acquired three pictures from Gerrit Dou, of which one was his *Young Mother*
(plate 87), which particularly pleased the King and displayed the technical virtuosity
of the Leiden school of *Feinmalerei* which fascinated collectors until the nineteenth
century; and the present included the superb Saenredam (plate 88), painted in 1648, of
the interior of the Church of St Bavo in Haarlem. Not for many years was a work by this
painter recorded in a foreign collection; and the royal collection under the later Stuarts
contained, as their father's had done, the most important collection of Dutch pic-
tures outside Holland.[20] Even more valuable was the group of Italian pictures
chosen by the States as the chief part of their gift to a King who was reported to like old
paintings, especially of the Italian masters, better than those by modern painters.
Twenty-four Italian pictures, and some pieces of sculpture, had been chosen in
September 1660 for the States by the sculptor Artus Quellin the Elder and the dealer
Gerrit Uylenburgh, at a cost of 80,000 *gulden*, from the celebrated collection formed in
Venice and Amsterdam by the brothers Gerrit and Jan Reynst. Both were now dead.
Gerrit, in his splendid house on the Keizersgracht in Amsterdam, had inherited some of
the works of art which his brother had acquired during the years he had spent as a
merchant in Venice; and it was from Gerrit's widow, Anna Reynst, that the selection
for the English King was made. It included the Bellinesque *Concert*, Titian's *Portrait of a
Man* (plate 89), the *Dominican* by Tintoretto, the *Marriage of St Catherine* by Veronese,
Cariani's *Venus*, two fine Schiavones (*The Judgment of Midas* and *Christ before Pilate*),
Parmigianino's *Minerva* (plate 91), Giulio Romano's *Isabella d'Este* (plate 90) and two
portraits by Lotto: the *Head of a Man* and, the finest piece in the present, the portrait
of Andrea Odoni (plate 92) which had been noticed in Gerrit Reynst's house as early as

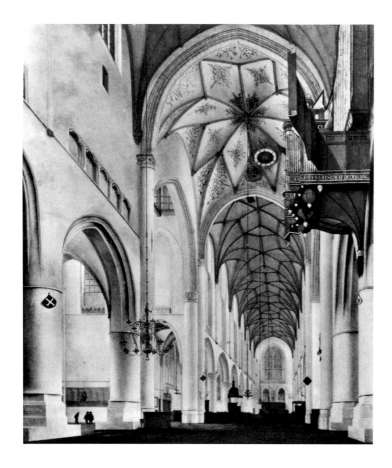

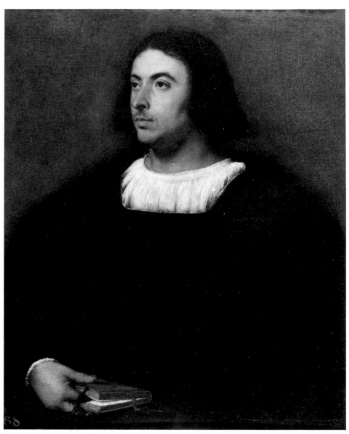

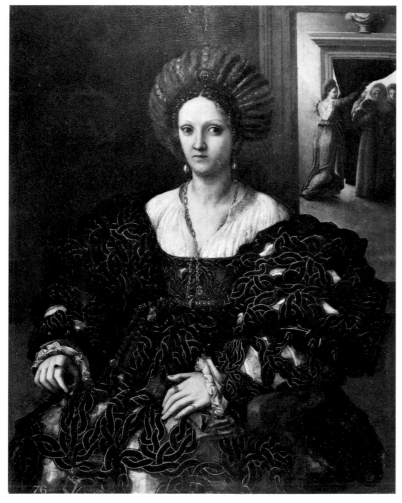

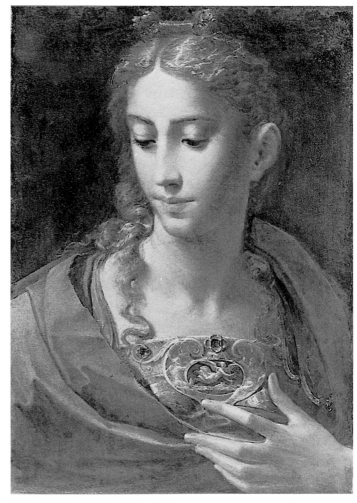

88 (far left) PIETER
JANSZ. SAENREDAM *The Interior
of St Bavo's Church, Haarlem.*
Private Collection

89 (left) TITIAN
Portrait of a Man

90 (far left) GIULIO
ROMANO *Isabella d'Este*

91 (left) PARMIGIANINO
Minerva

September 1639. In November 1660 the Dutch present was put on show in the Banqueting House. Not surprisingly the King was reputed to be very pleased with it, 'especially the pictures and statues in which he takes extreme delight'. Sadly, two particularly fine pictures from the Reynst collection have long since left: the brilliantly-painted early Jacopo Bassano of *Christ Carrying the Cross* (plate 93), which seems to have been placed by the King in the care of Catherine of Braganza; and Guercino's *Semiramis*, which may have been given by Charles II to Lady Castlemaine.[21]

The names of those who had given pictures to the King are recorded in his and his brother's inventories: among them the Earl of Sandwich (Palma Vecchio's *Sibyl*), Lord d'Aubigny, Lord Bellasis and the Earl of Pembroke. Sir Richard Bellings and Walter Montagu, Abbot of Pontoise, gave religious pictures to Catherine of Braganza. In June 1671 over £2,300 was ordered to be paid to Montagu for pictures and heads sold by him to the King; his cousin Ralph Montagu had encouraged him to let the King have them.[22] A group of pictures is described as coming from 'Mr Wright's Lottery': a possible allusion to John Michael Wright, who was intermittently employed by the royal family, styled himself on occasion 'Pictor Regius' and painted, but not apparently for the King, the most impressive presentation of the Sovereign restored. Sir William Temple may have been active on the King's behalf in the Low Countries. Certainly in 1666 he wrote from Brussels that he was sending over to the King a Holbein 'which was esteemed by my Lord Arundel among the best of that hand in his collection': conceivably a reference to *Derich Born*. At some stage the King acquired the two portraits by Piero di Cosimo, of Giuliano da San Gallo and Francesco Giamberti, now in the Rijksmuseum;[23] and such fine pictures as the Costa (plate XII) and Bassano's *Adoration of the Shepherds* (plate 94) are first recorded at this period.

The most ambitious architectural undertaking carried out by Charles II was the remodelling of the state apartments at Windsor Castle. In the later part of his life the King spent much of his time at the Castle. Pictures were selected as integral elements in the decoration of the rooms underneath Verrio's gay new ceilings. The payments for work carried out in the Castle in 1677–8 include a reward or gratuity of £50 to Uylenburgh 'for his Extraordinary Care and Paines in Enlargeing Painting fitting and placeing of severall of his Ma^ties Pictures sett over all the Chimneys and doores in the Kinges and Queenes Lodgings in Windsor Castle and for severall Journeys to some of his Ma^ties Houses to make Choice of such Pictures as were most fitt to be sett in the sever^ll places aforesaid according to his Ma^ties Direc̄c̄on'. In 1676–7 the young French painters Nicolas de Largillierre and Philip Dolesam had been employed on tasks of the same nature. The frames into which the pictures, selected and adapted, were to be set had been carved by Grinling Gibbons and Henry Phillips.[24] Charles II was particularly pleased with the way in which Largillierre had partly repainted for him the *Cupid Sleeping* by Caracciolo. A number of the pictures chosen by the King for use at Windsor, such as (probably) Fetti's *David with the Head of Goliath*, Michael Wright's portrait of Lacy, the four paintings by Gennari from his Eating-Room and Ribera's *Duns Scotus*, are still in the simple frames carved at this period; others were, of course, placed into the more elaborately carved settings of which some survive at Windsor, but mutilated and adapted at a much later date to a different disposition of pictures. *Duns Scotus* (plate 95) provides a clear example of the extent to which pictures were disfigured by additions to make them fit a chosen spot.[25]

Gerrit Uylenburgh, who had been involved in various ways with the Reynst collection and whom Charles II rewarded for his work at Windsor, was a cousin of Rembrandt's wife Saskia; when Rembrandt moved to Amsterdam in 1631 he had

lodged in the house of Gerrit's father. He had been a landscape painter before he turned to picture-dealing, but had been involved in a famous scandal in which pictures which he was hoping to sell to the Elector of Brandenberg were denounced as fakes. In 1675 Gerrit declared himself insolvent. He came to England, where he earned a living painting backgrounds for Lely.[26] In December 1676 the King made him 'Purveyor and Keeper' of his pictures, for the better preservation of them from decay, with an annual salary of £100.[27] The 'Cleanser' of the pictures was a post separate from that of the Keeper. Uylenburgh's tenure of office may not have been very long: by April 1679 Parry Walton was established as his successor. In 1682 Henry Norris is described as the Keeper, and Parry Walton as the Cleanser, of the pictures.[28] There is also a tradition that Charles II offered Largillierre the post of keeper of his cabinet of pictures,[29] but Parry Walton seems to have continued in office until after the Revolution.

It was, however, William Chiffinch, as Keeper of the King's Closet, who signed the

92 LORENZO LOTTO
Andrea Odoni

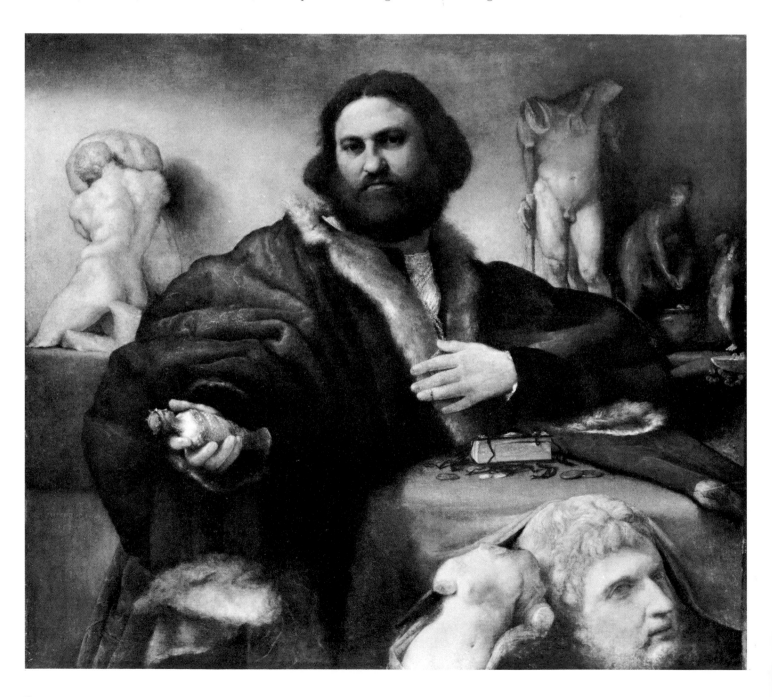

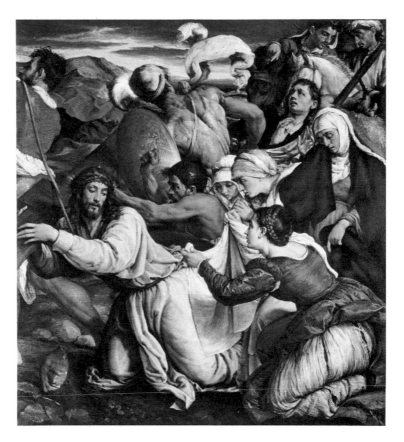

93 (right) JACOPO BASSANO
Christ Carrying the Cross.
Collection The Earl
of Bradford

94 (below) JACOPO BASSANO
The Adoration of the Shepherds

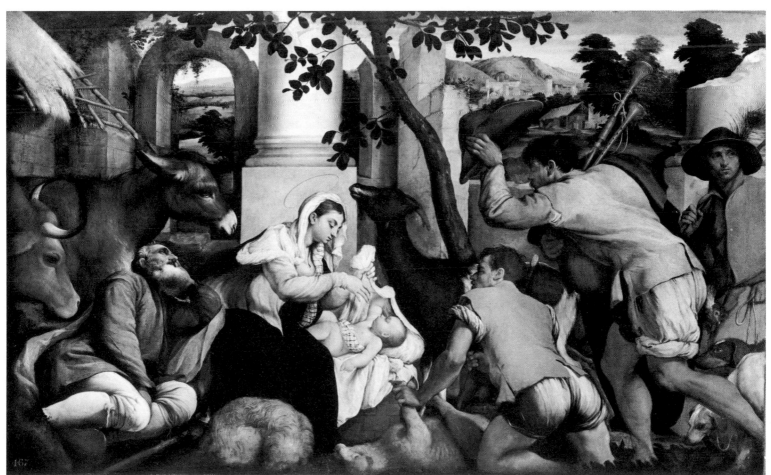

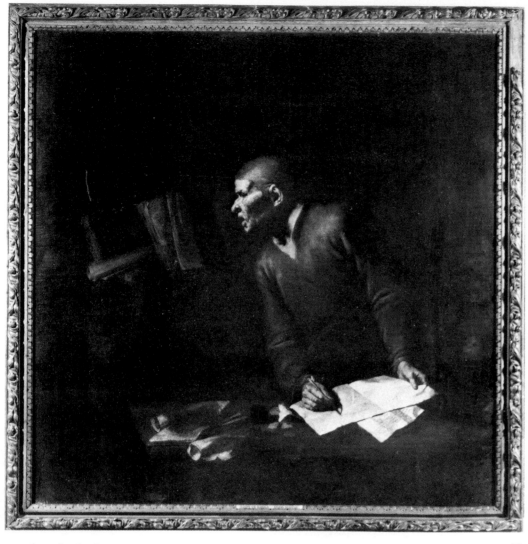

95 JUSEPE DE RIBERA
Duns Scotus

sections in the inventory of James II's possessions which cover the pictures and statues.[30] At Whitehall were some 650 pictures and miniatures; Queen Catherine had in her custody at Somerset House, which had been granted to her in October 1669, about fifty royal pictures; at Windsor there were now about 125 pictures; and at Hampton Court about a further 180. In addition there were at Windsor sixty-one, and at Whitehall thirty-five, pictures which had not belonged to Charles II; twenty-one miniatures and small pictures; and, at St James's, sixty-three pictures which seem always to have been King James's property.

When James II fled in 1688, therefore, his daughter Princess Mary and his son-in-law the Prince of Orange found themselves possessed of nearly 1,200 pictures. The serious-minded Prince, like many members of the House of Orange, was keenly interested in pictures. On his march to London he stopped at Wilton, on 4 December 1688, in order to see the Earl of Pembroke's Van Dycks, and advised his secretary, Constantine Huygens, to do the same.[31] Ten days later he was at Windsor and discussed the pictures there with Huygens; immediately after his arrival in London he was giving orders that nothing was to be moved from any of the royal houses without his orders; and on 13 February 1689, the day on which he and Princess Mary were offered the Crown, he talked with Huygens about the pictures at Whitehall, especially those in the Closet.

The new King and Queen were actively interested in architecture, interior decoration and gardening. The King was much concerned with his pictures and with their condition and arrangement, and they were now subjected to a great deal of movement. In the autumn of 1689 Huygens, who records many conversations

with the King about pictures, had been given a list of them – it may have been Chiffinch's inventory or a copy of the relevant parts of it – and was asked to inspect them on the King's behalf; and by the end of the year the King had given orders that the best were to be assembled at Kensington. He had bought the house from the Earl of Nottingham in June and the court was in residence by Christmas. From this moment, until early in the reign of George III, Kensington is the most important of the royal residences so far as the collection is concerned. The King at first chose the pictures which were to be hung in his Cabinet; but in November 1695 pictures were again being selected from Windsor and Hampton Court, chiefly for the embellishment of the new King's Gallery at Kensington. Huygens himself was employed in November and December to help in hanging the pictures there, assisted by Frederick Sonnius, Walton and John Norris, Joiner of the Privy Chamber, all under the keen eye of the King.

Frederick Sonnius was a shadowy portrait painter of Dutch origin who had been a friend of Lely and was employed by Roger North, after Lely's death, to take care of the pictures left in his house and eventually to help in organizing the sale of them.[32] He was now given rooms at Whitehall and an annual salary of £100, probably from 13 May 1690, as Keeper in Ordinary of the King's pictures, drawings and other rarities and antiquities.[33] Parry Walton, who had succeeded Uylenburgh as Surveyor and Keeper and was retained in the post at the outset of the reign of William and Mary, was retained as 'Mender and Repairer' of the pictures. He was a painter of still-life; 'but his particular Excellence lay in knowing and discovering Hands. He was well vers'd in *Italian* Pictures, and . . . was also remarkable for mending the Works of many of the great Masters, that had suffered either by Age or ill Usage, and this he did by several of the best Pictures at *Whitehal*.'[34] At the end of his reign, when both men were still in their respective posts – Sonnius as Keeper in Ordinary and Walton as Mender and Repairer, and each with annual salaries of £200 – William III expressed his intention of combining their two posts, after their deaths, with that of his Principal Painter (at that time Sir Godfrey Kneller) who was to have £200 added to his annual salary. Walton, however, was succeeded in March 1701 as Repairer by his son Peter and nothing seems to have come of William's scheme for simplifying the organization of this little department of his Household. Peter Walton became Surveyor and Keeper of Pictures. He occupied the post, with the same salary as his father, until his death in 1745.[35]

The King's Gallery at Kensington, hung with green velvet and white damask curtains, must have made a rich impression. It was tightly packed with pictures: seventy-one in number, predominantly Italian, some very large (such as the two great Tintorettos at Hampton Court, and the two huge Van Dycks marvellously sited at each end of the room).[36] Fine small pictures, and two cases of miniatures (twenty-four in one, twenty-seven in the other) were arranged in the Closet against crimson and olive damask. The staircase with which the King had been busying himself at the end of 1691 was thickly hung with pictures. The King's new state portrait by Kneller (plate 96) hung in the Council Chamber; it was later joined by the companion portrait of Queen Mary. Kneller's compelling image of Peter the Great was put up over the fireplace in the Drawing-Room next door, with the full-length Honthorsts of the King's forebears over the doors.

William III's most important architectural undertaking was the rebuilding and redecoration of a large part of Hampton Court. In the principal state rooms, which the visitor entered after he had mounted the King's Staircase, surrounded by Verrio's brassy new wall-paintings, very few pictures were set up: landscapes by Rousseau, Achtschellink and Danckerts; bird and flower pieces by Baptiste and Bogdani over the

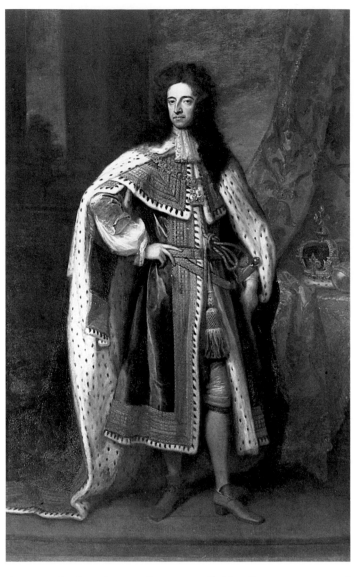

doors; and full-length portraits over the fireplaces, all surrounded by fine swags carved by Grinling Gibbons. Much of the original disposition survives to this day.[37] Opposite the Chair of State in the Presence Chamber was Kneller's vast equestrian portrait of the King, painted in 1701,[38] strategically placed to have the same effect on the spectator as Van Dyck's equestrian portrait of Charles I at St James's (a picture in which the King had been particularly interested as early as May 1689, when he altered its position at Hampton Court) or Kneller's of the King on a semi-illusionistic dais at the end of St George's Hall. The impact of the equestrian portrait would have been comparable to that made by Mignard's equestrian Louis XIV in the Throne Room at Versailles; the effect of the seated image would have recalled Testelin's portrait of the King's life-long enemy in the Grande Salle des Assemblées in the Louvre.

For the Queen, Kneller painted the series of 'principal Ladies attending upon her Majesty' which she placed in her Water Gallery by the river: 'the more beautiful Sight because the Originals were all in Being and often to be compared with their Pictures'. After her death and the pulling down of the Water Gallery, they were put in the Eating-Room below Stairs. In his Private Apartments the King placed a distinguished group of small pictures: Italian (the small Veroneses bought from Frizell, for example); little Dutch and Flemish pieces by Wouwerman, Dou, Poelenburgh, Steenwyck, Wouters and Eworth; and the Leonardesque panel, still at Hampton Court, of the *Infants Christ and St John*. As early as May 1689 Queen Mary had been

talking about the pictures in the King's Gallery in which Mantegna's *Triumph of Caesar* was hanging and about what should be done to them by Walton. Norris was also concerned with their repair, which was probably put in hand late in 1690. Among the payments to Walton at this time, the most interesting was made on 10 July 1693, when, in addition to payment for repairing the ceiling in the Banqueting House, he received £100, final payment of a total of £200, for repairing Raphael's Cartoons which, by the autumn of 1699, were fixed up in the remodelled Cartoon Gallery,[39] and £60 for lining and repairing three sections of the *Triumph*.[40] The principal work on the *Triumph* was, however, entrusted by the King to Louis Laguerre, painter to the Works, by an agreement dated 14 July 1701. It seems, from a petition submitted after the King's death, that Laguerre had completed by 8 July 1702 the work on the nine sections at an agreed fee of £360.[41]

Defoe, an ardent admirer of the King, claimed that he 'brought a great many other fine Pieces to *England*', and thus encouraged 'Nobility and Persons of Figure' to buy pictures;[42] but William III does not seem to have made any important additions to the collection, although on 23 November 1691 he told Huygens that he greatly desired to buy the collection of Queen Christina of Sweden and was recorded as upset by the news that he had been forestalled by Cardinal Azzolini. On the other hand, he dealt a serious blow to the collection when he removed to Het Loo a group of pictures which included Van Dyck's *Self-Portrait* and his double portrait of the King's parents; *Robert Cheseman* and the *Man with a Hawk* by Holbein (both now in the Mauritshuis); the two heads by Piero di Cosimo; the marvellous Dou given to Charles II by the States of Holland; and the large landscape (in the Mauritshuis) by Keirincx with figures by Poelenburgh. Queen Anne tried unsuccesfully to recover the pictures, which should have been part of her inheritance in 1702.[43]

Queen Anne, dullest and meanest of the Stuarts, added little of importance to the royal collection. The portrait of her devoted consort, Prince George of Denmark, painted in 1704 by the Tory painter Michael Dahl, was placed in a martial context, surrounded by trophies of arms in the Queen's Guard-Chamber at Windsor.[44] The Prince is shown as 'generalissimo' and Lord High Admiral; and it was probably he who commissioned Dahl and Kneller to paint a series of portraits (e.g., plate 97) of the principal naval commanders in the War of the Spanish Succession. They hung in the Little Gallery at Kensington, successors to the admirals Lely had painted for the Queen's father. Queen Anne carried out alterations to the pictures at Kensington, carefully recorded by Thomas Coke, Vice-Chamberlain of the Household; but an atmosphere of quiet domesticity seems to surround the private life of the last of the Stuarts. Celia Fiennes gives a charming account of the 'little box' the Queen had bought on the south side of Windsor Castle, where she saw in her Bedchamber portraits of Prince George and the young Duke of Gloucester.[45] Down the southern slope the Queen would have observed the aviary which Admiral George Churchill, the Duke of Marlborough's brother, kept on a site near the present Dairy at Frogmore. After his death in May 1710 the Queen bought from his executors a series of decorative canvases by Bogdani (e.g., plate 98) in which the Admiral's birds are faithfully delineated. A commission to paint, for £100, the no less exotic Iroquois *sachems* who visited London in 1710, was given to John Verelst.[46]

A surprisingly large number of pictures in the Queen's inventory was in store at Kensington, Hampton Court and Windsor; and by 28 October 1714, soon after her death, a store for pictures not in use had been established at Somerset House.[47] It is in this store that we last hear of such important lost pictures as the Saenredam which the

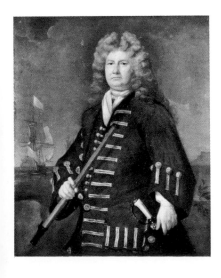

97 MICHAEL DAHL
Sir Clowdisley Shovell.
National Maritime Museum, Greenwich Hospital Collection

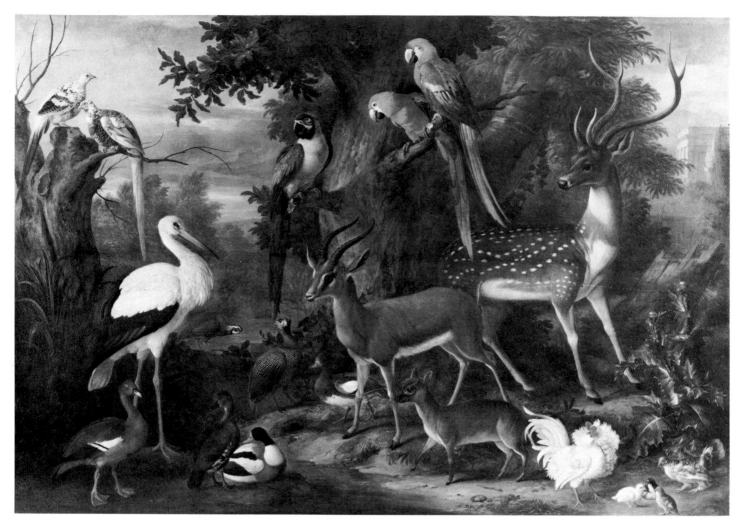

States of Holland had given to Charles II. Although, thanks to the energetic efficiency of Sir John Stanley, Secretary to the Lord Chamberlain, nothing seems to have been lost in the fire at Whitehall Palace in January 1698 (by which time so many of the best pictures would have gone to Kensington), courtiers may have removed pictures in the confusion of the Revolution (there is a tradition that the Duke of Buckingham took away Lely's portrait of the naked Nell Gwynn) and Catherine of Braganza is stated to have sent pictures from Somerset House to Lisbon before she finally left England in 1692. Horace Walpole assumed that pictures had slipped out of the collection between the death of Queen Anne and the arrival of George I.[48]

98 JAKOB BOGDANI
Birds and Deer in a Landscape

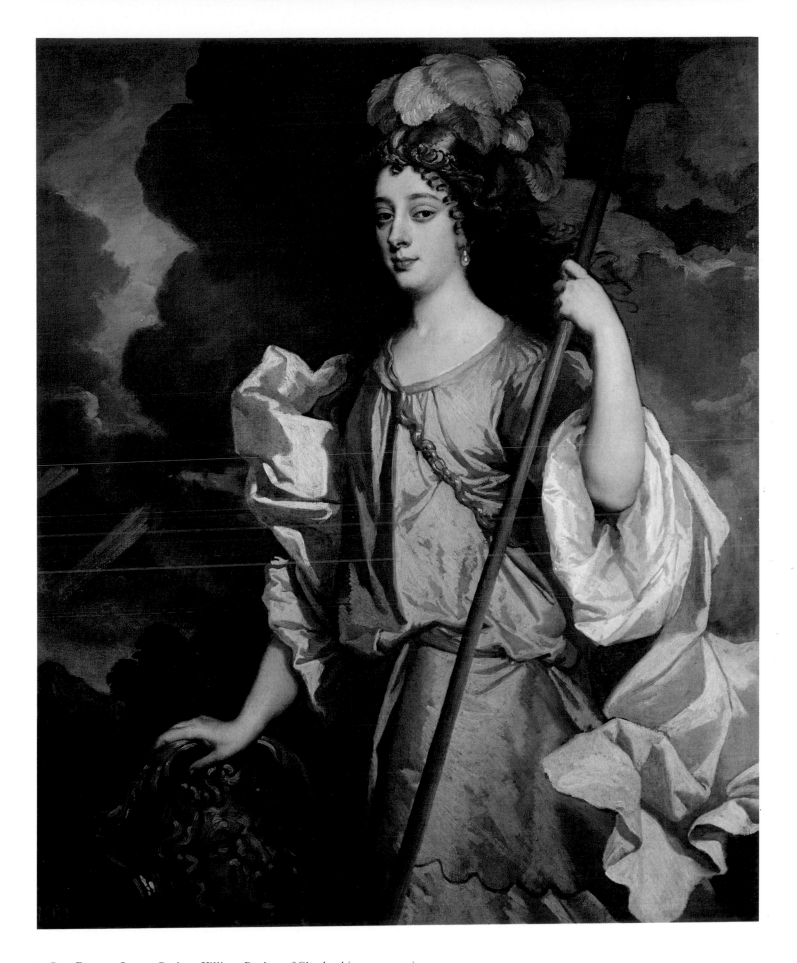

x Sir Peter Lely *Barbara Villiers, Duchess of Cleveland* (see page 70)

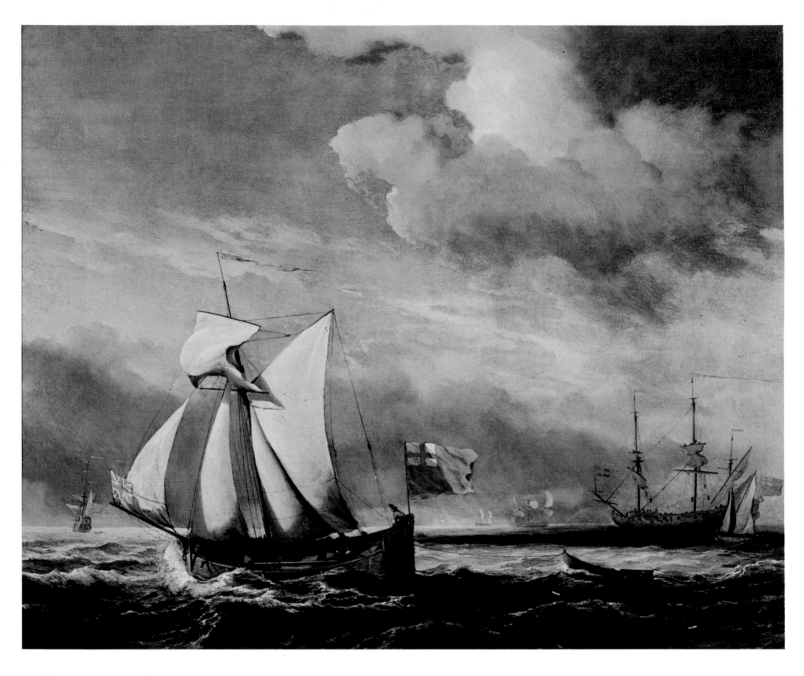

XI WILLEM VAN DE VELDE THE YOUNGER
The Royal Escape (see page 71)

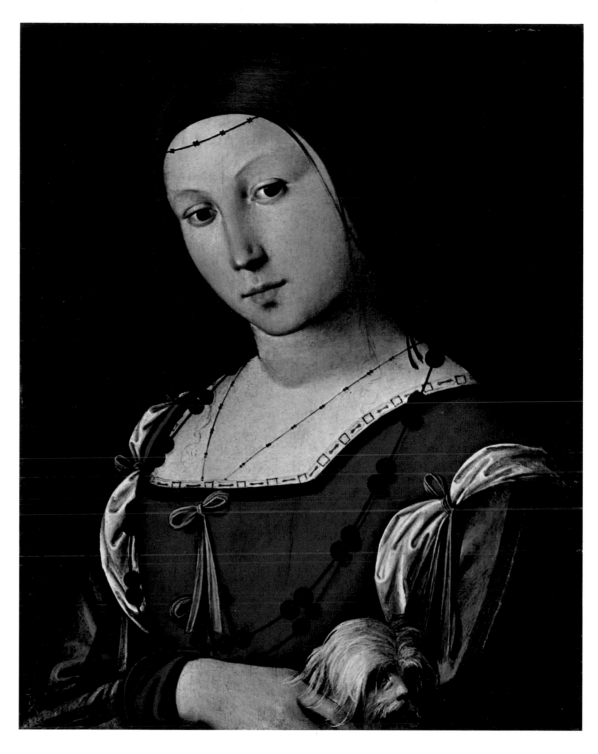

XII LORENZO COSTA
Portrait of a Lady with a Dog
(see page 81)

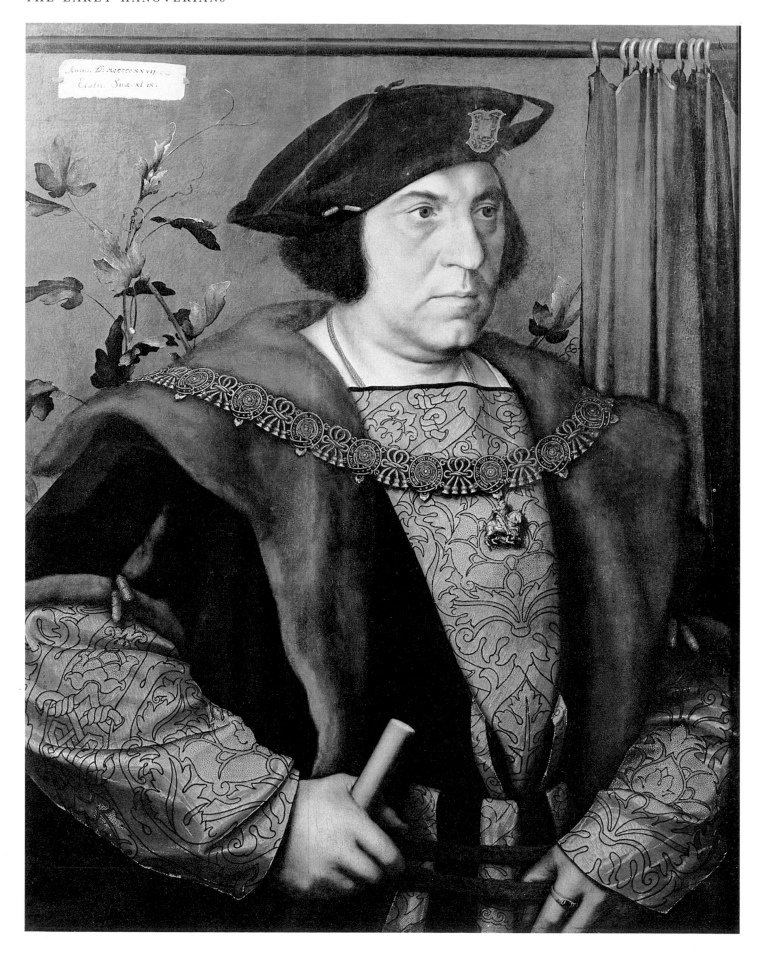

104 (above right)
SAMUEL COOPER *Barbara
Villiers, Duchess of Cleveland*

105 (below)
CHARLES BOIT *Queen Anne
with Prince George of Denmark*

heads by Cooper (e.g., plate 104) which are sometimes stated to have been acquired by Charles II, and are unique in Cooper's work. Among more modern portraits was Boit's large enamel (plate 105) of Queen Anne with Prince George of Denmark and, probably, contemporary enamels of the royal family by Zincke. Finally, there were a number of gold frames in which sets of miniatures were fixed. Many of them are unidentified in Vertue's list, but they included carefully arranged German relations and ancestors as well as English royal figures, some of which had been acquired by the Queen. In her enthusiasm for sets of small ancestral likenesses and her interest in the historical portrait in general, Queen Caroline was anticipating one of Queen Victoria's and Prince Albert's chief concerns. The Hanoverian and Saxe-Coburg families also continued to assemble portraits and groups of portraits on a large scale of their forebears: sinister, 'ill-coloured, ouran-outang-looking figures . . . in old-fashioned uniforms', who amused Sir Walter Scott and who still frown or grimace at the visitor in passages and store-rooms.

Queen Caroline's other purchases were of a more modest nature: a small Filippo Lauri, for example; a *Calm* by the younger Van de Velde; and Van Bassen's *King and Queen of Bohemia Dining*. In 1730 Charles Jervas, who had painted official portraits of the King and Queen soon after their accession, was stated to be on his way to Italy to purchase paintings for the royal family and to regain his health; but he died soon after his return in the following year and there is no evidence that he brought pictures back with him. Surviving accounts record payments, on Queen Caroline's and the King's behalf to Jervas for portraits; to Howard, Waters and Boson for frames; and to Kent, Zincke, Mrs Aikman and Mercier for pictures (unspecified)[16]. On Parry Walton's death the Surveyorship of the pictures was granted, on 24 June 1745, to Stephen

Slaughter, with the annual salary unchanged at £200. He was a portrait painter of solid, if rather unambitious, ability who numbered the Walpole family among his sitters; a group of the children of Sir Edward Walpole, painted in 1747, includes the eight-year-old Maria, who was to marry Queen Caroline's grandson.[17] The House-keeper at Kensington was asked by the Lord Chamberlain's Office on 23 March 1748 to provide Slaughter with 'a convenient place to work in' so that he could carry out the Lord Chamberlain's orders 'to clean and repair the pictures at Kensington'.[18]

Queen Caroline's interest in pictures can hardly have been unaffected by the superb collection which Sir Robert Walpole was assembling. It is ironical that her elder son Frederick, Prince of Wales, for whom she nurtured a morbid and unconquerable distaste and who was dabbling in opposition politics from his new base at Leicester House, should prove to be the first of the new dynasty to show enthusiasm as a patron and collector.

In a viciously detailed 'character' of the Prince of Wales, Lord Hervey likened him to Nero. 'Both . . . piqued themselves not only, like Princes, upon being patrons of arts and literature, but upon being great proficients in arts and letters themselves.'[19] In the pages of George Vertue's notebooks the Prince appears in a more favourable light: as one who, in contrast with his father, was 'conversable & void of ceremony', and 'whose affection and inclination to promote and Encourage Art and Artists is daily more and more evident, by the imployments he has given several Artists'. The iconographies of George I and George II were exceptionally dull, but Prince Frederick showed a cosmopolitan and unprejudiced interest in the painters of his time. He had sat to a number of minor portrait painters during his lonely childhood and youth in Germany, but soon after he came to England in December 1728 he visited the studio of Philippe Mercier, who had studied in Berlin in the studio of Antoine Pesne and who worked in a pretty rococo style, influenced by Watteau, which obviously appealed to the Prince. On 17 February 1729 he appointed Mercier to be his Principal Painter; in 1730 he was given the additional appointment of Library Keeper. The first post ceased to be his when the Prince replaced him with John Ellis or Ellys in October 1736 and at no stage did Mercier have a monopoly in portraits of the Prince; but his little picture of the Prince playing the violoncello, in company with his eldest sisters (plate XVI), is an innovation in English royal portraiture: a small informal conversation-piece in the tradition which Zoffany was to develop in the next generation, painted with a rococo touch and showing members of the royal family together, in this instance making music, with Hampton Court or (in other versions) Kew as the background.

In Mercier's little *Comedians by a Fountain*, which may have been painted for the Prince, the figures are directly derived from a group of *Personnages de fête galante* by Watteau;[20] and disbursements for pictures on the Prince's behalf between 1732 and 1735 included £21 in 1735 for a Pater of *Amphitrite*.[21] Charles Philips's work for the Prince and his circle included conversation-pieces which, though less accomplished than Mercier's, also showed his patron engaged in actual daily activities: with his hunting cronies round a punch-bowl, for example, in a room at Kew House. The formal portraits of the Prince and of his wife, Princess Augusta of Saxe-Gotha, are more accomplished than the stiffly articulated images of his parents by Kneller, Seeman or Jervas. The portrait of the Prince by Jacopo Amigoni (plate 106) is an essay in Venetian rococo as well as a tribute to Prince Frederick's enthusiasm for the arts and sciences, to his literary tastes (Pope's *Homer* is held in the right hand) and also perhaps to frustrated military ambitions; and the Prince seemed to have preferred to the solid English style of Richardson or Hudson (whose portraits of himself were not done for his

XV ISAAC OLIVER
Portrait of an Unknown Man
(see page 99)

XVI PHILIPPE MERCIER *Frederick, Prince of Wales, with Princesses Anne, Caroline and Amelia* (see page 96)

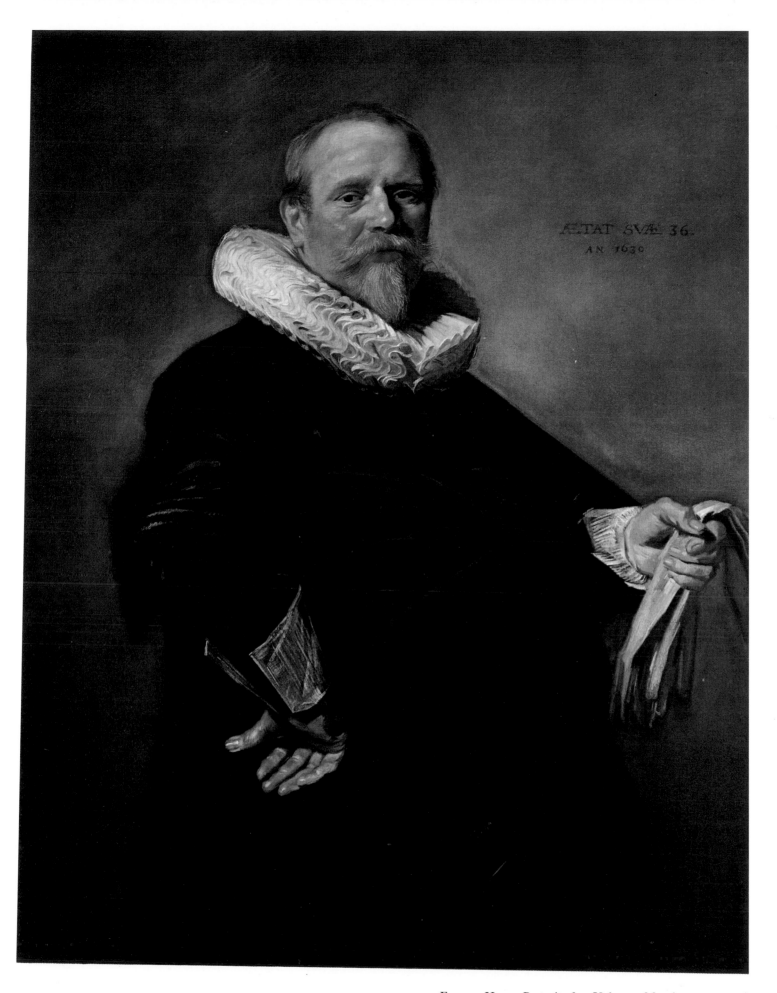

XVII FRANS HALS *Portrait of an Unknown Man* (see page 100)

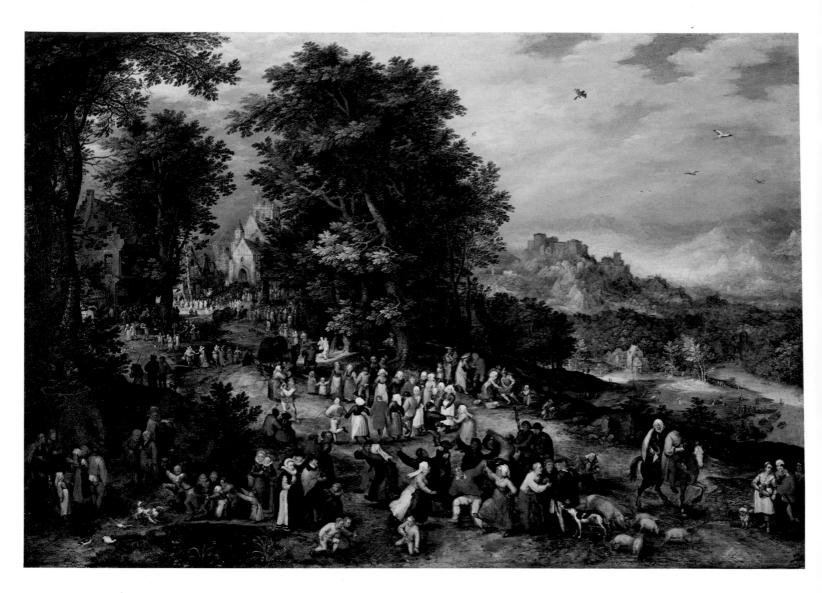

XVIII JAN BRUEGHEL
A Flemish Fair (see page 100)

own use) the elegance of Highmore or the essentially Frenchified court style of Vanloo (e.g., plate 107). His love of hunting and country life brought him into contact with John Wootton, who painted three views of his retreat at Park Place near Henley, in two of which the royal family are seen disporting themselves in the foreground; and, in the composition of one very large hunting piece (plate 109), briefly with Hogarth. When payment was made for the picture on 31 August 1734, £157 10s was paid to Wooton 'for the Landskape & Figures' and £31 10s to Hogarth 'for Painting Six Faces in the Picture at 5 Guineas Each Face'. It is possible that the Prince had earlier given Hogarth a sitting for an abortive royal conversation-piece.

Like his mother, the Prince had an affection for old portraits. This and his love of the chase may have led him to acquire Robert Peake's portrait of an earlier Prince of Wales in the hunting field, which had been, in iconographical terms, important for the evolution of one of Van Dyck's most famous presentations of Charles I. The huge group of the Prince's family, painted by George Knapton a few months after the Prince's death, is a statement of the new dynasty's pursuits and achievements, basically conceived along Van Dyckian lines, but also to be read as a sequel to Holbein's painting on the wall of the Privy Chamber at Whitehall. In July 1750 Vertue saw at Leicester House the portrait of the *Third Duke of Norfolk* which is certainly the best-known version of an important design by Holbein.

In their earliest conversations the Prince and Vertue discussed miniatures and enamels, which the Prince was buying 'in a very great number'. Apart from contemporary limned portraits – in 1732 he appointed the enamellist Christian Friedrich Zincke his 'Cabinet painter' – the Prince acquired earlier miniatures, a number of them through Mercier. His most important acquisitions in this field were made from the collection of Dr Richard Mead. These included a superb group of works by Isaac Oliver: the tiny *Self-Portrait*; the exceedingly fine *Unknown Lady*, thought at the time of its purchase to represent Mary, Queen of Scots; the fantastic profile of Anne

106 (below left)
JACOPO AMIGONI
Frederick, Prince of Wales

107 (below right)
JEAN-BAPTISTE VANLOO
Augusta, Princess of Wales, with Members of her Family and Household

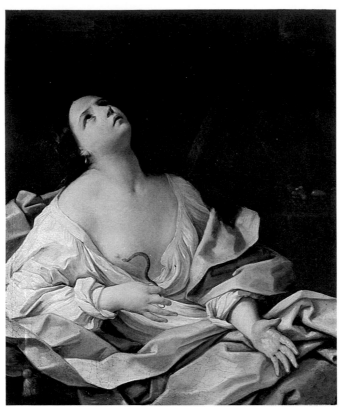

108 (left) GUIDO RENI
Cleopatra

109 (below) JOHN WOOTTON
AND WILLIAM HOGARTH
Frederick, Prince of Wales,
in the Hunting Field

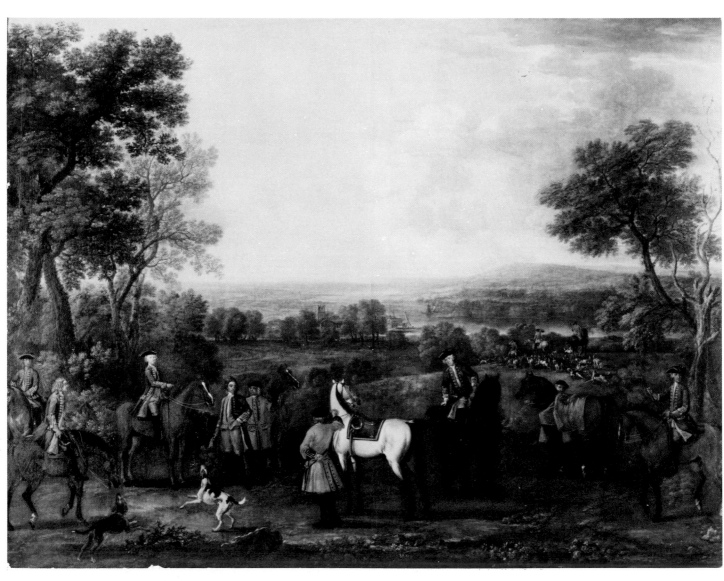

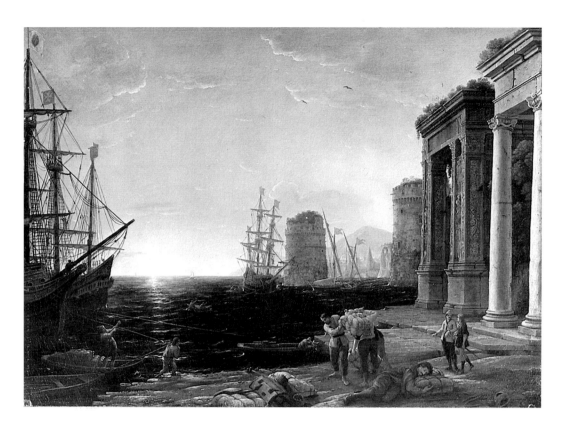

110 CLAUDE
A Harbour Scene

of Denmark; and the brilliant portrait of the melancholy young man (plate xv) who used to be identified as Sir Philip Sidney and is possibly the most beautiful Elizabethan work of art in the royal collection today.[22]

A few weeks after the Prince had visited his house, Vertue was summoned to wait on the Prince at Carlton House (which had been acquired in 1732), where the Prince showed him the 'Curious limnings & valuable pictures &c.' in his Closet; and a month later he was summoned to see the collections at the Prince's other London residence, Leicester House. The pictures the Prince most esteemed were in his Closet ('sublime Masters antient and scarse none modern nor none very large'). In especially admiring Guido Reni's *Cleopatra* (plate 108), the Prince shows his tastes to have been, for that period, conventional. He was particularly interested in Italian, Flemish and French painting of the previous century, but in the course of 'a long conversation on painting' with Horace Walpole, admitted to a special affection for Andrea del Sarto. He also reveals in a number of his purchases a feeling for quality and a delight in the texture of paint on canvas, panel or copper which, among the Hanoverians at least, was only shared by his grandson George IV.

Among the Italian pictures at Leicester House were the Marattesque *Infant Christ in a Garland of Flowers*; pictures by Filippo Lauri which may have included the *Jacob fleeing from Laban*; Guido Cagnacci's *Jacob peeling Rods*, probably a present from Lord Cholmondeley; and, perhaps the most important, a version of Pietro da Cortona's *Augustus and the Sibyl*. The Prince's special favourite, at least in the Closet at Leicester House, was a Marattesque *St Joseph with the Infant Christ* which he thought was by Guido Reni.

More important were the Prince's French classical landscapes. The references to Claude in the documents relating to the collection are obscure, but it is probable that the Prince acquired the *Harbour Scene* (plate 110), which is dated 1643 and has only comparatively recently been established as a fine original.[23] Vertue noted in the 'second room' at Leicester House 'paintings Landskips by Gasper & Nicolas poussin

figures – 4 of them large & fine', which included the freely painted *Jonah and the Whale* by Gaspar and the very good *Landscape with Figures by a Pool* (plate 111). Over the fireplace in the same room was the grave Le Sueur of *Nero with the Ashes of Germanicus* (plate 112).

The Prince does not appear to have bought important Dutch pictures, although he may have owned the Hals of an unknown man (plate XVII), painted in 1630; but the Flemish pictures were the finest in his collection. A number of these had been originally in the possession of Sir Daniel Arthur, a rich Irish Jacobite merchant who had died in Spain; and they had passed into the hands of a Mr Bagnall who had married Sir Daniel's widow.[24] From Bagnall the Prince acquired two Jan Brueghels of the highest quality and in a marvellous state of preservation, a *Flemish Fair* (plate XVIII) and the *Garden of Eden*; and a magnificent group of pictures by Van Dyck: the heroic early *St Martin* (plate 113) which had belonged to Rubens and was indeed attributed to him at the time of the purchase; one, and possibly two, fine full-length female portraits of the second Flemish period; and, in the double portrait of Thomas Killigrew with Lord Crofts (?) (plate 114), the most moving and perhaps the most beautifully painted of all the Queen's Van Dycks. Sir Paul Methuen was to acquire in 1747 from the same collection another great Van Dyck, the *Betrayal of Christ*, which is still at Corsham Court. From Bagnall the Prince also bought the *Self-Portrait* by Murillo (plate 116) which was soon after in the collection of Sir Lawrence Dundas and is now in the National Gallery.[25]

Prince Frederick's liking for Flemish pictures is another point of contact with the tastes of his grandson. From Bagnall he acquired Teniers's *Stolen Kiss* and the four early landscapes with shepherds and flocks which are said to represent the different times of day. The small, very freely painted – indeed, almost Brouwer-like – *Peasants outside a Country Inn* (plate 115), which was in his collection by June 1749, may have been the picture by Teniers which had been acquired for him by Mercier at fifteen guineas in 1735; and he also acquired two of the artist's little copies of pictures (in both cases by Titian) in the collection of the Archduke Leopold William. Far more important: at

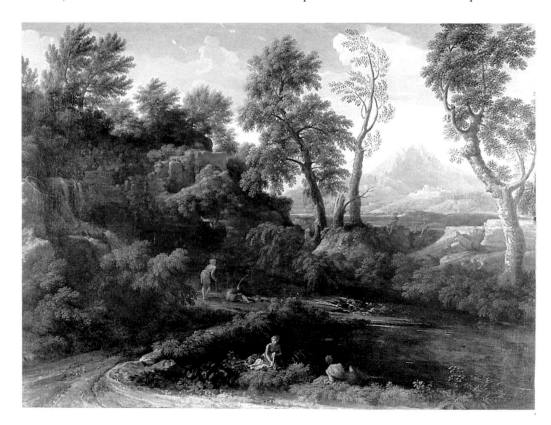

111 GASPAR POUSSIN
Landscape with Figures by a Pool

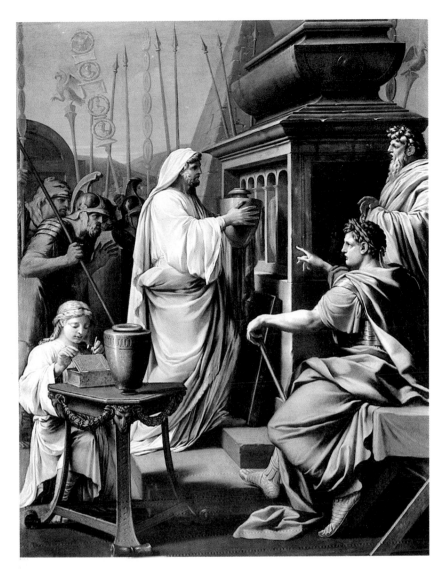

some date before September 1747, when John Anderson submitted a bill for cleaning many of the Prince's pictures, he had acquired the *Summer* (plate 117) and *Winter* landscapes which are thought to have belonged to the First Duke of Buckingham. They were not painted as a pair, but additions were made at top and bottom to *Winter*, probably so that they could hang as a pair in the Ante-Chamber at Leicester House (this was not the only example of such adjustments in the cause of symmetry in the Prince's collection), perhaps at the time when Benjamin Goodison carved for them frames 'ornamented w.^th Festoons & flowers all round ditto w.^th Mosaick work in y.^e Ground & a Canopy of Flowers at y.^e top all in Burnished Gold'.^26 Such documents give an impression of the quality of the work carried out on the Prince's pictures and of the imposing size of the pictures the Prince was buying, especially of the Flemish school; and, by implication, of his intention to form, as well as the closets so dear to all royal collectors, galleries of large pictures which would have resembled those composed by such collectors as Walpole and Methuen.

Among those who may have influenced the Prince's tastes were the old Duchess of Marlborough, who was always kind to him and whose pictures were then at Wimbledon House; the Spencer family, who incidentally, like the Prince, employed George Knapton about their pictures as well as their likenesses; General John Guise; and Sir Robert Walpole. Vertue indicates that the Prince valued advice from Guise; and

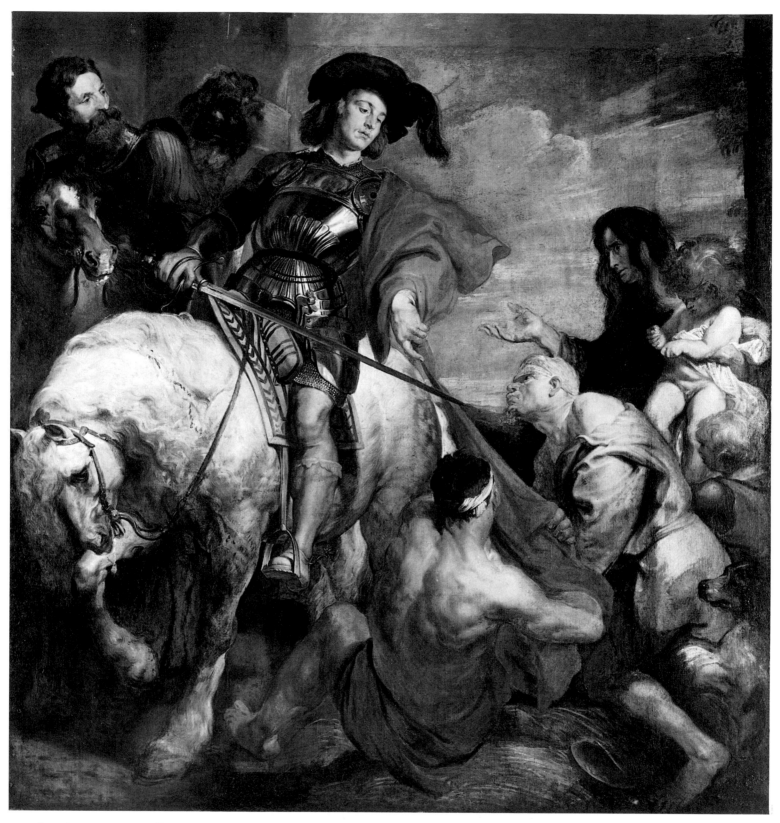

113 SIR ANTHONY VAN DYCK
St Martin dividing his Cloak

in the Prince's papers, among payments for work done by Paul Petit, is an entry under 6 December 1748 for going to Leicester House 'to Take Care of the picture of the Cruelty of Hearod to Send to Gen.ll Guies by Mr Goupy. Order'.[27] A bill from Goupy, dated 1 March 1751, for a number of miscellaneous tasks carried out for the Prince, included six guineas for going 'to Houghton in Norfolk by Command to see Pictures'.[28] Vertue, however, called Sir Luke Schaub 'his prime minister connaisseur in pictures'. Pictures were bought for the Prince at auction in London as well as on the Continent. He bought at the de Piles sale in 1742, for instance, and at the sale of Lord Orford's pictures in 1748; and he acquired pictures from Mr Edwin's collection.

The Prince employed minor artists, craftsmen and designers on a variety of tasks in the formation and maintenance of the collection. Joseph Goupy was a favourite with the Prince and had been sent over to France to buy on his behalf. He was also employed in lining, cleaning and mending the pictures, as were Wootton, Griffier and Isaac Collivoe, and, in the late 1740s, John Anderson. The Prince's accounts also provide a mass of information on the frames which were made for him by a number of craftsmen: George Murray, Joseph Dufour, Jacob Gossett, Waters, Benjamin Goodison, John Boson, John Bradburn and William France (for the Prince's widow) and, in particular, Paul Petit. At least two of Petit's superb frames survive, on pictures by Goupy and Wootton. The documentation at this point in its history is much richer than for any earlier period in the growth of the collection since the time of Charles I and provides many fascinating glimpses of day-to-day maintenance: of three days spent by Petit at Kew, for instance, 'helping to Carry the frames to The Water Side', or five men's wages for brushing the pictures and Frames and wiping the glasses 'Against the Drawing

114 SIR ANTHONY VAN DYCK
*Thomas Killigrew and William,
Lord Crofts (?)*

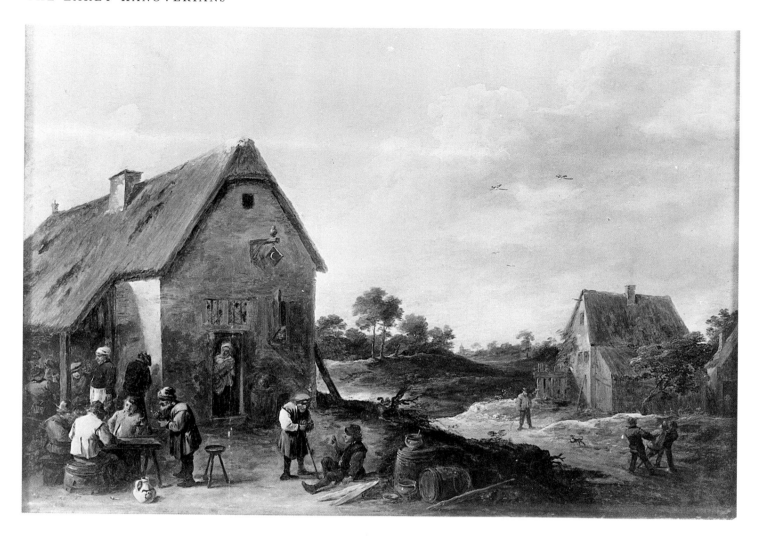

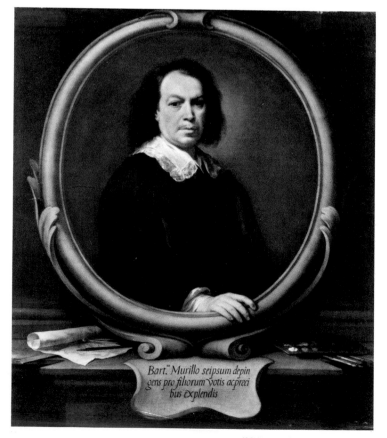

115 (above)
DAVID TENIERS
THE YOUNGER
Peasants outside a Country Inn

116 (left)
BARTOLOMÉ ESTEBAN
MURILLO *Portrait of the Artist.*
National Gallery, London

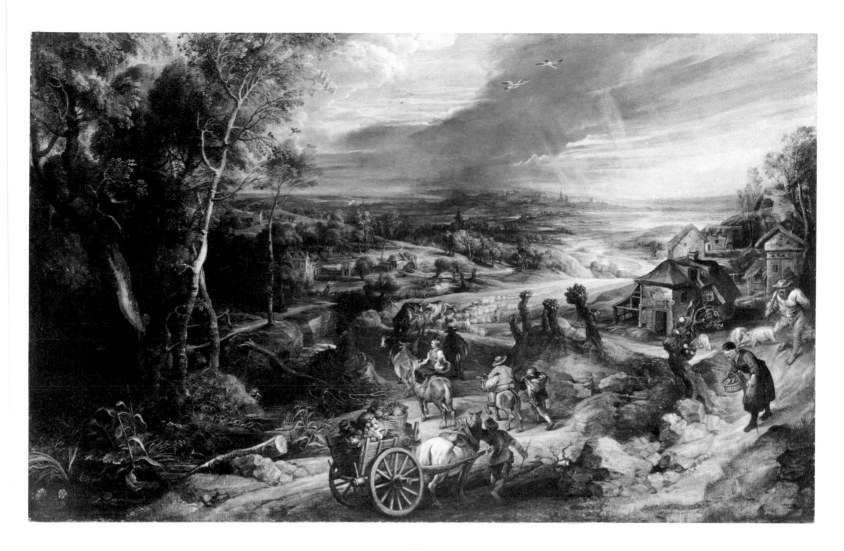

117 SIR PETER PAUL RUBENS
The Summer Landscape

Roome on the Birth Day'.[29] A great deal of care was lavished on the pictures by the Prince, and by his widow after his death, and he was equally interested in the pictures which would have been his if he had survived his father. On its maiden voyage his new state barge, designed by Kent, went down to Somerset House, bearing the Prince, his mother, brother and sisters, accompanied by 'a Set of Musick', to see Mr Walton's progress in cleaning and mending royal pictures.[30] In 1750 he went with Vertue and Knapton, who had been recommended to the Prince as a connoisseur of paintings, through the pictures at Kensington, Windsor and Hampton Court: 'taking as much delight & pains as any body coud. often asking enquiring for his better information – and discovering with surprising delight & pleasure to show his love to Art as his intelligence. or knowledge of those Curious works & the Masters of Art whose works they were'. On the basis of the housekeeper's books and his own notes Vertue compiled for the Prince, as a companion to the two handsome volumes on Charles I's collection, an inventory of the pictures in the three principal royal houses of resort.[31] 'I love Arts – and Curiositys', the Prince had once said to Vertue; and Vertue, remembering many kindnesses, wrote as a final tribute: 'no Prince since King Charles the First took so much pleasure nor observations on works of art or artists'.[32]

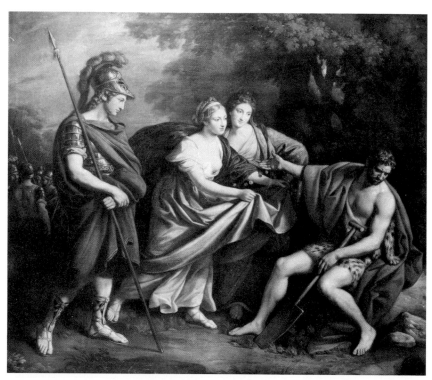

121 (left) NATHANIEL DANCE
Timon of Athens

122 (below) JOHANN ZOFFANY
*George, Prince of Wales, and
Prince Frederick*

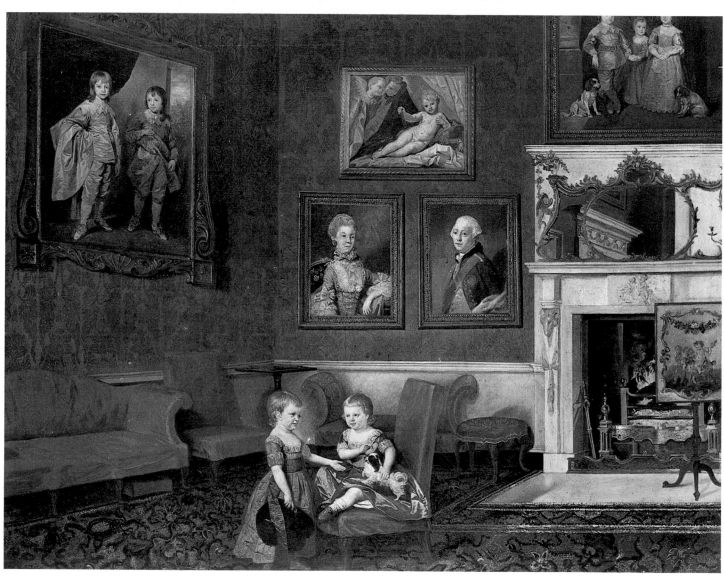

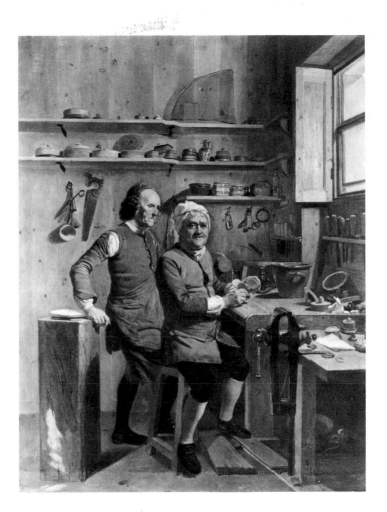

valuable record of the appearance of his patrons at this period. Of the pair painted in 1771, the King was described by Walpole as 'Very like, but most disagreeable and unmeaning figure'. In his four royal conversation-pieces Zoffany developed a semi-informal type of royal portrait on a small scale, for which Mercier, Hogarth and Wootton had each provided something of a precedent. In the picture of Queen Charlotte with members of her family, grouped round a rustic seat (perhaps at Kew), Zoffany created a pastoral scene to which the interplay of movement, glance and character and the variation in age imparts a true conversation air. The picture (plate 122) of two children, almost certainly the King's eldest sons, in the Second Drawing-Room or Warm Room at Buckingham House, gives an invaluable impression of how pictures were arranged and of the respect accorded to Van Dyck. The group of the King, Queen and their six eldest children is a conscious tribute to Van Dyck. The finest in the group, *Queen Charlotte at her Dressing-Table* (plate xx) is a touching presentation of the young Queen with her two little boys in fancy dress.[4] In a very different vein is the portrait by Zoffany of the optician and instrument-maker John Cuff (plate 123). Many of the artists whom George III and Queen Charlotte employed figure in Zoffany's group of the Academicians (plate 124) which he showed at the Royal Academy in 1772. It was presumably commissioned by the King, and it emphasizes the part he had played in the foundation of the Academy.

The King had signed the new body's Instrument of Foundation of 10 December 1768, he placed rooms at Old Somerset House at the society's disposal and, with his family, frequently visited the annual exhibitions. In one of his boyhood essays the King had written of the constitution as 'the patron of learning and arts', and this

ideal would have been partly realized in his own relation to the new Academy. The King and Queen were, however, always on bad terms with the Academy's first President, Reynolds. By 1773, when Lord Cathcart was endeavouring to secure portraits by Reynolds of the royal pair for Catherine the Great, it had become difficult for the painter to get sittings from the King and Queen. Although the Empress had read Reynolds's *Discourses*, seen prints after his work and presumably expected portraits from his hand, the commission was given to Dance.[5] A streak of prejudice probably led the King lavishly to patronize Francesco Zuccarelli but to ignore, perhaps even to laugh at, Richard Wilson; in Zoffany's group Wilson is in the shadows behind Zuccarelli.

Severely practical in their patronage, the King and Queen were concerned almost exclusively with portraits of their family. Their interest in portraiture naturally extended to the miniature. When Horace Walpole visited Buckingham House, probably in about 1780, he noticed in one room six large frames 'glazed on red Damask, holding a vast quantity of enamelled pictures, miniatures & Cameos'. They included survivors from the Stuart collection; a number which had been in Queen Caroline's Closet at Kensington; Prince Frederick's purchases from Dr Mead's collection; and some that had belonged to the Duke of Cumberland; 'but in general, the Miniatures are much faded, having been & being, exposed to the light & Sun'.[6] There were also modern enamels by Jeremiah Meyer and Ozias Humphry, among them probably the Meyers of the King and Queen, his portrait of the little Duke of York (plate 126), and Humphry's charming likenesses of the Queen and her eldest

124 JOHANN ZOFFANY
*The Academicians of
the Royal Academy*

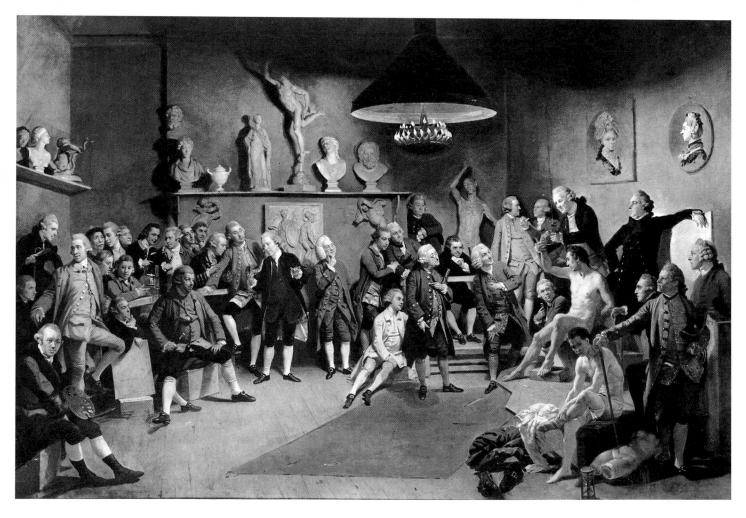

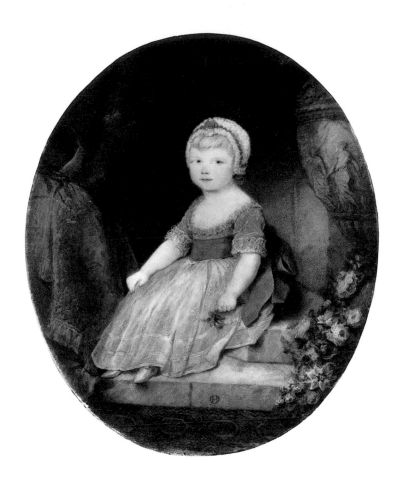

125 (right) OZIAS HUMPHRY
Charlotte, Princess Royal

126 (below) JEREMIAH MEYER
Frederick, Duke of York

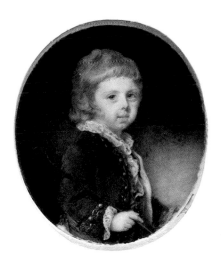

daughter (plate 125). Later in the reign the Queen was patronizing Edward Miles, to whom she was giving sittings in April 1794.

After Zoffany had departed for Italy in the summer of 1772, the painters whom the King and Queen most generously patronized were Gainsborough and Benjamin West. By 1781 Gainsborough was 'quite established at Buckingham House . . . vice Mr. Zoffannii and other predecessors, the Apollo of the Palace'. He had already worked for the King's brothers. Of all the likenesses of his family those by Gainsborough are the most beguiling: the great pair of full-lengths, shown at the Royal Academy in 1781 and first recorded in the Dining-Room at Buckingham House, or the set of fifteen oval portraits of the family, painted at Windsor in the autumn of the following year and hung by the Queen in her Closet at Buckingham House. Rapidly painted, superficial and pretty, the oval portraits, which had been placed by Queen Victoria in 1838 in the panelled decoration of her Audience Room at Windsor, were re-arranged (plate 127) in the Corridor at Windsor in obedience to the commands of King George VI. He had been fascinated, at the time of the exhibition of *The King's Pictures* at the Royal Academy, by the letter in which Gainsborough had set out his instructions to the Hanging Committee of the Royal Academy about the hanging of his portraits: 'with the Frames touching each other, in this order'. The full-length of the Queen (plate 128) is unsurpassed among English royal portraits for the magic of its paint, for a combination of majestic image and easy movement and for a rare, almost tender, sympathy between artist and patron. Sadly, the royal pair bought no more Gainsboroughs. The King admired the painter's *Cottage Children* and was rumoured to be intending to purchase his *Woodman*, but nothing came of it.

Benjamin West, on the other hand, was painting for the King and Queen for some twenty years from the later 1760s. His cardboard full-lengths of the royal family significantly illustrate their occupations and tastes. In the background to the portrait of

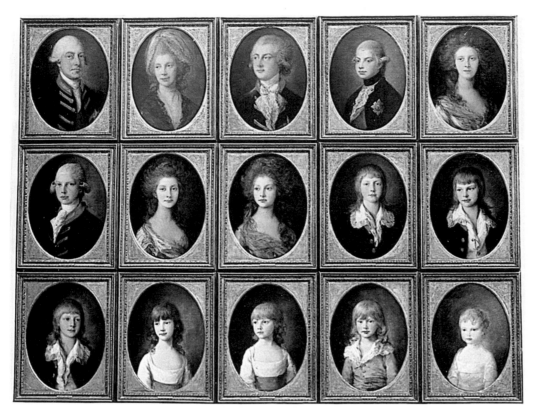

the King himself (plate 129), West strikes the same note as Dominic Serres in a fine set of views of the King's visit to the fleet, or De Loutherbourg in pictures of the review and mock attack (plate 130) at Warley Camp.[7] The King and his forces are in a state of readiness at a time of crisis. West added later to the series a portrait of Prince Octavius with his father's sword and, in 1783, the poignant *Apotheosis*, which moved the dead child's mother and sisters to tears when they saw it at the Royal Academy.

West had first come to the notice of the King and Queen when they were shown *Agrippina landing with the Ashes of Germanicus*, which he had painted in 1766 for Archbishop Drummond. They admired it (we know from a letter of Reynolds that the King liked the work of Poussin) and suggested to West 'another noble Roman subject', the *Departure of Regulus* (plate 131) for a special position in one of the apartments at Buckingham House. The King himself is said to have read West the story out of Livy. More pictures were commissioned: the *Oath of Hannibal*, two smaller classical and no less Poussinesque scenes, two heroic deaths (Epaminondas and Bayard) and the second version of the *Death of Wolfe*. The Warm Room became a shrine, hung with these dull designs, dedicated to the virtues the King most admired. By patronizing West he revealed his liking for neo-classical painting and was doing something to encourage a school of history painting in England; but, having employed him so long and paid him so generously, it is hard to believe that the King's encouragement of this particularly dull and self-righteous artist was 'rather the result of principle than of personal predilection'. In the 1780's West staked out a claim at Windsor Castle as a field where he could try his hand in the Gothic style, a style in which the King, rather to his own surprise, was showing an interest. The royal family was spending more and more time at Windsor and, to illustrate its long association with the Garter, West produced for the King's Audience Chamber, at amazing speed, a set of thoroughly pretentious pictures: the Institution of the Order and the exploits of Edward III, the Black Prince and some of the original Founders. They can be seen in Wild's

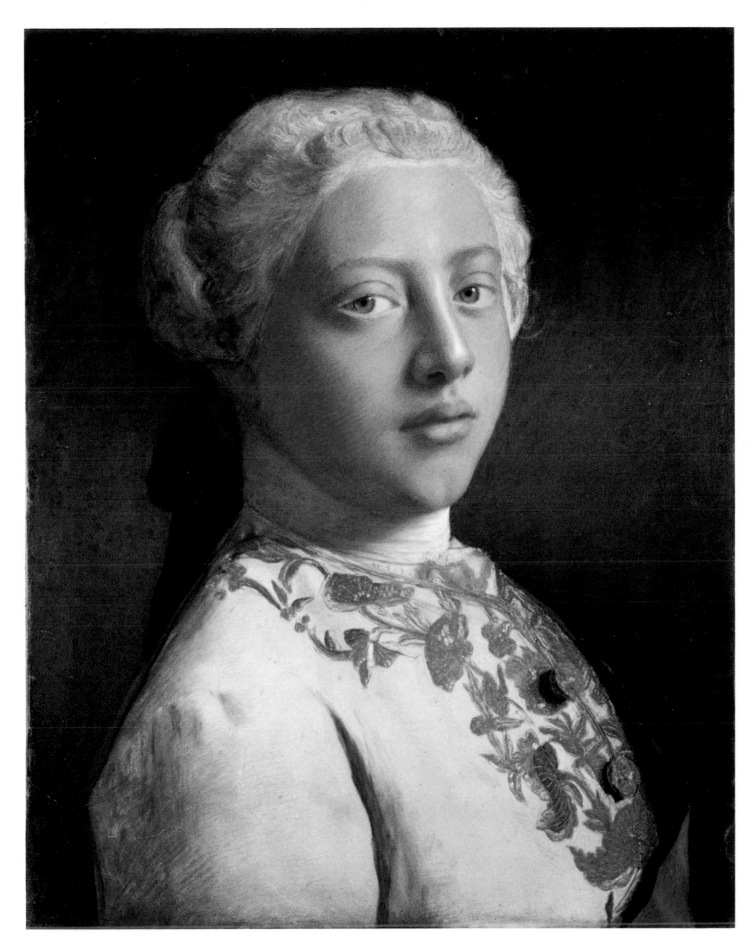

XIX JEAN-ETIENNE LIOTARD *George III* (see page 106)

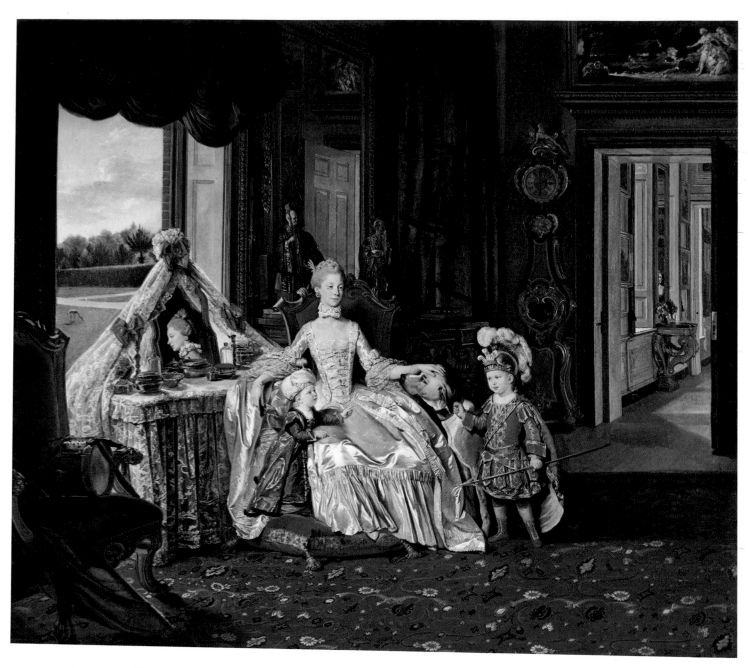

xx (above) JOHANN ZOFFANY
Queen Charlotte at her Dressing-Table (see page 109)

xxi (right) GIOVANNI BELLINI
Portrait of a Young Man (see page 122)

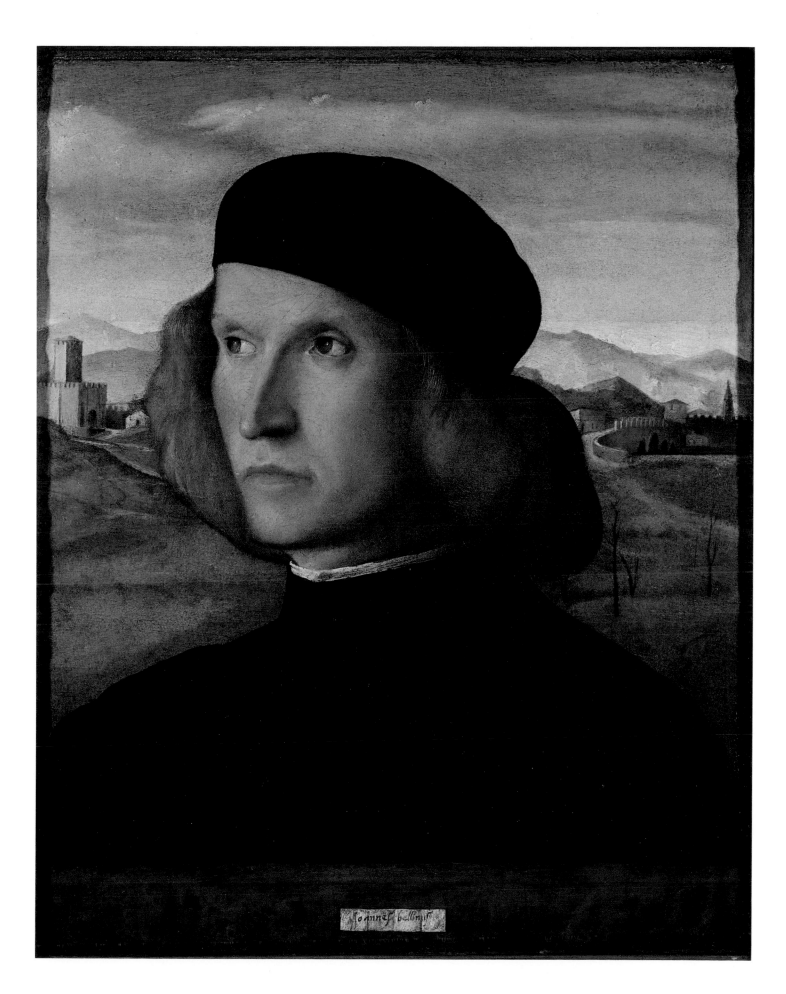

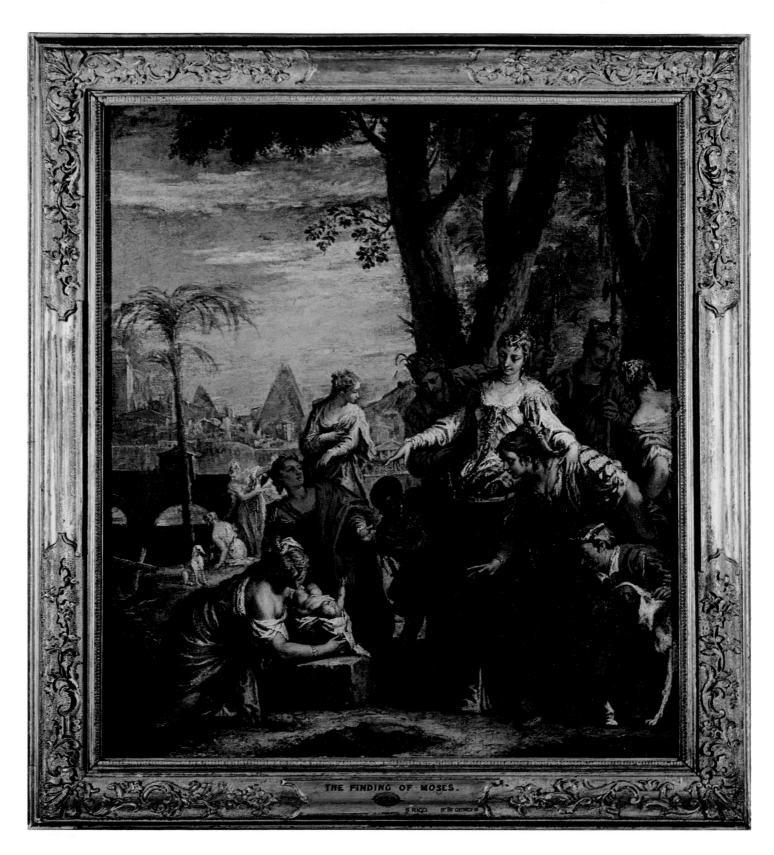

THE FINDING OF MOSES.

S RICCI B.T BY GEORGE III

XXII Sebastiano Ricci
The Finding of Moses
(see page 123)

128 THOMAS GAINSBOROUGH
Queen Charlotte

129 (left)
BENJAMIN WEST *George III*

130 (below)
P. J. DE LOUTHERBOURG
The Mock Attack

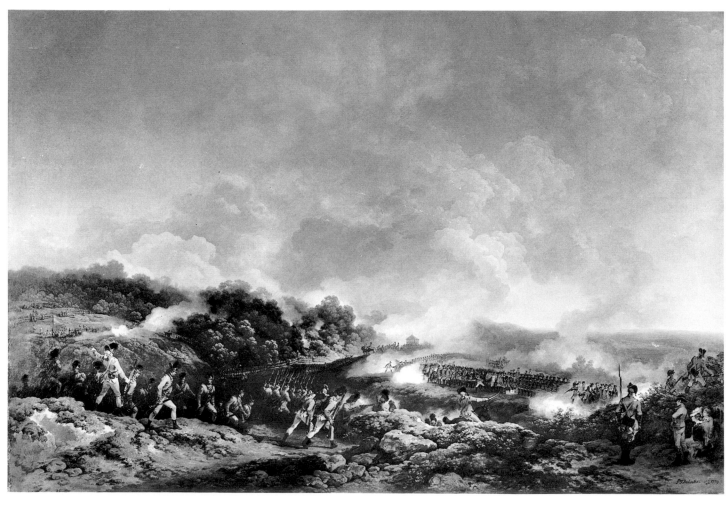

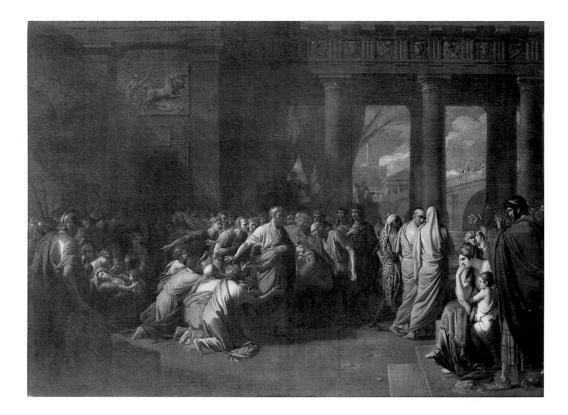

watercolour (plate 133): the smaller pictures, in which there are occasional, but rare, flickers of painterliness, are fitted into spaces round the doors; *St George and the Dragon* is over the fireplace; and three enormous canvases (e.g., plate 132) are ranged along the main wall. These last were later slung high up on the walls of the Grand Vestibule until King George VI, with characteristic and decisive good taste, caused them to be rolled up and banished to the Lower Stores.[8] In the eyes of George III, West's phoney mediaevalisms probably seemed more praiseworthy than the Black Prince's triumph as interpreted by Verrio for Charles II in St George's Hall. West also decorated a ceiling in the Queen's Lodge, where the family resided at Windsor, with representations of Arts and Sciences, Agriculture, British Manufacture and British Commerce;[9] a far more ambitious project was to decorate with thirty-five large canvases, on the theme of the history of revealed religion, a private chapel which the King was planning to construct in Horn Court. The scheme was abandoned by the turn of the century, probably at the instigation of the Queen. George IV had the good sense to return the finished paintings to West and in the fullness of time Horn Court was roofed in to become the Waterloo Chamber. As the King's health and temper deteriorated, his treatment of artists became increasingly unpredictable. Edridge found that the King could talk rationally about art and artists, but he quarrelled with Hoppner, who had painted very pretty portraits of his three youngest daughters. The girls also sat to Copley for the large group (plate 134), loaded with flowers, parrots, fruit and dogs, which the King placed at one end of the Queen's Ballroom at Windsor (it hangs there today), facing Ramsay's group of the Queen with her two eldest sons. Lawrence was summoned to Windsor in September 1789, but neither his enchanting portrait of Princess Amelia, nor his brilliant presentation of the Queen, proved acceptable (the portrait of the Queen is now in the National Gallery). Both King and Queen seem to have been at their most refractory in dealing with the young man. Beechey, popular with them in the 1790s, painted the last official pair of full-lengths for them (they were 'delighted' with his

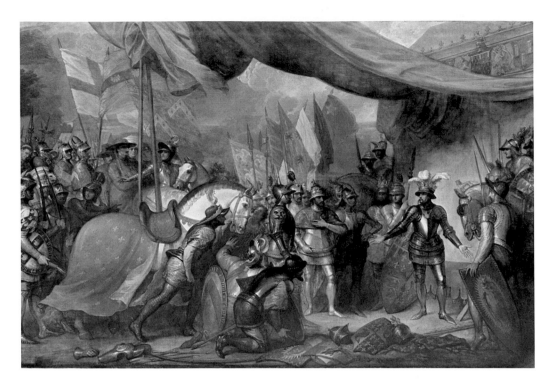

132 (left) BENJAMIN WEST
*The Black Prince after
the Battle of Poitiers*

133 (below) C. WILD
*The King's Audience Chamber,
Windsor Castle*

134 (right)
JOHN SINGLETON COPLEY
*Princess Mary, Princess Sophia
and Princess Amelia*

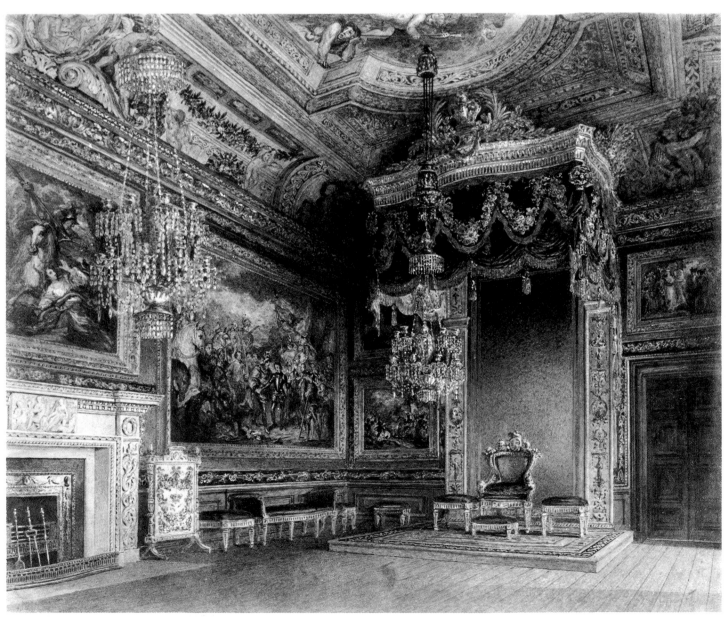

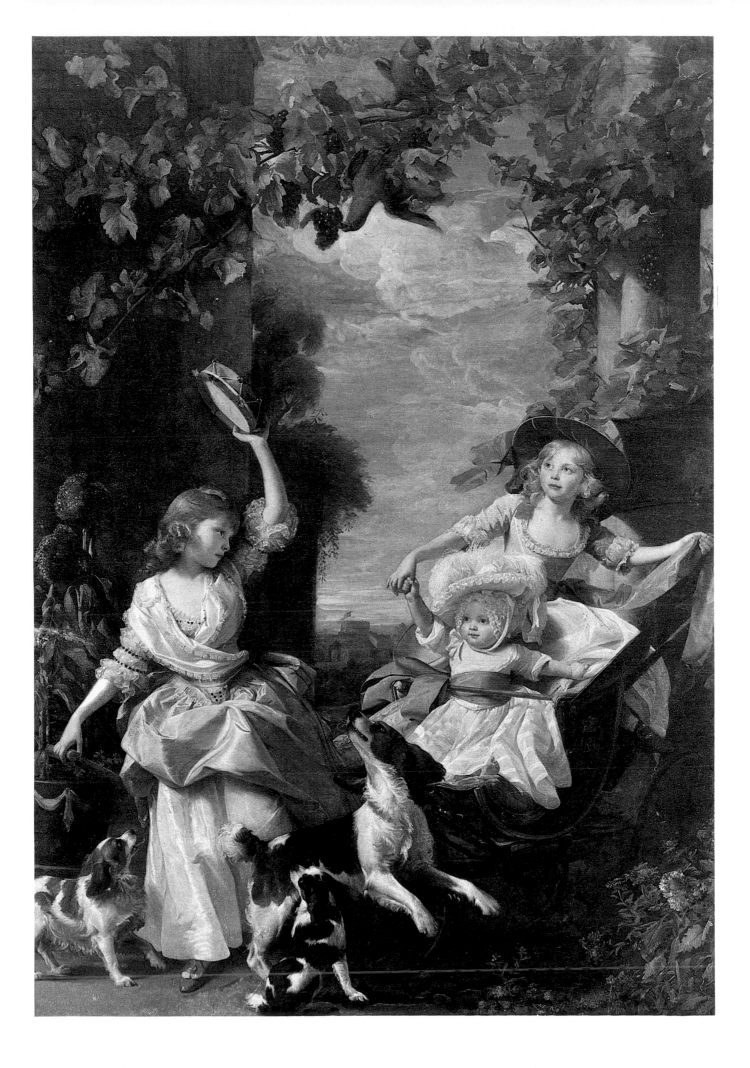

portrait of the Queen), full-lengths of two of their children and the colossal canvas of the King with his two eldest sons at a review. But Beechey, too, fell foul of the King. While trying to excuse himself to the King at Windsor, the King rounded on him: 'West is an American, & Copley is an American, & You are an Englishman, and were you all at the D—l I should not care.' By 1806 the King admitted to James Wyatt that his sight had become so bad that he could only see pictures 'in the most imperfect way'.

In the background of his picture of Queen Charlotte at her dressing-table, Zoffany had provided a glimpse of the pictures hanging in her apartments at Buckingham House: a reminder that in the first twenty years of his reign the King bought in Italy a large number of pictures which in quality and quantity constitute the most important acquisition made for the collection since the time of Charles I. Zoffany also reminds us that the principal motive in making these purchases was probably a typically practical one: to provide good pictures for Buckingham House. The King had bought the house as a dower house for the Queen in 1762 and it was transformed by Sir William Chambers on her behalf. In order to furnish the new house – the Queen's House, as it was frequently called – with pictures, the King 'stripped all his other palaces of almost all their finest pictures'. Pictures were brought from the stores at Somerset House to Kensington so that the King could select what should hang in the gaps which were left at Hampton Court and Windsor. Walpole, who describes these alterations, indicates that the residue was given away by the King at this time: 'as they said, to Earl Gower Lord Chamberlain'.[10] In the period between October 1762 and October 1763 Stephen Slaughter was employed in 'making out new Lists and taking the Dimentions of his Majesty's Pictures at the Palaces of Kensington Hampton Court and Windsor Castle'. During the next year, Raphael's Cartoons were brought up from Hampton Court to the Queen's House, where they remained for more than twenty years. This move was alleged to be necessary in order to preserve them from damp, but it was savagely attacked by Wilkes in the House of Commons.[11] Isaac Collivoe was still being employed, as well as the Surveyor, on cleaning and mending. In May 1765 Slaughter was succeeded by Knapton, who in turn was succeeded in December 1778 by Richard Dalton. The annual salary of the Surveyor and Keeper was unchanged at £200.

Dalton, the most disreputable man ever to hold the post, had a reputation for intrigue and unscrupulous behaviour. 'The most impertinent, troublesome, prating man in the world', Mrs Delany called him in 1772. A draughtsman and engraver by training, he had been in Italy in the 1740s and had travelled as far afield as Constantinople, Greece and Egypt. He was one of the first Englishmen to make drawings of ancient monuments in those parts and to publish engravings of them. He is referred to by Reynolds, writing from Rome in April 1751, as having been under the patronage of the Prince of Wales;[12] he was in favour with Bute; and he was appointed Librarian to George III before the King's accession. In his additional capacity as Antiquarian to the King, Dalton was in charge also of the medals, drawings and the like. He was involved, apparently not very creditably, in the negotiations which preceded the founding of the Royal Academy and was appointed its Antiquary. His behaviour in Italy, where he did not scruple to trade on the King's name, was described with a good deal of justification as 'dirty and low like himself'.[13] He and his creatures were determined that as much as possible of the management of the King's collections should pass through their hands.

In 1758–9, Dalton had been assiduously looking for works of art of all kinds, but especially drawings, for Lord Bute, visiting the more obvious places where good drawings could be found and, in his own words, ransacking 'a part of Italy where none

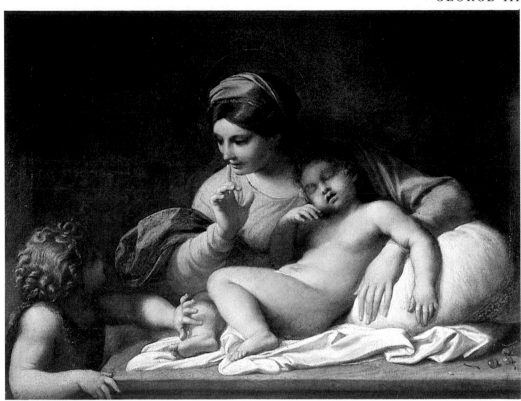

135 ANNIBALE CARRACCI
*The Madonna and Sleeping Child
with the Infant St John*

ever stray'. He was hoping to build up two collections of drawings, 'one for HRH and the other for your Lordship'; on 17 November 1758 he informed Bute from Florence that he had carefully packed up 'for HRH' nearly 700 drawings.[14] Horace Walpole, who wrote a caustic description of the Scots Maecenas endeavouring to rouse the interest of a sleepy young Augustus in drawings and medals, had also offered his services to the favourite if it would be of use to the King. 'The mere love of the arts, and the joy of seeing on the throne a prince of taste, are my only inducements for offering my slender services ... since his Majesty vouchsafes to patronize the arts, and your Lordship has the honour to countenance genius.'[15]

In the 1760s Dalton was once more busy in Italy on the King's behalf. Many of the payments made to him from the King's Privy Purse do not specify what the consignments contained and many of them must have been for drawings; but between December 1763 and Christmas 1772 nearly £9,000 was paid out to Dalton.[16] One such consignment, of which the contents are known, may have been typical of many: a set of casts, which had been bought for the Royal Academy; architectural and other drawings; prints; books (including Vasari's *Lives* and Winckelmann's *History of Ancient Art*); cameos and medals; inlaid cabinets and a harpsichord case; miniature copies of some well-known *seicento* pictures; and a group of not very distinguished pictures bearing attributions to Vanvitelli, Ghisolfi, Orizonte, Van Lint, Locatelli, Salvator Rosa, Cerquozzi, Cantarini, Grimaldi, Cignani, Bottani, Maratti, Wouverman and Nicolas Poussin.[17] In May 1766 Dalton was paid £262 for the charming little Annibale Carracci, the *Madonna and Sleeping Child with the Infant St John*, known as *Il Silenzio* (plate 135). It was placed in the Closet at Buckingham House; its tender domestic note would have appealed to the King and Queen and probably influenced Cotes's composition of the Queen with her sleeping baby daughter. Dalton may have been responsible, perhaps with the assistance in Bologna of Francesco Bartolozzi, for buying Guercino's *Libyan Sibyl* (plate 136); and three *Caprice Views* by Panini were probably acquired by George III, as were two canvases by Balestra. In 1764 the King had bought from Dalton

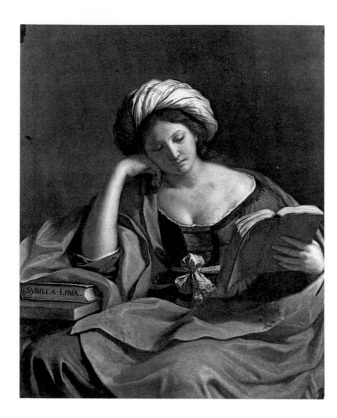

136 GUERCINO
The Libyan Sibyl

three views of Florence by Thomas Patch and it is partly in the context of the King's interest in what could be bought for him in Italy that we should place the Queen's commission to Zoffany in the summer of 1772, 'to paint for Her the Florence Gallery'. In this masterly record (plate 137), which Zoffany ultimately brought back with him to England in 1779, he was careful to record, by placing the *Venus of Urbino* so prominently in the foreground, that he was in Florence on the Queen's behalf. This Titian had become so popular with copyists that access to it had been forbidden, but on 24 November 1777 it was given to Zoffany to copy.[18] The *Samian Sibyl* by Guercino, lying unframed on the floor, had been acquired by the Grand Duke of Tuscany early in that year and could have been included by Zoffany as a polite reference to the King of England's own new Guercino. Zoffany, moreover, altered the design of the group of figures on the left so as to bring in himself showing to Lord Cowper, who had been asked by the Queen to help Zoffany while he was in Florence, the *Niccolini Madonna* by Raphael. Zoffany's *Tribuna* is to a large extent an essay in praise of Raphael; and Cowper and Zoffany, thinking of the King's Raphael drawings and remembering the move of the Cartoons to Buckingham House, may have been hoping to ingratiate themselves with the King by suggesting that he should enhance his reputation as a connoisseur by taking advantage of their offer. At the same period Cowper was employing James Macpherson to paint for the King a set of miniature copies of over 220 of the famous self-portraits in the Grand Duke's collection, which were despatched to London by instalments.[19] The most remarkable achievement by the King's agents in Italy was, however, the purchase of a large part of the collections which had been formed by the English consul in Venice, Joseph Smith.

As early as 26 November 1760 General William Graeme had written to Bute from Venice: 'If Smith retires I belive he would part with one of the choisest little colections of pictures and cameos that is in Venise.' Negotiations for the sale of part of the collection to the King had begun before his accession and were resumed in 1762. Dalton and Bute's brother, James Stuart Mackenzie, British Minister to the Court of Sardinia at Turin, were involved in the sale to the King; Stuart Mackenzie made the

purchase and arranged the despatch of 'Mr. Smith's noble collection'. It was to Stuart Mackenzie that Smith ultimately wrote the slightly disingenuous letter of 13 July 1762, expressing gratitude for enabling him 'to have this whole Collection removed to a more permanent & Glorious seat, and by rendering it famous to after Ages, confer on the Collector the greatest Honor He can possibly receive . . .' Tis the Royal Possessor that constitutes its Value.' He accepted Stuart Mackenzie's advice in offering the whole collection – books, gems, coins, drawings, prints as well as paintings – for £20,000. 'For thus', he claimed, 'this whole Collection, the Work of my Life, will be preserved entire.'[20] In fact it is almost certain that Smith did not sell all his pictures to George III, just as it is assumed that he continued to acquire pictures between the sale and his death in 1770. One cannot, from the surviving lists (so-called), be sure how many of his pictures were acquired by the King. These lists, moreover, are later copies, compiled from sources that are now lost, and they may include pictures that had not been in Smith's possession;[21] they undoubtedly include a number of pictures which were almost certainly never absorbed into the royal collection; and some pictures in the lists, including the *Deposition* by Rembrandt in the National Gallery, passed at some stage into the possession of Dalton.

137 JOHANN ZOFFANY
The Tribuna of the Uffizi

Joseph Smith is a shadowy, rather unattractive, figure, who provoked a good deal of dislike. A prosperous merchant in Venice since the turn of the century (he did not

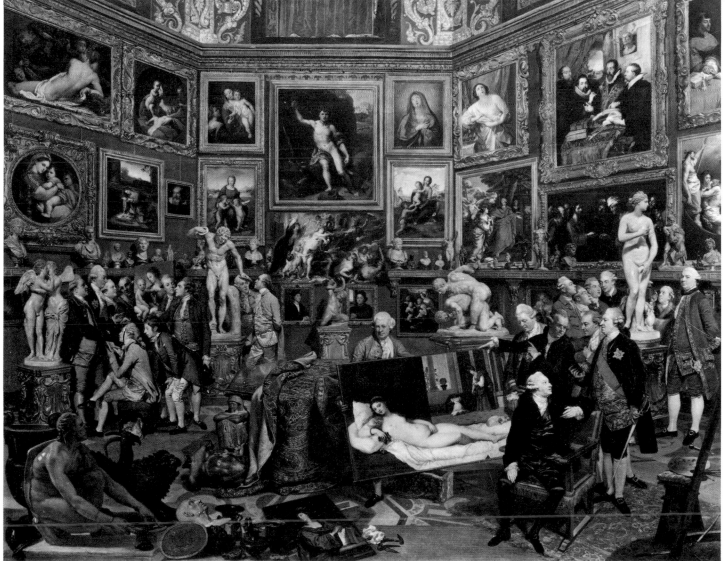

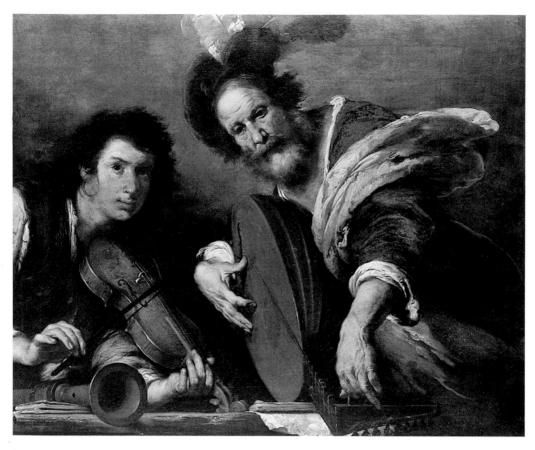

138 BERNARDO STROZZI
A Concert

become Consul until 1744), he had acquired pictures and works of art for distinguished patrons before he began, probably during the second decade of the century, to form his own collections. The buying of pictures was mixed up with mercantile dealings; pictures by the old masters were perhaps acquired in a rather haphazard fashion; but enthusiasm, discernment and a shrewd business sense were combined in Smith's dealings with the Venetian painters whom he knew. The pictures were to be seen either in the Palazzo Mangilli-Valmarana on the Grand Canal or in the villa at Mogliano on the mainland: 'as pretty a collection of pictures as I have ever seen' wrote Robert Adam, who saw the villa in 1757, 'not large pictures but small ones of the great masters and very finely preserved.'[22] The pictures which George III eventually bought included a good many dull or over-rated pieces, but the acquisition of the Smith collection in 1762 can be compared with the purchase of the Mantuan collection by Charles I; and it brought into the royal collection many charming, decorative and beautiful pictures – and a handful of masterpieces – which together constitute one of the collection's most delightful aspects.

Of the earlier pictures in Smith's collection – the attributions under which they came to England do not speak highly of his connoisseurship – the most spectacular were probably two by Giovanni Bellini: the *Agony in the Garden*, now in the National Gallery and one of the pictures which appear never to have been placed in the royal collection (in the so-called 'lists' it was ascribed to Mantegna); and the noble portrait of a young man (plate XXI) which the Consul had acquired from the Sagredo collection. A distinguished signed Licinio, now at Hampton Court, was attributed at the time of the sale to Pordenone and still bears the false inscription identifying the sitter as Palladio, an architect whom Smith venerated. The most important *seicento* pictures are Domenico Fetti's fine portrait of Vincenzo Avogadro (Smith thought it was by Van Dyck); Alessandro Turchi's four figures painted for the organ doors in the Accademia dei Filarmonici at Verona; and a very good version of Strozzi's *Concert* (plate 138).

Smith himself was particularly proud of the seven cartoons by Carlo Cignani for the decoration of the walls of a room in the Palazzo del Giardino in Parma.

More important, and of greater significance in the history of taste, are the pictures Smith assembled by living Venetian painters whom he had patronized and whose reputation with English collectors they partly owed to him: Marco and Sebastiano Ricci, Rosalba Carriera, Zuccarelli and Canaletto. It has been claimed that Smith's collection was at the time the 'most important collection of modern art to be found in Venice'[23]; and it is the pictures by these artists, and their pretty Venetian frames, that have given the particular Smith flavour to so many rooms in the royal houses. He owned a set of seven scenes from the New Testament by Sebastiano Ricci. Of these, the brilliant handling and silvery tone of the *Adoration of the Kings* most vividly evoke the artist's admiration for Veronese. Among the smaller works this is felt most strongly in the *Finding of Moses* (plate XXII), which had actually been engraved by Jackson in 1741 as by Veronese and bought as such by George III. There are also still in the collection seven of Ricci's studies of heads in Veronese's huge *Feast in the House of Levi*. Smith's landscapes by Marco Ricci include five paintings (one of which was claimed to have been his last work), in four of which some of the figures were painted by Sebastiano; and the set of little landscapes painted in tempera (e.g., plate 139) on leather of which at least one had been painted for Smith's first wife.[24] Of the very large number of pastel heads by Rosalba in Smith's possession, only two of importance are still in the collection: the *Self-Portrait*, given by her to the Consul and probably the last she painted before blindness overtook her, and – a total contrast in mood – a girl as *Winter* (plate XXV), 'allowed to be the most excellent this Virtuosa ever painted'. Of the unparalleled number of pictures – light-hearted, varied in scale and decorative – by Zuccarelli in the royal collection, almost all had been painted for Smith, to whose patronage the painter owed so much. The prettiest are those on a small scale; and the most interesting form a series of fanciful landscape settings for famous English neo-Palladian buildings painted by Antonio Visentini (e.g., plate 140), the architect who had designed a new façade for Smith's palace on the Grand Canal and who shared his enthusiasm for the work of Palladio: an enthusiasm no less apparent in

139 MARCO RICCI
A Ruin Caprice

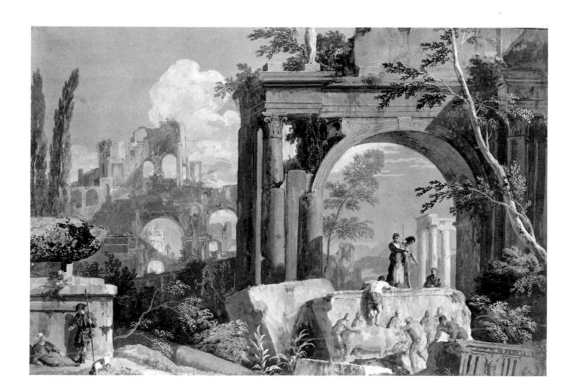

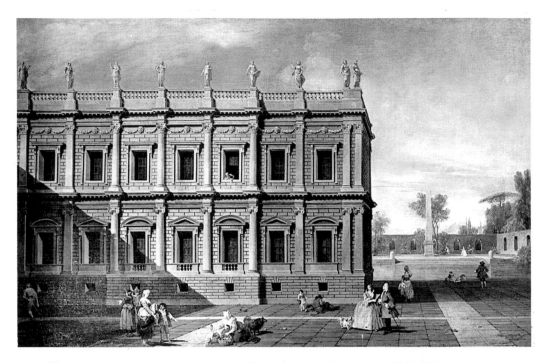

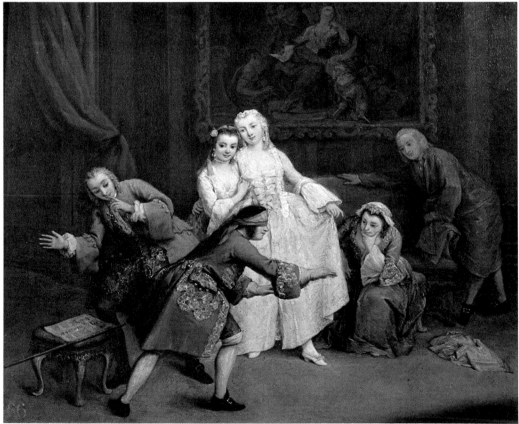

140 (above left)
ANTONIO VISENTINI and
FRANCESCO ZUCCARELLI
The Banqueting House

141 (left) PIETRO LONGHI
Blind Man's Buff

some of Canaletto's work for Smith. Significantly, among the portraits of painters done for Smith by Giuseppe Nogari, is a derivation of Van Dyck's portrait of Inigo Jones. Four pictures by Pietro Longhi are also in the Italian 'list'. Two are still in the collection: the *Morning Levée* and *Blind Man's Buff* (plate 141).

The bond between Canaletto and Smith, which had certainly been forged before 1730, was of practical use to both of them in building up contacts with English *cognoscenti*: those at home who would patronize the artist when he visited London in the 1740s and 1750s or those who would have seen on the walls of Smith's palace the

124

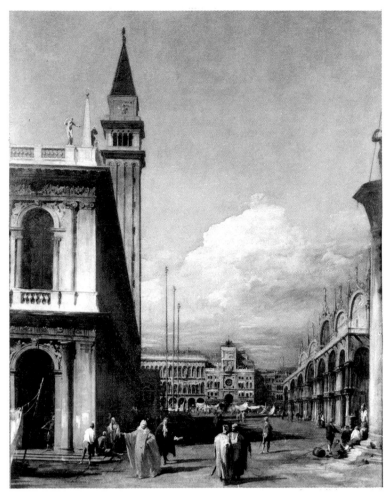

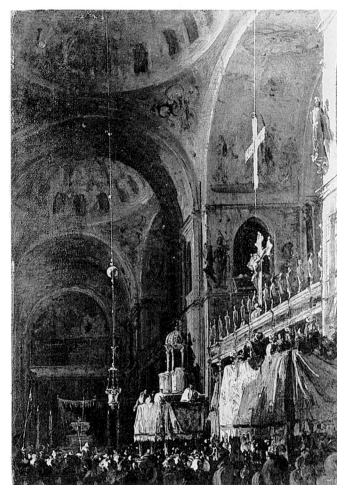

142 (above left)
CANALETTO *The Piazzetta towards the Torre dell' Orologio*

143 (above right)
CANALETTO *The Interior of St Mark's by Night*

pictures which were to be bought by the King. Perhaps they also got a glimpse of the great accumulation of drawings by Canaletto which Smith possessed. In the quantity of both drawings (142) and paintings (fifty) by the artist, the royal collection is unrivalled. The finest of the paintings are the six large canvases of Venice (e.g., plate 142) painted (probably in the late 1720s) with a freedom and strain of picturesque drama not to be seen in his later works. Slightly later Smith commissioned the set of twelve small views, uniform in size and more conventional in style, from points up and down the length of the Grand Canal, a series to which Canaletto added, as a festive climax, the two slightly larger, sparkling scenes in brilliant sunshine of the principal Venetian festivals: the *Regatta* (plate XXIV) and the *Bacino di S. Marco on Ascension Day*. Smith also owned, and presumably commissioned, two unusual themes by Canaletto: the interior of St Mark's by night and by day. The former (plate 143), on a tiny scale, is an exceptionally brilliant piece of painting. In 1742 Canaletto added to Smith's collection five large views of Rome, which are unusual in his work; and, in the following two years, the odd – occasionally rather dull – 'Palladian-Caprice' subjects, designed as overdoors.[25] Canaletto also painted for Smith, probably in London, the two large panoramic views of the Thames from the terrace at Somerset House. Smith had also acquired four excellent *capricci* by Carlevaris, which represent an earlier stage in the Venetian topographical tradition by a painter who had exercised considerable influence on Canaletto but who, by the end of his life, had seen his reputation dimmed by the success of the younger man.

From as early as 1710, Smith and his partner had business dealings in Amsterdam and he owned interesting northern pictures. Some of the most important are not in the royal collection: two *modelli* by Rubens, the *Assumption of the Virgin* and *Aeneas*,

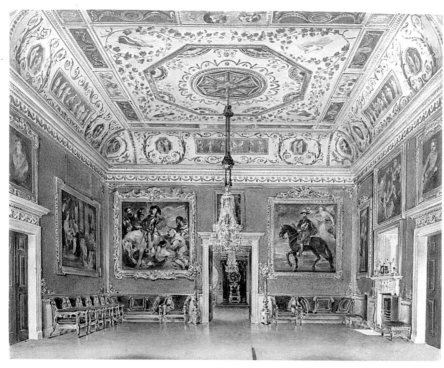

respectively in the Mauritshuis and at Dulwich; and Rembrandt's *Deposition* (National Gallery) and *Concord of the State* (Museum Boymans-Van Beuningen). There are still in the collection, however, the *Young Man in a Turban*, signed and dated 1631 by Rembrandt; the *Rabbi*, which is the work of an imitator; and good examples of, among others, Neefs, Teniers, Molenaer, Frans Francken II, Berchem, Wouwerman, the younger Weenix and Adriaen van de Velde. Perhaps the important northern pictures were bought with the collection of the painter Giovanni Antonio Pellegrini after his death early in November 1741. Pellegrini had been working in The Hague in 1718 and his collection was sold by his widow, a sister of Rosalba Carriera. *Una bella serie di singolari quadri fiaminghi*, it contained *Un Quadro . . . con villagio Americano*, which is Frans Post's little *View of a Village in Brazil* and, in another room, *Un Quadro . . . con Donna alla Spinetta*. When George III acquired the Smith pictures, this was attributed to Frans van Mieris. Pyne[26] thought it was perhaps by Willem van Mieris, 'as the colouring is cold, and the style not equal to the works ascribed to the father'. Waagen attributed it to Eglon van der Neer; Mrs Jameson had preferred Willem van Mieris. 'The management of this picture is very awkward and tasteless, the figures being too far back. The table covered with tapestry in the foreground appears the principal object'[27] – unconsciously pointing to the most telling aspect of the late masterpiece by Vermeer (plate XXIII), the most important picture that George III, albeit unwittingly, added to his collection.

The Public Advertiser had announced on 20 December 1762 that when the 'grand Collection' arrived from Venice it would be deposited in the Queen's Palace and that tickets of admission would be given to 'the Nobility and Gentry' who wished to view it. In fact the house was 'rather a difficulty to see at all'. Walpole, writing in 1783, was critical of the arrangement of pictures at Buckingham House, where he found 'the wretchedest copies are mixed promiscuously with the finest originals'. When he described the pictures at Buckingham House in more detail[28] he made the same criticism of the recent purchases: 'A very few fine by the present King, & most of the bad.' Some of Walpole's remarks show that his eye for pictures was as unreliable as his sense of artistic values; the impression from the inventory drawn up towards the end of the century, and from a series of measured drawings indicating the placing on some of

the walls, suggests careful if not very discerning arrangements in which much attention was given to the symmetrical disposition of the pictures.[29] The watercolours by Stephanoff for Pyne were drawn considerably later, but two of the rooms, the Crimson Drawing-Room (formerly the Japanned Room) (plate 144) and Second Drawing-Room,[30] are comparatively little changed from the 1760s and convey a distinguished impression: pictures in rich carved and gilded frames against a deep crimson, unpatterned fabric, relieved with white doorcases and fireplaces and surmounted by pretty neo-classical ceilings, designed by Adam and Chambers and decorated by Cipriani. Canaletto's large views of Venice and Rome – 'bolder, stronger & far superior to his common Works' – hung with seven of the Palladian subjects by Visentini and Zuccarelli in the Hall.

The influence of the Queen on the appearance of the royal houses, as well as on the patronage bestowed by the King on the arts in the early part of the reign, should not be underestimated. She was painted by Angelica Kauffmann in the act of 'raising the Genius of the Fine Arts', a portrait known only from the mezzotint published by Thomas Burke in 1772.[31] Her apartments at Buckingham House created a pretty impression: 'ornamented . . . with curiosities from every nation that can deserve her notice. The most capital pictures; the finest Dresden and other china, cabinets of more minute curiosities . . . a number of small and beautiful pictures . . . Round the dressing-room, let into the crimson damask hangings . . . frames of . . . miniatures.'[32] In her Bedchamber the Queen hung the Opie of her old friend Mrs Delany, a painting by Angelica Kauffmann of a *Lady at her Tambour Work* and one of the Gainsboroughs of Bishop Hurd. Queen Charlotte's personality was no less clearly stamped on Frogmore, which she acquired in 1792 and which was charmingly fitted out[33] and hung with portraits of her family by Ramsay, Cotes, Beechey, Zoffany, Dupont and others; Richard Wright's picture of the hideous crossing which the Queen had endured on her journey to England hung in the Green Pavilion; and a room was decorated for her by Mary Moser, one of the two female painters to be found in a modest place among the Academicians in Zoffany's group.[34] When Queen Charlotte's private property was sold after her death, two flower pieces by Van Huysum, which had been given to her in 1814 by her eldest son, were among the pictures sold at Christie's on 25 May 1819; a much more regrettable loss, sold at the same time, was Gainsborough's great full-length of Karl Friedrich Abel, who had been one of the Queen's chamber musicians.[35]

Some of the best of their acquisitions were hung by the King and Queen at Kew. Pictures from Smith's collection hung in the Coffee Room, the Queen's Work Room and the Queen's Drawing-Room and in bedrooms used by Princess Augusta and Princess Amelia; and twenty-four Canalettos hung in the Gallery, where they were still to be seen after the Queen's death.[36] In November 1804 the royal family took up residence in Windsor Castle. Earlier in the reign it was described as 'kept so very un-neat', but now a transformation of Charles II's state apartments and work on the Queen's private apartments were being carried out under the supervision of James Wyatt. In 1804 and 1805 many pictures were sent down from the other residences to embellish the Castle. Pictures were being sent to Windsor which have been there ever since: from Kensington the big canvases by Rubens and Van Dyck; early royal portraits and a run of state portraits; huge Zuccarellis and modern portraits by Copley, Zoffany and Ramsay; and, from Kew, the hunting pieces by Wootton. 'It gives me great pleasure', wrote the Princess Royal to her father from Germany on 5 July 1805, 'that the Castle affords Your Majesty so much amusement. The Queen and my Sisters

have indulged me with charming accounts of the improvements. I rejoice that the fine Pictures are set off to such advantage on the new Hangings which must be very favorable to the Vandykes and Rubens's.'[37]

Kensington, on the other hand, had fallen out of favour, and was 'entirely forsaken', a fascinating hunting-ground for anyone interested in old portraits and the early history of the collection. Horace Walpole, who had the care of the place during the absence of the Housekeeper, his sister Lady Mary Churchill, had discovered there the panels by Van der Goes and corresponded about them with Lord Buchan and John Pinkerton. Pinkerton was at work on his *Iconographia Scotica* and found that permission to copy a portrait in the royal collection cost no less than four guineas.[38] In 1818 the antiquarians Edward Balme and Thomas Kerrich were in correspondence about the 'hoards of Pictures never noticed' which William Seguier was finding at Kensington where, Kerrich was told, 'he may possibly like to admit *you* as a person who may give him information . . . but I believe you must be alone.'[39] The Prince Regent was interesting himself in the pictures he was soon to inherit and had ordered a survey of the whole collection to be made by Benjamin West, who, on Dalton's death in 1791, had succeeded him as Surveyor, Cleaner and Repairer of the King's pictures. There is an attractive glimpse of West, just after peace had been ratified between Britain and America, getting leave to show his compatriot John Adams 'the originals of the great productions of his pencil' in the Warm Room. 'In every apartment of the whole house, the same taste, the same judgment, the same elegance, the same simplicity, without the smallest affectation, ostentation, profusion or meanness. I could not but compare it, in my own mind, with Versailles, and not at all to the advantage of the latter.' West's fellow-countrymen preferred his pictures to those by Rubens and Van Dyck and admired them no less than the Cartoons.[40]

Lord Melbourne told Queen Victoria that George III, 'though accused of the contrary, was excessively fond of the Arts'.[41] Gainsborough praised the King's good judgment in pictures. At the outset of the reign, when the King and Queen had set themselves to encourage the arts, the throne had been hailed as the 'altar of the Graces', but this happy image was flawed by prejudice and ill-health. More perceptive than Walpole's sneer at the young Augustus drowsing over his medals and drawings was a remark he made in 1783 that the King did not 'seem to have more than a general disposition to make purchases, without judgment'. The King made his one great purchase without any idea of what the pictures actually looked like. In 1765 he had bought back for the collection Van Dyck's *Five Children of Charles I*, but he rejected five years later the offer made by his ambassador in Paris to attempt to buy for him no less a picture than Van Dyck's *Roi à la chasse*: 'I have, at least for the present, given up collecting pictures: therefore shall not trouble you with any commission for the Vandyke.'[42] One cannot imagine the chance to buy so beautiful a picture, so rare a synthesis of historical association with appealing subject-matter, being turned down by Frederick, Prince of Wales – still less by George IV, who was in all ways the exact opposite of his father.

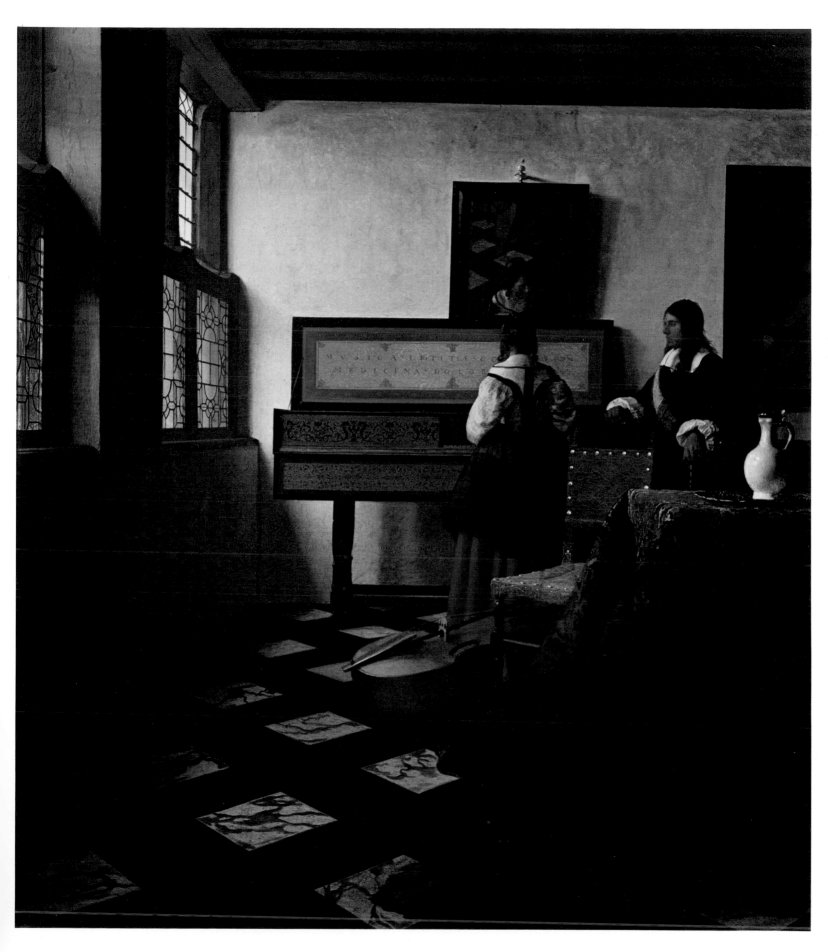

XXIII JOHANNES VERMEER *A Lady at the Virginals* (see page 126)

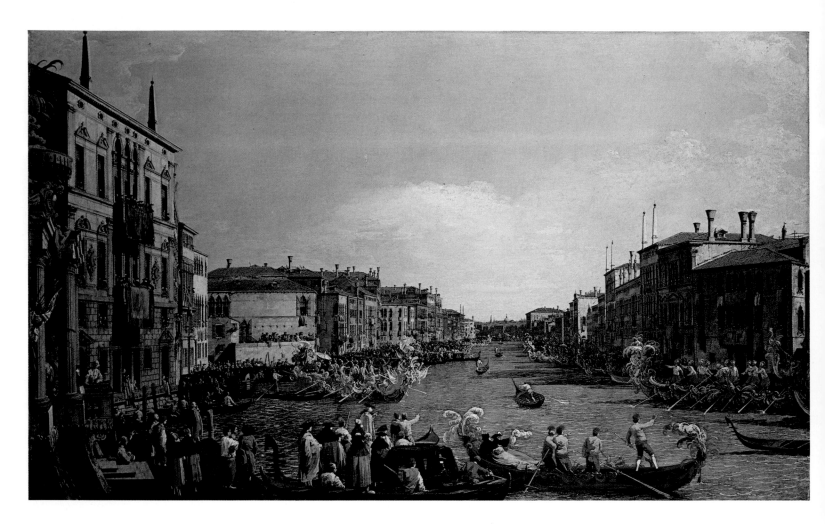

XXIV CANALETTO
A Regatta on the Grand Canal
(see page 125)

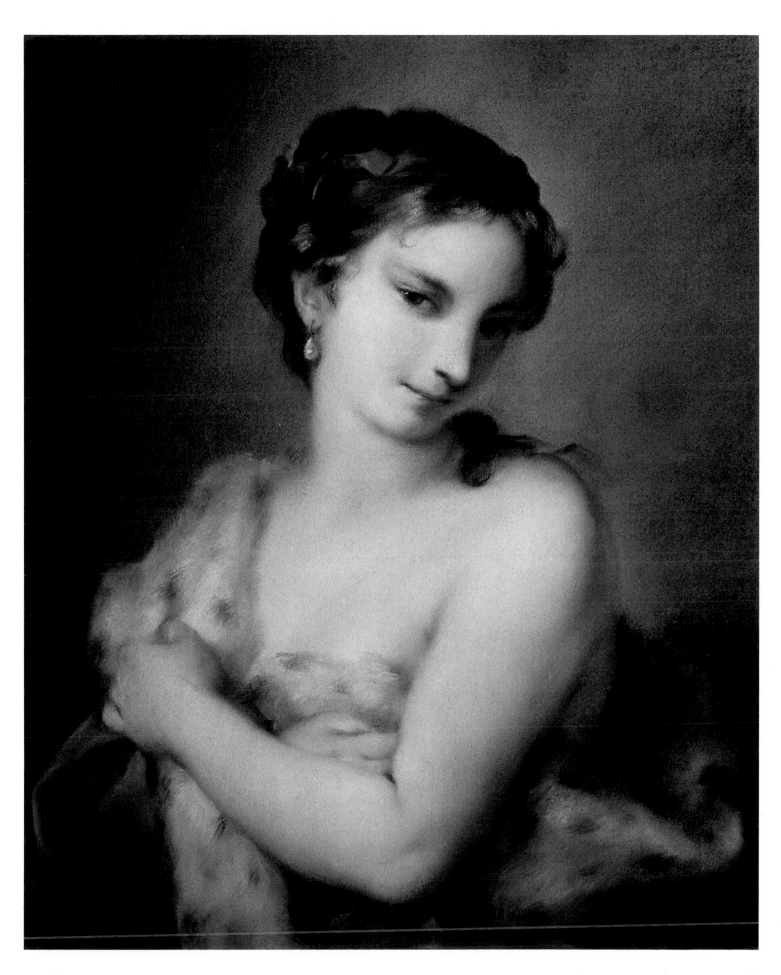

XXV ROSALBA CARRIERA *Winter* (see page 123)

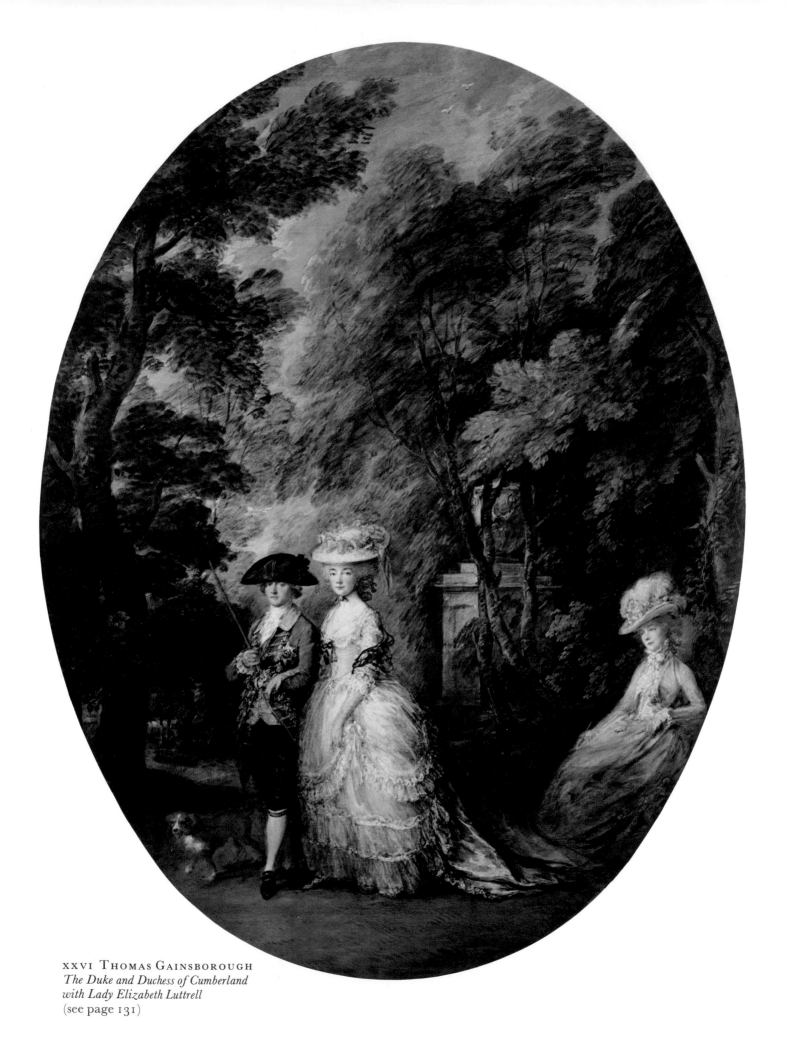

XXVI THOMAS GAINSBOROUGH
*The Duke and Duchess of Cumberland
with Lady Elizabeth Luttrell*
(see page 131)

7

GEORGE IV

WHEN THE PRINCE OF WALES came of age in 1783 he took over Carlton House, where his grandparents had lived. Glowing with charm, bursting with life and wildly extravagant, he had for a long time chafed under the discipline of a restricted and rather lonely life under his parents' roof at Buckingham House, and at eighteen had plunged into the dangerous delights of the fashionable world. Within a year his debts stood at nearly £150,000 and by 1792 they had reached £400,000. The remodelling and refurnishing of Carlton House had contributed towards the 'torrents of expense' which the Prince's advisers endeavoured to staunch.

Total disregard of any kind of financial prudence – one of the many aspects of the Prince's character which was anathema to his father – is a prime asset in a collector. To this the Prince added an increasingly appreciative eye for quality in pictures, delight in fine brushwork, and enjoyment of the narrative content of a picture, especially if it held a family interest. Like all keen collectors he was prepared to improve his collection and get rid of pictures. Almost all the pictures from his 'old collection' were dispersed, and he sent to Christie's a number of pictures to be sold on 29 June 1814. Perhaps more than any other English royal connoisseur, he had a feeling for the look of a room as a whole and for the part a picture could play in its design; and he so frequently altered the arrangement of the rooms at Carlton House that he was constantly changing the pictures round; many more pictures were in store at any given moment than were to be seen on the walls. When Sir Thomas Lawrence and Michael Bryan drew up their inventory of Carlton House in December 1816, less than 170 pictures, including a number in the Middle Attic, were actually hanging in the rooms, while some 240 pieces were in the store rooms. A few years earlier a visitor had described Carlton House as 'so magnificent just now. . . . He changes the furniture so very often, that one can scarcely find time to catch a glimpse at each transient arrangement before it is all turned off for some other.' Queen Charlotte might murmur 'Oh! vanity, vanity', but other visitors thought Carlton House more splendid than any other house in England; and Count Munster considered that in elegance and richness it surpassed even the Winter Palace.[1] In the annals of the collection George IV's achievements as patron and collector were the most brilliant, sustained and entertaining since the time of the Stuarts.

When attempts were made in the 1790s to settle the Prince's debts, artists and

craftsmen submitted their accounts. Bills came in from Mrs Gainsborough and the executors of Sir Joshua Reynolds; from Romney, John Russell, De Loutherbourg and Garrard; from Thomas Allwood and Sefferin Nelson, who had framed the Prince's sporting pictures; from Cosway for a very large number of miniatures; and from George Simpson for cleaning and repairing pictures.[2] Simpson's bill covers work he had carried out on a great many pictures in 1793–5. It was vetted by Richard Cosway, the foppish little figure strutting on the right of Zoffany's *Academicians*, who, as well as being *Primarius Pictor* to the Prince, clearly exercised some supervising authority over his patron's collections at this time and was involved in the interior decoration of Carlton House.

The pictures on which Simpson worked give an impression of the Prince's 'old collection' which is very different from the collection as he left it nearly thirty years later. It was more varied in period, in the schools of painting represented and in subject-matter. The collection in 1830 contained almost no Italian pictures; in the 1790s the Prince owned pictures with attributions to Bellini, Correggio, Titian, Tintoretto, Bordone, Bassano, Palma Vecchio, Parmigianino, Michelangelo, Albani, Maratti and Giorgione.[3] In 1830, moreover, there were very few religious pictures in the collection, whereas the 'old collection' contained a number. There are, nevertheless, in Simpson's notes clear indications of the kind of picture and the type of artist the Prince was going to like increasingly: a number of Flemish and Dutch pieces; one or two pointers towards his enthusiasm for the *Grand Siècle* (the first, perhaps, of his views of Louis XIV's campaigns in the manner of Van der Meulen, or a portrait of a lady 'said to have been Mistress to a French King') which later led him to make such a celebrated collection of French works of art and to buy in such profusion enamels by, and in the manner of, Petitot; portraits of his family; military subjects; and scenes of royal diversions. He by now already possessed, for example, the little canvas by Stalbemt and Belcamp showing the family and court of Charles I in the park at Greenwich; a Wootton of Prince Frederick with his hunt; and Philips's group of the same Prince with his companions of the Round Table.

George III and Queen Charlotte, who had no cronies, were distressed by the Prince's attraction to raffish company and by his friendships with men and women abhorrent to them on political and moral grounds. No other English royal collector has ever been at pains to assemble such a delightful portrait gallery of relations and friends as surrounded the Prince of Wales at Carlton House or, in his declining years, at Windsor (a gallery in which marble busts complemented the painted images); but no other Prince of Wales moved in such high-spirited, civilized and charming company. Nor, perhaps, to any other royal collector were pictures such an essential expression of the enjoyment of life.

The Prince had taken over with Carlton House his grandmother's family portraits by Cotes and Angelica Kauffmann and Ramsay's portraits of his parents; he then secured some of his parents' Zoffanys, including the masterpiece of his mother with himself and his brother Frederick, to whom he was devoted. He commissioned from Reynolds the splendid full-length of Frederick in Garter robes; he had told him earlier that he was 'keeping places in my House, on purpose for Portraits of you & Billy', and Hoppner painted for him the full-length (now sadly damaged) of the Duke of Clarence. The Prince had nothing of his father's stubborn prejudices where painters were concerned. He was always on friendly terms with Reynolds, whose niece in 1812 expressed her deep sense of the Prince's former goodness to him by giving him the original (plate 145) of 'the best portrait he ever painted of himself'. Gainsborough had

145 SIR JOSHUA REYNOLDS
Portrait of the Artist

such an affection for the Prince that he is alleged to have said that he would never send to the Prince's Trustees a demand for payment. He had worked for the Prince's uncles before being employed by the King and Queen and in 1783 was preparing for the Prince a pair of three-quarter-lengths of the Cumberlands who, in the eyes of George III, had played a leading part in the corruption of his eldest son.[4] Early in 1784 Gainsborough finished for the Prince the lovely group of his three eldest sisters for which the Prince had planned a special position among his other family portraits in the Saloon at Carlton House. The picture was tragically mutilated when it was cut down early in the reign of Queen Victoria so that it could be fitted into a position over a door. Landseer, who saw the 'Inspector of Palaces' cutting pieces off the canvas, was too late to save them from the flames. After Gainsborough's death the Prince secured the two most beautiful and unusual works by him in the collection: a marvellously preserved rococo idyll in Windsor Great Park, the *Duke and Duchess of Cumberland with Lady Elizabeth Luttrell* (plate XXVI) and, for little over £2 in a sale of Mrs Gainsborough's pictures, the very late, unfinished *Diana and Actaeon* (plate 146), which has the fluency of a large sketch and a brilliance of handling, as well as an intensely personal mood in the telling of the story, which remind one of Van Dyck's *Cupid and Psyche*.

The miniatures listed in the account which Cosway submitted as one of the Prince's creditors included many portraits of his patron, done as presents to relations or friends, a set of miniatures (e.g., plate 147) of his brothers and sisters; and at least one portrait of Mrs Fitzherbert. The portraits of her which had been painted for the Prince by Gainsborough, Romney, Reynolds and Russell were sent down to her at Brighton soon after his death. Gainsborough's portrait of Mrs Eliot was also disposed of; and in 1818 the Prince gave to Lord Hertford the full-length of Perdita Robinson, whose affair with the Prince – 'this shameful scrape' – had cost his father much distress and £5000,

though he retained the exquisite *modello* for it. The quality of his Gainsboroughs alone indicates that the Prince delighted in the appearance of such beautiful canvases, as well as in the subjects, with all their associations, which they depicted.

Of the Prince's other early friends, he secured very distinguished portraits by Reynolds of Erskine (plate 148) and Lord Hastings; he commissioned from Gainsborough the romantic full-length of Colonel St Leger and a smaller portrait of Lord Cornwallis; and Hoppner painted for him Hastings, the Duke of Bedford and Jack Payne, Keeper of the Privy Seal and Private Secretary, as well as one of his noblest works, the portrait of the Prince's old preceptor, William Markham, whose wise instruction, kindness and good nature, the Prince declared, would never be effaced from his heart. And there were portraits at Carlton House of Fox, Lord Spencer Hamilton, Sheridan, the Duchess of Devonshire, Lady Melbourne and Colonel Hanger. Unfortunately, neither of the full-lengths of Lady Hamilton which Romney painted for the Prince, one as Calypso (plate 149), the other as the Magdalen, are in the collection today. The portraits of his sisters by Beechey and a remarkable series of small full-lengths by Stroehling, painted on copper and crammed with neo-classical devices, are the only important likenesses of his family which he commissioned later in his life.

The Prince's amusements are illustrated in his pictures: his love of the stage in a huge collection of prints and drawings, in the Dupont of 'La Bacelli' and in the celebrated portraits of Garrick by Reynolds and Hogarth (plate XXVII); his enjoyment of music in a portrait of Abel, the elegant Gainsborough of the oboeist Fischer, and the unfinished portrait of Haydn which was commissioned by the Prince from Hoppner during the composer's first visit to London; and enthusiasm for the turf and the hunting field in a famous series of sporting pieces.

The Prince's debts in 1787 had included nearly £29,000 on his stable account. Until he grew too heavy for the back of any normal horse he had enjoyed hunting; he considered it an 'almost divine amusement'. The burden of debts had forced him to sell his stud in 1786 and terminate a rather chequered career on the turf; his second foray there ended with a famous scandal at Newmarket in 1791. This is the period in which he was employing Sawrey Gilpin, George Garrard, Marshall and Stubbs. Garrard's seven large pictures of the Prince's horses, a set completed in 1792, were sent down,

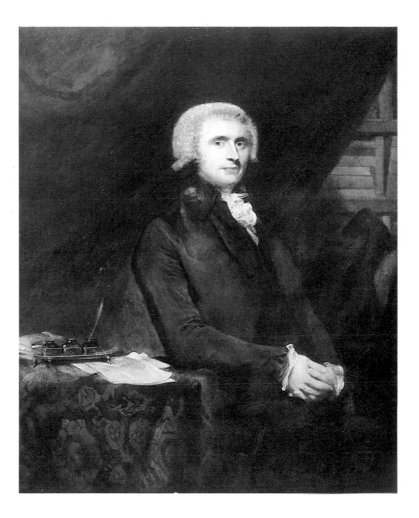

148 SIR JOSHUA REYNOLDS
Thomas, Lord Erskine

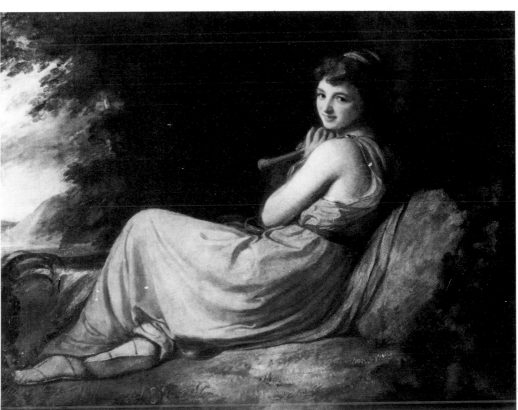

149 GEORGE ROMNEY
Lady Hamilton as Calypso.
National Trust,
Waddesdon Manor

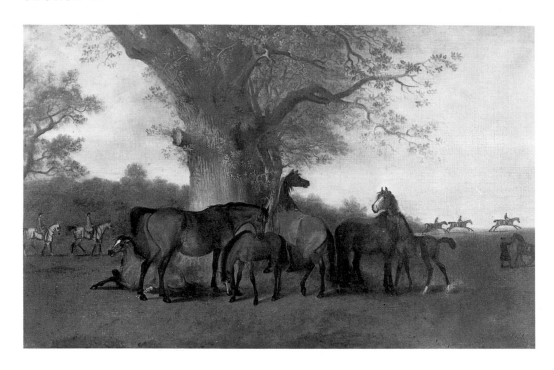

150 SAWREY GILPIN
Cypron with her Brood

framed and carefully labelled by Sefferin Nelson, to Kempshott House, near
Basingstoke, which was one of the hunting-boxes taken by the Prince; and it is probable
that the other sporting pieces were destined for such a location. Only one of Garrard's
seven pictures survive, a portrait of Saltram, with whose offspring the Prince won
£7,700 in 1792. Garrard may have been introduced to the Prince by the younger
Samuel Whitbread; Gilpin, on the other hand, who had also been lavishly patronized
by Whitbread, had been working for the old Duke of Cumberland at Windsor in the
early 1760s. His most important work for him had been the group, painted in 1764, of
Cypron, King Herod's Dam, with her Brood (plate 150). His rather old-fashioned little
pictures of the Duke's horses were taken over by the Prince of Wales; unfortunately
Gilpin's most important work for him, a large group of three horses in a landscape, on
which he had been arduously at work in 1804 – 'indefatigable through the whole
summer & autumn . . . sometimes painting 10 hours in a day' – has vanished.

Ben Marshall's horse-portraits for the Prince are probably among his earliest works,
still recognizably in the tradition of Wootton or the early Gilpin, but with a new feeling
for atmosphere and for the relation between the animal and his environment. Far more
important is the series of canvases, uniform in size and dated between 1790 and 1793,
painted for the Prince by George Stubbs. Thomas Allwood's account for eight frames,
'all of one pattern', for pictures by Stubbs is dated 1793.[5] The subjects, which comprise
perhaps the last, and one of the largest, of the sets of pictures which Stubbs painted for a
particular patron, were carefully chosen: portraits of the Prince himself, of one of the
most disreputable women in his circle and of some favourite dogs and horses. Four are
of particular interest: the famous group of the Prince's Body Coachman, Samuel
Thomas, about to harness two horses to a phaeton; a group of soldiers from the Prince's
favourite regiment (plate 151); a study of a red deer buck and doe; and the frieze-like
composition of William Anderson with two saddle horses (plate 152). Here the sea in
the background may allude to the Prince's affection for Brighton, which is recorded in
pastels by Russell of two characters from Brighton Beach, Martha Gunn and 'Smoaker'
Miles. The Prince had been buying animals and birds as early as 1786. Late in his life
he commissioned Jacques-Laurent Agasse to paint for him a pair of white-tailed gnus

151 GEORGE STUBBS
*Soldiers of the 10th Light
Dragoons*

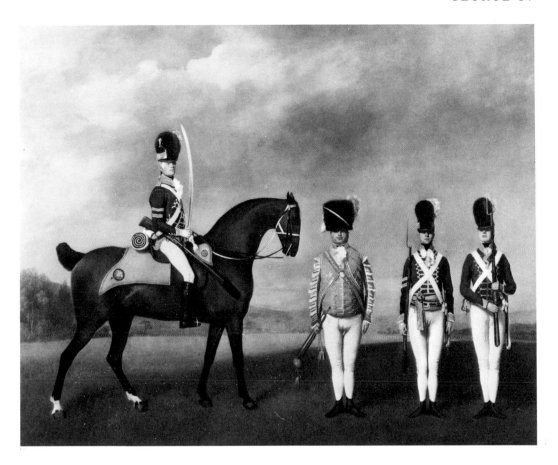

152 GEORGE STUBBS
*William Anderson with two
Saddle-Horses*

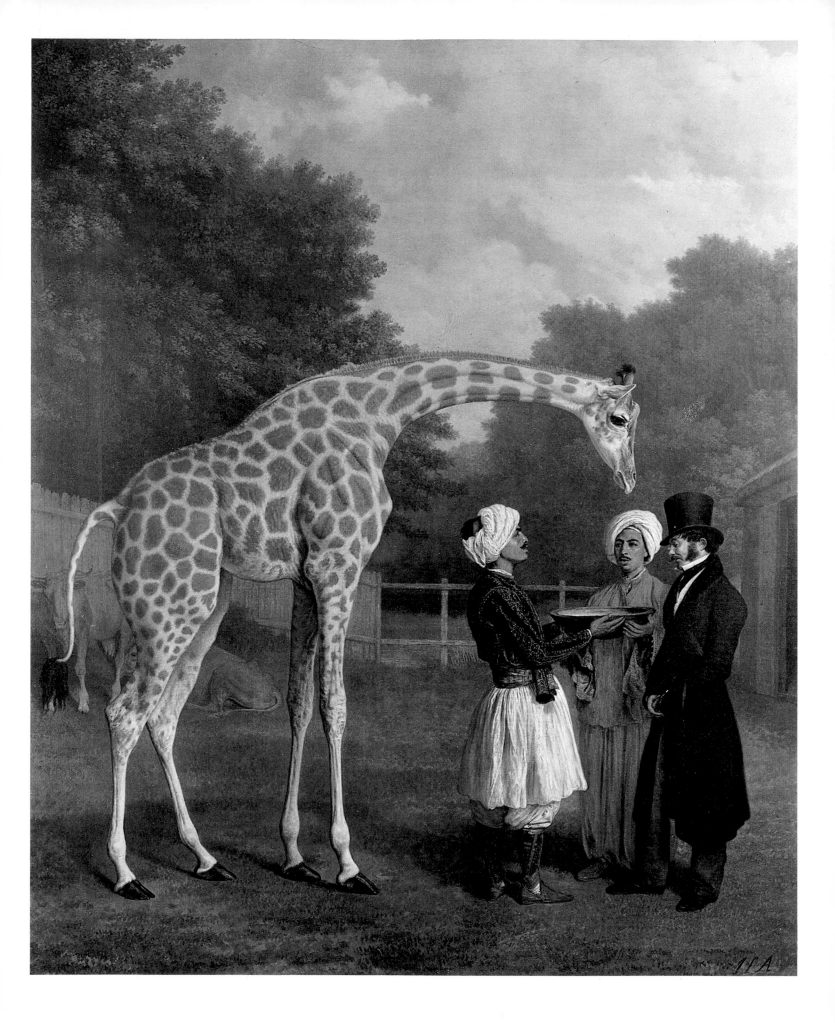

and the Nubian giraffe (plate 153) which were kept at Windsor. The portrait of the giraffe, in her paddock near Sandpit Gate, has much of the intensity and sympathy – and something of the subtle colour – of Stubbs's studies of wild animals. Its beautiful skin was ultimately stuffed by the young John Gould and given to the new Zoological Society.

In later years George IV commissioned portraits of his horses from Henry Bernard Chalon, Schwanfelder, R. B. Davis, Abraham Cooper and John Doyle; and J. F. Lewis worked among the animals at Windsor. Much the finest of the later pictures of his horses are those by James Ward (plate 154): painted with an understanding of the latent power of the animals and a feeling for landscape which owe much to Rubens and Teniers.

The oddest of Stubbs's pictures for the Prince of Wales shows the uniform and guard-mounting drill of the 10th Light Dragoons. The Prince was very proud of his Colonelcy of the regiment and loved wearing its uniform: to the Hanoverian passion for military matters he added a passion for dressing up.[6] Mather Brown, yet another American painter in the service of the Crown, painted him (plate 155) standing in an entirely fanciful military uniform, a jaunty parody of West's portrait – which was more serious in every way – of his father at a time of national emergency in 1779. Brandishing his sabre in his splendid Light Dragoon's uniform in Beechey's enormous canvas, the Prince wanted 'his share of the glory that is going'. He venerated the men who led his father's forces by land and sea in the Napoleonic Wars and took intense pride in the final outcome. In the tradition of James II and Queen Anne, he commissioned portraits of four naval heroes: Keppel and Rodney from Reynolds, St Vincent and Nelson (plate 156) from Hoppner. They hung first, in frames made by Edward Wyatt and enriched with marine trophies, in the Ante-Room at Carlton House. Lady Sarah Spencer, whose father had been First Lord of the Admiralty, wrote in 1810: 'I love him for having the finest possible pictures of Lord Rodney, Lord Keppel, Lord St Vincent, and, finest of all, that glorious Nelson, hung up as chief ornaments of his great room.'[7]

153 (left)
JACQUES-LAURENT AGASSE
The Nubian Giraffe

154 (right) JAMES WARD
Nonpareil

Wyatt had made military trophies for the frames on Reynolds's portraits of Granby and Schaumburg-Lippe, heroes of an earlier war, which hung in the Crimson Drawing-Room at Carlton House. For a short time, in the Ante-Room at St James's, Lawrence's portrait of George III hung between De Loutherbourg's *Glorious First of June* and Turner's *Battle of Trafalgar* (plate 157). Turner, who had probably been recommended to the King by Lawrence, began to gather material for his picture late in 1823 (he was paid five hundred guineas for it) as part of a carefully planned display of battle-pieces and portraits which was to be set up at St James's. In the Throne Room next door, Lawrence's portrait of George IV (plate 158) – which is still in position – was to be flanked by George Jones's huge canvases of Vittoria and Waterloo. Turner's picture was severely criticized and was eventually among the naval pictures to be included in the misguided gesture to Greenwich Hospital which deprived the royal collection of its only picture by England's greatest painter.[8] The King had acquired Denis Dighton's large painting of the battle of Orthez, which in 1815 he gave to Lord Anglesey; but he kept his important picture (plate 160) of the general advance of the British lines at the end of the battle in which Anglesey played a prominent part. Anglesey and George IV shared an admiration for the small military pieces by Stroehling. The King owned little equestrian portraits by him of Anglesey, Blücher and Platov, but he gave away many pictures by the artist, among them portraits of the Regent, as he then was, masquerading as the Black Prince (last heard of in 1826) and in Hussar uniform. It is ironical that neither the King himself, nor Sir Thomas Lawrence,

155 (below left)
MATHER BROWN *George IV*

156 (below right)
JOHN HOPPNER
Horatio, Viscount Nelson

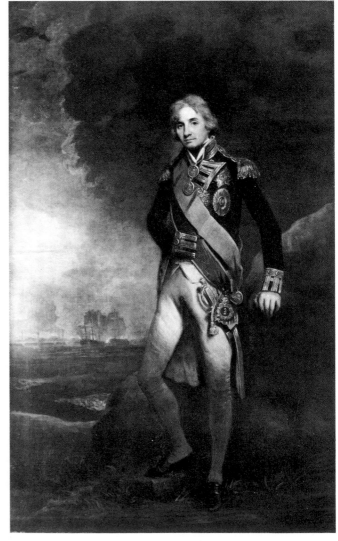

the painter especially associated with it, should have seen the chief surviving memorial in the royal collection of George IV's desire to celebrate the allied victory: the Waterloo Chamber at Windsor Castle.

Lawrence had stayed in the house of the Princess of Wales, where he had painted the extravagant full-length of her with Princess Charlotte, and his name had been unfairly linked with hers in the rumours which led to the Delicate Investigation into her conduct. He had painted for the Princess the fine portrait of Lord Thurlow which the old King thought to be 'his idea of a portrait', but which the Prince got hold of for himself. Not until the summer of 1814 was Lawrence presented to the Regent. In 1818 he produced the prototype for the new Sovereign's state portrait, of which a very large number of repetitions was to be ordered: in its flamboyant way as perceptive an image as Ramsay's had been of his father over fifty years before.

It was first proposed that the Restoration of the Bourbons should be commemorated in two historical compositions on a large scale, 'not inferior in size to that of West lately finished', but the theme, pursued after the final defeat of the French at Waterloo, was celebrated in the end more simply: in a series of full-length and three-quarter length portraits of the 'Monarchs, Statesmen, and General Officers who contributed most conspicuously to bring the Revolutionary War to its happy and glorious Termination'. The format and atmosphere of this marvellous series were developed perhaps from such portraits as Lawrence's dashing masterpiece of Lord Charles Stewart and established in full-lengths of Blücher and Count Platov which Lawrence painted in London

157 J. M. W. TURNER
The Battle of Trafalgar.
National Maritime Museum, Greenwich Hospital Collection

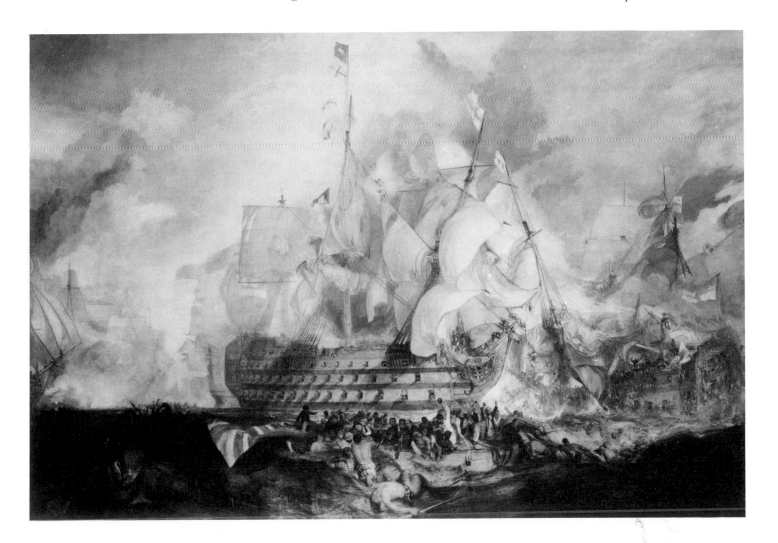

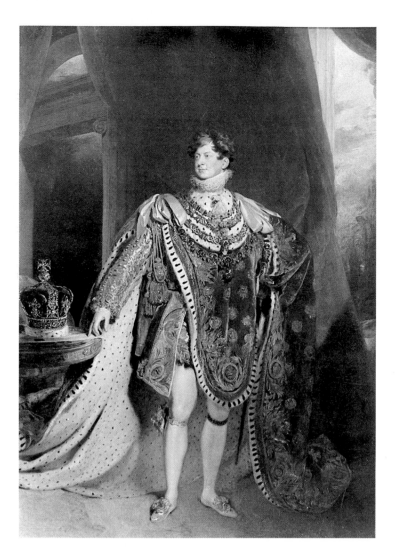

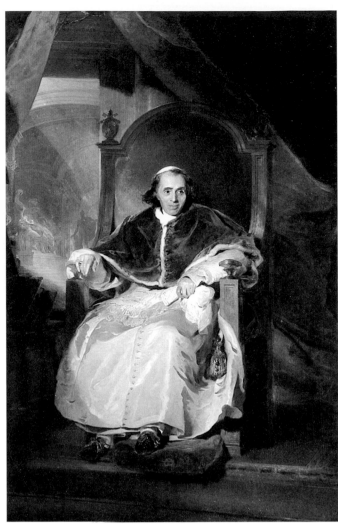

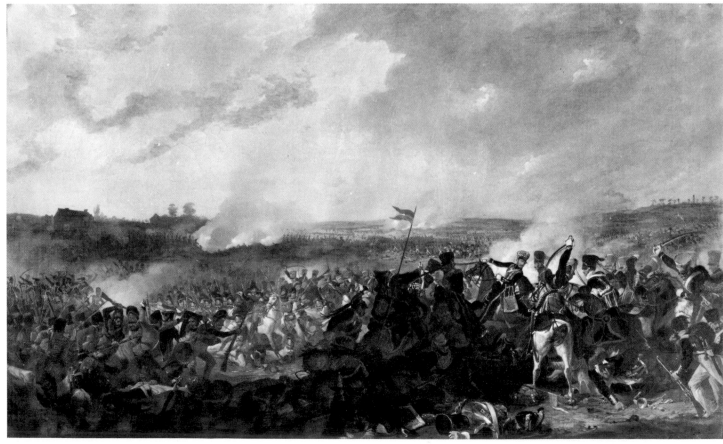

in the summer of 1814. At the same time he began portraits of Wellington, the King of Prussia and the Tsar. In September 1818 Lawrence set off for Aix-la-Chapelle to paint those who were gathering for the Congress. He had sittings from the Emperor of Austria, the Duke of Cambridge and a number of diplomats. Moving on to Vienna, he painted the Emperor, the Archduke Charles (plate XXVIII) – perhaps the most fascinating in the series – and Schwarzenberg; in Rome he painted Cardinal Consalvi and – the masterpiece in the set – Pius VII (plate 159): 'the Emperor and The Pope decidedly beyond himself', as Wilkie said when he saw the portraits on Lawrence's return early in 1820. Next year the King was talking of constructing at Carlton House a gallery to receive the portraits, but when Lawrence and his patron died the portraits were not quite finished, and had no permanent home. The series had been augmented with a number of English sitters (among others) and the full-lengths, painted in Paris in 1825, of Charles X and the Duke of Angoulême.

Before the portraits could be exhibited Seguier had to make them presentable: cleaning and varnishing, finishing backgrounds and working up 'hands and dress' in some of the portraits. In the following reign the Waterloo Chamber was completed to house the portraits. The decoration of the room and the arrangement of the canvases were originally simpler than they are today. Portraits were incorporated which were not part of the original series: appropriate sitters by Shee, Pickersgill and Wilkie, for example. Queen Victoria and Prince Albert also made additions to the scheme. The latest of such additions were wisely removed when the room was completely redecorated in 1974–5. In Lawrence's portraits, too, one can now see more clearly, since the recent cleaning of the series, the brilliance of handling, the dazzling display of Romantic bravura and the 'power that gave an air of fashion to the form and of beauty to the face, which enchanted his sitters & made them think higher of their own perfections'.[9] To the end of his life Lawrence continued to paint for the King, producing for him some of the best of his later works: *Prince George of Cumberland*, for example; the masterly *Sir William Curtis*; the charming *Devonshire*; or *Sir Walter Scott* (plate 161), who still hangs at Windsor only a few feet from where George IV placed him; 'to the perfect truth of the representation, everyone who ever surprised him in the act of composition at his desk, will bear witness'. The frames for Lawrence's later portraits for the King were made by George Morant. He made frames for the *Devonshire* and *Curtis*, for example, and in April 1827 submitted his account for £30 for 'A bold richly ornamented Frame for a large Portrait of Sir Walter Scott' (plate 161)[10].

The King and Sir Walter appear together in the painting by Wilkie which recorded the moment when the King entered Holyroodhouse during his visit to Edinburgh in the summer of 1822. Wilkie produced for the Royal Academy in 1830 the big full-length of his fat Hanoverian patron in the costume he wore at the Levee two days later: full Highland kit, 'made of the royal Stewart tartan'. The style and air of the figure had been suggested by a Sebastiano del Piombo, but it was 'at once a trial of Rembrandt all over'. Wilkie was illustrating a notable moment in the development of romantic interest in Highland lore and costume which was to be taken up with such enthusiasm by Queen Victoria and Prince Albert. When Wilkie had returned from his long trip on the Continent, the King bought two little pictures of Roman pilgrims, in which passages are strikingly reminiscent of Rubens, and three scenes (e.g., plate XXIX) (he later commissioned a fourth) from the Spanish guerrilla campaigns against the French. Wilkie was gratified that the King remarked the resemblance in these pictures to Rembrandt, Murillo, and Velazquez: 'Nothing seemed to escape.' The King admired the brilliance of Wilkie's mature technique and the excitement with which he

158 (far left)
SIR THOMAS LAWRENCE
George IV

159 (left) SIR THOMAS
LAWRENCE *Pope Pius VII*

160 DENIS DIGHTON
The Battle of Waterloo: General Advance of the British Lines

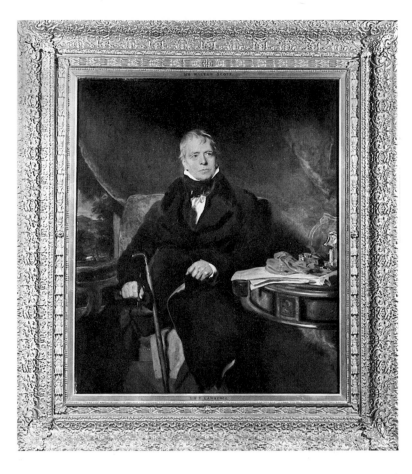

161 (left) SIR THOMAS
LAWRENCE *Sir Walter Scott*

162 (below) SIR DAVID
WILKIE *The Penny Wedding*

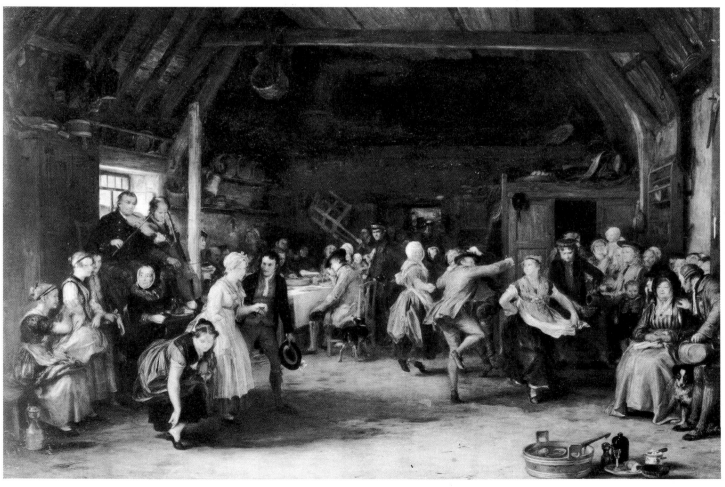

163 B.R. HAYDON
The Mock Election

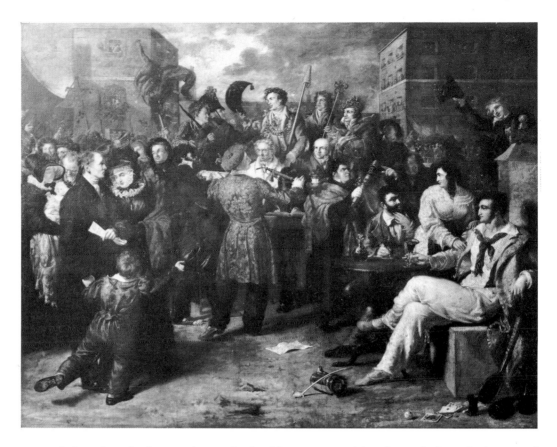

treated these heroic themes, just as he had been amused by the artist's early 'pan and spoon manner' in scenes of Scottish peasant life (plate 162) painted in a style so reminiscent of Dutch and Flemish Old Masters. One of Wilkie's early patrons had claimed that he would 'go beyond Teniers, Ostade and all who had preceded him'. The King owned two important subject-pictures by Reynolds and acquired one very dull piece by Northcote. In 1828 he was delighted with Haydon's *Mock Election* (plate 163). But it was his perennial interest in anecdote and his feeling for quality that led him to patronize Collins and Mulready (plate 164), painters who could admire the technical skill of the great Dutch masters but found their subjects 'gross, vulgar and filthy'.

The story of George IV's patronage of contemporary painters ends, therefore, on an almost Victorian note. He had talked much about 'advancing the art in this country', but caprice and indolence had prevented him fulfilling his declared aim of forming a representative collection of British painting. From 1812 the business of the Royal Academy was submitted to him instead of his father; he regularly attended the annual dinner. He lent his patronage generously to the British Institution; and its Keeper, John Young, described him 'as one of the best monarchs the country ever knew, whose consummate taste and munificence has done more for the arts during his short reign, than could have been expected in a century'. At the end of the reign Sir Robert Peel claimed that the King was admitted to be the greatest patron the arts had ever had in this country and that he was highly esteemed by British artists.

'He did not', wrote Young, 'collect his incomparable Dutch and Flemish pictures without encouraging the growing merit of his own Countrymen.' There is a connection between George IV's taste in old pictures and his commissions from contemporary painters, rather in the same way as Charles I's devotion to Titian had coloured his attitude to Van Dyck. George IV liked the work of Wilkie, Collins or James Ward because he recognized in it the influence of painters he particularly admired: Teniers,

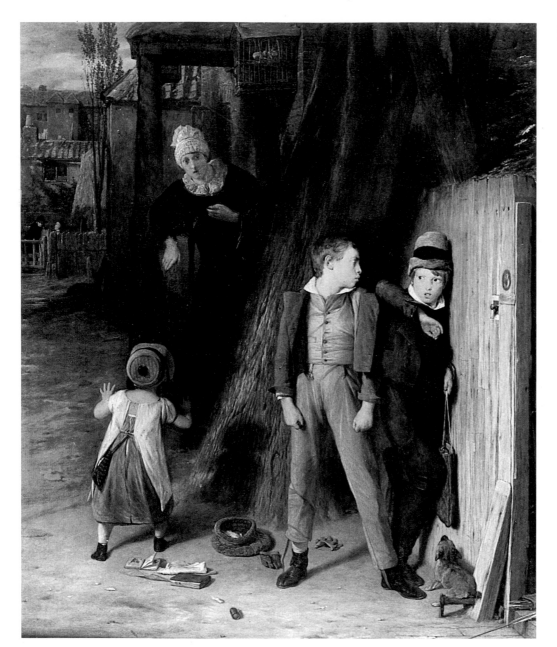

for instance, Adriaen van Ostade, Steen or Rubens. He had inherited the family liking for military subjects – hence his large collection of paintings in the manner of Van der Meulen and a copious collection of contemporary military pieces – and it is significant that some of his earliest surviving acquisitions by artists such as Hondecoeter, Wynants or Cuyp are akin in subject-matter to the sporting pieces he had commissioned or to those, by a painter such as Wootton, which he had bought.

As his own tastes developed, and with encouragement and advice from members of his circle, the Prince progressively improved the quality of his collection and narrowed its range; he made it more specialized than the rather miscellaneous group of pictures which Simpson had cleaned in the 1790s. At his death, George IV left a superb collection of Dutch and Flemish pictures, and a handful of French masterpieces, of the seventeenth century. Some of the pictures in his original collection may have belonged to *émigrés* from France in the early years of the French Revolution; and the Prince was, partly under their influence, following the example of the great French collectors of the eighteenth century who had hung Dutch and Flemish pictures with French furniture

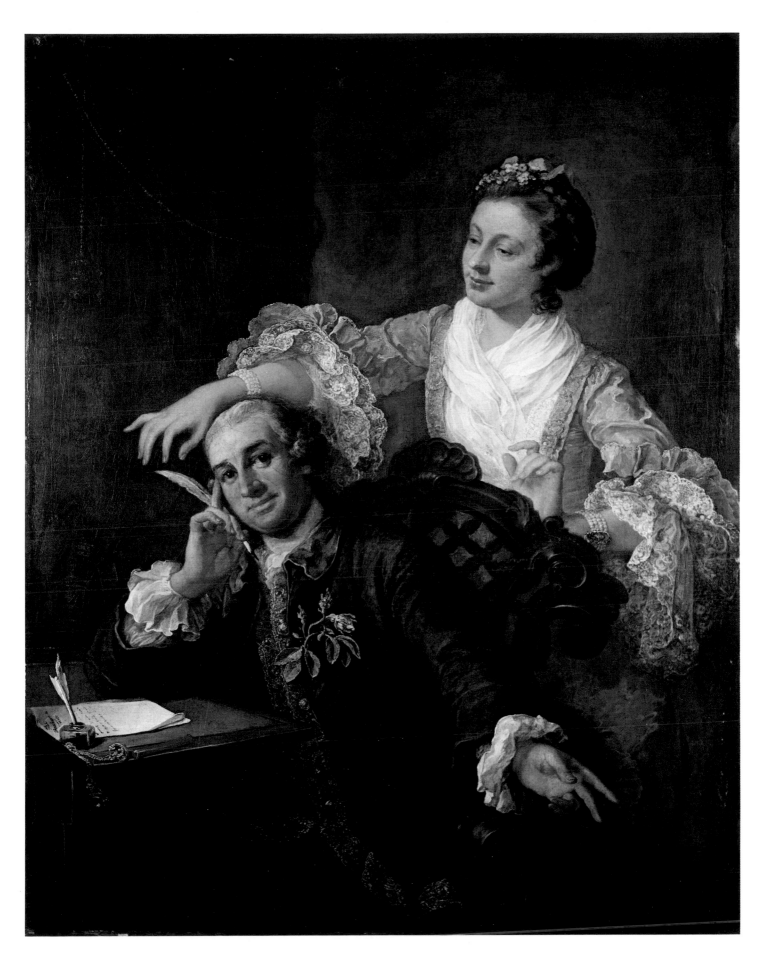

XXVII WILLIAM HOGARTH *David Garrick and his Wife* (see page 132)

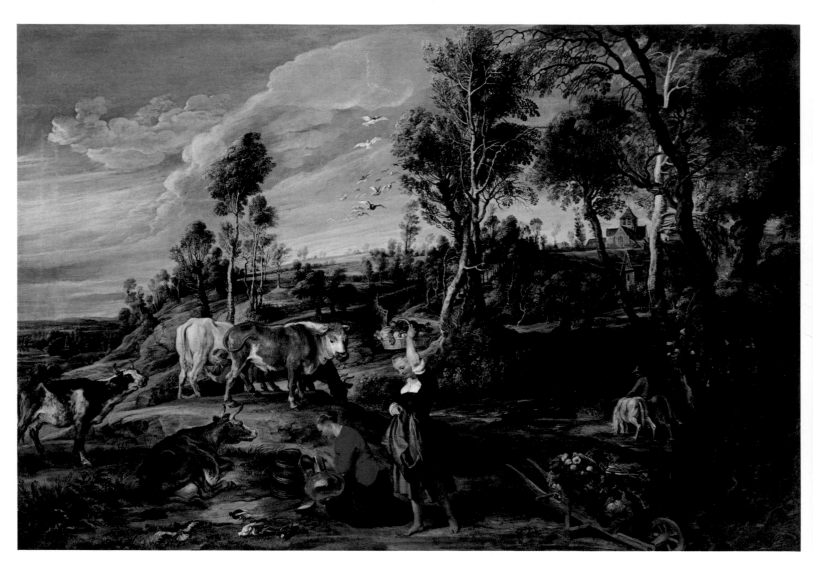

XXX SIR PETER PAUL RUBENS
The Farm at Laeken (see page 147)

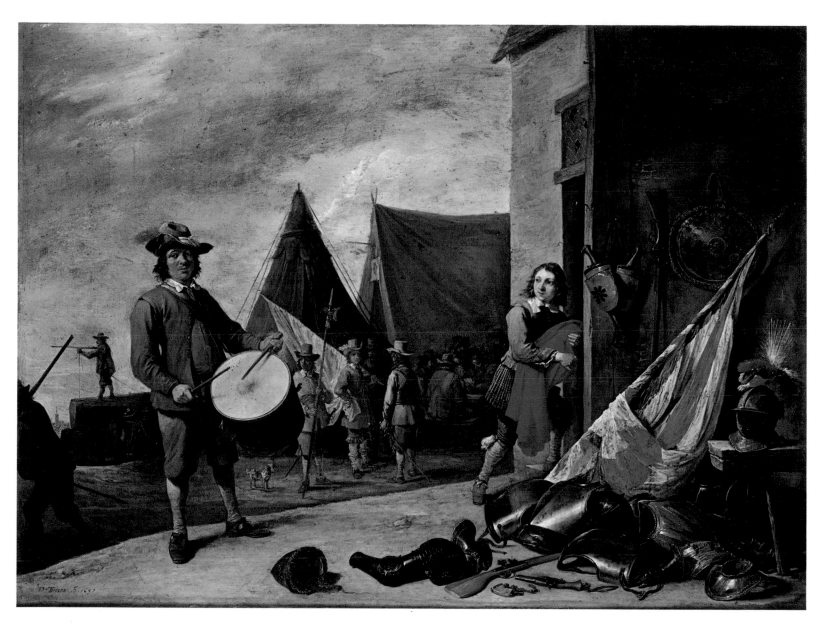

XXXI DAVID TENIERS THE YOUNGER
'*Le Tambour Battant*' (see page 150)

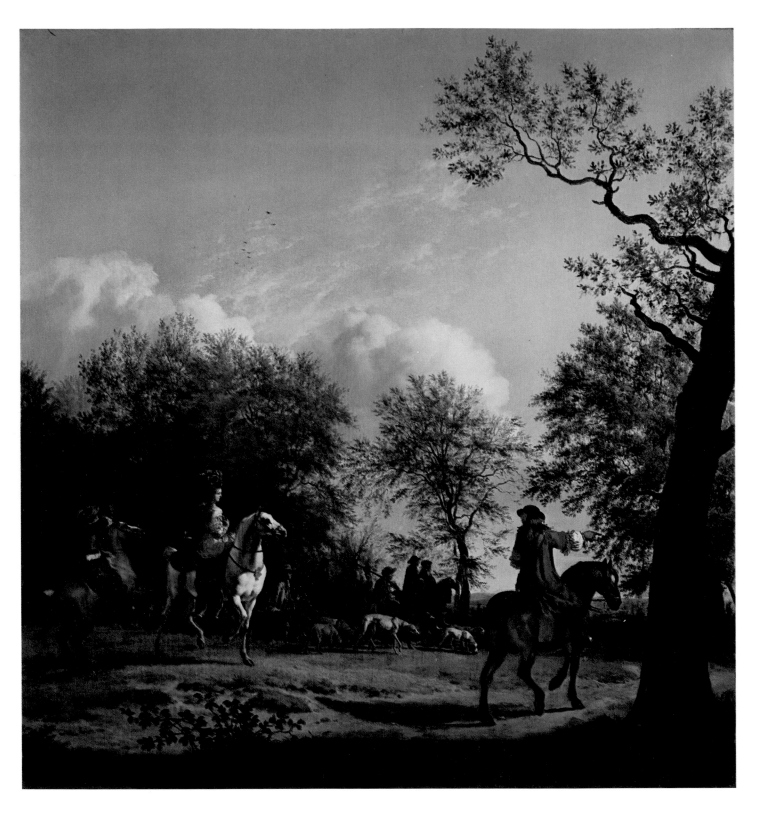

XXXII (above) ADRIAEN VAN DE VELDE
The Departure for the Chase (see page 150)

XXXIII (opposite) GERARD TER BORCH
The Letter (see page 147)

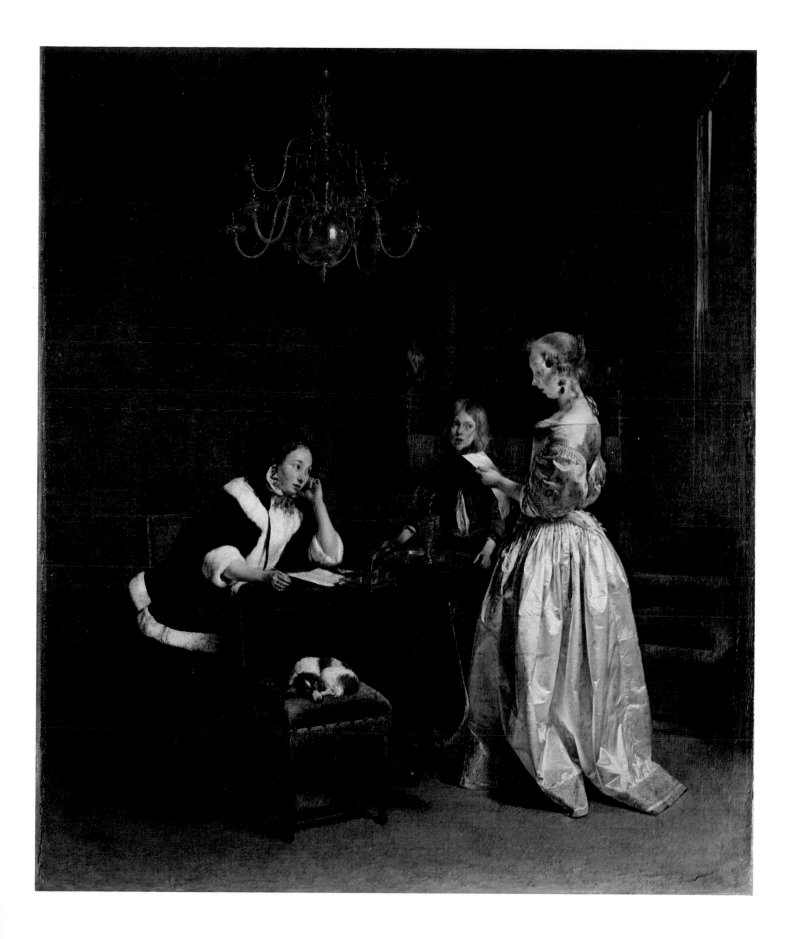

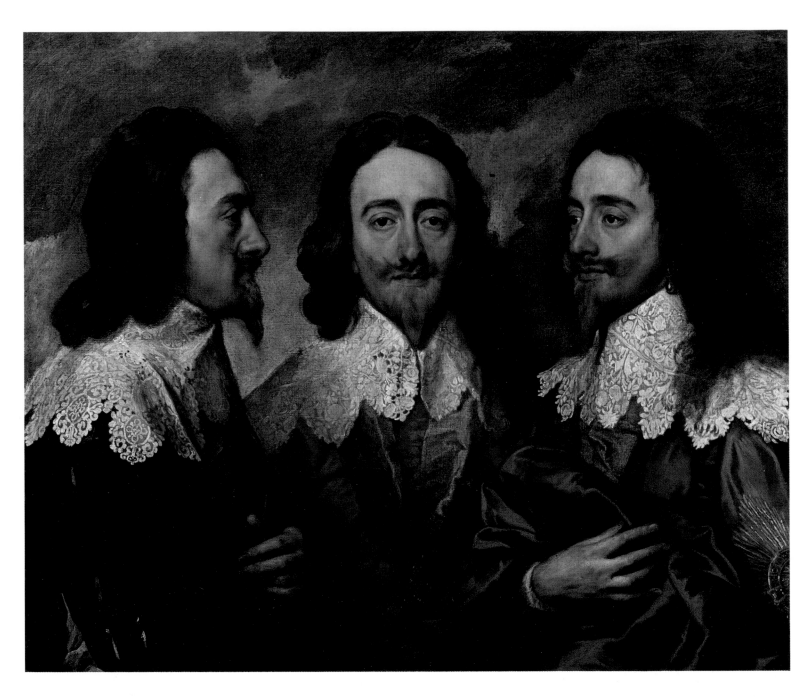

XXXIV Sir Anthony van Dyck
Charles I in Three Positions
(see page 156)

and works of art. To the flood of pictures which began to pour over from France at the time the Prince of Wales was beginning to collect, was later added those which were dispersed when the French armies overran the Low Countries. William Buchanan wrote that 'our principal riches in art' had been derived from the upheavals on the Continent. In the 1790s famous French and Dutch collections of Dutch and Flemish pictures were brought over to be exhibited and sold: the Orléans (1792), Calonne (1795) and Griffier Fagel (1801) collections, for instance. From the last the Prince ultimately acquired the little Pot of the family of Charles I; his finest French eighteenth-century picture was the portrait of Calonne himself (plate 165) by Madame Vigée-Lebrun which was at Carlton House by 1806; and the portrait of the Prince by this painter was given by him to Mrs Fitzherbert. Michael Bryan, who was paid £105 by the Prince 'for making sundry Catalogues of the Collection, and for making a valuation of the same, in conjunction with Sir Thomas Lawrence',[11] was a merchant with special knowledge of Dutch collections who sold in London pictures he had acquired in Holland and in Paris. He secured 'many of the best pictures of the Dutch school that are now in England'. Important pictures were brought over by Alexis Delahante and, in particular, by Buchanan himself, who was operating in the Low Countries as late as 1817. From the activities of such energetic agents and dealers

165 ELISABETH-LOUISE, MME VIGÉE-LEBRUN
Charles Alexandre de Calonne

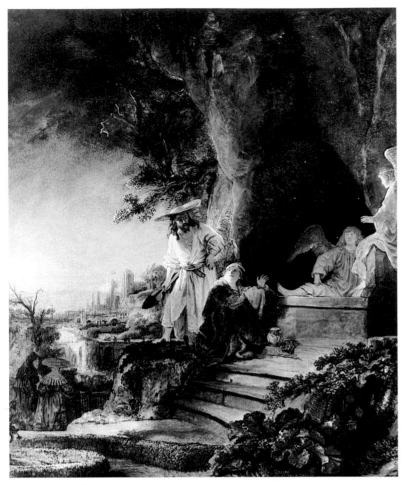

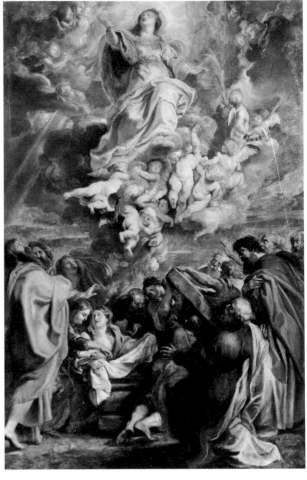

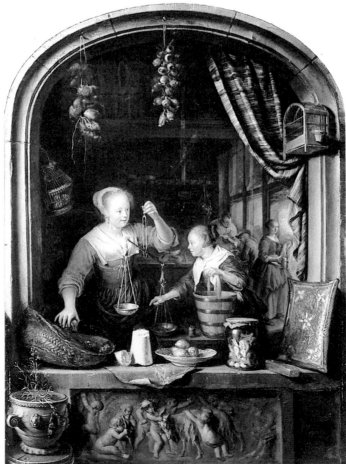

166 (above left)
REMBRANDT *Christ at the Tomb*

167 (above right)
SIR PETER PAUL RUBENS
The Assumption of the Virgin

168 (left) GERRIT DOU
The Grocer's Shop

George IV and his fellow collectors – the Duke of Bridgewater, Lord Bute, Lord Grosvenor, Lord Lansdowne or Sir Robert Peel, for example – reaped a remarkable harvest.[12]

Many of George IV's pictures had illustrious provenances. Rembrandt's *Christ at the Tomb* (plate 166), bought from Lafontaine in 1819, had belonged to the Landgrave of Hesse and subsequently to the Empress Josephine; Rubens's *Landscape with St George* (plate 33) had belonged to the Duc de Richelieu before it passed into the Orléans collection with which it came over in 1792; the *Seven Persons playing a Game* by Schalcken had belonged to Louis XVI; the *modello* by Rubens for the *Assumption of the Virgin* (plate 167), bought at auction in 1816, had been in the Comte d'Orsay's collection; and some of the King's Dutch pictures had come from the Duc de Choiseul's collection, the most famous of all French pre-Revolutionary cabinets: for instance, Dou's *Hachis d'Oignons* and *Grocer's Shop* (plate 168). The former had belonged also to the Prince de Conti. Pictures from two of the greatest Dutch collections, Braamcamp and Gildemeester in Amsterdam, found their way to Carlton House; fine examples by Adriaen van de Velde, Potter, Cuyp (plate 169), Ter Borch (plate XXXIII) and Rembrandt (plate 170). One of the finest Teniers in the collection, the *Peasants Feasting and Dancing* (plate 171), had been painted for Charles I's son-in-law, William II of Orange; the King's two finest works by Rubens, the *Farm at Laeken* (plate XXX) and the *Portrait of a Woman* which arrived at Carlton House in 1821 and 1818 respectively, shared a splendid provenance from the Lunden family in Antwerp.

The formation of the collection as we know it today began at the turn of the century. Dealers such as Delahante and John Smith supplied pictures; others were bought at auction, where the bidding was often done by Lord Yarmouth (he succeeded as Third Marquess of Hertford in 1822) on the Prince's behalf. Twice in April 1812, for example, he was busy on the Prince's behalf at Christie's. After attending the sale of John Humble's pictures he sent a note to the Prince: 'I bought for your Royal Highness

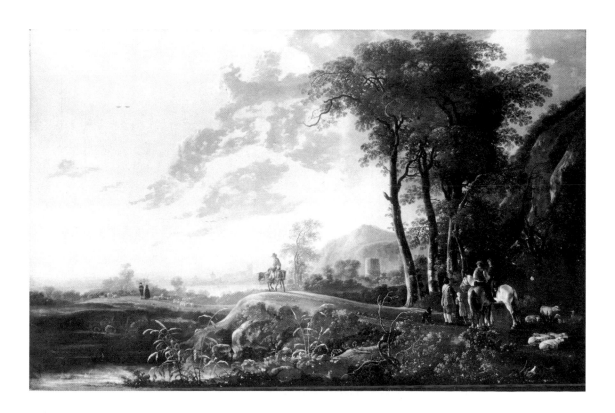

169 AELBERT CUYP
An Evening Landscape

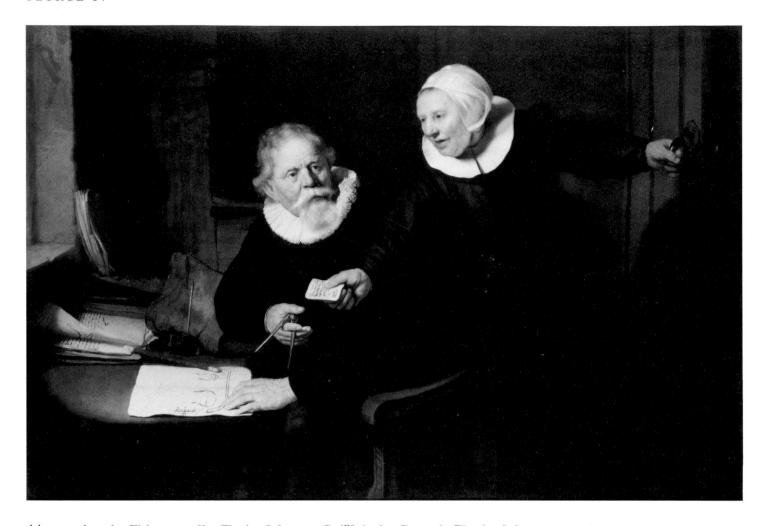

this morning the Fishermen [by Teniers] for 430 Guins & the Coup de Pistolet [plate 172] for 390 Guins – the Horse fair being by Peter not Philip Wouv:ns I left at 230, Lord Mulgrave bought it – I thought his Lordships bidder a puffer & having seen the picture sold last year by Phillips for Eighty I did not like to Treble the sum.' Later he reported that he had bought pictures for the Prince on 25 April 1812: 'I enclose the catalogue with the prices of some of the best pictures marked.'[13] Sir Charles Long (he became Lord Farnborough in 1820) was also associated with the formation of the collection, and the Prince had secured the professional services of William Seguier. He succeeded West as Surveyor, Cleaner and Repairer of the King's Pictures in March 1820, at an annual salary of £143, but had been consulted by the Prince earlier and employed on the pictures at Carlton House since at least 1818 before stepping officially into West's shoes. The thwarted and embittered Haydon regarded his influence as malign. Antiquaries like Balme or Kerrich were critical of Seguier's historical knowledge so far as the royal pictures were concerned ('he knows nothing of History and merely considers them as works of art'), but Seguier was a sensible man who knew a lot about pictures. He, and perhaps the cleaner George Simpson, must be given no little credit for the quality and state of preservation of George IV's pictures.[14]

The Prince's acquisitions early in the first decade of the century, at auction or from the trade, were of a fairly modest nature: pieces by Adriaen and Isack van Ostade, Schalcken, Eglon Hendrik van der Neer and a good *Breeze* by the younger Willem van de Velde. The Prince was never very interested in still-life (he got rid of a pair by Ruysch and gave away a pair by Van Huysum); but his love for military and sporting

170 REMBRANDT
Jan Rijcksen, the Shipbuilder, and his Wife

171 (right) DAVID TENIERS THE YOUNGER *Peasants Feasting and Dancing*

172 (below) PHILIPS WOUWERMAN *The Pistol-Shot*

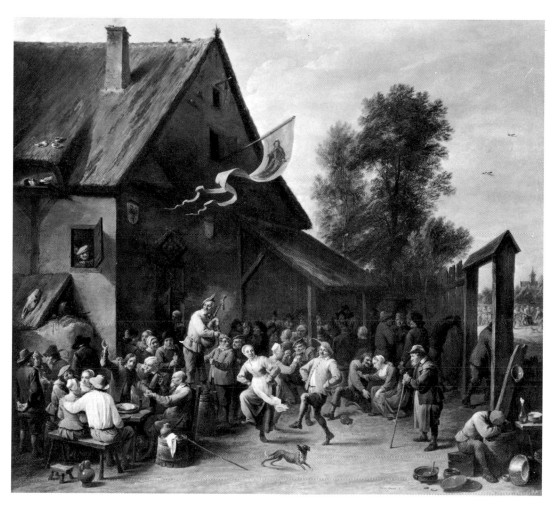

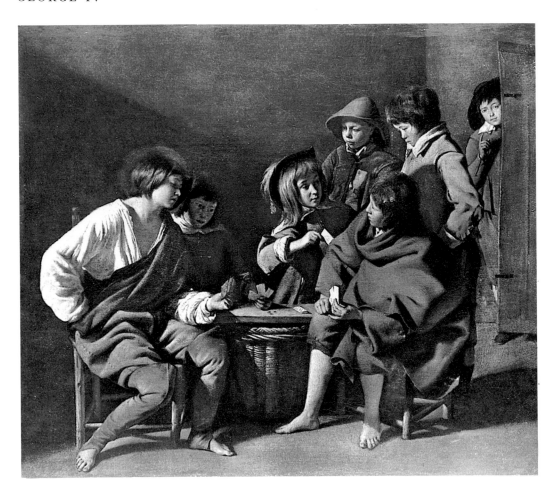

173 MATHIEU LE NAIN
The Young Gamblers

subjects may have prompted him to acquire, soon after the turn of the century, an early *Skirmish* by Wouwerman; a fine *Stag-Hunt* by Hackaert and Berchem (now in the National Gallery); a particularly Stubbs-like Cuyp, the *Trooper with a Grey Horse*; the magnificent *Negro Page* which had been bought at Lord Rendlesham's sale in 1806; the three pictures by Hondecoeter of Johann Ortt, his castle, his dogs and his horses, which had appeared at Christie's in 1802; or a set of horse-pieces by Parrocel bought from Colnaghi in 1808 and 1809. For sheer quality, one of the finest of the Prince's early purchases is the copper by Teniers, *Le Tambour Battant* (plate XXXI), which was bought for him by Phillips in the Walsh Porter sale at Christie's on 23 March 1803. So avid a collector of arms and armour would have enjoyed the virtuoso passage in the right foreground. In the same sale he secured the *Young Gamblers* by Mathieu Le Nain (plate 173), an interesting French essay in the type of subject-matter which he particularly liked. A persistent interest in the age of Louis XIV is evinced in the purchase of the canvas attributed to Van der Meulen of the building of Versailles; as early as 1799 he had bought from Cosway the vivid little picture of the funeral of Louis XIV; a good version of Philippe de Champaigne's full-length of Richelieu was presented by Lord Fife in 1819; and among George IV's latest purchases were panoramic views of Marly and Versailles with the French court hunting in the foregrounds.

The second decade of the century was the period of the Prince's keenest buying. One of the finest of his Dutch landscapes, Jacob van Ruisdael's *Windmill*, was bought in 1810. A superb group of sporting scenes – Wijnants's *Hawking Party*, the *Sportsmen* by Potter (plate 174) and Adriaen van de Velde's *Departure for the Chase* (plate XXXII) – were all bought early in the decade. The Potter was one of the five pictures bought from

William Harris for £2,625 on 7 February 1811; the others included two *Calms* by Willem van de Velde the Younger and Van der Heyden's *Approach to the Town of Veere* (plate 175). Later in the same year – an *annus mirabilis* in the history of the collection – a group of pictures was bought at the Lafontaine sale, among them good examples of Adriaen van de Velde and Wouwerman; the magnificent Italianate *Landscape with the Baptism of the Eunuch* by Both; the *Peasant Family* (plate XXXVI) by Adriaen van Ostade, which for quality is perhaps the finest of the genre scenes of this nature acquired by the Prince; and the first of his Rembrandts: *Jan Rijcksen, the Shipbuilder, and his Wife* (plate 170), a marvellous instance of the psychological intensity and dramatic invention in the portraits from Rembrandt's early years in Amsterdam.

The culmination of this surge of energetic collecting came in 1814, when the Prince acquired eighty-six pictures from the collection of Sir Thomas Baring. They arrived at Carlton House on 6 May 1814. A few were sent to be auctioned at Christie's,[15] but the purchase of this group of pictures of such remarkable quality was one of those

occasions which have from time to time transformed the appearance of the collection. Among examples by Teniers were two exceptionally fine little rocky landscapes, the *Interior of a Kitchen with an old Woman peeling Turnips* and the *Card-Players*, both exceedingly relevant for Wilkie; and the very fine *Peasants Dancing* of 1645 which had originally been designed as the lid of a harpsichord. The genre scenes include two more panels by Adriaen van Ostade; Jan Steen's *Twelfth Night Feast* (plate 176), in which the riotous atmosphere is muted by a colour scheme of exceptional subtlety; and the *Letter* (plate XXXIII) by Ter Borch, exquisite in its rendering of still-life and fabric, the scene suffused by an almost tangible atmosphere. Of the landscapes in the Baring purchase it is difficult to speak without repeated use of superlatives. Among the examples by Adriaen van de Velde is the enchanting little *Coast at Scheveningen* (plate 177); there is another superb Van der Heyden and two Hobbemas: the *Watermill* (plate 178) and the *Wooded Landscape*. In a particularly good selection of works by the Italianate landscape painters is a brilliant early example, the magic *Shepherds with their Flocks in a Landscape with Ruins* (plate 179) by Poelenburgh. From the second generation of the Italianate painters there is a group of Berchems, among them the late and rather romantic

175 JAN VAN DER HEYDEN
The Approach to the Town of Veere

176 (right) Jan Steen
A Twelfth Night Feast

177 (below)
Adriaen van de Velde
The Coast at Scheveningen

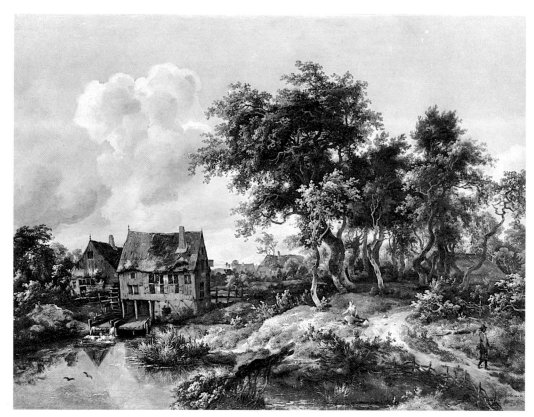

Mountainous Landscape and the exquisite *Italian Landscape* (plate XXXV), which seems to stand between Gainsborough and early Corot. Potter and Du Jardin were also well represented; there were also two superlative Cuyps, the *Evening Landscape* and the *Passage Boat*; a particularly good *Calm* by Van de Velde (plate 180); Metsu's *Self-Portrait* and good examples by Mieris and Van der Werff; and the *Self-Portrait* by Rembrandt.

Some acquisitions were made through exchanges. Rubens's *Landscape with St George* was offered to the Prince by William Harris in May 1814 at £2,700. Harris received £500 in cash; and the balance was made up with two Van Huysums from the Baring collection, a Teniers and an Adriaen van Ostade which he himself had sold to the Prince earlier. To secure Wouwerman's *Horse-Fair* and Dou's *Carpenter's Wife*, the Prince sold to the French dealer Lafontaine in July 1819 eight lesser pictures, among them the *Stag-Hunt* by Hackaert and Berchem. At the end of the year Jutsham received from the Custom House three pictures that Lafontaine was offering to the Prince. He only wanted one, the profoundly beautiful Rembrandt of *Christ and the Magdalen at the Tomb*, and offered in exchange two *Calms* by Van de Velde (e.g., plate 180), an *Alchemist* by Teniers and an alleged Massys.[16]

Of pictures offered to George IV but not eventually acquired, two are especially to be regretted. Between 10 October 1816, when Lawrence delivered it to Carlton House, and 25 April 1818, when it was sent back to him, no less a picture than Jan van Eyck's *Marriage of Giovanni Arnolfini* was in the Middle Attic at Carlton House: '. . . in a Gilt Frame . . . sent for The Regent's inspection . . . by John Van Heyk – the person who first discovered the art of Painting in Oil Colours'.[17] Early in 1823 Rubens's *Chapeau de Paille* was at Carlton House for a fortnight. The King was 'greatly delighted' with the picture and anxious to buy it, but was advised that the price, some three thousand guineas, was too high; an attempt to effect a part-exchange came to nothing as the pictures offered were not good enough.[18]

179 CORNELIS
VAN POELENBURGH *Shepherds
with their Flocks in a Landscape
with Ruins*

180 WILLEM VAN DE VELDE
THE YOUNGER *Ships in a Calm*

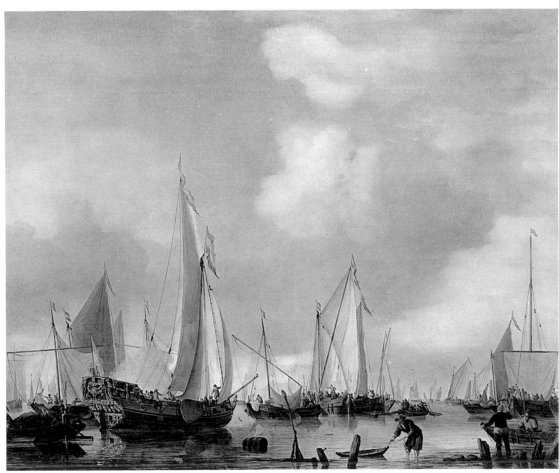

After the great wave of purchases at the time of Waterloo, the Prince bought selectively and not *en bloc*: only 'certain works which the collection at Carlton House actually wanted'. From the Aynard collection, for example, which (or so Buchanan told Long in 1819) could be acquired for him, he bought only Rubens's *Farm at Laeken*. After Lawrence and Bryan had finished their catalogue of the pictures at Carlton House, Jutsham kept it up to date by inserting the pictures bought in the next few years, among them: Greuze's *Le Silence*, the *Interior of a Tavern* by Steen, and the *Grocer's Shop* by Dou for which the Prince paid Thomas Thompson Martin a thousand guineas in June 1817. In the summer of 1819 the purchases included the *Horse Fair* by Wouwerman, and the Prince's most beautiful Rembrandt: *Agatha Bas*, 'the Lady with a Fan' (frontispiece). It is a significant commentary on the remarkable popularity of Gerard Dou at this period that the Prince paid less for this Rembrandt than for the *Grocer's Shop*. A beautifully preserved Flemish conversation-piece of the Anthoine family by Coques (plate 181) was bought in 1826. In 1811 he had acquired Van Dyck's *Christ healing the Paralytic*; in 1821 the artist's *Mystic Marriage of St Catherine* arrived at Carlton House; in 1822 the King eventually secured, for a thousand guineas, the celebrated portrait of Charles I in three positions (plate XXXIV), which had been on the market for nearly twenty years and, since 1809, 'expressly designated' for the Prince's collection. All this time less important pictures, many of a sporting, historical (especially French), domestic or family flavour, were being acquired; in 1828, for example, Lord Ravensworth gave the King Hieronymus Janssens's intriguing picture of the ball at The Hague on the eve of Charles II's Restoration. In July 1821 the King bought from Delahante a sparkling, immaculately preserved Jan Steen, the *Morning Toilet* (plate XXXVII) of 1663; in 1825 he acquired the great *Card-Players* (plate 182) by De Hooch. The other masterpiece from De Hooch's best period, the *Courtyard in Delft*,

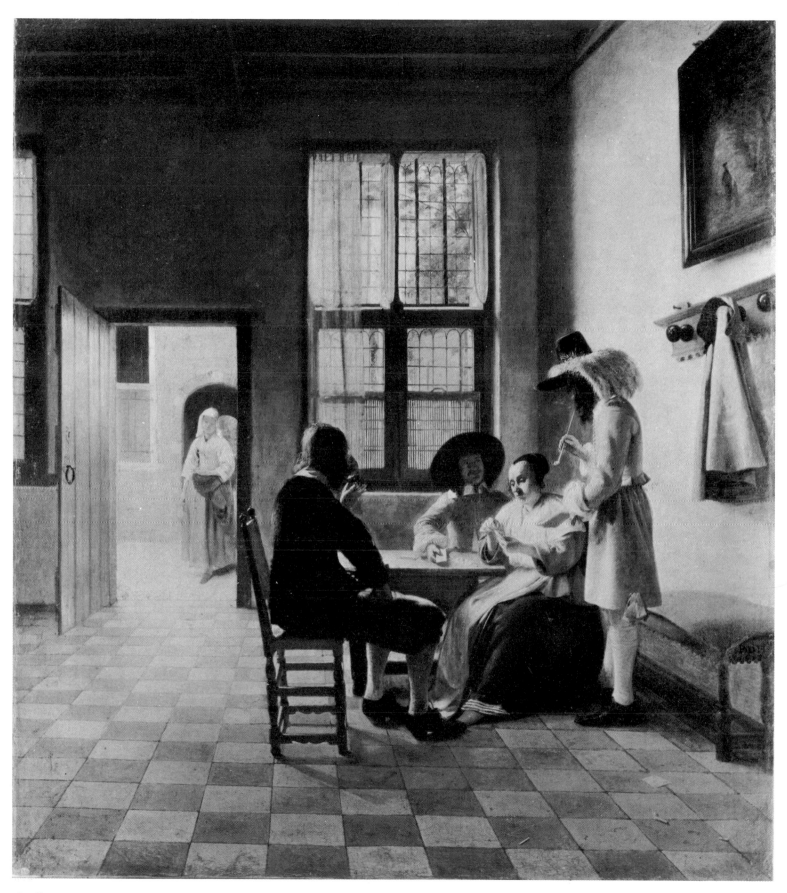

182 Pieter de Hooch
The Card-Players

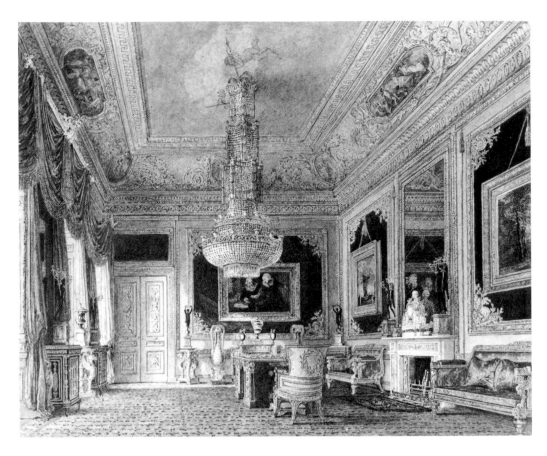

183 C. WILD *The Blue Velvet Room, Carlton House*

was one of his last purchases, acquired from Seguier in May 1829. In the same month he bought perhaps his most beautiful picture, the *Rape of Europa* by Claude (plate XXXVIII), for which Seguier bid £2,100 at Lord Gwydir's sale at Christie's. Affection for the memory of his brother, the Duke of York, led him to buy pictures at the dispersal of his possessions at Christie's in April 1827.

From the pages of the catalogue by Lawrence and Bryan and the watercolours by Wild[19] one gains a clear impression of the splendour of Carlton House in its prime. The West Ante-Room was hung with royal full-lengths, some of which were severely damaged in a fire on the night of 8 June 1824. Reynolds's magnificent full-length of the Duke of Orléans was a principal sufferer; and a Highmore of George II, hanging over one of the doors, was wholly destroyed.[20] In the Crimson Drawing-Room fine portraits by Lawrence and Reynolds hung near the *Landscape with St George*; and royal full-lengths by Ramsay, Hoppner and Reynolds hung in the Ante-Chamber or old Throne Room. The Bow Room or Rose Satin Drawing-Room, in the centre of the south front on the principal floor, overlooking the garden, contained a rich display of smaller Flemish and Dutch pictures, among them Rubens's *Self-Portrait* and his portrait of Van Dyck, which are among the few pieces taken by George IV from the royal collection before his accession. The South Ante-Room, dividing the private from the state apartments, was principally hung with Beechey's portraits of his sisters, a likeness of Madame de Pompadour, and two full-length Van Dycks. In the Blue Velvet Room (plate 183), the private audience chamber, hung the Both, Cuyp's *Evening Landscape*, Van Dyck's *Christ Healing the Paralytic*, and, in the place of honour on the West Wall, Rembrandt's *Shipbuilder*. The Blue Velvet Closet contained more fine Dutch pictures; and the sequence of rooms on the ground floor ended with the East Ante-Room, entirely hung with portraits by Hoppner. In the superbly decorated lower rooms were some of the finest smaller Dutch and Flemish pictures. There was never so lustrous a range of rooms at any other stage in the history of the collection: 'the splendour of the

184 DOUGLAS MORISON
The Picture Gallery,
Buckingham Palace

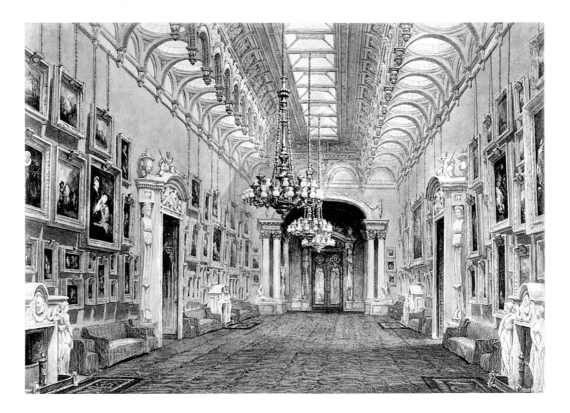

furniture at Carlton House is so great that let the company who go there be ever so finely dressed they are not seen, the eyes of all being drawn off by the gorgeous decorations of the apartments.' Many pictures were kept on the attic floor. The Prince's bedroom was hung with his collection of elaborately-framed enamel copies by Bone after well-known pictures by Reynolds, Hoppner, Beechey, Opie and Italian old masters such as Correggio, Annibale Carracci, Parmigianino and Domenichino.

Nevertheless, the Prince Regent was dissatisfied with Carlton House and hoped, on his mother's death, to remove to Buckingham House. He was still living at Carlton House in 1822, but when authority was given to rebuild Buckingham House its days were numbered. By the autumn of 1828 the house had been gutted: 'The whole collection of Pictures the Private property of His Late Majesty' was deposited in store at 105 Pall Mall, where, under difficult conditions, Waagen saw them in the summer of 1835.[21]

Waagen concluded his account of the late King's pictures with the sententious wish that the new King would present them to the National Gallery. As early as 1822 it was being said that George IV had promised to contribute to the projected National Gallery his collection at Carlton House and a selection from elsewhere; in 1826 the rumour was still alive. The new Picture Gallery at Buckingham Palace was unfinished when the King died. Seguier, asked to report on the Gallery, stated on 23 June 1831 that 'the Picture Gallery in the New Palace St James's Park' was 'from its noble dimensions, admirably adapted to hold His Majesty's valuable collection of Pictures'. Nash met an objection to the method of lighting by citing the approbation of Lawrence whom he had consulted.[22] Seguier was presumably responsible for putting the pictures up in the Gallery; the collection was being removed to the Palace from Pall Mall in the spring of 1836. One sees them tightly packed, and almost all uniformly framed, in Douglas Morison's watercolour (plate 184): a collective monument to the taste of the old King. There was above all (to some extent there still is) a demonstration in the Picture

Gallery of the qualities he and his contemporaries had admired in certain Dutch and Flemish painters: 'the brilliancy, force and harmony of colouring, the truth of character and expression, and the wonderful facility and power of execution'. When the British Institution put on, in 1826, their second showing of the King's Dutch and Flemish pictures, some works by Reynolds were included among them:[23] 'such as fully to justify the eminent station in which he is placed among the professors of the Art of Painting'. In the Picture Gallery at Buckingham Palace the same honourable juxtaposition was effected with the *Self-Portrait*, *Cymon and Iphigenia* and the *Death of Dido*. Zoffany's *Tribuna* and *Academicians* and Wilkie's *Entrance of George IV* were added to the company. By 1841, when Seguier published his little *Catalogue* of the pictures in the Palace, no less than 185 pictures were crammed into the Gallery, a few having been brought in by Queen Victoria and Prince Albert.[24] A number of portraits had by that date also been fitted up in the adjoining rooms, Throne Room, Dining-Room and the Large, Yellow and Green Drawing-Rooms. In principle these arrangements have survived, with some modifications, to the present time.

It is a saddening thought that for the last years of his life George IV, restless, unhappy and unloved, was unable to enjoy the Carlton House pictures on which so much had been lavished; but at Windsor, in the King's (or Royal) Lodge as well as in the Castle itself, the King was able to deploy favourite pictures to advantage. The King's Lodge received the genre scenes by Bird, Wilkie, Collins and Mulready and many of the sporting pictures: on 31 May 1822, for instance, seventeen of the pictures by Stubbs were sent down to the Lodge. The sequence of state portraits, set high into the north wall of St George's Hall, was planned by George IV and culminated in a version of his own image by Lawrence. More important was the opportunity offered for a splendid display of pictures, furniture and sculpture in Sir Jeffry Wyatville's new Corridor

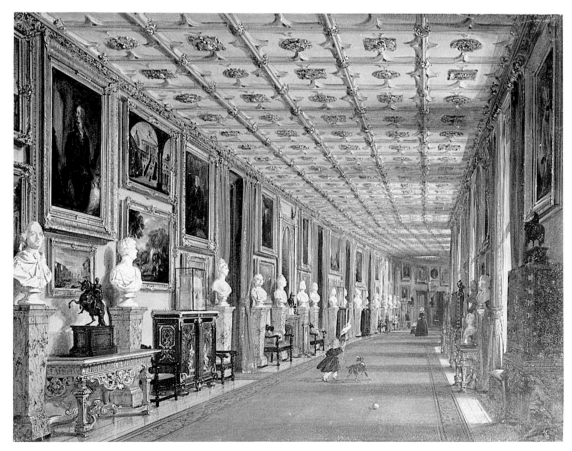

185 JOSEPH NASH
The Corridor, Windsor Castle

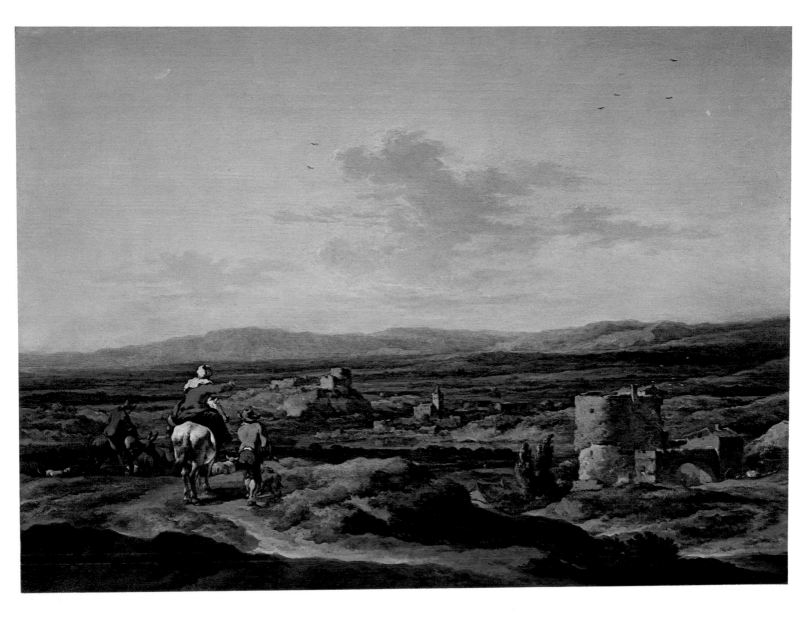

XXXV NICOLAES BERCHEM
*An Italian Landscape with Ruins
and Figures* (see page 154)

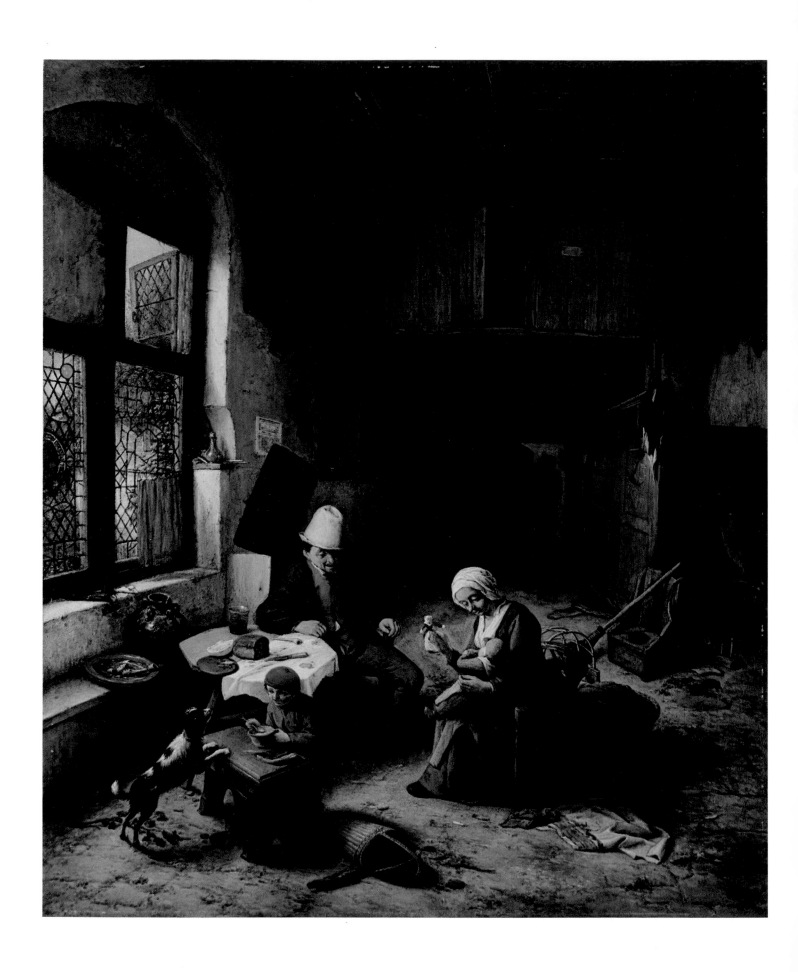

XXXVI ADRIAEN VAN OSTADE
A Peasant Family at Home (see page 151)

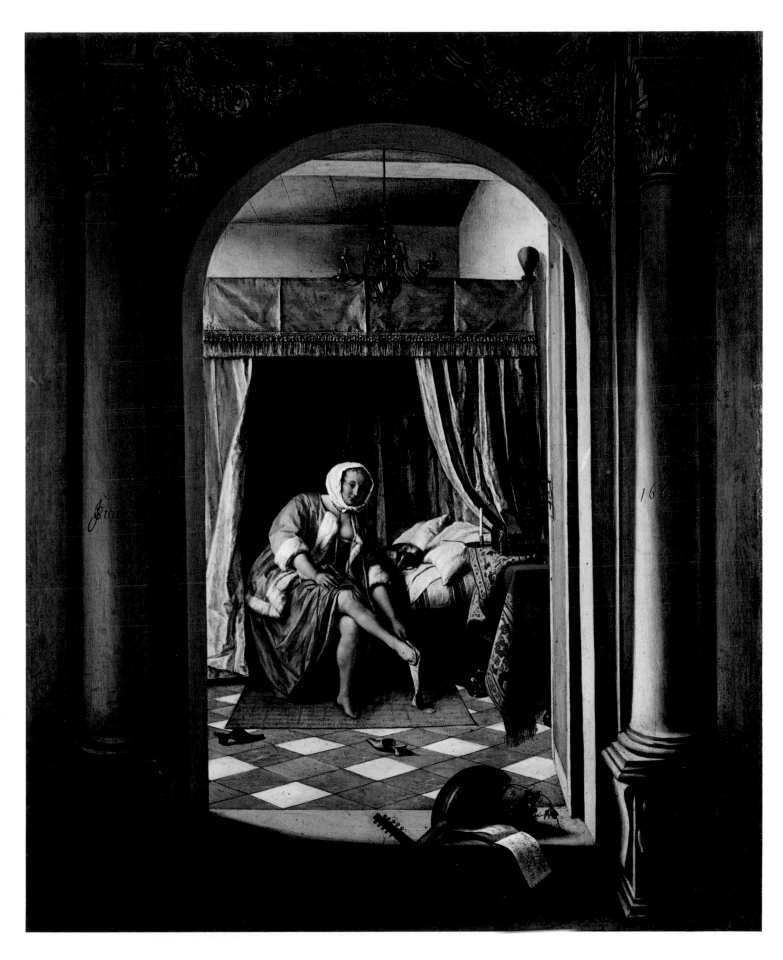

XXXVII JAN STEEN *The Morning Toilet* (see page 156)

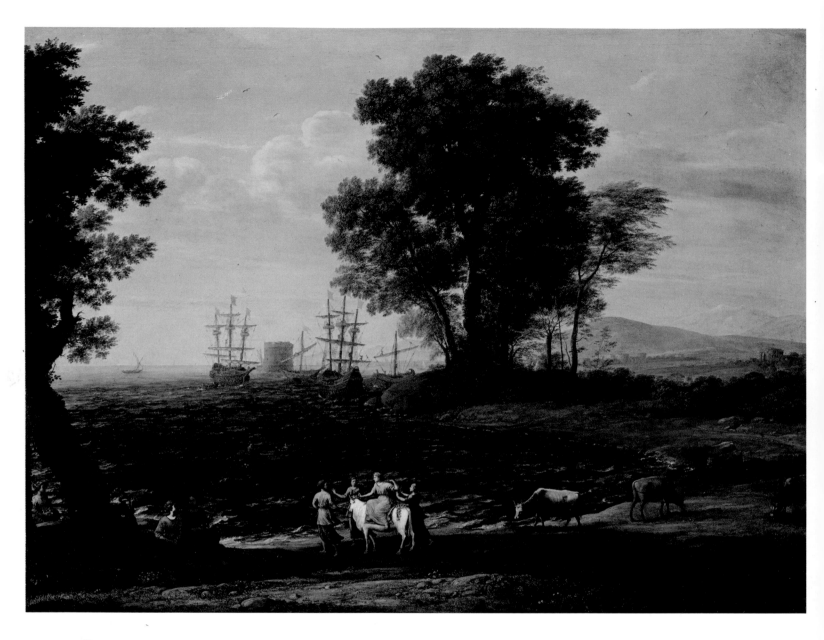

XXXVIII CLAUDE
The Rape of Europa
(see page 158)

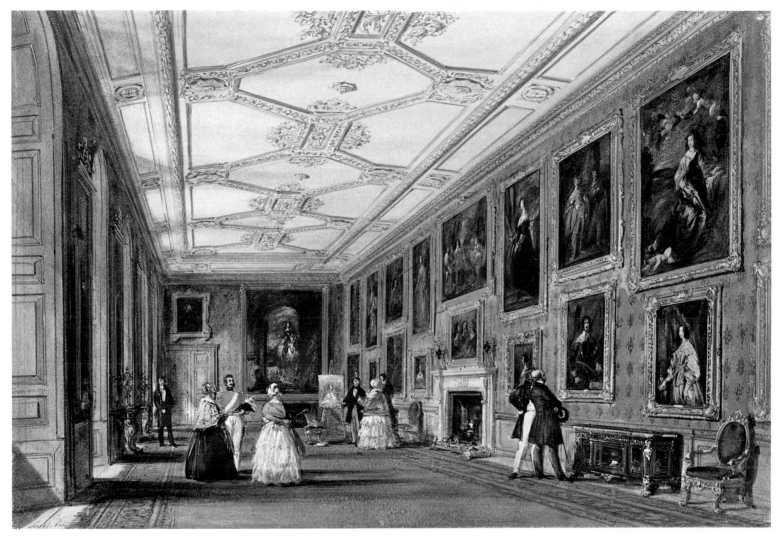

186 JOSEPH NASH
The Van Dyck Room, Windsor Castle

(plate 185) on the east and south sides of the Quadrangle. In the autumn of 1828 Wilkie and Sir Francis Chantrey spent two days at Windsor helping the King arrange pictures and busts. The type of pictures chosen – some of the best English portraits by Hoppner, Gainsborough and Lawrence, a large number of views by Canaletto, landscapes by Zuccarelli, military and sporting scenes by De Loutherbourg and Wootton – set a pattern which has been little altered and which still makes the Corridor one of the most delightful displays in the royal collection, especially after dark, when it is lit only from the lights above the pictures. The Consul Smith frames were enriched and enlarged by Crouzet to give them more weight.[25] Slightly later, in the reign of William IV, two rooms in the old state apartments were arranged in an appropriate gesture of homage to two painters for whom George IV had had particular affection; in June 1835 Waagen found them not quite completed. The old King's Drawing-Room became the Rubens Room, and the Ball Room became the Van Dyck Room. They can be seen, soon after they had been completed, in Joseph Nash's watercolours (plate 186); the dispositions survived until the Second World War, but the original nomenclature has been revived.

There is, in the history of the collection, an inevitable anti-climax in the reign of William IV. He had little feeling for painting; he was as philistine as George II and took pleasure in being offensive to painters. His principal interest, so far as pictures were concerned, lay in marine subjects and portraits of Mrs Jordan. He commissioned R. B. Davis to paint his Coronation procession and he employed William Huggins and

Clarkson Stanfield. He added portraits by Pickersgill and Shee (who painted the most successful portraits of himself and his Queen) to the Waterloo Chamber and sat at Brighton to Wilkie for the full-length which was to join his father and brothers on the north wall. The kindly Queen Adelaide encouraged the young George Chambers and her disbursements include payments to Beechey and Lucas and to such miniaturists as Anthony Stewart and Ross. In 1835 she paid Edwin Landseer £78 15s for a picture of 'Prince George's Horse'.[26] The King hated Buckingham Palace and did not want to leave St James's. A new scheme for St James's, put forward by Wyatville, had included a Picture Gallery extending southwards towards the Mall. Accompanied by a note dated 1 November 1834, a plan at Windsor bears the inscription: 'Commanded me to ask Mr Seguier for the quantity of space required for His Majesty's Pictures'. To the beauty of a picture William IV was apparently impervious. When he was shown one which George IV had particularly admired, he made the famous remark: 'Ay, it seems pretty – I daresay it is – my brother was very fond of this sort of nicknackery. Damned expensive taste though.'[27] Perhaps George IV's most potent legacy had been a dread of the consequences of such improvidence as he had shown; certainly one senses in the annals of the collection, for about a hundred years after his time, that it was thought unnecessary, in an odd way improper, to spend a lot of money on pictures or on their conservation. A complete change of taste, too, is signalled in a conversation between Melbourne and the young Queen Victoria on 31 July 1839, when they talked 'of the beautiful pictures in the Gallery here . . . of their being all Dutch, which we agreed was a low style; our preferring the Italian Masters'.

8

QUEEN VICTORIA AND PRINCE ALBERT

QUEEN VICTORIA WAS BORN in the lifetime of Benjamin West. When she died, Henry Moore was within sight of his third birthday. It is not surprising that her personality should still be so strongly felt in so many parts of the royal collection or that we should still be surrounded by so much of what she and the Prince Consort accomplished. She was born with the high spirits and strong emotions of her father's generation; but her father and George IV had hated each other 'most sincerely'; the old King had disliked her beloved uncle Leopold; and she regarded George IV's vast possessions with awe mingled with envy, and with a horror of the extravagance of which they were the spoils. On one occasion she spoke with Lord Melbourne about the immense amount of money being spent in the full Regency spirit on furniture and pictures by the Duke of Sutherland and 'about my wishing, but fearing, to buy pictures'.[1] As late as 1847 she maintained that she was not rich enough to buy the large English historical pictures she particularly liked. She was interested from childhood in the techniques of painting, drawing and (later) etching. She reacted swiftly and with enthusiasm to anything she saw. The Journal of her girlhood is full of visits to country houses, regular visits to the Royal Academy and the British Institution, sittings to artists; she loved to be given pictures or drawings and after her marriage works of art of all kinds provided her with much pleasure. She and Prince Albert delighted in giving each other, on their birthdays or at Christmas, surprises for their collections.

Before her marriage she talked a great deal about pictures and painters with Melbourne. Amusing, unkind and superficial, his comments on contemporary painters had inevitably a greater effect than they should have done on an admiring and uninformed girl. A wiser and better-educated counsellor could have brought out in the Queen a surer judgment and better taste. When she visited an exhibition of Old Masters at the British Gallery on 3 August 1836 she was overwhelmed. 'Never did I see anything more beautiful than this collection of the *Immortal Masters'* paintings, for so I must call them as their names will never pass away.' The artists she most admired were Murillo and Guido Reni and she especially liked the Murillos which the Duke of Sutherland had bought the year before from Marshal Soult. But when she mentioned Murillo to Melbourne he wrote him off as 'low', describing the angels in the Duke's *Abraham and the Angels* as 'more like shepherd boys than Angels'.[2] She was of course

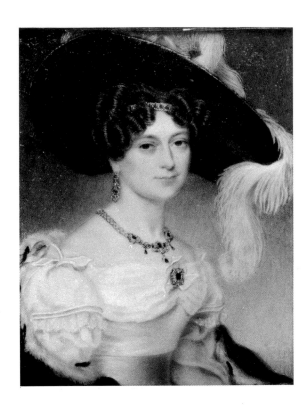

fascinated by his reminiscences of George III, Reynolds and West. Gainsborough, he told her, was 'a great artist, both in Landscape and Portrait'. He liked her having put up the oval portraits of the old royal family so that surviving members could see them: 'he said, with tears in his eyes: "It's a very good thing having those pictures; it makes a great impression upon old People, who always think they are forgotten, as they generally are".' Haydon's *Mock Election* struck them as 'being clever, but the colouring not English'. They talked about her Cosway of Lord Melbourne's mother ('the same fine forehead – the same nose – mouth and chin, in fact quite the same cut features . . .');[3] and she was enchanted when, in 1841, he unearthed and gave to her the portrait Hoppner had begun of him in Montem dress at Eton forty-five years earlier. While she was talking to Melbourne about Gainsborough and Haydon, Prince Albert was in Italy. 'I am often quite intoxicated with delight', he wrote from Florence, 'when I come out of one of the galleries'; and later: 'my range of observation has been doubled, and my power of forming a right judgment will be much increased by having seen for myself.'[4]

After their marriage, the Prince, serious, well-educated, orderly in all things, immediately replaced Melbourne as the one to whom she would unswervingly look for guidance in artistic matters. Together they devoted an immense amount of time and thought to the inherited collections. Many of the happiest hours they spent together were employed in putting drawings, prints and miniatures in order; and she venerated all that the Prince had done for the pictures. Between them they acquired or commissioned many pictures: a few were good; hundreds were repetitive, indifferent or worse; and a handful were masterpieces of rare quality and great significance. Yet, with their resources and enthusiasm, one feels they could have achieved much more. Their patronage of contemporary painters was narrow and prejudiced: the Queen could be moved to enthusiasm by intricacy, high finish, proper feeling, a facile display with brush or pencil, a pleasing story, or by a fetching likeness to a child or favourite dog; the Prince, governed by his intellect, was seldom stirred by the sheer beauty of paint or by works of imagination. Perhaps he too, in a much subtler way,

inhibited, as Melbourne did, a natural flowering of connoisseurship in the Queen: a taste for good pictures which their eldest son also might have developed, as opposed to the Prince's intellectual, almost art-historical, attitude which influenced his eldest daughter. Nevertheless, the painters they liked found the Queen and Prince delightful to deal with. Frith remarked that 'they knew quite as much about art as most painters; and . . . their treatment of artists displayed a generous kindness delightful to experience'. This kindness makes a contrast with Melbourne's caustic lack of charity.

The Queen set aside, soon after her marriage, an annual £2,000 to be spent on works of art for herself; a special allocation of £300 was made for miniatures. Only as she neared the end of her life did the Queen's attitude towards the arts become rather thrifty and unimaginative. No period in the history of the collection is so richly documented. Expenditure and accessions were carefully recorded by the Queen. The first acquisitions noted in the Queen's Catalogue[5] were miniatures: a little view of Ischia by her uncle Leopold I, King of the Belgians, and given by him in 1827; and portraits of her parents – her mother by Henry Collen (plate 187) and her father by Johann Fischer. They mark the beginnings of a collection of family portrait-miniatures which was to become overwhelmingly complete. As a child the Queen had been painted by Fischer (plate 188) and Anthony Stewart, who had probably been a protégé of Sir John Conroy and had painted portraits of the Queen's beloved half-brother and

188 J. G. P. FISCHER
Princess (later Queen) Victoria

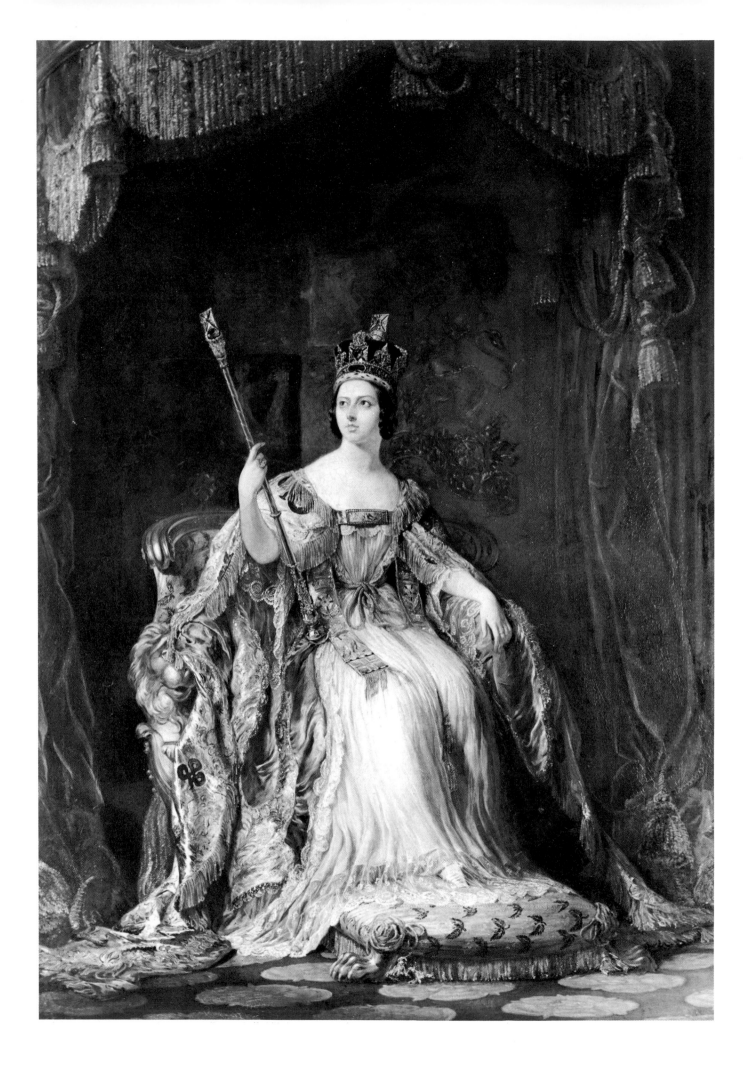

half-sister. In 1830 the King of the Belgians gave her his portrait in miniature by George Hayter 'in the Armour of the Black Prince'. Hayter had worked as early as 1816 for Leopold, on whose advice the Duke and Duchess of Kent also patronized George Dawe. The earliest important portrait of the little Princess Victoria was painted in 1830 by Richard Westall, 'my poor old worthy drawing-master' (her mother left it to her in 1861); in 1833 she was sitting to Hayter for a full-length for the King of the Belgians: the portrait with the little spaniel, 'sweet Dash'. The portrait was burnt in the fire at Laeken but the *modello* was bought by the Queen in 1871. In 1834 the Princess was given by her mother on her birthday Hayter's big full-length of the Duchess with Dash which was ultimately set up on the Staircase at Buckingham Palace; and on 7 July she visited the artist's house where she thought all his pictures 'beautifully painted and very like'. She was particularly struck by his *Circassian Women sold to Brigands*;[6] and the impression made by his picture of the House of Commons encouraged her ultimately to commission from him not only her state portrait (plate 189) but also large canvases of her Coronation, her marriage and the Christening of her eldest son, and to appoint him, after her accession 'my "Painter of History and Portrait".' She was obviously pleased with the head of herself in the marriage picture and ordered numerous copies of it in miniature which could be set in bracelets and given to her most valued friends. The taking of the Sacrament at the Coronation was, however, recorded by C. R. Leslie, who was rewarded for his success (the Queen thought the picture 'lovely' and the likeness of Melbourne in it 'quite perfect') with the commission to paint the *Christening of the Princess Royal* (plate 190). Before her marriage the artists' progress on these complex designs provided the Queen with endless pleasure and was frequently discussed with Melbourne who told her he thought Leslie 'far superior to Hayter' and 'the only painter in this country now, for taste'. She liked Wilkie's late subject-pictures. His painting of her First Council, the earliest in a succession of painted records of ceremonial occasions in her long reign, had at first pleased her, but she came to detest it: 'one of the worst pictures I have ever seen, both as

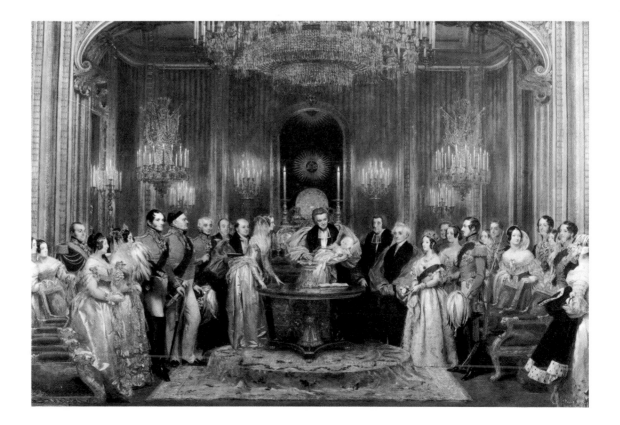

191 (left) SIR EDWIN
LANDSEER *Dash*

192 (below) SIR FRANCIS
GRANT *Queen Victoria with
Lord Melbourne, the Marquess of
Conyngham and others*

193 (right) SIR WILLIAM
CHARLES ROSS *Princess Feodora
of Hohenlohe-Langenburg*

194 (far right) SIR WILLIAM
CHARLES ROSS *Prince Albert*

to painting & likenesses'. The state portrait Wilkie exhibited at the Royal Academy she thought 'atrocious'; it confirmed Melbourne's view that Wilkie 'never could paint portraits'.

Apart from the miniaturists and Westall, whose *Wild Huntsman* was given to her in 1834, the first painter whose works were acquired by Princess Victoria was the animal painter George Morley. In 1832 and 1833 she was given by her mother pictures of favourite horses and ponies: Tommy, Huntly, Fanny, Rosa and Bruno. Morley also painted a number of dogs, but in 1836 the Duchess of Kent gave her daughter as a birthday present her first picture by Landseer, the portrait of Dash (plate 191): 'most beautifully painted . . . extremely like'.[7] Late in 1837 she commissioned from Landseer the large composition – which she thought 'exquisitely painted' – of three dogs, Hector, Nero and the inevitable Dash, with the Lory given to her by her uncle Ernest. Landseer showed her a sketch for it on 24 November; she found him 'an unassuming, pleasing and very young looking man, with fair hair'.[8] In 1839 she acquired his *Isaac van Amburgh with his Animals* as a record of a performance she had seen at least five times. In 1839 she bought two '*beautiful*' pieces by Daniel Maclise, the *Scene from the Burletta of Midas* and the *Second Adventure of Gil Blas*. The year before she had thought his exhibited works 'wonderfully clever'. In the sporting vein, the most successful commission from this period was to Francis Grant for the equestrian group (plate 192) of the Queen attended by Lord Melbourne and Lord Conyngham. When she began to sit to Grant she found him 'very good looking and gentlemanlike'.

Among portrait painters the most lavishly patronized at this period was, quite rightly, the miniaturist William Charles Ross. He had painted a miniature of the Queen in 1837 as a present for the Princess of Leiningen and thereafter painted many portraits, remarkable for their charm, freshness and sincerity, of the Queen's family (plate 193) and friends. In November 1839 he painted his first likeness of Prince Albert (plate 194) which 'is now and always standing before me. It is quite a speaking likeness and is my delight'.[9] To the Prince she gave a little sketch of herself by Landseer.

In 1842, as if to acknowledge the services of the two painters whom she had most generously patronized before her marriage, she knighted both Hayter and 'Good Ross', although as early as 1837 she had thought Landseer 'certainly the cleverest artist there is'. She admired his speed and skill; the little sketch of her on horseback (plate 195), done perhaps before the formal sittings in a black velvet habit and mounted on Leopold, is the most beautifully painted of the portraits before her marriage; but she had realized by then that Landseer was not good at getting likenesses and had other problems too. He was idle and never sent in his bill.[10]

The marriage to Prince Albert revived the Coburg influence on the Queen's tastes, an influence felt at once in the choice of portrait painters. In 1836 the Queen had been shown by John Partridge some portraits he had painted in Brussels of the Belgian royal family and in 1840 she and the Prince (plate 196) began to sit to him for the portraits eventually shown at the Royal Academy in 1842. Her own portrait she thought 'very good and like', but within a few weeks she, the Prince and their eldest child were sitting

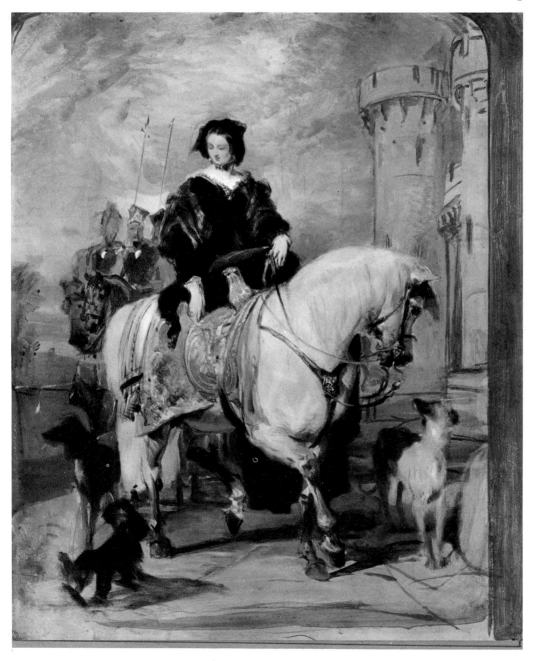

195 SIR EDWIN LANDSEER
Queen Victoria

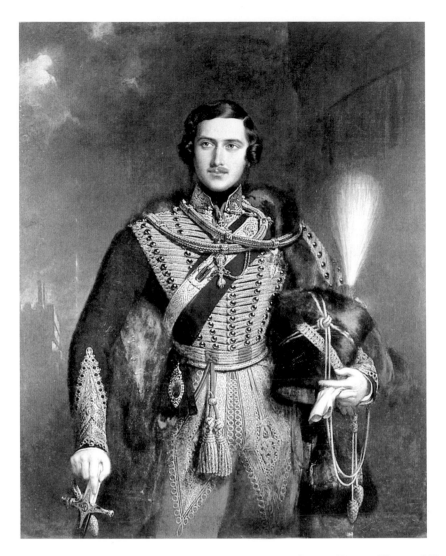

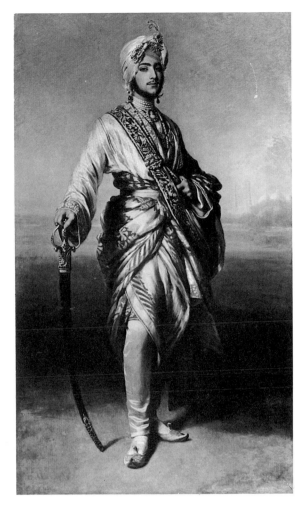

196 (left) JOHN PARTRIDGE
Prince Albert

197 (right)
F. X. WINTERHALTER
The Maharajah Duleep Singh

to a new painter, Franz Xaver Winterhalter. He, too, had worked earlier for the Belgian relations. In December 1838 the Queen of the Belgians had sent over the portrait of herself with the little Duke of Brabant: 'quite lovely, so like her, and beautifully painted (in oils) by a German painter called Winterhalter'.[11] The new portraits were obviously better than Partridge's. In the Queen's eyes, the portrait of herself was 'very fine' and the likeness perfect, that of the Prince '*such* a beautiful picture'; one sitting took place with the Queen watching and her band practising 'that beautiful new Symphony by Mendelssohn'. When finished the new portraits were placed in the panelling of the White Drawing-Room at Windsor.[12] From that point onwards, for nearly twenty years, Winterhalter was extensively patronized by the Queen, painting for her a huge number of pictures – there are still well over a hundred in the collection today – of themselves, their children (e.g., plate XXXIX), of relations abroad and of friends and visitors (e.g., plate 197) at home, on a scale which varies from large groups to sketch-like studies. The royal images were copiously reproduced (the pair of 1842 were being copied almost at once); heads from the large groups were likewise copied repeatedly and made available in a smaller format. Winterhalter's more formal portraits are perhaps the last convincing presentations in the grand manner; certainly the multiplication and distribution of the types he evolved provide a classic instance of the organization of a portrait factory in the tradition which goes back to the Tudors. The Queen was constant in her admiration for the work of 'excellent, delightful Winterhalter'. She thought them beautifully painted, wonderful as likenesses and 'so cleverly managed' as to the backgrounds. She was certain that

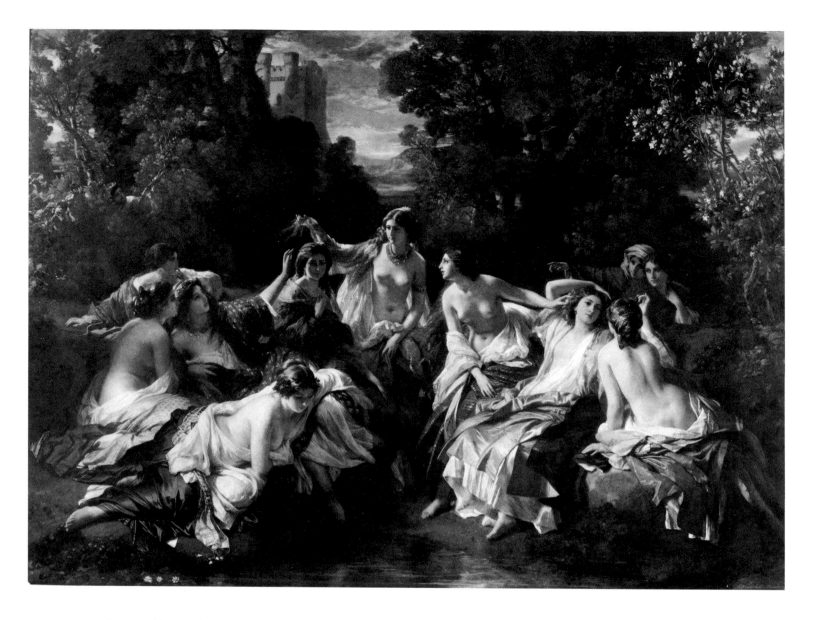

posterity would put him in the same class as Van Dyck. The large family group of 1846 she considered 'a *chef d'œuvre*, like a Paul Veronese – such beautiful, brilliant fresh colouring'.[13] The most important pictures Winterhalter painted for them afterwards were the *First of May*, for which the Prince, 'with his wonderful knowledge & taste', had given the painter the idea; and the 'most lovely' *Florinda* (plate 198) which the Queen bought for the Prince's birthday[14] and which was put up in her Sitting-Room at Osborne.

In the summer of 1851 Winterhalter was still in trouble with the *First of May* (he was also giving the Queen lessons in painting); Landseer had got stuck with the Queen's countenance in a large group. Winterhalter attended a sitting given to Landseer on 8 July and helped him get it 'into right drawing & proportions. It is delightful to see 2 such great artists, so devoid of jealousy & so ready to aid one another.'[15] Landseer's conversation-piece, *Windsor Castle in Modern Times* (plate XL), is in the tradition of Zoffany's dressing-table picture. Finished in 1845 when the Queen paid £840 for it, and hung up in the Sitting-Room at Windsor, it had been started in 1840: 'the dogs & game are exquisitely painted; the portraits of the former are so like & lifelike'.[16] Like Winterhalter, Landseer's portraits of his royal patrons included them

172

in fancy dress. His facility, and his sympathy in painting dogs, never failed to delight the Queen.

A picture such as the *Sanctuary* (plate 199), given by the Queen to the Prince in 1842, illustrates one aspect of the fascination exerted by the Scottish Highlands. In 1850, at Balmoral, Landseer was planning and making sketches for a huge design, *Royal Sports on Hill and Loch*. An oil sketch and a number of drawings survive for what was to be, in the Queen's words, 'a beautiful historical exemplification of peaceful times, & of the indepedent life we lead in the dear Highlands'.[17] As with the Windsor scene, the Queen and the Prince eagerly followed the progress of the picture and of the preparatory drawings. The ghillies were made to look like the Apostles (Landseer himself likened Macdonald to a Giorgione); the agony in the faces of the dead stags is reminiscent of heads of Saints being torn apart in the more violent altarpieces of the Counter-Reformation. The Queen's final addition to her large collection of Landseer's work was his very late and remarkable *Baptismal Font* (plate 200). When she heard of the peaceful death of 'the great artist & kind old friend' she realized it was 'a merciful release'.[18]

Other animal painters were, of course, employed by the Queen and the Prince; Joy, Morley, J. F. Herring (plate 201), Keyl, C. Burton Barber, Gourlay Steel and Thomas Sidney Cooper (plate 202) painted for them dogs, horses and farm animals. Their favourite parts of the world were painted for them, in oils, by James Giles, August Becker and Peter Graham.[19]

The excessive amount of patronage given to Winterhalter and Landseer over-shadows such encouragement as the Queen and Prince Albert gave to other contemporary British artists. Their tastes were conventional. To paint the frescoes in their Garden Pavilion at Buckingham Palace they commissioned the artists most in fashion: Stanfield, Uwins, Leslie, Ross, Eastlake, Landseer and Etty. They showed, apparently, no interest in Turner or the Pre-Raphaelites; King George V was to assert that his grandmother had always averred that Turner was mad. Turner, however, may have hoped for royal patronage. In the autumn of 1840 he had made a special detour to Coburg on his return from Venice and at the Royal Academy in the following year he exhibited (No. 541) a view of Schloss Rosenau as 'seat of H.R.H. Prince Albert of

199 SIR EDWIN LANDSEER
The Sanctuary

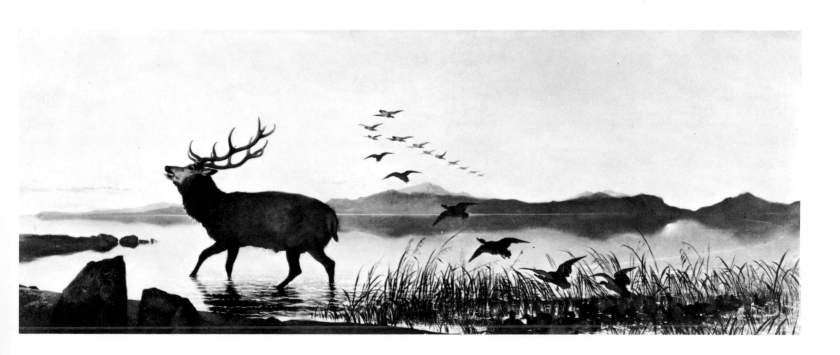

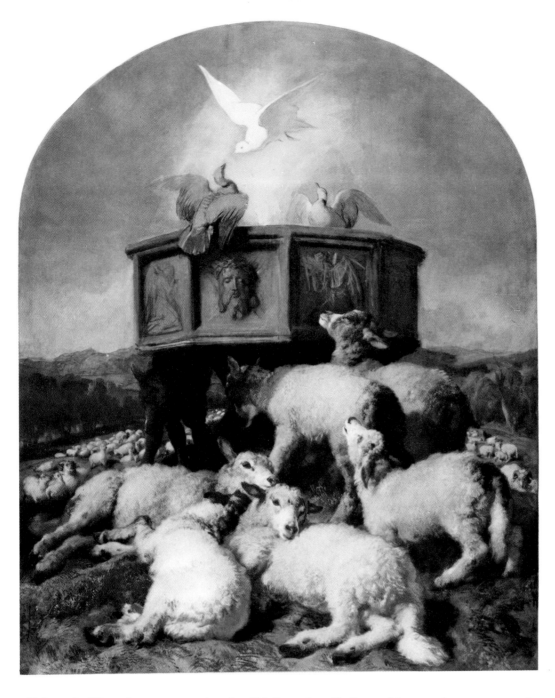

Coburg'. The picture, now in the Walker Art Gallery, Liverpool, was savagely attacked in *The Times*. At the height of the controversy which raged around Millais's *Christ in the Carpenter's Shop* when it was shown at the Royal Academy in 1850, it was said 'on undoubted authority' that the Queen had the picture sent round for her inspection as she was recovering from an accouchement (Prince Arthur had been born on 1 May) and was unable to visit the exhibition.[20] The Queen and the Prince preferred the superficially more intricate style of Maclise or George Cruickshank or the amiable charm of Clarkson Stanfield. Cruickshank's *Disturbed Congregation*, painted in 1850, was bought by the Prince; for his birthday in 1843 the Queen gave him Maclise's *Scene from Undine* (plate 204), an essay in fairy painting steeped in Germanic influences.[21] 'Wonderful work and detail' were the qualities the Queen admired in Maclise. A different type of Germanic influence, coupled with a Raphaelism no less attractive to the Prince, permeates the *Madonna and Child* (plate 203) which he bought from William Dyce in 1845. 'Quite like an old Master', the Queen said, '& in the style of Raphael – so chaste, & exquisitely painted':[22] a synthesis, in short, of Overbeck and of a classicism

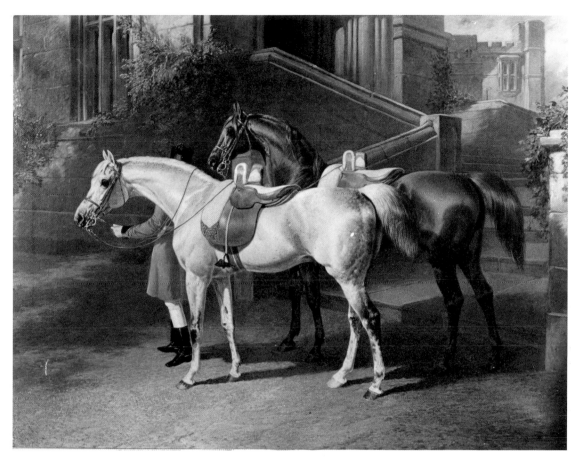

201 J. F. HERRING
Tajar and Hammon

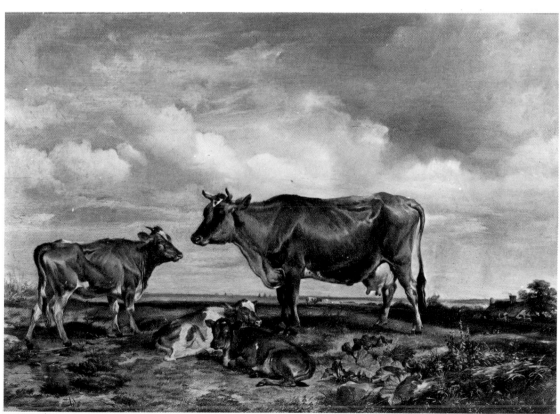

202 THOMAS SIDNEY COOPER
The Victoria Jersey Cow

tinged with a suggestion of Venetian colour. In 1846 the Prince bought a companion *St Joseph* and in 1847 he gave to the Queen the oil sketch by Dyce for his fresco, *Neptune resigning the Empire of the Seas to Britannia*, on the staircase at Osborne.[23] The display of nudity in Dyce's design, which is said to have disturbed the Prince more than the Queen, is a good deal more outspoken in the two large canvases by Frost, scenes from Spenser and Shakespeare, which the Queen gave to the Prince in 1847 and 1849. A laughably bad masquerade, *Gli Amanti*, was bought by the Prince from Augustus Leopold Egg in 1841.[24] It was placed over the fireplace in his Dressing-Room at Buckingham Palace. The other principal pictures in the room were Landseer's portrait, which had been a Christmas present from the Queen in 1841, of the favourite greyhound Eos (the Prince's top hat, painted in the picture behind the dog, rested on the piece of furniture below the picture); and the Prince's most arresting contemporary English picture, John Martin's *Eve of the Deluge* (plate 205), which had been painted for him in 1840.[25]

The Queen's favourite Scottish painter, brought to her notice by Landseer, was John Phillip. He painted for her one or two portraits, one (plate 206) particularly delightful; and a number of his Spanish subjects were Christmas presents between the royal pair: the *Spanish Gipsy and Child* in 1852, the *Letter-Writer of Seville* in 1853, *El Paseo* in 1854, and the *Dying Contrabandista* (plate 207) in 1858, in the tradition of Wilkie's guerrilla themes.[26] In 1854 the Queen acquired her most important painting of contemporary life, Frith's *Life at the Seaside* or *Ramsgate Sands* (plate 208), which had been bought at the

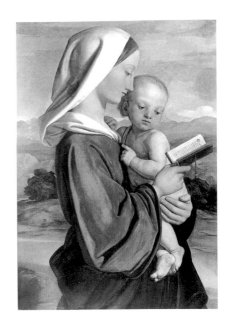

203 (above) WILLIAM DYCE
Madonna and Child
204 (below) DANIEL MACLISE
A Scene from Undine

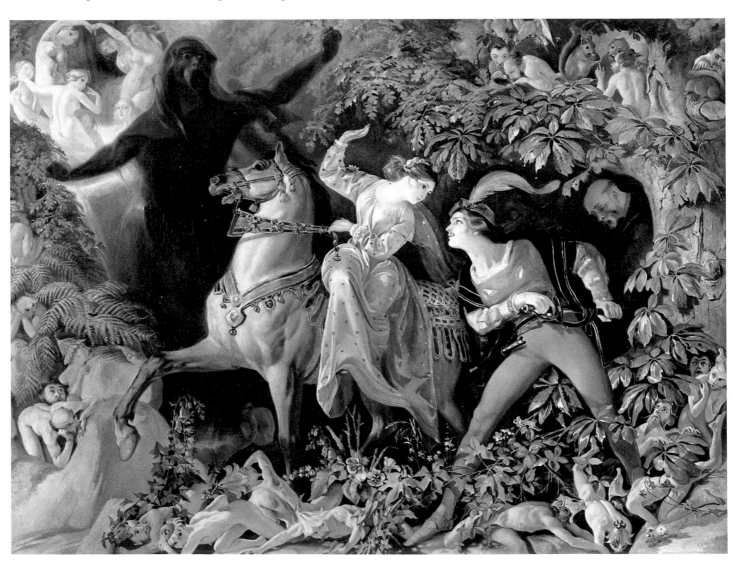

205 JOHN MARTIN
The Eve of the Deluge

206 JOHN PHILLIP
*Princess Feodora of
Hohenlohe-Langenburg*

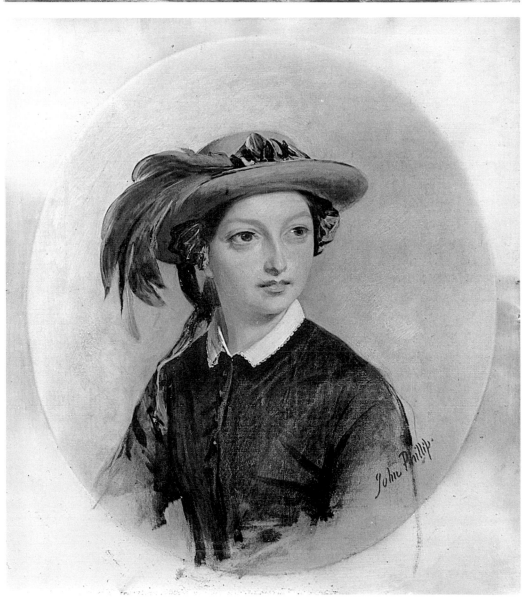

Royal Academy in 1854 by the dealers, Messrs Lloyd, but ceded by them to the Queen at £1,000.[27] Part of the charm it held for the Queen may have lain in its record of a seaside resort which she had known as a girl, though not in very happy circumstances. So successful was the work of these two painters in the eyes of the Queen that they were commissioned to paint the first, and much the best, in the series of canvases recording the weddings of her children. Philip painted the wedding of the Princess Royal; Frith exhibited at the Royal Academy in 1865 his enormous picture of the wedding of the Prince of Wales. In 1855 the Queen made one of her most significant purchases at the Royal Academy, the first work exhibited there by the young Frederick Leighton: *Cimabue's Madonna carried through the Streets of Florence* (plate 209). 'A beautiful painting', she called it, 'quite reminding me of a Paul Veronese, so bright & full of lights.'

The Queen and the Prince had a passion for dressing up and she loved a costume piece. De Keyser's *Battle of Courtrai* had moved her to ecstasy in 1837 – 'the finish, the effect, the costume, all is very fine' – as did Maclise's vast *Marriage of Strongbow and Eva* in 1854. In 1847 the Queen had been much impressed by the large historical pictures she saw at the exhibition in Westminster Hall; and in the same year C. W. Cope exhibited at the Royal Academy the very big *Cardinal Wolsey at the Gate of Leicester Abbey* (plate 210), which the Prince had commissioned and which is still at Osborne. In Leighton's carefully-worked pageant there was an echo of the Nazarenes; and it extolled Florence and the Florentine artists who had filled the Prince with such enthusiasm in his youth. It was the Prince, joining the chorus of praise of the theme and of the way it had been carried out, who persuaded the Queen to buy it.[28]

To the end of her reign the Queen ordered pictures of royal weddings, and other royal ceremonies were also faithfully recorded. The most accomplished were those by G. H. Thomas and E. M. Ward: executed with a painterly touch, often preceded by some charming preparatory studies, and providing valuable records of important and often glamorous occasions. Ward painted for the Queen companion pictures of the Investiture of Napoleon III with the Order of the Garter on 18 April 1855 and the royal visit to the tomb of Napoleon I during the State Visit to Paris in the following August. Thomas painted the review (plate 211) held on the Champ de Mars in the Queen's

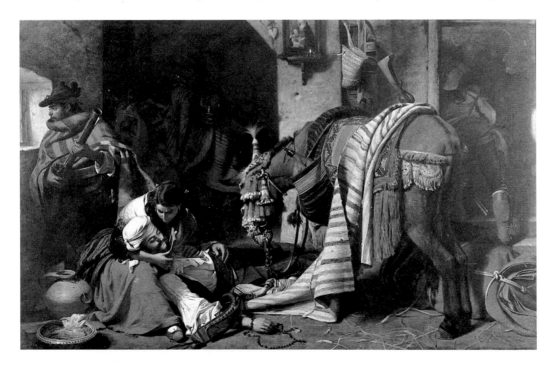

207 JOHN PHILLIP
The Dying Contrabandista

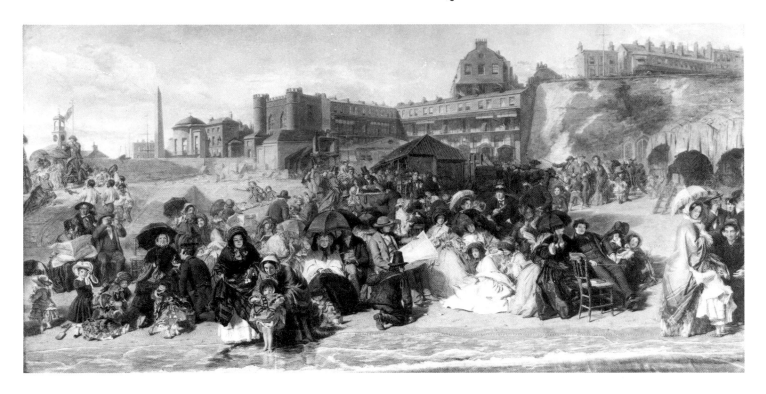

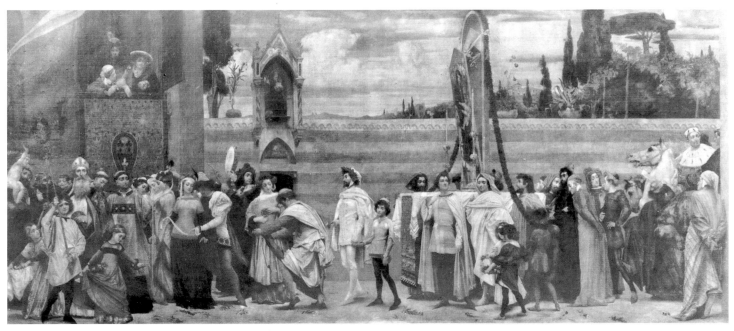

208 (top) W. P. FRITH
Life at the Seaside

209 (above) FREDERICK,
LORD LEIGHTON *Cimabue's
Madonna carried through the
Streets of Florence*

honour two days earlier. Inevitably a number of views, in watercolour and oils, were commissioned of the Great Exhibition of 1851, the triumphant scene on which the sun rises in Winterhalter's 'clever background' to the *First of May*; the most successful is David Roberts's view (plate XLI) of the inauguration by the Queen and the Prince. Episodes on visits abroad were painted by such artists as Jacquand, Knell and Kendrick.

The later paintings of important royal occasions, down into the twentieth century, are dull or downright vulgar, the best all too reminiscent of steel engravings in the *Illustrated London News* and the worst unable to outface the increasingly formidable challenge of the camera: processions by Nicholas Chevalier or John Charlton, Jubilee

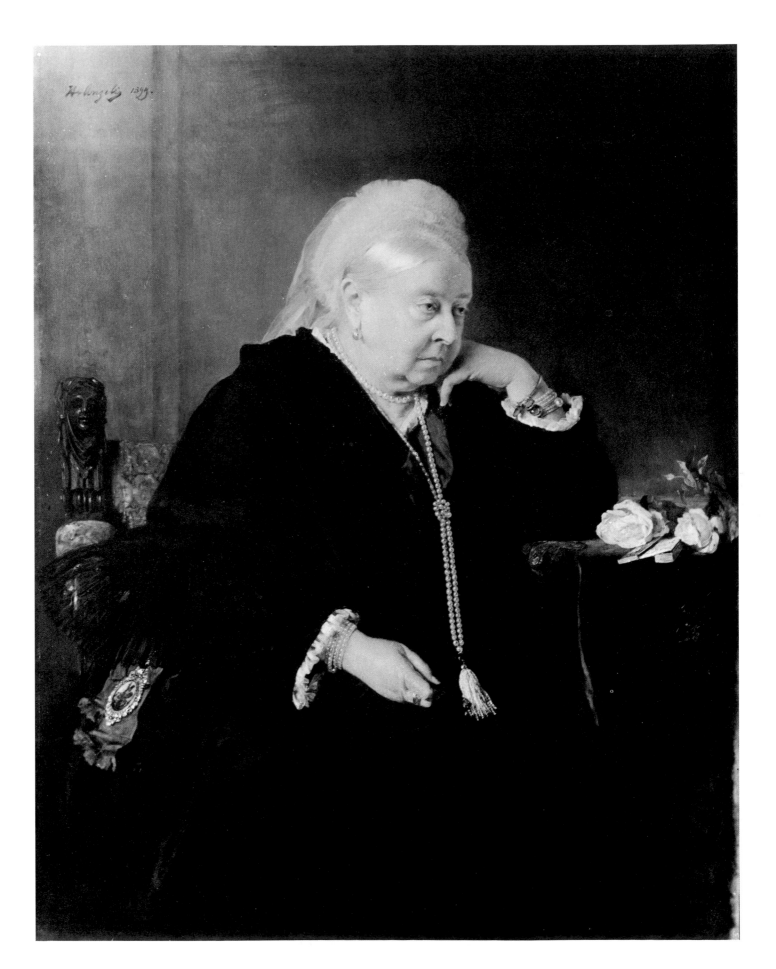

213 (left) HEINRICH
VON ANGELI *Queen Victoria*

214 (right) SIR EDWIN
LANDSEER *Queen Victoria
at Osborne*

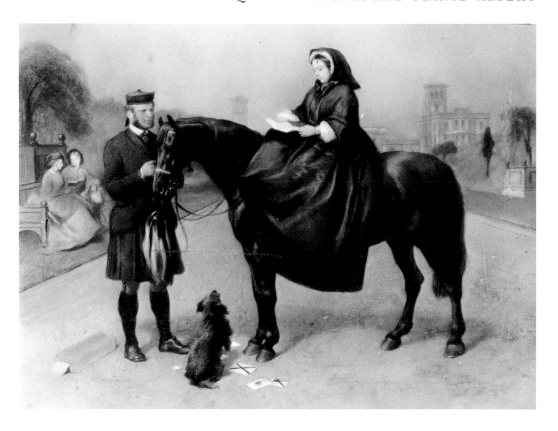

215 Queen Victoria and
John Brown (photograph)

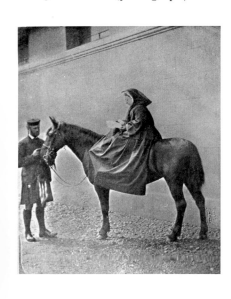

repertory of the portrait painter who works in the twentieth century. The work of Kelly, Salisbury and Gunn is in all ways inferior to their nineteenth-century predecessors; and an essay in these genres nowadays is, predictably, a disaster.

In at least one of Tuxen's wedding pictures he had relied on photographs to help him compose the scene; for some of the foreign sitters in his *Wedding of the Prince of Wales* Frith had likewise been reduced to 'that most unsatisfactory process'. The Queen and Prince Albert had been fascinated by photography from the early days of its invention. As early as March 1842 Prince Albert was sitting to 'a man who makes photographic likenesses'. In building up her collection of miniatures the Queen relied more and more on photographs – from life or from painted portraits – which could be worked on by professional miniaturists so as to simulate a miniature: a practice which was to destroy the miniaturist's art for ever. When, in 1865, she was seized with a 'great wish' that Landseer should design two compositions for her, which she later entitled *Sunshine and Sorrow*, she realized that he would need photographs. The second subject (plate 214) was to be 'the reverse of that bright happy time, I, as I am now, sad & lonely, seated on my pony, led by Brown'.[30] To help the artist she arranged for him to have a print of a recent photograph by Bambridge (plate 215). Millais's portrait of Princess Marie of Edinburgh, commissioned by the Queen, was painted entirely from photographs.[31]

The Queen's pride in her Empire and her armies brought a number of pictures into the collection. The most interesting Australian piece is Marshall Claxton's view of the Cove of Sydney in 1853 (plate 216), which Miss Burdett-Coutts gave to the Queen on her birthday in 1854. The Queen secured two impressive canvases by the first important Canadian landscape painter, Homer Watson: the *Pioneer Mill*, purchased for her by Lord Lorne in 1880 at the first exhibition of the Royal Canadian Academy, and the *Last Day of the Drought* (plate 217), painted in 1881.[32] George III and George IV

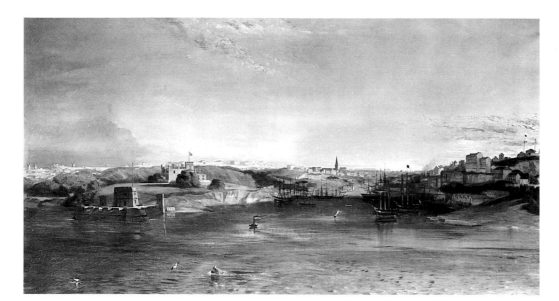

216 (left) MARSHALL
CLAXTON *The Cove of Sydney*

217 (below left) HOMER
WATSON *The Last Day of
the Drought*

had owned interesting portraits of Indian rulers by Willison, Place and Robert Home.
The last shows Ghazi-ud-din Haidar, King of Oudh, receiving tribute. In 1845 the
Queen brought a large canvas by Dufay de Cassanova, showing the next King of Oudh
receiving John Low as British Resident at Lucknow. In 1881 Sir Henry Ponsonby, the
Queen's Private Secretary, was being badgered by Val Prinsep over a suitable place
where his huge picture of the *Proclamation of the Queen as Empress of India* could be placed.
It had been painted as a present to her from the Indian potentates who appear in the
picture. It was eventually set up in the Banqueting Hall at St James's, an idea which
the Queen had at first stoutly refused: 'She has been told it would not suit well – and if it
goes there she will never see it. As it is a present to her She wants to have it somewhere
where she can study it.'[33] At Osborne there still hang, principally in the Durbar
Corridor, Indian portraits painted for the Empress. The majority are by the Viennese
Rudolf Swoboda. To the portraits he had painted in India for the Queen in 1886 are

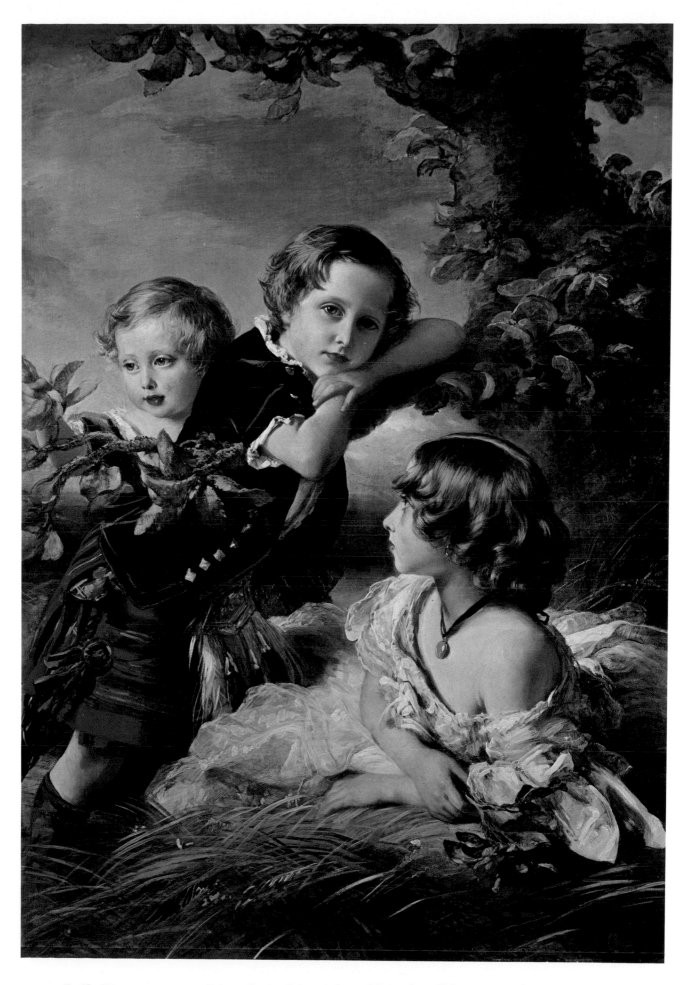

XXXIX F. X. WINTERHALTER *Princess Louise, Prince Arthur and Prince Leopold* (see page 171)

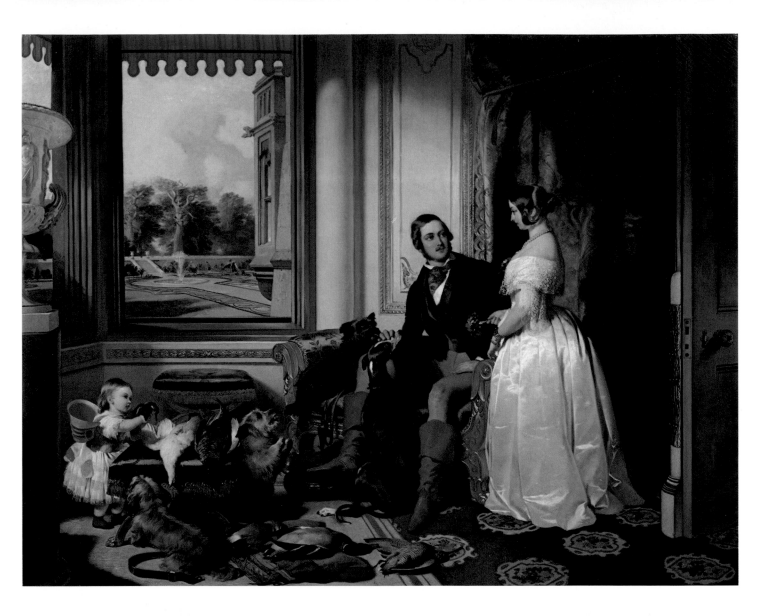

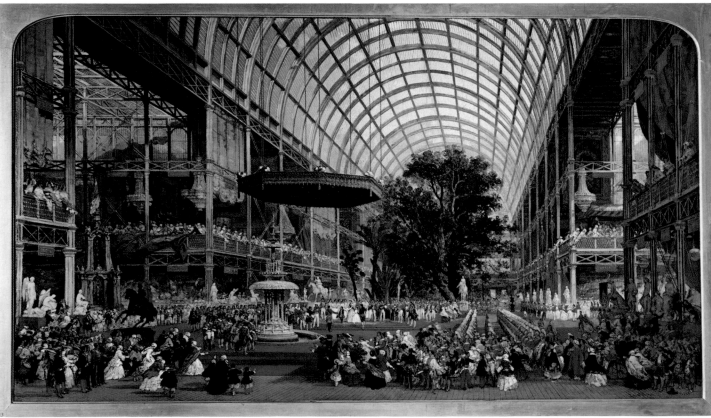

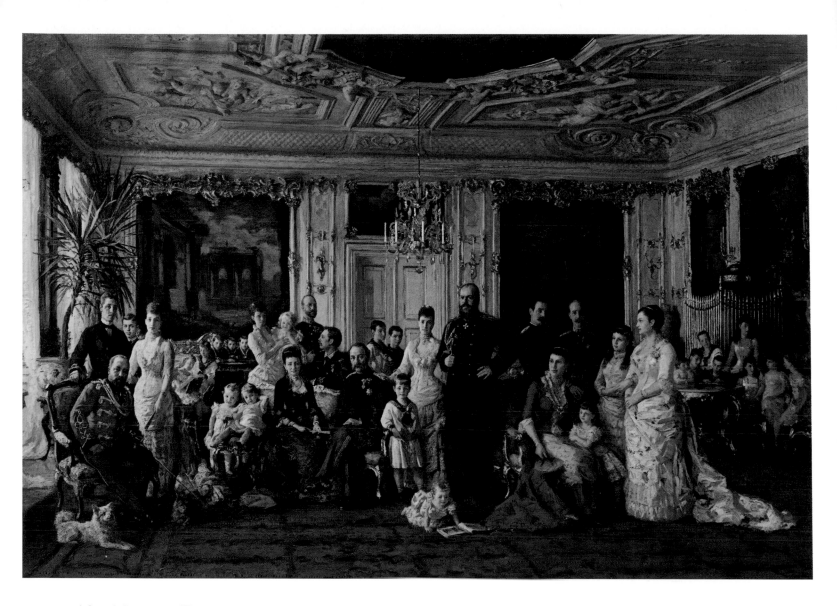

XLII (above) LAURITS TUXEN
The Family of King Christian IX
and Queen Louise of Denmark
(see page 180)

XL (opposite top) SIR EDWIN LANDSEER
Windsor Castle in Modern Times:
Queen Victoria, Prince Albert and
Victoria, Princess Royal
(see page 172)

XLI (opposite bottom) DAVID ROBERTS
The Inauguration of the Great Exhibition
(see page 179)

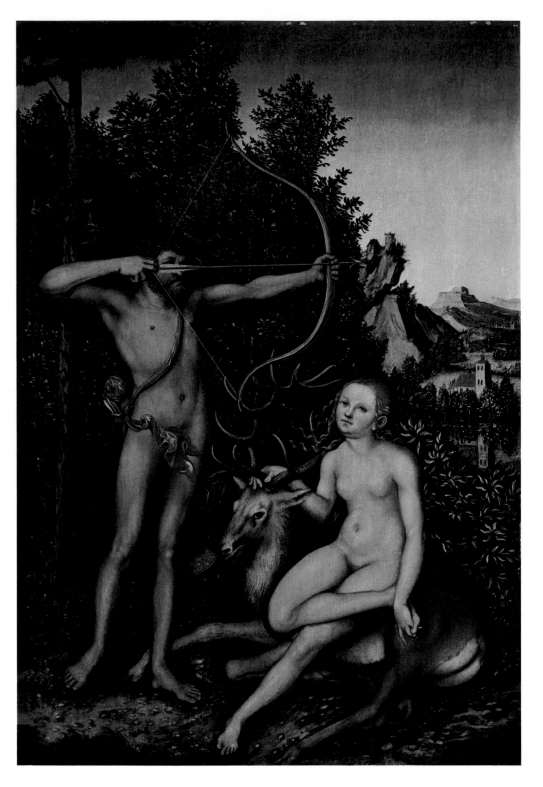

XLIII Lucas Cranach
the Elder *Apollo and Diana*
(see page 192)

added those done in 1893, when Indian and Colonial contingents visited England for the opening of the Imperial Institute, and in 1897 when an Indian contingent came over for the Diamond Jubilee. Swoboda's paintings of Indian soldiers are straight from the pages of Kipling, whose father, Keeper of the Museum at Lahore, had supervised the decoration of the Durbar Room.[34]

Opposite the enormous Prinsep in the Banqueting Hall at St James's has hung since the early 1860s the colossal canvas of the Battle of Meeanee by Edward Armitage (plate 218), which had been purchased by the Prince. The Queen's devotion to her soldiers is well illustrated in the copious collection she assembled of photographs from the Crimea. She felt deeply for the wounded, and to present them with medals provided her with a precious opportunity of making contact with them. The moving scene at the Horse Guards in May 1855, 'the 1st time that a simple Private has touched the hand of his Sovereign', was painted for her by G. H. Thomas in a companion picture to the dashing make-believe on the Champ de Mars. She commissioned Noel Paton's *Soldier's Return* (plate 219) as a Christmas present for the Prince in 1859.

Episodes from the Crimea, and later from the Zulu War and the Sudan, were painted by Elizabeth Thompson and Caton Woodville. The Queen had been profoundly moved by Gordon's death and Caton Woodville's two canvases, *Too Late* and the *Memorial Service for General Gordon*, were bought for the collection. Carl Sohn was commissioned to paint the captured Cetewayo and Queen Victoria showed the warmth of her affection for her generals by buying portraits of Wolseley, Roberts, Kitchener and Sir George White, the last a gaunt figure straight from the relief of Ladysmith and the first sitter painted in England by De Laszlo. Caton Woodville's picture of the Duke of Connaught at the battle of Tel-el-Kebir and his large canvas of the Jubilee review at Windsor in 1897; or the colossal picture by Edouard Detaille, painted for the Prince of Wales as a Jubilee present to his mother, and showing him and the Duke at a review at Aldershot, could be seen as the last essays in the Morier tradition and as splendid illustrations of British Imperial power.

On the whole the works of contemporary painters abroad bought by the Queen and Prince Albert are unimportant. Among her earliest presents to him were a little panel

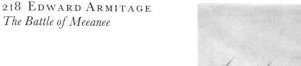
218 EDWARD ARMITAGE
The Battle of Meeanee

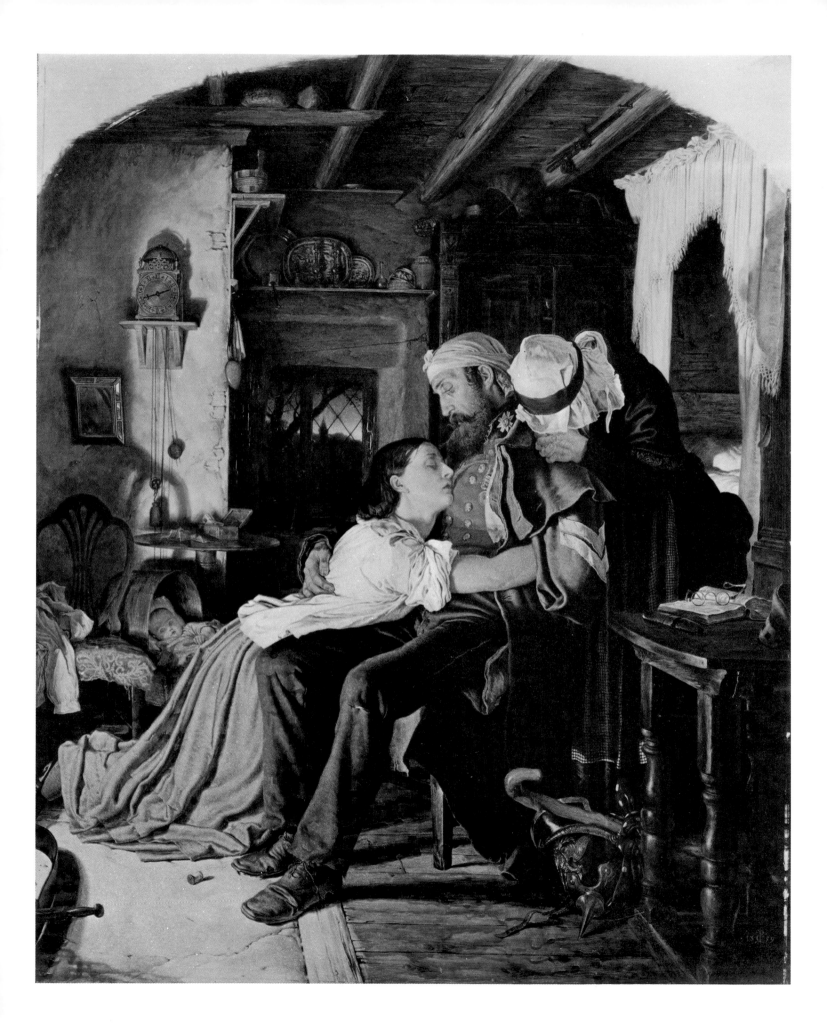

of *Pigeons at a Pigeon House near Laeken* by Voordecker (in 1841) and (in 1845) Van Schendel's *Market-Place by Candlelight*. On their visit to Belgium in September 1843 they had met painters and visited exhibitions; the following Christmas the Queen gave the Prince pictures by Verboeckhoven and Van Meer (which he had especially admired) and in 1844 she acquired two pictures by Gustave Wappers. The King of the Belgians probably also encouraged them to buy works by Louis Gallait. Pictures by Van Eycken and E. J.-B. Tschaggeny were also acquired. In 1844 the Queen bought a scene from *Wilhelm Meister* which Ary Scheffer had painted for the Duke of Chartres, who had not lived to see it. In 1855 Napoleon III gave to the Prince Consort Meissonier's *La Rixe* (plate 220) (in 1847 the Queen had bought a little picture by him for the Prince's birthday); and the Queen, always fascinated by the legend of Napoleon and by his descendants, assembled a set of three pictures by Paul Delaroche of the Emperor at different stages of his career. In 1857 she bought *Zouaves at the Malakoff* by Horace Vernet as a present for the Prince. The French painter Boutibonne collaborated with Herring in equestrian portraits of the Queen, Prince, Emperor and Empress. Among pictures by German and Austrian artists bought by the royal pair were works by Waldmüller, Andreas Achenbach and Gegenbauer. Two landscapes by Koekkoek were given to the Prince by the King of the Netherlands in 1845. Not the least attractive of the Queen's Jubilee presents in 1897 was Hermann Corrodi's painting, which he gave to her, of herself with her attendants on the terrace of the Villa Palmieri outside Florence, the house Lord Cowper had lived in when Zoffany came to Florence to paint for the Queen's grandmother.

On 16 December 1843 the Queen noted in her Journal that she had 'looked over some curious old pictures in St George's Hall, which have been sadly neglected at Hampton Court'. At the end of the month, after more sessions with the old pictures, she was:

... thunderstruck & shocked ... at the way in which the pictures, many fine ones amongst them, & of interesting value, have been thrown about & kept in lumber rooms at Hampton

219 (left) SIR JOSEPH
NOEL PATON
The Soldier's Return

220 (right) JEAN-LOUIS-
ERNEST MEISSONIER
La Rixe

Good early Flemish and German pictures had been bought by Charles I and an English interest in early Italian pictures can be traced back to the time of Zoffany and Thomas Patch, but collecting them had not been a fashionable activity. In a taste for German painting the Prince was following to some extent the example of such men as William Roscoe or William Young Ottley; but he was also following his own inclinations, stimulated to some extent by what he had absorbed from the Nazarenes in Italy and Germany. The first picture recorded in the 'List of Pictures presented to or purchased by . . . Prince Albert',[45] brought over from Coburg in 1840, was a panel from the school of Cranach of Frederick the Wise, Elector of Saxony. At Christmas the Queen gave him a copy of a Cranach of Sybilla, Electress of Saxony, with her son and Lord Robert Grosvenor gave him portraits of Duke Frederick William and Duchess Sophia of Saxony. To the Prince, who shared to the full his wife's enthusiasm for family history, such portraits were ancestral images as well as good and instructive works of art. Of the pictures which went under Cranach's name, the most important to be acquired by the Prince were a *Lucretia* in 1843 and the *Apollo and Diana* (plate XLIII)

222 AFTER HUGO
VAN DER GOES *The Coronation
of the Virgin*

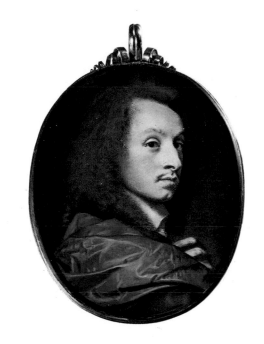

XLIV SAMUEL COOPER
Hugh May (see page 218)

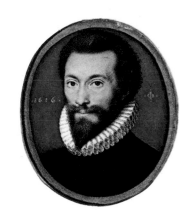

XLV ISAAC OLIVER
John Donne (see page 197)

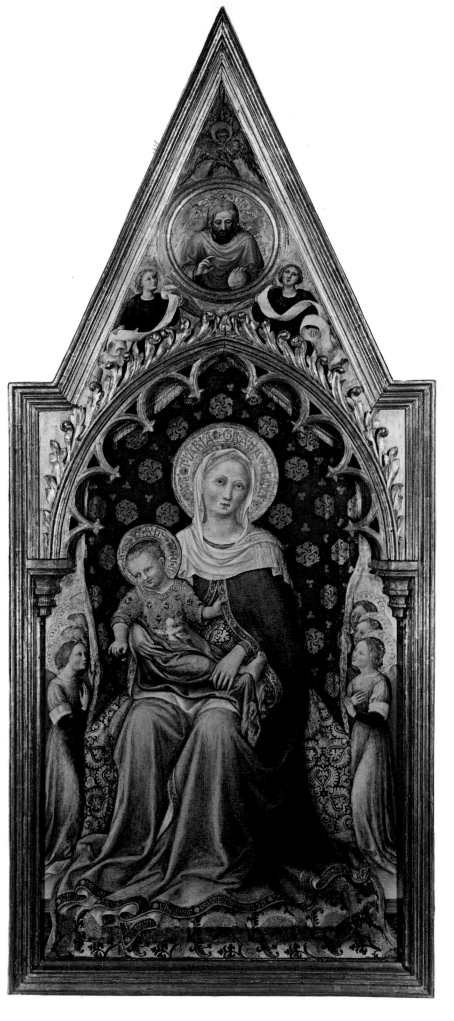

XLVI Gentile da Fabriano
Madonna and Child with Angels
(see page 193)

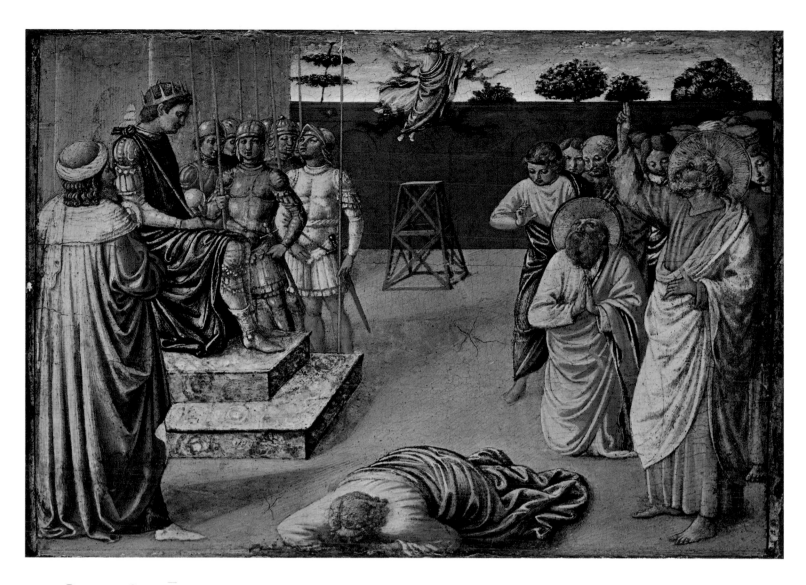

XLVII Benozzo Gozzoli
The Death of Simon Magus
(see page 193)

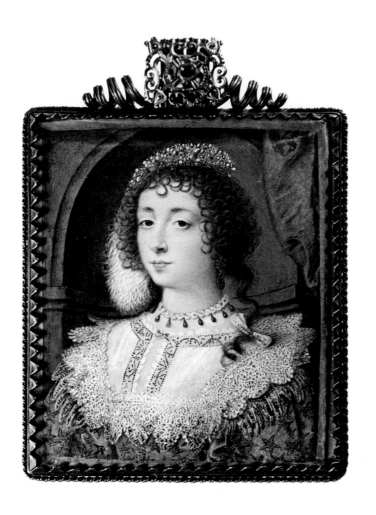

XLVIII JOHN HOSKINS
Queen Henrietta Maria
(see page 218)

which was bought in 1846. A 'Fine Picture Fund' was set up and from it was acquired in 1860 a *Judgement of Solomon* which was also attributed to Cranach.[46]

In 1851 the Prince became possessed of the collection of Byzantine and early German, Flemish and Italian pictures belonging to Prince Louis of Öttingen Wallerstein. These pictures had in 1847 been taken, as a kindly gesture, by the Prince, as security for a loan of £3,000, and had been placed on show at Kensington Palace. Prince Louis had been warned by George Anson, Prince Albert's Private Secretary, that, in the view of many connoisseurs who had seen the collection, 'a very great number of these pictures cannot maintain their claim to be painted by the Masters whose names are attached to them.' Nevertheless it had been suggested by Prince Louis's agent that the collection might have been acquired by the National Gallery and it was with this in mind that the Queen, after the Prince Consort's death (Prince Louis having proved quite unable to repay the loan), and in accordance with his wishes, gave the twenty-two best pictures from the collection to the National Gallery, leaving in the royal collection an interesting, if not very important, group of pictures.[47] They include the triptych, the *Coronation of the Virgin* after Van der Goes (plate 222); the Antwerp Mannerist triptych of the *Adoration of the Kings*; the *Lamentation* triptych by the Master of the Groote Adoration; the little *Adoration* by Coecke; and the very early portrait by Baldung, attributed in 1854 to Kulmbach.

One of the most charming of Prince Albert's early Flemish pictures was the *Virgo inter Virgines* by a follower of Van der Goes, which had been acquired through Gruner from Metzger in Florence in 1845. The superb *Portrait of a Man* by Memlinc, however, sometimes associated with the Prince Consort, had almost certainly been bought at an earlier date.

The Prince is naturally given credit for buying these early pictures, but it is worth pointing out that it was often the Queen who actually provided the cash. In 1846, for instance, she paid £26 5s for '3 old Pictures for Albert's birthday' and £270 (paid to Warner Ottley, a relation of William Young Ottley) 'for several old Pictures for Albert for his birthday & Xmas'. In 1847 she paid Gruner £400 for six pictures by old masters for the Prince's birthday. She paid £150 in 1848 for a *Holy Family* then attributed to Ghirlandaio and now to Mainardi; and in 1854 she paid the dealer William Blundell Spence £52 10s for the little Fra Angelico of *Christ Blessing*.[48] The pictures acquired in 1846 included the Prince's greatest single acquisition, the triptych by Duccio (plate 223), for which, with the *Madonna and Child with Angels* from the school of Fra Angelico, he paid Gruner £190 on 7 April. Both pictures had been acquired from Metzger. At the same period Gruner bought for the Prince from Metzger the *Ecce Homo* by Francesco and Bernardino Zaganelli.

Among the pictures bought from Ottley in 1846 were the exquisite *Death of Simon Magus* by Benozzo Gozzoli (plate XLVII), the Triptych from the School of Jacopo di Cione and the noble *Madonna and Child with Angels* by Gentile da Fabriano (plate XLVI). On the Prince's birthday in 1846 he also got from the Queen the *Marriage of the Virgin* by Daddi which had been bought through Gruner from Metzger. In the following year the little panels by Cima (plate 224) and the Parentino *St Sebastian* were bought through Gruner from Minardi in Rome and were among the Prince's birthday presents from the Queen. The 1840s were, in short, one of the golden periods in the history of the collection. Perhaps the most important picture acquired thereafter was the large panel (plate 225), now attributed to Justus of Ghent and then to Melozzo da Forlì, which had been acquired by Woodburn in Florence and bought at his sale at Christie's on 25 June 1853 by the Queen. Its importance in her eyes lay to a great extent in the representation

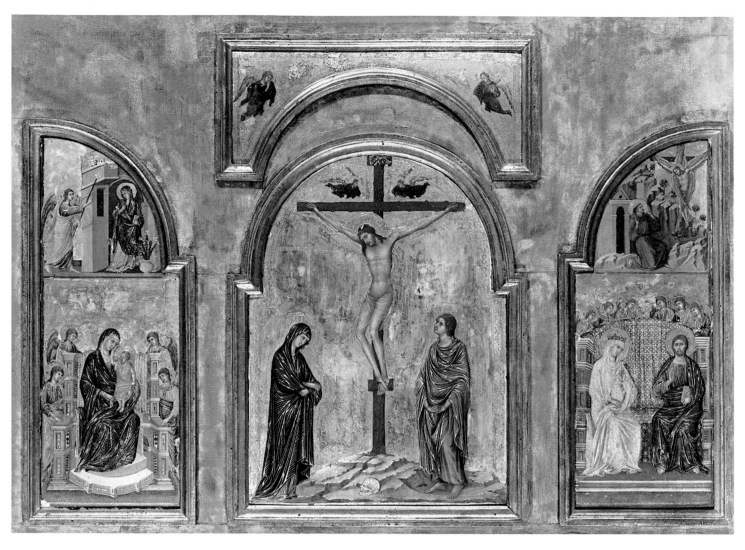

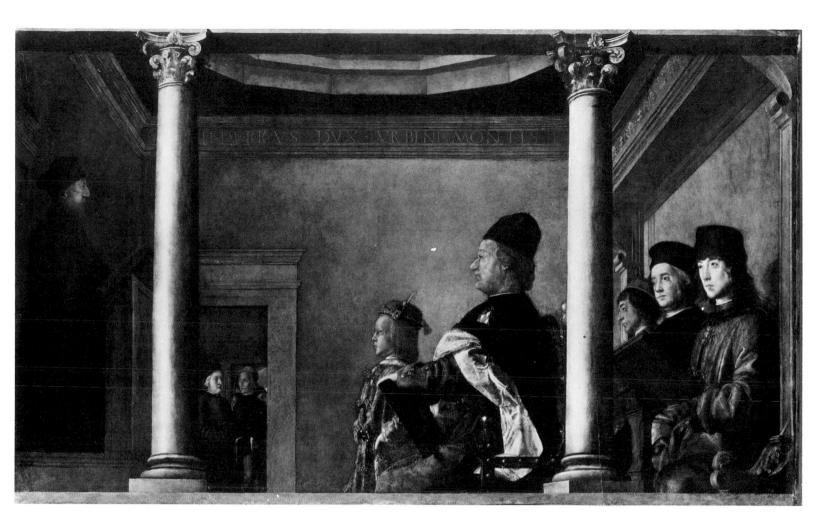

of an Italian prince of the Quattrocento in the mantle of the Garter. It is probably the earliest surviving life-size painted portrait of a Knight of the Order wearing his insignia; and the Queen placed it in the Corridor. In the same year the Queen acquired the important Peruginesque altarpiece by Berto di Giovanni, then ascribed to Tiberio d'Assisi.

The early pictures were hung, in the main, at Osborne, where Gruner had been particularly active: some of the best northern pieces, with the Gentile da Fabriano, in the Page's Waiting-Room, the smaller Italian pictures in the Prince Consort's Dressing- and Writing-Room.[49] After the Queen's death these early pictures were brought up to Buckingham Palace and placed in the Private Apartments. Since the Second World War the finest of them have been on show at Hampton Court.

As Chairman of the Royal Commission 'to take into consideration the Promotion of the Fine Arts of this Country', especially in connection with the rebuilding of the House of Commons, the Prince scored his first success in the field he was to make his own: the arts in the service of the public. He showed a remarkable grasp of artistic practice and 'an understanding of the artist's mind'.[50] The decoration of the Houses of Parliament with paintings in fresco in the Germanic-Raphaelesque style was, or so he hoped, to inspire a native school of fresco-painting: a technique which had been essayed in a lighter vein in the Garden Pavilion. It was to encourage such a school of fresco-painting that the Prince had bought a large fresco of *Hercules and Omphale* by Gegenbauer and the set of frescoes, from the Palazzo Sacchetti at Brescia, by Lattanzio Gambara.

Eastlake, at the Prince's insistence, became Secretary of the Royal Commission. The

tremendous success of the Great Exhibition was a personal triumph for the Prince and for his dedication to the cause of improvement, in and through the arts, in British industrial design. The Prince was, finally, largely responsible for the exhibition of Art Treasures of the United Kingdom at Manchester in 1857, inspired once again by 'zeal for educational usefulness' and, on this occasion, to stimulate the imagination, to give pleasure as well as instruction to those unversed in art history. It was the first large exhibition of works of art from private collections, selected in the main by the ubiquitous Dr Waagen and formally opened by the Prince. The exhibition gave a tremendous impetus to new trends in connoisseurship, above all to the increasing interest in the early Italian and Northern Schools. To the section devoted to British Portraits the Queen lent nine pictures; to the display of Modern Masters she lent a further nine and the Prince two; but to the galleries of Ancient Masters she lent forty pictures and the Prince no less than forty-two. This was the first occasion that the royal collection was drawn on to a considerable extent in a huge loan exhibition (one can hardly cite as a precedent the borrowing of royal pictures by the British Institution in the time of George iv): the first in a succession of large, important and deservedly popular manifestations to which successive owners of the pictures have always lent so generously. Probably the last were the famous winter exhibitions at the Royal Academy in our own time.

Lady Eastlake wrote that connoisseurship requires 'unwearied diligence, sound sense and true humility'. These qualities the Prince undoubtedly possessed; and 'there must be enthusiasm, pure and engrossing'.[51] No other figure in the history of the collection could have drafted the letter he sent in 1853 to the Committee of the National Gallery, enclosing a plan for the arrangement of pictures 'so as to afford the best means of instruction and education in the art to those who wish to study it scientifically in its history and progress'.[52]

9

MODERN TIMES

WHEN SIR HENRY COLE was at Windsor in June 1862 to discuss with Queen Victoria the National Memorial to the Prince Consort, she 'said she had not taste ... used only to listen to him ... not worthy to untie his latchet.'[1] Pictures had been so much part of their life in the former bright happy time that it is understandable that she could not sustain alone the enthusiasm they had shared. She did not buy a really important picture after the Prince's death; but she did acquire, at the advice of her Surveyor, some interesting early historical pieces: the *Family of Henry VII* from Strawberry Hill in 1883, the fine full-length of Edward VI from Hamilton Palace in 1882 and Michael Wright's *Charles II* (reluctantly) in 1889; Marianne Skerrett bequeathed to her in 1887 the little Hogarth of the Popple and Ashley families. Of later pictures, the most attractive was the delightful view of the Long Walk by Gilpin and Marlow, acquired in 1883. By 1900, however, she could not be persuaded to buy the important Richard Wilson of the young George III with his brother and their tutor, Dr Ayscough: 'The Queen does not think it necessary.'[2] Much sadder, it seems that in 1886 the Queen lost an opportunity to buy Holbein's *Lady Guildford* which the owner, a Mr Frewen, was apparently willing to sell to the Queen for some £1,500.[3] She did, however, continue to make important additions to the miniatures. Her collection, which had been listed for her by Fraser Tytler in the 1840's, was now being set in order and catalogued by the Librarian, Richard Holmes.[4] In 1881 Holmes bought for her, for example, at the sale of the Sackville Bale collection a group of miniatures which included the very fine Isaac Oliver of John Donne (XLV), a Zincke alleged to represent Addison, a likeness of Henry VIII's bastard son, the Duke of Richmond, and an interesting early sixteenth-century miniature then said to be a Holbein of Mary I. At the Golden Jubilee Lord and Lady Rosebery gave the Queen a little Hilliard of Queen Elizabeth. The Queen was obviously anxious to fill gaps in the iconographical display of royal portraits in her miniature collection; and at the same time, perhaps stimulated by the Duke and Duchess of Buccleuch, she was interested in a general way in early English miniatures. Unfortunately it was decided to commission Hatfield to reframe in a particularly repellent uniform, brightly gilt, metal frame the entire miniature collection except for those actually hanging in rooms or retained by the Queen herself. The portraits in miniature of the Prince, including the large enamel painted for him by Thorburn in

1844 as a birthday present to the Queen ('a chef d'œuvre, and *so like*'), were placed with the miniatures in the Print Room. Very few important modern pictures were bought. *No Tidings from the Sea* (plate 226) was painted for her by Frank Holl in 1870. In 1898, twenty-five years after she had asked for it to be painted, the Queen received from Holman Hunt *The Beloved*, a copy of the head in *The Shadow of Death*, which she had so much admired.[5]

By 1879 the Queen had to admit that Redgrave was 'a little old'; and it was suggested to the Queen that the pictures at Hampton Court 'are not cared for as they shd be.' Bell was at pains to point out the difficulties, chiefly lack of funds, that confronted Redgrave. The Princess Royal, who had been described long ago as 'quite your dear, beloved Papa's child', had first, it seems, raised the issue. She wrote to her mother on 2 June 1878:

I wrote to Beatrice yesterday about the Hampton Court Pictures. *How* I wish you could name a Commission of artists with dear old Mr. Redgrave (who is getting a little weak of sight) at the head, & with Mr. Bell who understands pictures, their history & their preservation so well, as one of the number – just to look after them, hang them in a better light, give them their right names, do up some of the frames, put other pictures under glass, – & *weed* some out which are altogether unworthy of being hung up where they are much seen! I am sure thus both in the interest of the *Crown* whose property they are – of the nation to whom they are precious & of all lovers of art, a *great thing could be achieved*! I hope I am not wrong in mentioning the matter! But if dear Papa lived, I should not hesitate to say so to him! *One* room he arranged & that is the only one that looks well & where the pictures are seen to advantage. There are 2 *Tintorettos* which I feel sure would be far better at the 'National Gallery' (*as your property*) but still far better seen and cared for there than at Hampton Court also the 'procession of Mantegna's.'

The Queen was anxious that the Princess's advice should be taken on this problem: '*No* one understands it better than the Crown Princess'.

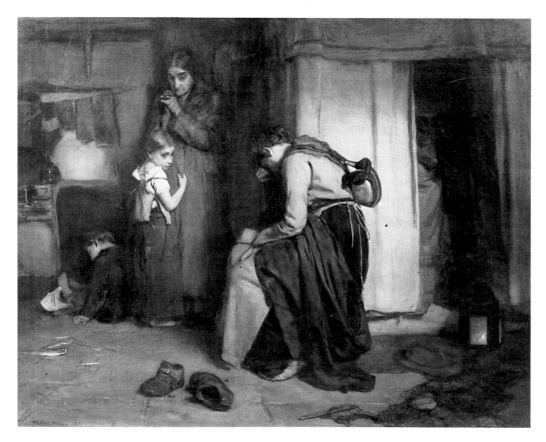

226 FRANK HOLL
No Tidings from the Sea

On 9 December 1880 the Queen wrote to her daughter that Redgrave had retired and, knowing what a keen interest the Princess took in the matter, asked her opinion on the appointment of a successor: Poynter was a very good artist, so was J. C. Horsley, but 'poor dear' Corbould was hardly fit. Eventually John Charles Robinson, for whom the Princess had a high regard (she had been anxious that he should get the Directorship of the National Gallery) was chosen. In the Crown Princess's eyes he was '*without* a *doubt* the 1^{st} authority & connoisseur in England. You know dear Papa thought *so* highly of his knowledge of ancient art.'[6] Robinson was a more brilliant connoisseur, and had a wider range of knowledge, than Redgrave. As the first Superintendent of the art collections at South Kensington he had, with a succession of marvellous purchases, laid the foundations of the collections there. After his resignation in 1869 he had acted as adviser to private collectors, in particular to Sir Francis Cook, and had formed an extensive collection on his own behalf. He brought possible purchases more forcibly before the Queen than Redgrave perhaps had felt able to do. He carried on Redgrave's programme of restoration at Hampton Court, but had the intelligence to recommend in 1894 (without success) that the pictures should be cleaned at the National Gallery instead of being placed with scattered private restorers. He created a new display of pictures at Holyroodhouse, taking up there such important works as the *Memorial of Lord Darnley*. Nevertheless he seems to have lost the confidence of the Queen.

In 1881 he reported that he was worried by the state of the pictures in the Picture Gallery at Buckingham Palace, 'the entire Collection, I think, not having received any systematic examination for many years.' He wished to glaze the pictures as a protection against the London atmosphere, but the Queen doubted the expediency of this plan and 'does not wish any pictures to be moved from their places at present'. Eventually she allowed the smaller pictures to be covered with movable glasses which could be taken off when she was in the Palace. In 1898 Robinson broached once again the cleaning and rearrangement of the pictures at Buckingham Palace; and this time he enlisted the help of his old ally, the Princess Royal, now the Empress Frederick. He described the Gallery as dark and inadequately lit (plate 227) and the pictures invisible under Seguier's hard and darkened varnish. Robinson was very hurt when it was decided, as the result of advice given to the Queen at Balmoral by A. J. Balfour, to call in outside opinion: from Claude Phillips and Poynter, Director of the National Gallery. Robinson was eventually allowed to experiment with the removal of the varnish; suggestions for improving the lighting were to be put forward; but no pictures were to be removed from the Gallery: 'The pictures at Windsor and Buckingham Palace were settled by the Prince Consort, and the Queen desires that there shall be no change.' Finally, on 9 June 1900, Sir Arthur Bigge, the future Lord Stamfordham, wrote to the Comptroller:

The Queen does not wish anything done with regard to *pictures*, their care and restoration until you hear again.

There is evidently a strong opinion growing from Her Majesty downwards through the family – excepting the Empress Frederick – that there is not sufficient attention bestowed upon the pictures by Sir C. Robinson.[7]

Within a few weeks of the Queen's death Robinson had been supplanted.

By the end of the reign the old Queen must have woven around her something of the atmosphere of the Sleeping Beauty's castle; and no one, certainly not Robinson, armed though he was with the support of the Empress, could hack his way through the thorns. An impression of the claustrophobic, cluttered surroundings in which she chose to live

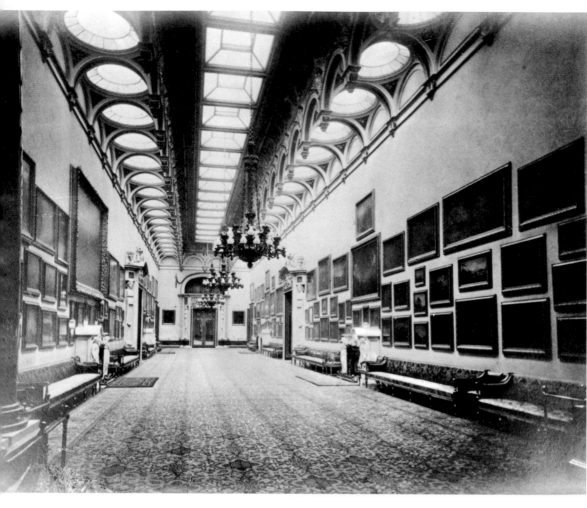

227 The Picture Gallery,
Buckingham Palace (photograph)

can be gained by comparing the famous photograph of the Queen in her Sitting-Room at Windsor in 1895 (plate 228) with a view of the same room (plate 229) in her early days. At first we can perceive that we are in a room which has something still of a Regency air, with only the favourite canvases by Landseer and Grant, one on each side of the fireplace and each with a case of miniatures below; two small portraits on the wall facing the window; a flower piece over the door and, at most, three more pictures. By 1895 the walls are covered with pictures, principally portraits, and pictures and miniatures stand around on easels and tables. As Lady Augusta Stanley had written earlier, 'the space is limited in which Her Majesty likes to place the pictures which She would wish to have near Her.'[8]

Edward VII succeeded to the throne on 22 January 1901. On 5 March 1901 Robinson's place as Surveyor of the King's Pictures and Collections of Works of Art,[9] was filled by Lionel Cust. The new Surveyor was of a different breed from his predecessors. After a distinguished career at Eton and Trinity College, Cambridge, he had worked in the Print Room at the British Museum and in 1895 had succeeded Scharf as Director of the National Portrait Gallery. Though fond of describing himself as 'a quiet, struggling Civil Servant', Cust and his wife, a daughter of the Fourth Lord Lyttleton, rarely forgot their lineage, their numerous connections at court or their friends in the new Household. When, in 1896, he first met his future Sovereign, in the smoking-room of the Marlborough Club, Cust was reminded by the Prince of Wales that his wife's grandmother, Lady Lyttleton, had been his Governess; it was she who, in her youth, had been so pleased to see the Admirals hanging up at

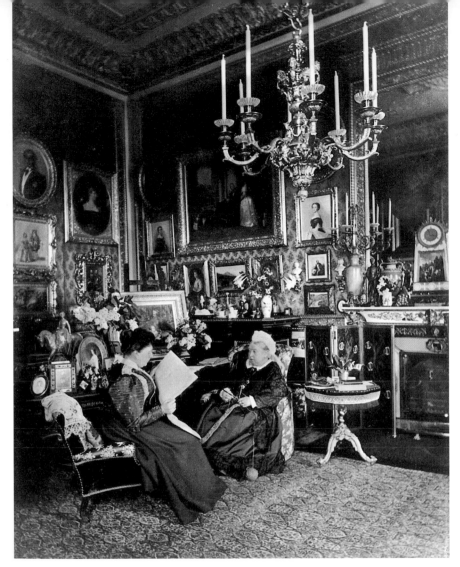

228 Queen Victoria in her
Sitting-Room, Windsor Castle
(photograph)

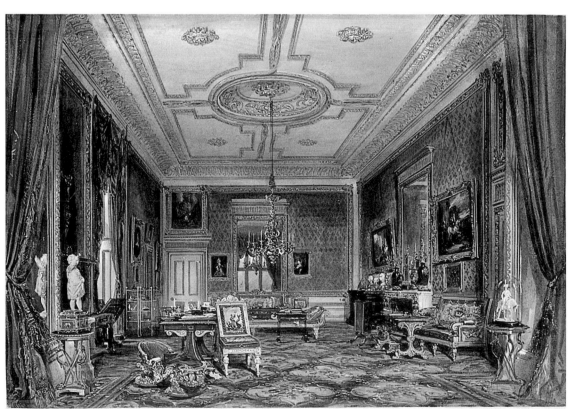

229 JOSEPH NASH *The Queen's
Sitting-Room, Windsor Castle*

Carlton House. Cust – it must have been within a few days of the Accession – approached Lord Esher. 'With hardly any delay I found myself appointed to this very important post, for which my heart had yearned.' The Trustees of the National Portrait Gallery raised no objection to his combining his responsibilities to them – what he described as 'ordinary jogtrot work' – with his more glamorous new duties.

The King and his advisers, the new Surveyor prominent among them, explored the palaces from end to end as a first step to make each one 'a suitable residence for the Sovereign and his Court at the beginning of the twentieth century'. The new King had a ruthless streak and he destroyed with characteristic nervous energy the atmosphere which had been gathering thickly around the Queen since the death of the Prince Consort. 'Alas', Queen Alexandra wrote to the Empress Frederick from Buckingham Palace on 14 May 1901, 'during my absence Bertie has had all your beloved Mother's rooms dismantled and all her precious things removed.'[10] The King did not overlook the chance of revenge on at least one figure from the past. The younger Carl Sohn had painted for the Queen in 1883 a large full-length of John Brown. On 28 January 1901, less than a week after her death, it had been despatched from Windsor to William Brown of Crathie. It has now come to rest in the Scottish Tartans Society Museum at Comrie. Boehm's statue of Brown, formerly prominent outside the entrance to Balmoral, was banished to a thicket on the slopes behind the house now occupied by the Factor.

Cust once referred to Carlton House as having been 'a monument of ostentatious bad taste'; but it was unwise to provoke a comparison between the Sovereign to whom he was so uncritically devoted[11] and his great-uncle, George IV. Like his predecessor, Edward VII had endured constraints at home which led him 'to dive headlong into all the varied delights which a rich and sophisticated society had to offer'; but whereas Carlton House became one of the most beautiful of all English royal houses, there was little taste or artistic judgment to be discerned in the luxurious surroundings which Edward VII created at Sandringham and Marlborough House. The King laid claim to some flair for arrangement, but he honestly admitted to knowing little about art; in their different ways, both houses – to say nothing of York Cottage – reveal the inborn philistinism so prevalent in the ruling classes in that confident age.[12]

Cust was, in fact, a respectable scholar and a conscientious Surveyor; although he wasted time in additional duties as a Gentleman Usher, which he much enjoyed, he got through a lot of work. From 1909 to 1919 he was also Editor and Director of the *Burlington Magazine*; and in the pages of the magazine, between 1904 and 1918, he published a series of notices on pictures in the collection.[13] He compiled for the King two sumptuous volumes on the pictures at Buckingham Palace and Windsor.[14] At Hampton Court, however, the pictures and the history of the Palace had been the special preserve of Ernest Law, an energetic little barrister whose mother occupied a Grace and Favour Residence. His first *Historical Catalogue* of the pictures had appeared in 1881, to be followed by a succession of official *Guides* to the pictures at Hampton Court, Kensington and Kew. Law gratefully acknowledged the privilege of using Redgrave's sheets; and he received help from Robinson; but for some reason he declined at first to help Lionel Cust in compiling catalogues.[15] The rearrangements carried out by Cust, working in close association with the King, were, on the whole, sensible and orderly.[16] Those at Buckingham Palace, which were the most important, are embodied in the privately printed *Catalogue* (1909) which Cust prepared for the use of the King and Queen. The arrangement of some of the Prince Consort's early pictures on the Chapel Staircase and in the Royal Closet lasted until comparatively recently.

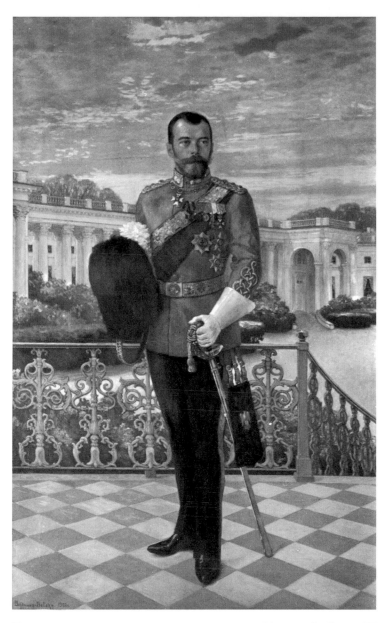

There were now over 200 pictures in the Picture Gallery. The Italian primitives had been brought up from Osborne and the finest placed in Queen Alexandra's private apartments. The state portraits of foreign rulers, presented to the King, hung in the room behind the Balcony on the east front: the Kaiser by Cope, the Emperor Francis Joseph by von Benczur, the King of Sweden by Perséus, the Tsar by Bogdanoff-Bjelski (plate 230). In the King's Corridor Cust placed a series of pictures of royal marriages and christenings which survives, virtually unchanged, today. At the same time he set the restorer Haines to work on a massive programme of cleaning and restoration.

King Edward VII, though very possessive of his collections, added little of importance to them. He had never shown any real interest in pictures since the days when he had been sent to Berlin and Rome by his father to study art and archaeology and it had become clear that he had inherited nothing of his father's intellect or curiosity; and no attempt seems to have been made by anyone around them to interest King Edward, Queen Alexandra, King George V or Queen Mary, in the modern movements in contemporary British painting, still less in what was happening on the Continent. It would be difficult to find a single important contemporary British or French picture acquired between the last years of Queen Victoria and the accession of King George VI. It is remarkable how little there is to show in the way of pictures for Edward VII's love of Paris.

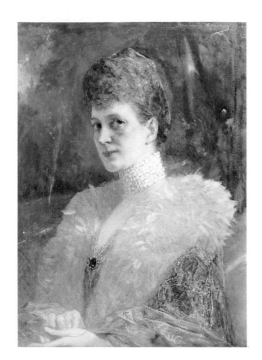

231 (far left)
BENJAMIN CONSTANT
Queen Alexandra

232 (left)
J. BASTIEN-LEPAGE
Edward VII

233 JOHN SINGER SARGENT
The Duchess of Connaught

The personal collection of Edward VII and Queen Alexandra, now to be found almost entirely at Sandringham, contained a number of family portraits by such artists as Von Angeli, Fildes, Sohn, Sant, Bauerle and Constant (plate 231); there is an unusual image (plate 232) of the King himself in Venetian sixteenth-century costume, painted by Bastien-Lepage in 1873. The worst portraits of this period are the ineffably cloying confections by Edward Hughes: the Queen, Princess Victoria and Princess Maud, all painted in 1896 and set into the panelling of the main Drawing-Room at Sandringham. Almost the only good portraits from the Edwardian period in the collection are the two Sargents of the Duke and Duchess (plate 233) of Connaught, painted in 1910, and given by Lady Patricia Ramsay to King George VI; the most glamorous royal portrait for this period is the full-length of Queen Alexandra by François Flameng which looks down from the mantelpiece of the White Drawing-Room at Buckingham Palace.

Edward VII's love of the sea and yachting is illustrated in innumerable works on a wide range of scale by his marine painter, Edouard de Martino, who was also to paint some large historical sea-pieces; he acquired pictures of shooting parties in Hungary and India; and he had many pictures, some of them good, of his favourite horses by, for example, Emil Adam (who painted Persimmon in 1896), and of his dogs. Wright Barker painted Caesar in 1905. The two painters Fred Morgan and Thomas Blinks collaborated in 1902 to produce a picture of the Queen with her three eldest grandchildren near the Kennels at Sandringham, but this was only acquired in 1957. Military subjects by Caton Woodville and Detaille were also bought by the King. Much more interesting are two very large New England landscapes, painted by George Loring Brown: a view of New York (plate 234), painted in 1850 and given to the Prince of Wales, as he then was, in New York in 1860, and the *Crown of New England*, bought in the following year as a pendant to it. Edward VII acquired works by Prinsep and by

234 GEORGE LORING BROWN
A Distant View of New York

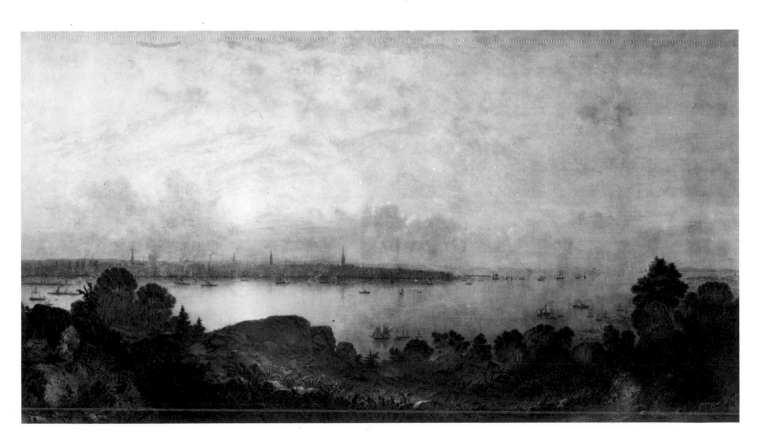

Leighton, whom he met in Rome in 1859 (and immediately liked) and who painted for him a picture of Nanna Risi, *La Nanna*; the companion, *Bianca* (plate 235) was bought by the Prince at a slightly later date.[17] Of his pictures of pretty women without much on, the best is perhaps the *Sea-Nymph* by Frost in its intricate leather frame (it hung in the King's private apartments at Buckingham Palace with others of its kind); and a nymph is prominent in one (plate 236) of the three pictures at Sandringham by Gustave Doré which the Prince is presumed to have acquired.[18] The early portrait by Watts of Lady Holland was left to the Prince by the sitter herself.[19] Of the Danish pictures in their collection, the most interesting is Tuxen's group (plate XLII) showing the Prince and Princess of Wales in Copenhagen with their children and other members of the family of King Christian IX and Queen Louise. In his private apartments at Buckingham Palace the King retained, in fact, many of his parents' pictures – Grants, Landseers, Winterhalters, Phillips, the Paton, *Ramsgate Sands*, the pieces by Delaroche and Meissonier – with his own acquisitions. The best historical portrait he acquired was Beechey's dashing three-quarter-length of George IV.

King George V had his father's intensely proprietary attitude towards his possessions. He instinctively mistrusted expertise, opposed changes in arrangement and to some extent resented the suggestion that anything could be wrong with the pictures or that money need be spent on them. Though very generous in lending pictures to exhibitions, he did not really like people writing about them; there are, for instance, indications that he had not approved of Cust's articles in the *Burlington*. To Queen Mary, however, pictures and works of art were a never-ending source of pleasure. She

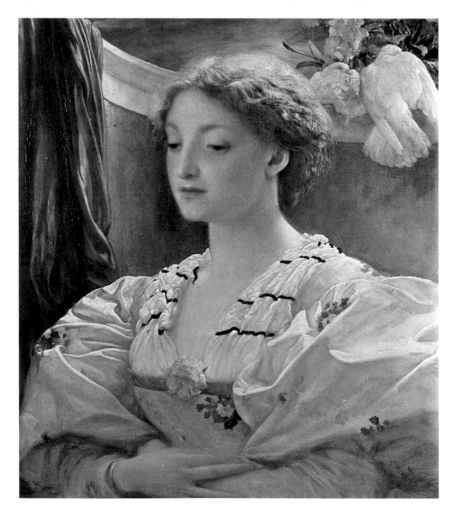

235 FREDERICK, LORD LEIGHTON *Bianca*

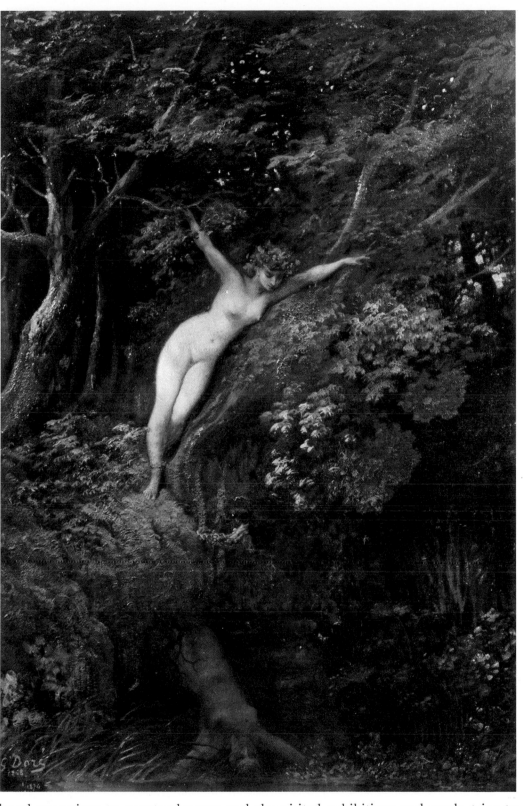

236 GUSTAVE DORÉ
A Nymph by a Pool in a Wood

loved excursions to country houses; and she visited exhibitions and made trips to favourite dealers right up to the end of her life. The last letter she wrote was to thank a friend for sending her the catalogue of the Goya exhibition at Basle.[20]

So far as pictures were concerned, however, her approach was strictly historical and, within that narrow scope, governed by an unquenchable devotion to the memory of her great-grandparents, George III and Queen Charlotte. No praise of a brother's or a child's appearance could be warmer than a hint that he or she was showing something of the well-loved features of these ancestors or their more recent descendants; of her

207

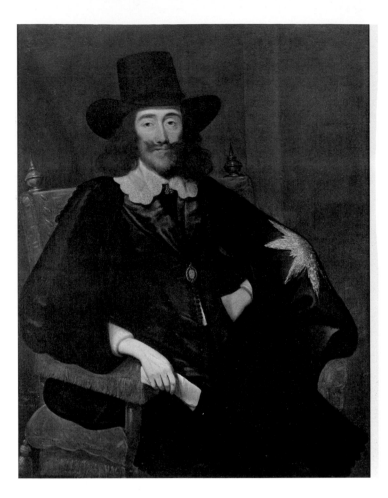

237 EDWARD BOWER
Charles I at his Trial

brother Prince Adolphus she wrote in 1890, 'his profile is lovely & he is more like the pictures of the old Royal Family than ever'.[21] A coloured print, a needlework picture, a porcelain figure or a Wedgwood plaque, the lid of a box, a Battersea enamel, proved irresistible if the image it displayed had been derived from a family portrait, even if the prototype and a number of painted derivations (which the Queen had herself probably secured) were already in the collection. In fact Queen Mary never bought a really good or important picture. Of the historical portraits she acquired, the most interesting were a Mytens of Charles I from the Sneyd collection, the group (begun by Lely and finished by Gennari) of the Duke and Duchess of York with their daughters, from Ditchley, a pair of portraits by Charles Philips of Frederick, Prince of Wales, and his wife, a Wootton of one of George I's Arabians, a fine Cotes, and good pieces by West and Beechey; but it is perhaps significant that when Bower's portrait of Charles I at his trial (plate 237) first appeared on the market (in 1947) she did not consider it a proper acquisition for the royal collection. The King and Queen also felt that in the times through which they were living it would not have been seemly, even if they thought it otherwise desirable, to spend large sums of money on pictures. This is perhaps one reason why the Queen, if she had been made aware that they were coming on the market, did not acquire such very important portraits as, for example, Wilkie's *Duke of York*, which the National Portrait Gallery acquired in 1938, or, infintely more essential for Windsor, Lawrence's full-length of Queen Charlotte which was bought in at Lord Ridley's sale at Christie's in July 1927 and which Queen Mary described at the time as a 'nice portrait'. The bequest to the King in 1914 of Sanders's delightful portrait of the young Byron may have struck a discordant note. The contemporary portraits, and pictures of royal events, which the King and Queen commissioned are unexceptionable; the best are by Cope, Birley or Munnings.

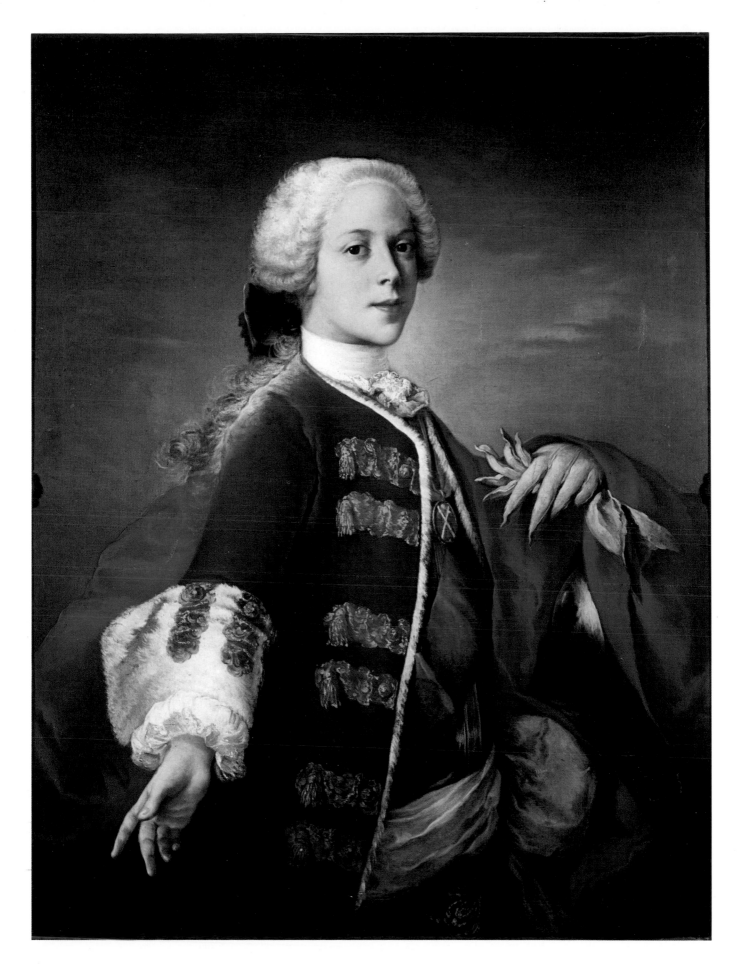

XLIX LOUIS-GABRIEL BLANCHET
Prince Henry Benedict Stuart (see page 217)

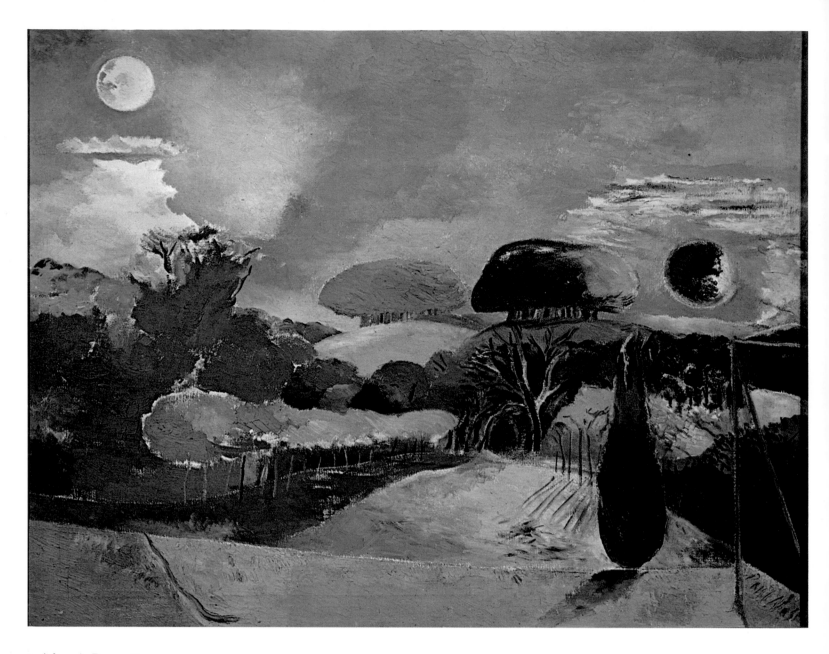

L (above) PAUL NASH
Landscape of the Vernal Equinox
(see page 210)

LI (opposite) GRAHAM SUTHERLAND
Study for Christ in Glory
(see page 220)

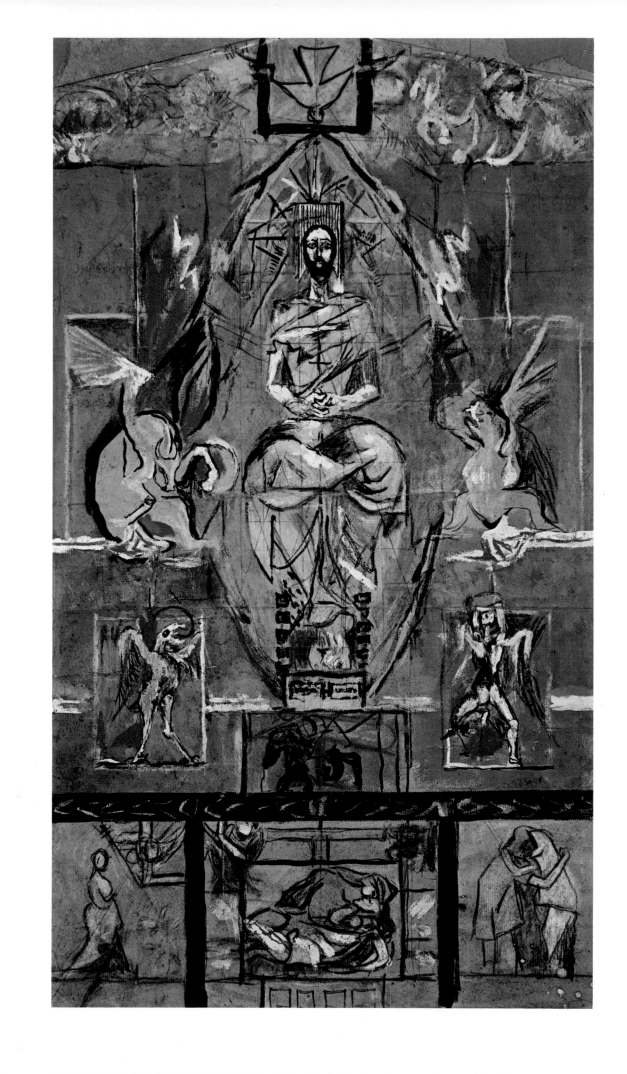

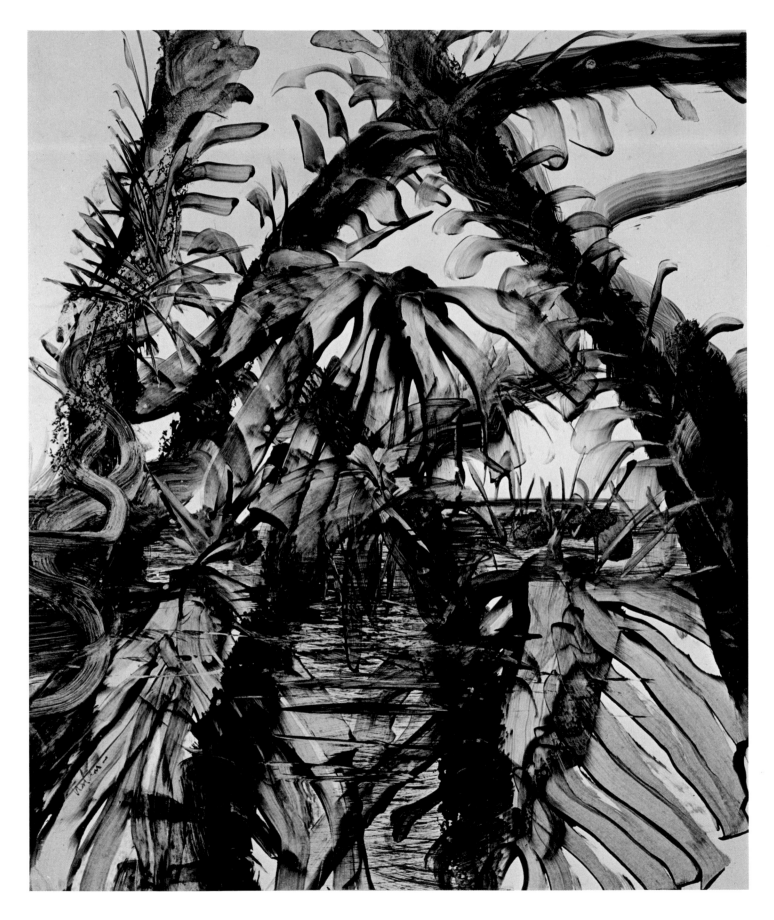

LII Sidney Robert Nolan *Strange Fruit* (see page 222)

The Queen was deeply interested in the history of the royal collection, and she had a passion for arrangement and classification: neatly labelling her acquisitions, carefully recording them in her own faultlessly compiled catalogues or tying them in with references in early sources. This reorganizing of the royal collection was, in her own words, her 'one great hobby'. She stood, in short, in the best tradition of those who, partly inspired by the Prince Consort (whom King George v described as 'an intellectual'), had begun to build up the great national collections in the nineteenth century; but she was by temperament unable to impart her knowledge, still less her enthusiasms, to the next generations.[22] Her tastes were essentially conservative and her affection for a safe pastiche of the styles of William and Mary, Queen Anne or the Georges, produced, in the reconstruction and redecoration of the Picture Gallery at Buckingham Palace,[23] for example, or of some of the rooms at Holyroodhouse, interiors which seem, to modern eyes, unimaginative and inhibiting. Her tastes can, of course, be studied in microcosm in her famous Dolls' House at Windsor.

Lionel Cust resigned the Surveyorship on 31 December 1927 (he had been knighted a fortnight previously); his successor, C. H. Collins Baker, was appointed from 2 January 1928. On 2 July 1934 Kenneth Clark succeeded to the post, after Collins Baker had been appointed to the Research Staff at the Huntington Library. In fact attempts had been made to secure Clark's services as early as the autumn of 1933, but his appointment to the Directorship of the National Gallery had prevented this. However, as Lord Clark has himself related,[24] he was dragooned by the King into accepting the position of 'expert adviser' on the royal pictures.[25] Clark and his predecessor realized that it was wholly impossible to do the job adequately, so far as the pictures were concerned, on a part-time basis, with virtually no staff and on a stringent budget.

Collins Baker, who had studied in the Royal Academy Schools and been Secretary of the New English Art Club, was Keeper and Secretary of the National Gallery. A nice and kind man, but untrained in scholarly method, he had a painter's sensitive temperament and perceptive eye, and he inspired sincere affection in those who knew him. He has been described by one of his friends as 'very unassuming and unsuspicious and totally unsnobbish and miraculously unsuited to having anything to do with a world of royal servants'.[26] Unlike Cust, Collins Baker was never happy in that world, which must at that time have been fairly formidable and, in part, unsympathetic. His belief in the largely untried and expensive methods of Kennedy North, to whom he entrusted the cleaning and relining of Mantegna's *Triumph of Caesar*, led him into further difficulties. The King himself was sceptical about Kennedy North's methods, which to him smacked of the charlatan, and aghast at the expense. Collins Baker's position became increasingly difficult. He was instructed that no pictures were to be moved and no restoration undertaken without reference to the King. In his Catalogue of the pictures at Hampton Court, which had appeared in 1929, he had been at pains to consult the eminent art historians whose names are mentioned in his Preface, but it was not difficult to make certain criticisms of it and the King's son-in-law, Lord Harewood, when Collins Baker's Catalogue of Windsor pictures was being planned, was sceptical of his new attributions, at Windsor as well as at Hampton Court: 'I could give you concrete instances at Hampton Court of labels put there by him which are ridiculous even to an amateur'.[27] Lord Harewood was of the opinion that Tancred Borenius, who published his *Catalogue of the Pictures and Drawings at Harewood House* in 1936, should be consulted about the Windsor Catalogue if it could be done without hurting the feelings of Collins Baker; and Kenneth Clark even considered that Borenius had the ideal qualifications for a Surveyor of Pictures.

Kenneth Clark soon found, in his own disarming words, that he was 'ill qualified for the kind of work expected of me'.[28] He could not, of course, in conscience swallow George v's confident assurance that there was nothing wrong with the pictures. He had neither time nor inclination to become familiar with the historical aspects of the collection. The Surveyor has to be patient with idle enquirers as well as researchers, with those who choose to pursue portraits of the Reuss-Ebersdorf or Mensdorf-Pouilly families, the iconography of royal pets, even the source of images on postage stamps as well as the *œuvre* of Cuyp. Lord Clark and his successors have never quite had the courage to follow King George's advice: 'Don't answer 'em'. At least Lord Clark has been spared, in these days of loosely planned but lavishly illustrated volumes, the disorganized importunities of the 'picture researcher' and the omnivorous demands of a television production team and its acolytes. Lord Clark enjoyed carrying out some characteristically sensitive rearrangements at Hampton Court; and it is sad to reflect that, but for the approach of war and his duties in Trafalgar Square, the collection might now reflect a little more of the special flair of one who remains, in his own words, 'obstinately committed to aesthetic values'. King George vi had assured him that he considered his pictures 'could not possibly be in better hands'. Fortunately Kenneth Clark secured the appointment on 1 April 1939, of Lionel Benedict Nicolson as his Deputy. The elder son of Harold Nicolson and Vita Sackville-West, Ben had studied at the Fogg and at I Tatti after coming down from Balliol. He rendered two signal services to the collection. In the short time available to him, he managed to bring order to a mass of documentary material which had been accumulating in the Surveyor's office, by now moved from Windsor to St James's, and, as the War drew nearer, took on himself much of the responsibility of evacuating the principal pictures to Wales and placing in safety those that remained.[29] At the end of the War Clark resigned. On 1 April 1945 he was succeeded by Anthony Blunt, at that time Reader in the History of Art in London University and Deputy Director of the Courtauld Institute.

The accession of King George vi in December 1936 is a watershed in the history of the royal collection. The King had inherited his father's pride in the pictures and Queen Mary's methodical approach to arrangement; and he took an understanding interest in the progress of the work that needed to be done, much encouraged by Queen Elizabeth's spontaneous enjoyment of good, amusing or attractive pictures. 'The Queen's choice of pictures', an old friend once wrote, 'is very apt to depend upon the pleasure which their contemplation gives her'. A new purchase, the surprise appearance of a picture after restoration, ideas for a new display, suggestions for frames, could add to the happiness of the day.

Queen Elizabeth has also assembled a small, but very distinguished, collection of French Impressionist and modern English pictures. Although they do not form part of the royal collection, they play a very special part in the history of royal connoisseurship in modern times. The most important are, of course, *The Rock* (plate 238) by Monet and the Sisley of the *Seine near St Cloud* (plate 239). Good English pictures hang with them: by, for example, Steer, Charles Sims, Sickert, Dame Ethel Walker, Sir William Nicholson (plate 240), Alfred Stephens, John (e.g., plate 241), Lowry, Matthew Smith (plate 242), Duncan Grant, Paul Nash (plate L) and Rodrigo Moynihan. An interesting group of Australian pictures includes works by Nolan, Drysdale, Kenneth Jack and Clifton Pugh. Among earlier British pictures are two particularly pretty sketches by Wilkie, one of them being the intriguing group of Queen Victoria as a girl with members of her family in 1836; sporting pieces, among them a good Seymour and

238 CLAUDE MONET
The Rock

239 ALFRED SISLEY
The Seine near St Cloud

240 SIR WILLIAM NICHOLSON
The Gold Jug

some very attractive pieces by J. F. Herring, associated with the Earl of Strathmore (plate 243); and Millais's *Eve of St Agnes*. The views of Windsor by John Piper are original essays in the tradition of the Sandbys or Joseph Nash. Edward Seago was always a favourite painter. Of the historical portraits which have such an appeal for Queen Elizabeth, the most important are a fine version of Largillierre's double portrait of Prince James Francis Edward and his sister, the amusing full-length by Simon Verelst of Charles II, and the poignant Bower (plate 237) of Charles I on trial. Among the pictures bought for the royal collection by the King were a sketch by Sebastiano Ricci for the huge *Feast in the House of Simon*, Kneller's portrait of Henry Wise, a Frye of Frederick, Prince of Wales, and Leonard Knyff's bird's-eye view of Hampton Court.[30]

The post-War phase in the history of the collection was initiated by the great exhibition, *The King's Pictures*, at the Royal Academy in the winter of 1946–7, the first large exhibition to be mounted in London after the War and seen by over 366,000 visitors. Queen Mary, in her diary, recorded her visit on 23 October 1946:

. . . At 3. to Royal Academy to see the wonderful colln. of pictures from Buck. Palace, Windsor, St. James's, Hampton Court., & Holyrood which Bertie has lent for the winter exh. Met Bertie & all the family there, many artists etc – The pictures looked lovely & were well hung by Mr. Blunt & the Committee, all the rooms were filled – A most enjoyable afternoon . . .

The Committee and Hanging Committee were composed of Academicians and members of the Royal Household. On the Hanging Committee was the Hon. Sir

241 AUGUSTUS JOHN
Dorelia and Caspar

242 SIR MATTHEW SMITH
Still-Life: Jugs and Apples

Richard Molyneux, KCVO, whose manner and appearance will not be forgotten by those who enjoyed his friendship. Rather deaf, always immaculately dressed in the style of the previous reign and with a head which was like a smaller, aristocratic and faultlessly groomed version of Sir C. Aubrey Smith in the part of Colonel Sapt in *The Prisoner of Zenda*, he had been a regular officer in the Blues and a courtier for many years, though by now officially only an Extra Equerry to Queen Mary. For most of his life he had devoted his time to the conventional seasonal peregrination and the slaughter of game; but he had once been kept indoors by a cold when staying at Knole. Sir John Murray Scott, who was also in the house-party, suggested he might, instead of bemoaning the loss of a day at the pheasants, enjoy a look at the contents of the house. A morning that had started badly led to the Damascus road and thereafter he derived enormous pleasure from works of art. Moreover, he used his friendship with the royal family to encourage enjoyment in pictures and furniture, to suggest many improvements in display and to clean some pictures. Dick Molyneux, a very good, kind friend to the Surveyors, deserves a niche in the annals of the collection, as an example perhaps of the influential courtier, with lots of spare time, who may have gone unsung in earlier reigns but exercised a valuable influence. Also on the Committee was Sir Owen Morshead of whose support, wisdom and hospitality the Surveyors all have the tenderest memories.

The catalogue of *The King's Pictures* embodied much new information and contained Anthony Blunt's history of the collection. He and Ben Nicolson had borne the brunt of selection (with the help of Sir Gerald Kelly, who had originally thought of such an exhibition, and Sir Ellis Waterhouse) and cataloguing. Ellis Waterhouse had prepared the entries for the English portraits and Dutch pictures, Ludwig Burchard drafted

entries on the subject-pictures by Rubens and Van Dyck which hung in Gallery VIII, and Sir Martin Davies and Dr F. Grossmann gave assistance with the early Flemish and German pictures. This little volume was the nucleus of a new full-scale Catalogue Raisonné the preparation of which, in collaboration with colleagues from outside, has been one of the most important of the Surveyor's preoccupations in the age of enlightenment that Anthony Blunt's appointment ushered in.[31] The new Catalogue has been planned to cover the pictures by Schools instead of, as in the past, by palaces, because that classification can so rapidly become out of date. In the preparation of entries, the pictures are all (with the exception of a small number of enormous or inaccessible canvases) removed from the wall and examined in a revealing light; and the marshalling and indexing of a considerable quantity of documentary material, much of it untapped before, has provided the basis of fuller and more precise provenances than had been constructed earlier. These have in many cases dispelled some hoary traditions and helped to provide more valid attributions as well as more accurate identifications. So far entries for just over 1600 pictures have been published. With the help of our colleagues entries are at least in draft for a further substantial part of the collection.

The rearrangements of the pictures since the present Queen came to the throne have been so extensive that almost no room in any of the palaces, so far as the pictures are concerned, looks as it did in 1952. The State Apartments at Windsor, for example, have been redecorated and this has meant altering dispositions which, in essence, went back almost to the time of William IV; but to have weeded out of the Van Dyck Room studio pieces and copies, to have displayed the remainder in the Queen's Drawing-Room (thereby making the old Van Dyck Room – now the Ball Room – available for eighteenth-century pictures) and, above all, to have made of one small room, the King's Dressing-Room, a 'Cabinet Room' in which the finest pictures in the Castle (and from elsewhere) have been assembled, must surely be counted as beneficial. Flexibility and adaptability to change give the general public and those who live and work in the palaces more varied pleasure in the Queen's pictures than the old unchanging patterns could provide, fascinating though they may seem when seen in the watercolour views of Pyne or Joseph Nash. Nevertheless there is much that can be learned from past arrangements, especially in the confident use of strong colours in the fabrics seen in these views. From looking at these watercolours and from practical experience one realizes that a desire to improve an arrangement or the appearance of a picture must take into account the style in which rooms are decorated, and be tempered with respect for earlier Surveyors and those for whom they worked.

It seemed a good idea, in a fit of purist enthusiasm when Canaletto's two *Views of London* were cleaned in 1964, to take off the frames the additions and enrichments put on by Crouzet for George IV. Now, though the pictures would look entirely right in a rococo interior in Consul Smith's residence, they lack the sheer physical presence which George IV and his advisers realized they would need in his new Corridor. Two unnecessarily immense frames, for Van Dyck's companion portraits of Henrietta Maria, made in the time of George IV (they can be discerned on either side of the fireplace in plate 186), were replaced in the same spirit by narrow frames of the Sunderland type which would be correct in the Long Gallery at Althorp but look insignificant in a state room at Windsor. To replace the awful frames put on the Dutch pictures in the Picture Gallery at Buckingham Palace must be right; but the black and brown frames which in isolation do so much for the pictures, are not easy to incorporate in a room which is heavily enriched with fabrics and gilding. On the other hand, when

the Prince Consort gathered together the early portraits in the Holbein Room at Windsor, he put them in frames of uniform size and pattern, building out the portraits which were too small to fit them. To have restored these important early images to their true proportions and to put them in appropriate frames has literally brought them back to life. At Hampton Court, Kensington and Kew much has been done in collaboration with the Department of the Environment. The arrangement of pictures in the two last palaces had been for a long time shamefully unimaginative and depressing; but the interiors of both houses have now been charmingly done up. Kew contains a selection of portraits of the time when George III and his family lived there and of small pictures he had acquired. At Kensington a much more ambitious operation was undertaken: to show, so far as the pictures were concerned, a little of the importance of Kensington in the early Hanoverian period, to hang the King's Gallery with a range of pictures of which William III might have approved, and to embellish the rooms associated with Queen Victoria with suitable portraits and some of the most important English pictures acquired early in her reign.

The most significant development in the showing of the Queen's pictures to the public was the opening in July 1962 of the first exhibition at The Queen's Gallery at Buckingham Palace. The Gallery was constructed in one of the conservatories on John Nash's garden front which had been converted by Blore in 1842–3 into the Private Chapel, which had been in turn badly damaged in the War. To build a public picture gallery in the garden of Buckingham Palace was an idea that had originated in the time of Kenneth Clark; and in adapting the ruined Chapel to this purpose the Queen, the Duke of Edinburgh and those involved with them in the scheme – principally the late Lord Plunket[32] and the Minister of Works (Lord Molson) – were developing this conception. From the beginning the Queen and the Duke of Edinburgh let it be understood that the Surveyors could count on being able to borrow for exhibitions in the new Gallery pictures and works of art from all parts of the collection, wherever they might normally be housed. With characteristic persistence and good taste, strengthened sometimes with a necessary touch of ruthlessness, Patrick Plunket succeeded in improving the interior decoration and lighting of the little Gallery. It can be argued that the Gallery is too small and therefore allows very little modification in methods of display. Nevertheless, in the first twelve years of its existence more than 1,700,000 people have passed through the turnstiles and it has provided opportunities to put on show pictures, which might not normally be on view, in exhibitions which have been planned to illustrate the work of individual artists or a variety of themes. Apart from the first exhibition, an anthology of treasures from the collection, the most popular exhibitions have been those which have attracted the public with a big name: Van Dyck, Gainsborough or Leonardo.

To commemorate the opening of the Gallery, the *Burlington Magazine* devoted its number for August 1962 to the royal collection. 'Anyone', wrote Benedict Nicolson in the Editorial, 'who retains a clear impression of the great exhibition of the King's Pictures at the Royal Academy in 1946–7 . . . will be struck by the remarkable change that the masterpieces of the collection have undergone over the last fifteen years . . . the majority has been sensitively cleaned and restored and many are in fine, newly acquired frames . . . Indeed, so unobtrusive is the restoration, so free from idiosyncrasies, that no-one could say which restorer has been responsible for which picture.' Plans for cleaning and restoration are inevitably to some extent linked with plans for exhibitions in the Gallery; but since the War very many pictures throughout the collection have been cleaned and most of the really important pieces have received attention.

In general the problems of conservation in the collection are unique. It is vast in size; and below the level of the masterpieces is a broad stratum of pictures, many of them important and interesting, on which the insensitive handling of cleaners and liners who have worked on them since the days of the Stuarts have added to the difficulties which face a restorer who tackles them today. The large number of nineteenth-century canvases present a special problem. Many of them are very large; almost all of them are due for relining. It can, moreover, cost as much to line and clean a full-length Winterhalter as it does to clean a Gainsborough; and the cleaning and lining of a late Wilkie or a canvas by Frith or Landseer may require more sensitivity and patience than the restoration of a Steen or an Ostade acquired by George iv. Determined efforts need to be sustained, therefore, to arrest deterioration of works which may be aesthetically unimportant but are integral parts of the collection, as well as to continue the cleaning and restoration of the best and most prominently displayed pictures; and in times such as these the cost of maintaining the collection in the condition it deserves would be formidable. The outstanding single achievement of the reign in this context has been the restoration and new presentation, in the Lower Orangery at Hampton Court, of Mantegna's *Triumph of Caesar*, that great work of art whose fate runs uneasily through the story of the collection since the time of Charles i. The presentation in the reconstructed and air-conditioned Lower Orangery is the most impressive monument to fruitful collaboration between the Department of the Environment and the Lord Chamberlain's Office; and restoration of the canvases themselves must always be regarded as the chief memorial to Anthony Blunt's Surveyorship: to his own sense of values and idealism and to the enduring energy and devotion to a Herculean task, to say nothing of unsurpassed technical skill, with which Mr John Brealey, whom Anthony Blunt entrusted with the task as early as 1962, brought the work to a genuinely triumphant conclusion in 1975.

In steady encouragement in the work of research, display and conservation, and in the acquisitions made by the Queen and the Duke of Edinburgh, the years since their marriage have been the most fruitful and stimulating since the death of the Prince Consort.

The Queen has added important historical portraits to the royal collection. In 1955, at the time of the raising of funds for the restoration of Winchester Cathedral, the Queen acquired from the Dean and Chapter Honthorst's group of the children of the King and Queen of Bohemia (plate 244) which can be traced back to the possession of Ruperta Howe and thus, almost certainly, to the collection of her father, Prince Rupert. In Lord Darnley's sale in 1957 the Queen acquired possibly the most distinguished full-length of Charles i painted before his accession, a portrait probably painted by the brother of the Surveyor of Pictures. Of the pictures bequeathed to the royal collection by Cornelia, Countess of Craven, in 1961 (a gesture inspired long ago by Queen Elizabeth and Dick Molyneux), the most valuable additions were a splendid *ad vivum* full-length of Charles i by Daniel Mytens and the portrait of Charles ii, when Prince of Wales, painted at Oxford by Dobson in 1644. In 1966 the Queen, in conjunction with the Holyrood Amenity Trust, bought for Holyrood the enchanting pair of portraits by Louis-Gabriel Blanchet of Prince Charles Edward Stuart and his younger brother Prince Henry Benedict (plate XLIX).[33] They are more important than the sad exiled images which had come into George iv's possession in 1819; and the portrait of the elder boy is a much-needed corrective to Pettie's *Bonnie Prince Charlie* at Holyroodhouse, which might be chosen in an unguarded moment as a jacket for a novel by D. K. Broster, but would be more at home on a tin of Edinburgh rock in Prince's Street.

The Hanoverian portraits which have been acquired are more important than those bought by Queen Mary. The full-length by Jacopo Amigoni of Anne, Princess Royal, painted for Lord Hardwicke at the time of her marriage in 1734, was acquired in 1954. One – possibly the first – of two *modelli* which Hogarth, a few years earlier, had produced for a conversation-piece of the family of George II, was bought in 1955. In 1957 the Queen acquired the most interesting little sketch by Zoffany for his group of the family of George III in Van Dyck dress: apparently the only example in Zoffany's work of such a preparatory study for a composition and containing interesting differences from the finished picture in costume and posture. Another good acquisition was Alexander Nasmyth's view, painted in 1824, of the Lawn Market in Edinburgh, showing the demolition of the old Weigh House before the visit of George IV. In 1975 Kneller's portrait, painted in 1715, of Mehemet (plate 245), George I's closest personal servant, his Keeper of the Closet and Groom of the Chamber, was bought by the Queen. Two exceptionally fine miniatures have also been acquired: in 1960 a scintillating image of Henrietta Maria (plate XLVIII), bought as an item by Hoskins which had been in the collection of Charles I but apparently bearing on the reverse the initials of Samuel Cooper; and, in 1953, the portrait of Hugh May (plate XLIV), the

244 GERRIT VAN HONTHORST
The Children of the King and Queen of Bohemia

245 SIR GODFREY KNELLER
Mehemet

architect entrusted by Charles II with the remodelling of the State Apartments at Windsor, which, even in company with the Coopers already in the collection, stands out as a compellingly sympathetic – and marvellously preserved – likeness. Finally, in 1962 the Queen bought back for the collection the miniature which had belonged to Charles I and had been catalogued by Van der Doort as 'supposed to have bin Queene Elizabeth before shee came to the Crowne'.

At the same time a collection of modern pictures has been made. At the time of their marriage the Queen and Prince Philip selected, as one of their wedding presents, a painting of *Tamaris* by Paul Nash from a number submitted to them as the possible nucleus of a collection of modern English pictures. In 1960 a small committee was set up, within the Household and under Anthony Blunt's chairmanship, to stimulate the acquisition of works of art by contemporary British and Commonwealth artists either for the royal collection or as presents to visiting Heads of State and other important

246 (above) IVON HITCHENS
Firwood Ride, Gentle Spring

247 (left) SIR ROBIN
DARWIN *Castle Howard*

persons. In that year eleven pictures were acquired: by Roger de Grey, Mary Fedden, Ivon Hitchens (plate 246), Wirth Miller, Robin Darwin (plate 247), James Taylor, Kenneth Rowntree (two by him), Sydney Nolan, Barbara Hepworth and Alan Davie (plate 248). These had been selected by the Queen and were hung in the suite of rooms in Edward III Tower at Windsor which had been newly redecorated by Sir Hugh Casson. *The Carriage* by Lowry (plate 249) was acquired in 1963. In 1957 the Queen had commissioned Graham Sutherland to paint two pictures; one was given to the visiting President of Portugal, the other, the *Armillary Sphere* was retained; and in 1962 the Queen bought from the Marlborough Gallery the large *Christ in Glory* (plate LI), which is one of the preparatory studies for the tapestry in Coventry Cathedral.

248 ALAN DAVIE
Throne of the Eye Goddess

249 L. S. LOWRY
The Carriage

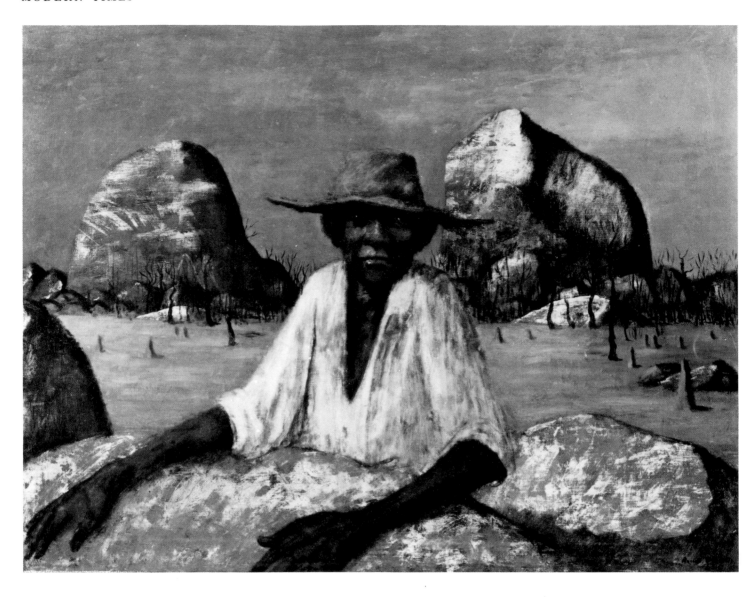

These English pictures have been complemented by a good small collection of Australian pictures. An *Australian Landscape* by Nolan had been included in the purchase made in 1960; his finely wrought *Strange Fruit* (plate LII) was given to Prince Philip in Perth in 1962 and in the following year the Queen bought for the Duke Nolan's *Herd at the Waterhole*. Russell Drysdale's *Man in a Landscape* (plate 250) was given to the Queen in 1963, on the occasion of her visit to Australia, by the Government and People of the Australian Commonwealth; and two pictures by William Dobell, *Country Race Meeting* and *Beach Carnival*, were presented by the artist in 1961. The Duke of Edinburgh began to collect aboriginal paintings during his visit to Australia in 1956 and in 1963 two pictures by Rex Batterbee, by whom the aboriginal painters were first inspired, were bought.

A number of contemporary painters are represented by drawings, commissioned, presented or acquired, which fall technically outside the scope of this survey; and in the Queen's and Queen Elizabeth's collections are works by popular or more conventional artists such as Cundall, Norman Wilkinson, Topolski, James Gunn, Gerald Kelly, Winston Churchill – and De Laszlo and Birley from an earlier period – and many lesser pieces of royal horses, dogs and events. Of the numerous works by Seago, the most interesting are those painted on board H.M.Y. *Britannia* on the Duke of Edinburgh's

250 SIR RUSSELL DRYSDALE
Man in a Landscape

tour in 1956–7. Many pictures have been acquired by the Queen and the Duke of Edinburgh, for Holyroodhouse, at the annual exhibitions of the Royal Scottish Academy.

It would not be possible nowadays to fill the gaps in the royal collection, to buy for instance the large Turner or Constable or the important Pre-Raphaelite which one feels the Prince Regent or Prince Albert ought to have acquired; but to fill a gap from an art-historical motive would perhaps be to misunderstand the nature of the Queen's collection as it is today. Two of the motives which give it its character, an interest in royal historical portraits and a desire to encourage contemporary British (and Commonwealth) painting are, as we have seen, very much alive. The collection still fulfils its ancient threefold function. The pictures enrich the private apartments of the Royal Family; in state rooms at Buckingham Palace they give pleasure to the thousands who are received, entertained or honoured by the Queen in the course of the year; and in the State Apartments at Windsor as well as at Hampton Court, Kensington, Holyroodhouse and Kew they are a chief attraction for visitors. For the new displays, especially those in The Queen's Gallery, the pictures have been more frequently moved about than was conceivable in the past. Since the Second World War, moreover, an enormous number of pictures have been lent from the collection to exhibitions in the United Kingdom and overseas, in the generous tradition established in the time of Queen Victoria. At the present time, therefore, it is true to say that more and more people are enabled to enjoy more of the Queen's pictures, and with fuller understanding, than at any time in their history.

NOTES

BIBLIOGRAPHICAL NOTE

A full bibliography of the sources for the history of the Queen's pictures will be found in the volumes, listed below, by Mr Michael Levey and myself. I have refrained from providing references in every instance to these volumes and have restricted bibliographical references in the main to those which provide information which has come to light since they were published. The catalogues of the following exhibitions in The Queen's Gallery provide a certain amount of specialized information: *George IV and the Arts of France* (1966), *Animal Painting* (1966–7), *Van Dyck* (1968), *Gainsborough* (1970), *Dutch Pictures* (1971–2), *George III* (1974–5).

ABBREVIATIONS

B.M.	British Museum.
Burl. Mag.	*The Burlington Magazine.*
D. of Cornwall MSS.	MSS. in the Duchy of Cornwall Office.
Levey	M. Levey, *The Later Italian Pictures in the Collection of H.M. The Queen* (1964).
Millar	O. Millar, *The Tudor, Stuart and Early Georgian* (1963) and *The Later Georgian* (1969) *Pictures in the Collection of H.M. The Queen.*
Pyne	W. H. Pyne, *The History of the Royal Residences*, 3 vols. (1819).
P.R.O.	Public Record Office.
Sainsbury	W. N. Sainsbury, *Original Unpublished Papers . . .* (1859).
Sale	'The Inventories and Valuations of the King's Goods', ed. O. Millar, *Walpole Society*, vol. XLIII (1972).
Van der Doort	'Abraham van der Doort's Catalogue of the Collections of Charles I', ed. O. Millar, ibid., vol. XXXVII (1960).
Vertue	G. Vertue, *Notebooks*, 6 vols. with index vol., ibid., vol. XVIII (1930), XX (1932), XXII (1934), XXIV (1936), XXVI (1938), XXIX (1947), XXX (1955).
Walpole, *Visits*	H. Walpole, 'Journals of Visits to Country Seats, &c.', ibid., vol. XVI (1928), pp. 9–80.
W.R.A.	Windsor, Royal Archives.

CHAPTER ONE

1. Comte de Laborde, *Les Ducs de Bourgogne*, seconde partie, *Preuves*, I (Paris, 1849), p. 97. I am grateful to Dr Lorne Campbell for giving me this reference.

2. *Treasures of Art in Great Britain* (1854), vol. II, p. 437.

3. *Van der Doort*, pp. 23–34.

4. The inventories were edited as *Three Inventories . . . of Pictures in the Collections of Henry VIII & Edward VI* by W. A. Shaw (1937).

5. Research using the science of dendrochronology has produced the dates 1534–40 as the likely period of use of the panel on which *Edward IV* is painted, and 1518–23 for the other three (J. Fletcher, 'Tree Ring Dates for some Panel Paintings in England', *Burl. Mag.*, vol. CXVI (1974), pp. 250–8). See also Pamela Tudor-Craig, *Richard III*, National Portrait Gallery (1973), p. 80, P4, P44.

6. Dr Lorne Campbell has suggested that the portrait of Margaret of Savoy may be one of those sent to Henry VII in 1505, when negotiations were undertaken for her possible marriage to Henry VIII, perhaps the one for which Pieter van Coninxloo was paid in October of that year. The *Louis XII* should perhaps be associated with the moment when he was, in 1514, seeking the hand of Mary, Henry VIII's sister, in marriage (see Grete Ring in *Burl. Mag.*, vol. LXXXIX (1947), p. 236). Christina of Denmark, the youngest child in the Mabuse, was under consideration as a bride for Henry VIII after the death of Jane Seymour.

7. Millar, *Tudor, Stuart*, p. 12. For the exchange of portraits in diplomacy in the time of Elizabeth I see R. Strong, *Portraits of Queen Elizabeth* (1963), pp. 23–7.

8. W. B. Rye, *England as seen by Foreigners* (1865), pp. 18–19, 99.

9. To the discussion of these in Millar, Nos. 23, 24 and 25, add R. Strong, *Holbein and Henry VIII* (1967), pp. 25–6; he considers them to be Elizabethan copies of lost Tudor frescoes. A painting of the Battle of Pavia, now in the Armouries, Tower of London, may have been in the Tudor collection and is clearly by the same hand as *The Meeting of Henry VIII and Maximilian I*.

10. P. Pouncey, 'Girolamo da Treviso in the Service of Henry VIII', *Burl. Mag.*, vol. XCV (1953), pp. 208–11; see R. Strong, op. cit., p. 9.

11. A *Holy Family with an Angel playing the Lute* at Hatfield, which was almost certainly No. 105 in the inventory of 1547, is the only one of Henry VIII's religious pictures which can be identified (E. Auerbach and C. Kingsley Adams, *Paintings and Sculpture at Hatfield House* (1971), No. 102).

12. 'Nicholas Hilliard's Treatise concerning "The Arte of Limning"', ed. P. Norman, *Walpole Soc.*, vol. I (1912), p. 28.

13. E. Dhanens, *Het Retabel van het Lam Gods* (Ghent, 1965), p. 116; M. J. Friedländer, *Die Altniederländische Malerei*, vol. VII (Berlin, 1929), p. 113.

CHAPTER TWO

1. *Calendar of State Papers, Domestic*, (1611–18), (1858), p. 96.

2. The inventory of Somerset (or Denmark) House, drawn up by virtue of the King's commission dated 19 April 1619, is in the Duchy of Cornwall Office.

3. *Van der Doort*, pp. 196–8.

4. R. Strong, *The English Icon* (1969), p. 88.

5. D. Thomson, *Painting in Scotland 1570–1650*, Scottish National Portrait Gallery, Edinburgh (1975), No. 8.

6. These included the two contemporary Flemish scenes from the Life of Christ in the Montreal Museum of Fine Arts (see J. Steegman in *Burl. Mag.*, vol. XCIX (1957), pp. 379–80).

7. The Oatlands inventories, preserved at Glynde Place, are dated October 1616 and 7 October 1617; of the later document there are revisions made in 1618. The Glynde MSS. include other interesting notes about the maintenance of the collection, including arrangements for some of the Queen's pictures to be sent, apparently by boat, to be hung in her gallery at Hampton Court. Salamon Mansell was paid in 1616 for a frame made for the Queen.

8. C. Thompson and L. Campbell, *Hugo van der Goes and the Trinity Panels in Edinburgh* (1974).

9. *Van der Doort*, p. 107.

10. Book I, chapter VIII of *The Book named The Governer* (1531).

11. T. Birch, *The Life of Henry, Prince of Wales* (1760), p. 389.

12. ibid., pp. 485–6, 487, 489, 491, 496, 499.

13. J. G. van Gelder, 'Notes on the Royal Collection – IV: The "Dutch Gift" of 1610 . . .', *Burl. Mag.*, vol. CV (1963), pp. 541–4; see also J. Walsh, Jr., 'The Dutch marine painters Jan and Julius Porcellis – I', ibid., vol. CXVI (1974), pp. 654–7.

14. *Calendar of State Papers, Venetian*, vol. XII (1905), p. 106.

15. *The History of the King's Works*, ed. H. M. Colvin, vol. III, part I (1975), pp. 121–7. It is clear from documents printed therein that the Florentine artist, Constantino de' Servi, was active in the Prince's service; and may have painted the horse in his equestrian portrait at Parham Park.

16. W. B. Rye, op. cit., pp. 159–67. The Duke noticed the Prince's *Battle of Pavia*; his marine paintings ('particularly fine'); two paintings of gardens and palaces 'perspectively painted', presumably in the tradition of De Vries; and a Kitchen Scene.

17. *Sale*, p. 305.

18. *Van der Doort*, p. 185.

19. P.R.O., S.P. 14/57, 87. A painting of *The Parable of the Tares* from Prince Henry's collection is at Somerville College, Oxford (Ashmolean Museum, *Dutch Pictures in Oxford* (1975), No. 9, attributed to Abraham Bloemaert; but see C. Brown in *Burl. Mag.*, vol. CXVII (1975), p. 495).

20. K. Watson and C. Avery, 'Medici and Stuart . . .', *Burl. Mag.*, vol. CXV (1973), pp. 493–507.

CHAPTER THREE

1. Sainsbury, pp. 273–8.

2. The picture is now in the Kunsthistorisches Museum, Vienna. The inventory of Buckingham's pictures at York House, drawn up in 1635, was printed by R. Davies in the *Burl. Mag.*, vol. X (1907), pp. 376–82.

3. *Calendar of State Papers, Venetian*, vol. XVII (1905), p. 452.

4. M. Kusche, *Juan Pantoja de la Cruz* (Madrid, 1964), pp. 145–6, 154, 244. A full-length of James I in the Prado (1954) may have been a portrait sent in exchange; *Calendar of State Papers, Venetian*, vol. X (1900), pp. 97–8; M. de Maeyer, *Albrecht en Isabella en de Schilderkunst* (Brussels, 1955), p. 278.

5. National Library of Scotland, Misc. MSS. 1879.

6. *Van der Doort*, p. 19; P.R.O., S.P. 94/28/223, a reference most kindly given to me by Father A. Loomie, S.J.

7. Pacheco, the artist's father-in-law, wrote: '*Hizo también de camino un bosquexo del Príncipe de Gales, que le dió cien escudos*' (*Velazquez*, Instituto Diego Velázquez, Madrid (1960), p. 16; J. López-Rey, *Velazquez' Work and World* (1968), p. 40).

8. J. Shearman, *Raphael's Cartoons in the Collection of H.M. The Queen* (1972), pp. 145–7.

9. E. Harris, 'Velázquez and Charles I', *Journal of the Warburg and Courtauld Institutes*, vol. XXX (1967), pp. 414–19; E. du Gué Trapier, 'Sir Arthur Hopton and the interchange of paintings . . .', *Connoisseur*, vol. CLXIV (1967), pp. 239–43, vol. CLXV (1967), pp. 60–3. The three Spanish royal portraits were hung at Somerset House (*Sale*, pp. 317, 319).

10. F. Grossmann in *Burl. Mag.*, vol. XCIII (1951), p. 25; *The Letters of Peter Paul Rubens*, ed. R. S. Magurn (Cambridge, Mass., 1955), pp. 101–2 (10 January 1625); Sainsbury, pp. 56–8, 355. Before he became King, Charles I had also acquired Rubens's very early portrait, now at Saltram, of Francesco Gonzaga (M. Jaffé, 'The Deceased Young Duke of Mantua's Brother', *Burl. Mag.*, vol. CIII (1961), pp. 374–8).

11. *A Panegyrick to King Charles* in *Reliquiæ Wottoniæ* (1651).

12. *Academie der Bau-, Bild- und Mahlerey-Künste von 1675*, ed. A. R. Peltzer (Munich, 1925), pp. 22–5.

13. Letters to Dupuy and Peiresc, 8 and 9 August 1629 (ed. R. S. Magurn, op. cit., pp. 320, 322).

14. R. W. Lightbown, 'Van Dyck and the purchase of paintings for the English Court', *Burl. Mag.*, vol. CXI (1969), pp. 418–21.

15. *Memoirs of the Life of Colonel Hutchinson*, ed. C. H. Firth (1885), vol. I, pp. 119–20.

16. The picture is now in the National Museum in Warsaw (954): *Catalogue of Paintings in Foreign Schools*, vol. II (Warsaw, 1970), p. 34.

17. *Van der Doort*, pp. 22, 40, 45, 79, 81, 89, 158, 190. The

portrait of a young woman by Bellini, in the exchange with the Third Earl of Pembroke, was sold at Sotheby's on 24 March 1976 (6) as by Catena.

18. *Van der Doort*, p. 161.

19. G. Burnet, *Memoirs of the Lives . . . of James and William Dukes of Hamilton etc.* (1878), pp. 28–9.

20. The Cranach, an *Adam and Eve*, was last seen at Christie's, 20 March 1959 (54).

21. *Van der Doort*, p. 62. The picture, now in a private collection, was brought to my notice by Dr. Paul Boerlin of the Kunstmuseum, Basel.

22. M. J. Friedländer and J. Rosenberg, *Die Gemäldte von Lucas Cranach* (Berlin, 1932), p. 28.

23. Now in the National Gallery of Art, Washington, D.C. (M. Jaffé, *Report and Studies* (Washington, 1970), pp. 7–18).

24. *Sale*, p. 64.

25. W. Vaughan, *Endymion Porter and William Dobson*, Tate Gallery (1970), pp. 10–11.

26. F. C. Springell, *Connoisseur and Diplomat* (1963), pp. 86, 129–31.

27. *Calendar of State Papers, Domestic (1660–1)*, (1860), p. 23.

28. Sainsbury, pp. 311–13.

29. Information kindly given to me by Mr David Howarth.

30. A. Luzio, *La Galleria dei Gonzaga venduta all'Inghilterra* (Milan, 1913), and Sainsbury, pp. 320–40. Pictures acquired with the Mantuan collection are indexed as such in *Van der Doort*. I am very grateful to Mr F. Lanier Graham for allowing me to read his thesis, *The Earlier Life and Work of Nicholas Lanier (1588–1666), Collector of Paintings and Drawings* (Faculty of Philosophy, Columbia University, 1965).

31. R. Wittkower, 'Inigo Jones – Puritanissimo Fiero', *Burl. Mag.*, vol. XC (1948), pp. 50–1.

32. *Van der Doort*, pp. 173–5, 179, 180, 191–2; notebook of R. Symonds, B.M. Egerton MS. 1636, f. 30; references most kindly given to me by Sir John Summerson: P.R.O., E.351, 3265, 3267, 3269, 3270; A.O.I. 2429/71.

33. R. Strong, *Portraits of Queen Elizabeth I* (1963), p. 27; D. H. Willson, *King James VI and I* (1956), p. 433.

34. Mary F. S. Hervey, *The Life . . . of Thomas Howard Earl of Arundel* (1921), p. 393; J. Bruyn and O. Millar, 'The "Dutch Gift" to Charles I', *Burl. Mag.*, vol. CIV (1962), pp. 291–4; Staatliche Kunstsammlungen Dresden, *Niederländische Malerei 15. und 16. Jahrhundert* (1966), pp. 28–31; K. Garas, 'Die Entstehung der Galerie des Erzherzogs Leopold Wilhelm', *Jahrbuch der Kunsthistorischen Sammlungen*, vol. LXIII (Vienna, 1967), pp. 61–2. The King also owned good examples by Jan Provost, Jan van Hemessen and Gooswijn van der Weyden, all still in the collection.

35. P. de la Serre, *Histoire de l'Entrée de la Reyne Mère . . .* (1639); *Van der Doort*, pp. 226–8.

36. Millar, *Tudor, Stuart*, pp. 16–20; M. Levey, *Painting at Court* (1971), pp. 124–33.

37. For Charles I's collection of contemporary Italian pictures, see especially Levey, pp. 10–19.

38. R. W. Lightbown in *The Connoisseur*, vol. CLXIX (1968), p. 220.

39. For an indication of the documentary sources on which the account of the sale is based and for the valuations of the goods, see 'The Inventories and Valuations of the King's Goods', *Walpole Soc.*, vol. XLIII (1972).

40. For M. de Bordeaux's reports see Comte de Cosnac, *Les Richesses du Palais Mazarin* (Paris, 1884), pp. 169–240. See also *Mazarin Homme d'État et Collectionneur*, Bibliothèque Nationale, Paris (1961), pp. 137–75.

41. H. Trevor-Roper, *The Plunder of the Arts in the Seventeenth Century* (1970), pp. 53–9.

42. The identification of the sitter in this portrait has recently been made by Professor John Shearman.

CHAPTER FOUR

1. Letter sold at Sotheby's, 27 October 1970 (342), bt. Quaritch.

2. MSS. at Penshurst, 1160, 14.

3. *Calendar of State Papers, Domestic (1660–1)*, (1860), pp. 200–1.

4. 12 Car. II, cap. xi.

5. *Calendar of State Papers, Domestic (1672–3)*, (1901), p. 3; *Calendar of Treasury Books*, vol. III, part II, pp. 1081, 1251.

6. *Calendar of State Papers, Domestic (1661–2)*, (1861), p. 564. The activities of the original Lords' Committee can be followed in the *Journal of the House of Lords*. The declarations to the Committee, made in May 1660, are in the House of Lords Library (calendared in H.M.C., *Seventh Report*, part 1 (1879), pp. 88–93). A volume in the B.M., Add. MS. 17916, is apparently, at least in part, a record kept by Col. Hawley of the goods recovered by him.

7. MS. in the office of the Surveyor of The Queen's Pictures.

8. *Relations Historiques et Curieuses de Voyages* (Paris, 1674), pp. 169–71.

9. *Diary*, ed. E. S. de Beer (1955), vol. III, pp. 260–1, 262–3.

10. *Journal des Voyages* (Lyon, 1665–6), vol. II, pp. 57–8.

11. These inventories of the Duke of York's possessions are in the Bodleian Library, MS. 891.

12. See Millar, Nos. 398–401.

13. *The Journal of James Yonge*, ed. F. N. L. Poynter (1963), p. 200.

14. See especially Levey, pp. 19–23.

15. Isham MSS. (at Lamport Hall), c.1071, Robert Harper to Sir Thomas Isham, Rome, 9 December 1677.

16. His *Holy Family*, painted for Mary of Modena's chapel at St James's, was sold at Sotheby's on 11 June 1969 (1); his *Annunciation* for the chapel at Whitehall is in the John and Mable Ringling Museum of Art, Sarasota (*Catalogue* of 1949 by W. E. Suida, p. 119, as by an unidentified painter).

17. B. Nicolson and C. Wright, *Georges de la Tour* (1974), p. 169.

18. Historical Manuscripts Commission, Buccleuch MSS., vol. I (1899), pp. 439–40, 444–5, 455.

19. The inventory is in the P.R.O., S.P. 78/128, 209–25. It includes goods in Paris and at Chaillot which had belonged to Henrietta Maria.

20. Charles II also acquired pictures by Jan de Bray, Van Aelst and Withoos.

21. The definitive study of the 'Dutch Gift' of 1660 is by D. Mahon in the *Burl. Mag.*, vol. XCI (1949), pp. 303–5,

349–50; vol. XCII (1950), pp. 12–18, 238. On the Guercino, see the same author in the *Art Bulletin*, vol. XXXI, No. 3 (New York, September 1949), pp. 217–23. See also *Het Nederlandse Geschenk aan Koning Karel II van Engeland 1660*, Rijksmuseum, Amsterdam (1965), and a study, so far only issued in typescript, by Elisabeth Reynst, 'Sammlung Gerrit und Jan Reynst' (Hobbach, n.d.). Not the least valuable outcome of Denis Mahon's researches was to dispel the legend, which goes back to the time of George Vertue, that the Reynst brothers had acquired pictures from the collection of Charles I and that the gift in 1660 was in some way a restitution. In fact none of the pictures in the gift can be shown to have belonged to Charles I. A volume of engravings of pictures in the collection of Gerrit Reynst was published in Amsterdam between the date of the gift and Anna Reynst's death in Nobember 1671. Horace Walpole's copy of this volume is now in the Surveyor's office.

22. *Calendar of Treasury Books*, op. cit., p. 885.
23. See E. De Jongh in *Bulletin van het Rijksmuseum*, No. 4 (1961), pp. 123–34.
24. W. H. St John Hope, *Windsor Castle* (1913), vol. I, pp. 315, 316, 317, 319, 320, 328.
25. A very good description of Windsor Castle, after the completion of the work initiated by Charles II, is that by Celia Fiennes, in 1698 (*Journeys*, ed. C. Morris (1947), pp. 277–81).
26. S. Slive, *Rembrandt and his Critics 1630–1730* (The Hague, 1953), pp. 67, 160.
27. *Calendar of Treasury Books (1676–9)*, (1913), pp. 1154, (*1681–5*), p. 8; *Calendar of State Papers, Domestic (1678)*, 1913, pp. 119–20.
28. *Angliœ Notitia* (1682), p. 181–2; ibid. (1684), p. 181. In 1684 Anthony Hobzafel (Holzaffel or Hobraffeth), who had come over from Paris in 1682 to work on the pictures, was listed as 'mender' and 'repairer'.
29. Dezallier d'Argenville, *Abrégé de la Vie des plus fameux Peintres*, vol. IV (Paris, 1762), p. 297.
30. B.M., Harl. MS. 1890 (1689); Vertue's copy (B.M., MS. 15752) was the basis of the reasonably accurate edition printed by W. Bathoe in 1758. Horace Walpole's copy is in the Royal Library.
31. Huygens, *Journaal, Werken uitgeven door het Historisch Genootschap gevestigd te Utrecht* (Nieuwe Reeks, vols. 23 (1876) and 25 (1877)). I am most grateful to Mr Stephen Baxter for drawing my attention to this source.
32. R. North, *The Lives . . . with the Autobiography of the Author*, ed. A. Jessopp (1890), vol. III, pp. 192–3.
33. *Calendar of Treasury Books (1689–92)*, vol. IX (1931). p. 686.
34. From the *Lives* of English painters added to the English edition (1706) of *The Art of Painting* by De Piles, p. 476. A *Still Life* by Walton at Dulwich (429) is so Dutch in every way that it would seem to be copied from a Dutch picture. He had appeared before the Court of the Painter-Stainers Company on 1 July 1674 and promised to bring in his proof piece.
35. Establishment book, *temp*. William III (Royal Archives); *Calendar of Treasury Books*, vol. XVII (1939), pp. 119–20, 979, 980.

36. A list of the King's pictures, 'as they are now placed in Kensington House. – 1697' is in the B.M. (MS. 7025, ff. 188–94). For a valuable insight into the appearance of Kensington in the time of William III, see Th. H. Lunsingh Scheurleer, 'Documents on the Furnishing of Kensington House', *Walpole Soc.*, vol. XXXVIII (1962), pp. 15–58. Evelyn visited the house on 23 April 1696: 'very noble, tho' not greate; the Gallerys furnished with all the best Pictures of all the Houses'.
37. The inventory of the pictures in the following reign, drawn up *c*. 1705–10 by or under the auspices of Peter Walton, is preserved in the Surveyor's office. See also Celia Fiennes's account of Hampton Court early in the reign of Queen Anne (*Journeys*, op. cit., pp. 353–7).
38. D. Stewart, 'William III and Sir Godfrey Kneller', *Journal of the Warburg and Courtauld Institutes*, vol. XXXIII (1970), 330–6.
39. Shearman, op. cit., pp. 148–9.
40. *Calendar of Treasury Books*, vol. XVII, op. cit., pp. 707–8.
41. Ibid., p. 59.
42. *A Tour thro' . . . Great Britain* (ed. of 1928), vol. I, p. 178.
43. The 'List of Pictures and Hangings sent into Holland' is in the archives at Blenheim (MS. F1.56); S. W. A. Drossaers and Th. H. Lunsingh Scheurleer, *Inventarissen van de Inboedels in de Verblijven van de Oranjes*, vol. I (The Hague, 1974), pp. 695–700.
44. It can still be seen in its original setting in Pyne, vol. I, p. 88.
45. Op. cit., pp. 357–9.
46. Correspondence with Mr Richmond Bond in the Surveyor's office. Small versions of the portraits are at Ingatestone Hall, but the originals were last recorded at Hampton Court in 1835.
47. B.M., Add. MS. 19933.
48. Vertue, vol. I, pp. 97, 161, vol. IV, pp. 77–8, 100. MS. notes in a copy, now in the Surveyor's office, of Queen Anne's inventory.

CHAPTER FIVE

1. *Anecdotes of Painting in England*, ed. R. N. Wornum (1888), vol. I, p. 261. Walpole's is the first attempt at an extended account of Charles I's activities as patron and collector.
2. See Millar, Nos. 597 (in reality the *Battle of Dettingen*) and 600 and A. E. Haswell Miller and N. P. Dawnay, *Military Drawings and Paintings in the Collection of H.M. The Queen*, vol. II (1970), pp. 12–27. For a very interesting contemporary comment on Morier's abilities see Earl of Albemarle, *Fifty Years of my Life* (1876), vol. I, pp. 107–10. An inventory of Cumberland's possessions in his houses in Windsor Great Park (1765) is in the Royal Archives.
3. Now in the collection of Mr and Mrs Paul Mellon (exh., R.A., *Painting in England 1700–1850* (1964–5), No. 301).
4. J. Ireland, *Hogarth Illustrated* (ed. of 1791), vol. I, pp. 295–6.
5. 'The Tabley House Papers', ed. D. Hall, *Walpole Soc.*, vol. XXXVIII (1962), p. 110.
6. Haswell Miller and Dawnay, op. cit., Nos. 2094–2180. The picture showing an officer of the 7th Fusiliers, originally

part of the series, was acquired for the royal collection in 1975.

7. Historical Manuscripts Commission, Cowper MSS., vol. III (1889), p. 187; letter from Henry Lowman to Coke, n.d., as from Hampton Court but in fact from Kensington.

8. Vertue, vol. III, p. 19.

9. Both were presented to the National Gallery (Nos. 90 and 87) by William IV in 1836 (M. Levey, *The Seventeenth and Eighteenth Century Italian Schools*, National Gallery (1971), pp. 190–1, 192).

10. Vertue, vol. II, p. 89.

11. Lord Hervey, *Some Materials towards Memoirs of the Reign of King George II*, ed. R. Sedgwick (1931), vol. II, pp. 488–90. The two Van Dycks were the *Villiers Boys* and *Sir Kenelm Digby*; they had been brought up in 1736 to replace two Carlo Dolcis. The 'nasty little children' may have been a painting of the three eldest children of the Queen of Bohemia (now at Buckingham Palace); the 'gigantic fat Venus' may have been the canvas by Palma Giovane or the Michelangelesque panel at Hampton Court (Nos. 579 and 463 respectively). There are in the Surveyor's office two inventories of Kensington in the time of George II.

12. Vertue, vol. IV, p. 65.

13. Vertue drew up an inventory of the contents of this room (B.M., MS. 15752, ff. 34–43) and made drawings of the disposition of objects on the walls. He dates this inventory 1745, but when it was printed, as an addendum to Bathoe's *James II* (1758), it is stated to have been made by Vertue at the Queen's command in September 1743.

14. Their contents are listed in an inventory of the time of George I (B.M., Stowe MS. 567, ff. 7–9v).

15. B.M., MS. 20101, ff. 28–9.

16. Vertue, vol. III, pp. 85, 93; W.R.A., Geo. 52771, 53998, 54020, 54022.

17. A. C. Sewter, 'Stephen Slaughter', *The Connoisseur*, vol. CXXII (1948), pp. 10–15. See also *Irish Portraits 1660–1860*, National Gallery of Ireland and Ulster Museum (1969–70), pp. 15, 38.

18. B.M., MS. 20101, f. 42.

19. Lord Hervey, op. cit., vol. III, p. 866.

20. *Philip Mercier 1689–1760*, City Art Gallery, York, and Iveagh Bequest, Kenwood (1969), especially Nos. 15, 24–6, pp. 25–9. For Mercier's role in disseminating Watteau's paintings in England, see also M. Eidelberg, 'Watteau Paintings in England in the early Eighteenth Century', *Burl. Mag.*, vol. CXVII (1975), pp. 576–82. Dr Mead, from whose collection the Prince acquired miniatures, had befriended Watteau on his visit to London in 1719–20.

21. D. of Cornwall MSS., vol. V, f. 229v.

22. Horace Walpole noted at Buckingham House 'the Isaac Olivers bought of Dr Meade by the late Prince' (*Walpole Soc.*, vol. XVI (1928), p. 79) and lists them in *Anecdotes of Painting*, ed. R. N. Wornum (1888), vol. I, p. 178.

23. M. Kitson in *The Art of Claude Lorrain*, Arts Council (1969), No. 17.

24. Lord Egmont saw Bagnall's pictures in Soho Square on 3 February 1729 (Historical Manuscripts Commission, Eg-
mont MSS., *Diary of the 1st Earl of Egmont*, vol. III (1923), p. 344). Vertue records (vol. V, pp. 126–7) the Prince's acquisition of some of them.

25. N. MacLaren and A. Braham, *The Spanish School* (1970), pp. 71–4.

26. W.R.A., Geo. 54559.

27. D. of Cornwall MSS., vol. XVII, vouchers, f. 531. See J. Byam Shaw, *Paintings by Old Masters at Christ Church Oxford* (1967), pp. 4–5; the Prince may have been involved in some way in the General's interest in fragments from the cartoon, attributed to Raphael, of this subject.

28. W.R.A., Geo. 55240. It was Goupy and Guise who were sent over to Flanders on the Prince's behalf to report on the *Gerbier Family* (the Rubens school piece now at Windsor) which they bought for him (letters cited by C. Whitfield in *Studies in the History of Art*, National Gallery of Art, Washington, D.C. (1973), pp. 27–31).

29. W.R.A., Geo. 54961; D. of Cornwall MSS., vol. XLI, vouchers, f. 26.

30. G. Beard, 'William Kent and the Royal Barge', *Burl. Mag.*, vol. CXII (1970), p. 492.

31. The three volumes are preserved in the Surveyor's office. The fourth volume ordered by the Prince, which was to describe his collections at Leicester House, Carlton House ('Pellmell house'), Kew and Cliveden does not survive and may not have been compiled before the Prince's death. The pictures at Kew are described by Sir William Chambers in *Plans, Elevations, Sections, and Perspective Views of the Gardens and Buildings at Kew . . .* (1763).

32. Vertue, vol. I, pp. 8–14, vol. III, pp. 142, 152, 154, vol. V, pp. 126–7, and B.M. MS. 19027.

CHAPTER SIX

1. *Letters*, ed. D. C. Tovey (1912), vol. III, p. 25.

2. Walpole to the Rev. Henry Zouch, 3 January 1761 (*Letters*, ed. Mrs Paget Toynbee, vol. V (1904), p. 16).

3. Bute to Prince George, September 1759, quoted in J. Brooke, *King George III* (1972), pp. 64–5.

4. Miss Olwen Hedley has identified the room in which the Queen is seated with her sons as the Centre Room or Crimson Boudoir and has also identified the two fancy dresses, a Telemachus dress for the Prince of Wales and a Turk's for Prince Frederick, which arrived (and were first worn) on 8 September 1764 (letters in the Surveyor's office). For the dressing-table itself, made by William Vile and covered with lace supplied by 'Priscilla MacEune', see K. M. Walton in *Journal of the Furniture History Society*, vol. XI (1975), pp. 112–13.

5. The full-lengths are probably the pair in The Hermitage (4469, 9566), where they are attributed to West. The King owned, incidentally, a version of the state portrait of Catherine the Great by Eriksen and a good Pesne of Frederick the Great.

6. Walpole, *Visits*, p. 79.

7. *P. J. de Loutherbourg, R.A.*, Kenwood, The Iveagh Bequest (1973), Nos. 59 and 60. The King expressed approbation of

Paton's views of dockyards (Millar, Nos. 980–4), but does not seem to have bought them. He collected painted perspective views of men-of-war, some of which are on loan to the Science Museum, London.

8. In 1968 they were placed on loan in the Palace of Westminster. For the possible significance of West's mediaeval subjects for the political and historical thought of the time see J. Sunderland in *Burl. Mag.*, vol. CXVI (1974), p. 326, and E. Morris, ibid., p. 672.

9. The sketches were shown at the Royal Academy in 1790 (110, 117) and 1791 (167, 189). The sketch for Agriculture was sold at Sotheby's, 17 March 1971 (17).

10. Notes by Horace Walpole (one dated 1783) in a copy (now in the Surveyor's office) of an inventory of Queen Anne's pictures. Lord Gower was Lord Chamberlain, 1763–5. See his *Letters*, ed. Mrs Toynbee, vol. XII (1900), p. 149; ed. W. S. Lewis, vol. IX (New Haven, 1941), p. 377, vol. X (1941), p. 33.

11. P.R.O., A.O. 1, 420, 200; ibid., 201; J. Shearman, *Raphael's Cartoons*, op. cit., pp. 152–4. At Buckingham House they were hung in the Great Room, or Grand Saloon, on light green damask.

12. *Letters*, ed. F. W. Hilles (1929), p. 12.

13. Dalton appears in a particularly discreditable light in Robert Strange, *An Inquiry Into the Rise and Establishment of the Royal Academy of Arts* (1775) and A. Lumisden, *Memoir of Sir Robert Strange* (1855).

14. MSS. in the possession of the Marquess of Bute. I am most grateful to Lord Bute for permission to quote from these papers and to Miss Catherine Armet for providing me with copies of them.

15. *Memoirs of the Reign of King George the Third*, ed. G. F. Russell Barker (1894), vol. I, pp. 15–16; letter to Lord Bute, 15 December 1760 (*Letters*, ed. Toynbee, vol. V (1904), pp. 11–12).

16. W.R.A., Geo. 17111–17288.

17. ibid., Geo. 15602–3.

18. Information provided most kindly by Mary Webster from Filze X (1777), 94, in the Archivio degli Uffizi.

19. J. Fleming, 'James Macpherson: a Florentine Miniaturist', *Connoisseur*, vol. CXLIV (1959), pp. 166–7; see also Mary Webster in *Firenze e l'Inghilterra*, Palazzo Pitti, Florence (1971), No. 59.

20. Printed in K. T. Parker, *The Drawings of Antonio Canaletto . . . at Windsor Castle* (1948), pp. 61–2.

21. These lists are in a volume of miscellaneous inventories in the Surveyor's office. The first ('Catalogue of Paintings of the Italian School all in fine preservation, and in carved Gilt Frames in modern & Elegant Taste. Bought by His Majesty in Italy & now cheifly at Kew') was published by Sir L. Cust in the *Burl. Mag.*, vol. XXIII (1913), pp. 150–62, 267–76; he included the third part of the lists: 'Particular description of 13 Door Peices by Antº Canal – & 11 Peices by Vissentini & Zuccarelli'. The second section ('Catalogue of the Flemish & Dutch Schools all in fine Preservation, in new gilt carved Frames. in Elegant Taste.') was printed by Sir A. Blunt in *Venetian Drawings . . . at Windsor Castle*

(1957), pp. 19–23. In addition to the work of Sir Anthony and K. T. Parker (op. cit.), the principal accounts of Smith's collection are: F. Haskell, *Patrons and Painters* (1963), pp. 299–310, 391–4; Levey, pp. 28–35 and *passim*; and F. Vivian, *Il Console Smith* (Vicenza, 1971).

22. J. Fleming, *Robert Adam and his Circle* (1962), p. 236.

23. F. Haskell, op. cit., p. 304.

24. The works by Sebastiano Ricci are discussed most recently by J. Daniels, *Sebastiano Ricci* (1976), pp. 46–54.

25. See Levey, pp. 31–3 and Nos. 367–416 for a detailed account of Smith's Canalettos; the reader is also referred to the same author's *Canaletto Paintings in the Collection of H.M. The Queen* (1964).

26. Vol. I, pp. 137–8.

27. *A Handbook to the Public Galleries of Art in and near London* (1842), vol. I, p. 249. For the purchase by Smith of the Pellegrini collection, see F. Vivian, 'Joseph Smith and Giovanni Antonio Pellegrini', *Burl. Mag.*, vol. CIV (1962), pp. 330–3.

28. *Visits*, pp. 78–80, c. 1780.

29. The inventory is in the Surveyor's office; the measured drawings are in the Royal Library.

30. The second of the two rooms was the setting for Zoffany's group of the King's two eldest sons at play.

31. It is reproduced by Mary Webster in *Burl. Mag.*, vol. CXIII (1971), p. 220.

32. *Passages from the Diary of Mrs. Philip Lybbe Powys*, ed. E. J. Climenson (1899), p. 116.

33. See in particular the watercolours by Wild published in the section dealing with Frogmore at the end of Pyne, vol. I.

34. It is not clear whether Miss Moser's flower pieces formed part of the original decoration of the room at Frogmore which was named after her.

35. It is now in the Huntington Library and Art Gallery, San Marino.

36. B.M., Egerton MS. 3706, C, f.10.

37. W.R.A., Geo. 51713–4. The removals are recorded in a volume in the Surveyor's office. A good impression of the rooms, as they were to be seen in the next decade, is to be gained from the watercolours in Pyne, vol. I. Red was, once again, a favourite background for pictures, but blue was used in, for example, the King's Drawing-Room and Audience Chamber. The decorative schemes were still enriched by Gibbons's carving and Verrio's painting.

38. Walpole, *Letters*, ed. Mrs. Paget Toynbee, vol. X (1904), p. 354, vol. XII (1904), pp. 149–50, vol. XV (1905), p. 338.

39. MSS. in the Library of Corpus Christi College, Cambridge, Kerrich Correspondence, vol. XIX, f. 261. I am most grateful to the Librarian for enabling me to examine these MSS. and to Dr Tudor-Craig for bringing them to my attention. A clear impression of the pictures hanging at Kensington at this period is provided by Stephanoff's and Wild's plates in Pyne, vol. II, *Kensington*, pp. 32, 46, 56, 62, 67. In the Old Dining-Room, crammed with old portraits, Van der Goes's panels can be seen.

40. *Diary and Autobiography of John Adams*, ed. L. H. Butterfield (Cambridge, Mass., 1961), vol. III, pp. 150–1. West's survey

of the collection is contained in three uniform inventories, in the Surveyor's office, of the pictures at Kensington (1818), Buckingham House and St James's (1819) and Carlton House (1819).

41. *The Girlhood of Queen Victoria*, ed. Viscount Esher (1912), vol. II, p. 11.

42. *The Harcourt Papers*, ed. E. W. Harcourt, vol. III, p. 102.

CHAPTER SEVEN

1. *Correspondence of Sarah Spencer Lady Lyttelton*, ed. Hon. Mrs. Wyndham (1912), pp. 103–4; *Memoirs of the . . . Life of Robert Plumer Ward*, ed. Hon. E. Phipps (1850), vol. I, pp. 399–400; Mary Frampton, *Journal*, ed. Harriot Mundy (1886), pp. 158–9.

2. These papers, largely unsorted, are in the P.R.O., H.O. 73.

3. The 'Giorgione', for example ('a small whole length in Armour – by Georgoni') was probably lot 34 ('Gaston de Foix, small whole length'), as by Giorgione, in the sale at Christie's on 29 June 1814. It is probably the picture now in the National Gallery (269). An unusual acquisition, already in the Prince's collection, was the Flemish *Man with the Watch* at Hampton Court (902).

4. The marvellous pair of full-lengths of the Cumberlands was bequeathed by the Duchess to the Duke of Clarence.

5. The canvases which are of uniform size and probably comprise the series are Millar, Nos. 1109–12, 1115–18, 1122–6. Allwood's bill, dated 14 February 1793, is endorsed by Stubbs: 'NB This is a true Bill – Geo: Stubbs' (P.R.O., H.O. 73, 17). Two more frames, perhaps of the same type, were included in a second account, 11 May 1793, likewise authorized by Stubbs.

6. The accuracy required in painting military details for George IV is attested in the volume of 'Arms Deliveries' kept by Benjamin Jutsham, Inspector of Household Deliveries. Weapons and military and Highland equipment were sent to the studios of such painters as Copley, Stroehling, Hoppner, Phillips, Lawrence and Wilkie.

7. *Correspondence*, op. cit., p. 101.

8. Information kindly provided by Mr Evelyn Joll; G. Finley, 'J. M. W. Turner's Proposal for a "Royal Progress"', *Burl. Mag.*, vol. CXVII (1975), p. 31. I have found no evidence in the records of George IV's collection to confirm the statement that De Loutherbourg's *Taking of Valenciennes*, now at Easton Neston, was part of the display at St James's.

9. To the account of the Waterloo Chamber in Millar, *Later Georgian*, pp. XXXII–VI, should be added M. Levey, 'Lawrence's Portrait of Pope Pius VII', *Burl. Mag.*, vol. CXVII (1975), pp. 194–204. The original appearance of the room can be seen in Joseph Nash's watercolour, published in his *Views of the Interior and Exterior of Windsor Castle* (1848).

10. W.R.A., Geo. 26558, 26559. John Smith and Francis Collins were also employed on frames for the King. Collins, for example, made the frames on Wilkie's Spanish pictures.

11. His account, submitted in 1817, was settled on 12 August 1819 (W.R.A., Geo. 27003); his catalogue of the pictures at Carlton House, dated December 1816, is in the Surveyor's office. A late inventory of George IV's pictures includes nearly 700 items. This includes some enamels and an occasional drawing, but gives an indication of the size of his final contribution to the collection.

12. For this period, see especially ch. 2, 'Revolution and Reaction', of F. Haskell, *Rediscoveries in Art* (1976).

13. W.R.A., Geo. 26918, 26924.

14. A typical bill from Simpson, for work done in 1811, is W.R.A., Geo. 27830. It includes work on panels, cleaning, varnishing, 'washing off', repairing, providing a stretcher and moving pictures. One of the pictures cleaned and repaired was the 'Capital high finish'd' *Departure for the Chase* by Adriaen van de Velde (plate XXXIV), which is in superb state. The cleaning and repair of pictures was apparently taken over by Seguier c. 1818. One of his tasks was repairing the panel of the *Farm at Laeken*: 'having Slightly opened where they are joined on the Right hand side . . . at the Top.' For a good assessment of Seguier see G. Martin in *The Connoisseur*, vol. CLXXXVII (1974), p. 108. In the work of cleaning and restoration he was, of course, assisted by his brother John.

15. The arrival of the pictures, and the dispersal of a few of them, are recorded in Jutsham's day-books. One of the pictures sent to Christie's was the *Maas in a Storm* by Cuyp, now in the National Gallery (6405).

16. These exchanges are recorded by Jutsham in the volume of Receipts and Deliveries, ff. 150, 153, 307, 318, 320; volume of Receipts, f. 86.

17. ibid., f. 6.

18. J. Smith, *A Catalogue Raisonné of the Works of the most eminent Dutch, Flemish, and French Painters*, part II (1830), pp. 229–30.

19. Drawn for the section on Carlton House in Pyne, vol. III.

20. The pendant of Queen Caroline survives at Hampton Court.

21. W.R.A., Geo. 32710; G. F. Waagen, *Works of Art and Artists in England* (1838), vol. II, pp. 348–77.

22. *Report of Select Committee appointed to enquire into Matters connected with Windsor Castle and Buckingham Palace*, printed 14 October 1831.

23. *Cymon and Iphigenia*, the *Death of Dido* and the portraits of Schaumburg-Lippe, Rockingham, the Duke of York and the copy of Guido Reni's *St Michael*. Very few of the frames of the type seen on the pictures in Morison's watercolour survive; the largest is on Granet's *Refectory of a Monastery*.

24. An important early account of the Gallery is in Mrs Jameson's *Companion to the most celebrated Private Galleries of Art in London* (1844), pp. 3–68. She thought it 'too lofty, and the light not well contrived for such small and delicate pictures'.

25. A *Descriptive Catalogue* of the pictures in the Corridor was printed in 1845; an incomplete MS. list (1838) is in the Surveyor's office.

26. W.R.A., Geo. 89668.

27. M. Joyce, *My Friend Hobhouse* (1948), p. 207.

CHAPTER EIGHT

1. Journal, 8 May 1838. The most valuable study of the Prince Consort's achievements is J. Steegman, *Consort of Taste 1830–1870* (1950); much information is to be found in W. Ames, *Prince Albert and Victorian Taste* (1967). Much useful material is to be found in Haskell, op. cit., especially pp. 42, 46–57. The tastes and patronage of the Queen and the Prince are brilliantly dissected by M. Levey in ch. VI of *Painting at Court* (1971).

2. Journal, 3 August, 1836, 15 July 1838.

3. ibid., 23 September, 30 October, 25 November, 3 March 1838.

4. T. Martin, *The Life of H.R.H. the Prince Consort* (1875), vol. I, p. 31.

5. MS. in the Surveyor's office, entitled: 'Catalogue of Her Majesty's Private Pictures, Miniatures, Enamels &c. &c.', running from 1828 to 1856.

6. Journal, 7 July 1834. The *Circassian Women* is reproduced, T. S. R. Boase, *English Art 1800–1870* (1959), pl. 62b.

7. ibid., 23 May 1836.

8. ibid., 24 November 1837.

9. ibid., 7 January 1840.

10. ibid., 7 December 1837, 9 January 1839.

11. ibid., 24 December 1838.

12. ibid., 25 June, 27 July, 25 August 1842.

13. ibid., 18 December 1846.

14. ibid., 21 May 1851, 3 April 1852.

15. ibid., 8 July 1851.

16. ibid., 28 May, 2 October 1845.

17. ibid., 19 September 1850.

18. ibid., 1 October 1873.

19. For the patronage of the animal painters, see the catalogue, *Animal Painting* (The Queen's Gallery, 1966–7); there is a useful account of the work of Giles for the Queen at Balmoral in D. and F. Irwin, *Scottish Painters at Home and Abroad* (1975), pp. 312–14.

20. *Præraphaelite Diaries and Letters*, ed. W. M. Rossetti (1900), pp. 274–5.

21. R. Ormond, *Daniel Maclise*, National Portrait Gallery (1972), No. 80.

22. Journal, 9 August 1845.

23. The sketch, given later to the Duke of Connaught, was sold at Christie's, 26 July 1974 (252); reproduced, *Burl. Mag.*, vol. CXVII (1975), p. 324. See also D. and F. Irwin, op. cit., pp. 317–18.

24. *The Victorian Vision of Italy*, Leicester Museums and Art Gallery (1968), p. 13.

25. W. Feaver, *The Art of John Martin* (1975), pp. 142, 161–2.

26. D. and F. Irwin, op. cit., pp. 322–3. At the time of his death the Queen considered Phillip 'our greatest painter . . . darling Papa had such an admiration for him'.

27. W. P. Frith, *My Autobiography and Reminiscences* (1887), vol. I, pp. 257–8.

28. L. and R. Ormond, *Lord Leighton* (1975), pp. 26–31. The payment to Leighton of £630 was made on 30 July 1855 (W.R.A., P.P. 2/12/5683).

29. ibid., pp. 114–15.

30. Journal, 6 May 1865.

31. 'Letters from Sir J. E. Millais . . .', ed. M. Lutyens, *Walpole Soc.*, vol. XLIV (1974), p. 49.

32. National Gallery of Canada, *Homer Watson* (1963), Nos. 6, 11.

33. P.R.O., L.C.1/380, 4–6.

34. For Swoboda's portraits see A. E. Haswell Miller and N. P. Dawnay, *Military Drawings and Paintings in the Collection of H.M. The Queen*, vol. II (1970), Nos. 2499–2513.

35. Journal, 8, 16, 31 December 1843. In February the Prince was hanging up many of the pictures from Hampton Court in the Visitors' Rooms at Windsor where they 'look so well'.

36. W.R.A., Vic. Add.C.5, 13–23.

37. Mrs. Uwins, *A Memoir of Thomas Uwins, R.A.* (1858), vol. II, pp. 285–7.

38. P.R.O., L.C. 11/134.

39. *Richard Redgrave, A Memoir, compiled from his Diary* by F. M. Redgrave (1891), pp. 176, 345. Doyne Courtenay Bell was Assistant Secretary, and ultimately Secretary, to the Privy Purse. He had some reputation as an expert on pictures.

40. W.R.A., Vic. Add. c.5/21; P.R.O., L.C.1/69, 122, 123.

41. P.R.O., L.C.1/96, 103; 1/110, 9; 1/229, 51, 115.

42. ibid., L.C.1/328, II, 5.

43. ibid., L.C.1/139, 234; 1/513, II, 7.

44. ibid., L.C.1/217, 35.

45. MS. preserved in the Surveyor's office.

46. W.R.A., P.P. 2/42/428; Add. MSS.T.232, f. 181.

47. W.R.A., Add. MSS.T., 25–29; two printed catalogues of this collection were published, in 1848 and 1854, the latter by Waagen; *Report of the Director*, National Gallery, 16 January 1864, pp. 129–31.

48. W.R.A., Add. MSS.T.231, ff.117, 131, 148; P.P. 2/5/4194.

49. A *Catalogue of the Paintings, Sculpture and other Works of Art, at Osborne* was published in 1876.

50. J. Steegman, op. cit., p. 130.

51. For the importance of the Art Treasures exhibition, see especially ibid., ch. x. Steegman rightly drew attention to Lady Eastlake's remarkable obituary tribute to the Prince, published in the *Quarterly Review*, January 1862. See also Haskell, op. cit., pp. 96–9.

52. T. Martin, op. cit., vol. IV, pp. 14–15.

CHAPTER NINE

1. *Fifty Years of Public Work* (1884), vol. I, p. 359.

2. P.R.O., L.C.1/718, 65, 67, 76. This picture is now dismembered (W. G. Constable, *Richard Wilson* (1953), p. 153).

3. ibid., L.C.1/457, 70. It appears that the Queen, in 1882, might have acquired an equestrian portrait of Henry, Prince of Wales, for which George IV was said to have offered a considerable sum (L.C.1/402, II, 107a). This is almost certainly the portrait now at Parham Park which, as it happens, was again turned down as a purchase for the collection in 1947 (reproduced, R. Strong, *The English Icon* (1969), p. 338).

4. His inventory, in the Surveyor's office, is dated April 1881;

annotations and additions to it were made as late as February 1905.

5. '. . . just the head of Christ – the Queen admires the expression of Our Lord's face so much and would frankly wish that Mr Hunt should copy the head himself or suggest some one who would be able to do it – Her Majesty would desire just the head & shoulders like the Christ's head of Carlo Dolce' (Lady Augusta Stanley to Holman Hunt, MSS. in the possession of Mrs Cuthbert which include a little sketch by the Queen of what she required; I am very grateful to Mrs Cuthbert for permission to examine these MSS).

6. W.R.A., L 5/22; Vic. Add. MSS. A 22/321; Add MSS. U 32; Z 34/63. For Robinson see a useful note in Haskell, op. cit., p. 65.

7. P.R.O., L.C.1/386, II, 93, 104; 1/680, 117, 119, 127–9, 147–9a, 153–4, 160; 1/697, 7, 9; 1/699, 4, 97; W.R.A., P.P., Buckingham Palace, 1615.

8. Letter to Holman Hunt, 10 April 1879 (MS. in possession of Mrs. Cuthbert).

9. The Surveyor of Pictures appears to have had the royal works of art under his charge (except for the arms and armour which were the responsibility in Cust's time of Sir Guy Laking) until the appointment of Sir Cecil Harcourt Smith as Surveyor of Works of Art on 2 January 1928. Sir Cecil had formerly acted as Adviser for the Royal Art Collections.

10. Quoted in Sir P. Magnus, *King Edward the Seventh* (1964), p. 290.

11. It is curious to find someone of Cust's background writing 'I sometimes sat by him at table'. By his desk hung always a photograph of the King, with a frame, designed by Cust, inscribed 'MASTER/KING/FRIEND'. This account of Cust is based mainly on his own *King Edward VII and his Court*, published in 1930 with a Memoir by his widow.

12. Sir P. Magnus, op. cit., p. 75. For York Cottage and the environment in which King George V and Queen Mary brought up their children, see Frances Donaldson, *Edward VIII* (1974), pp. 17–19.

13. The first of these were printed in book form in 1911 by special permission of King George V.

14. They were published in 1905 and 1906 respectively, by Heinemann, by command of the King.

15. P.R.O., L.C. 1/380, 28; L.C. 1/382, 11; L.C.1/756, 69. In April 1891 the Lord Chamberlain's Office had facilitated the visit to Hampton Court by Berenson and Mrs Costelloe (ibid., L.C. 1/552, 18) which bore fruit in her pamphlet, *The Guide to the Italian Pictures at Hampton Court*, published (1894) as by Mary Logan: an interesting essay, by contrast with Law's strictly historical approach, in 'the study of Italian pictures . . . as a recognised science, upon a level at least with Archaeology'. She found 'a large percentage of the labels of Italian pictures . . . incorrect'.

16. See his *King Edward VII*, op. cit., pp. 11–46, 175–88.

17. L. and R. Ormond, *Lord Leighton* (1975), pp. 42, 45–6, 152, 153. In 1868 the Prince was given by the Queen Leighton's *Duett*, a portrait of J. Hanson Walker.

18. The official destruction of the King's papers renders impossible any accurate account of how his pictures were assembled or his tastes, such as they were, developed. A *Catalogue of the Works of Art at Marlborough House and at Sandringham* was printed in 1877.

19. The King also received a bequest of pictures from Mrs Maidstone-Smyth, which included a portrait of Sir Robert Murray-Keith by Anton Graff and a little conversation-piece of Sir Robert with two ladies.

20. J. Pope-Hennessy, *Queen Mary* (1959), pp. 620–1.

21. ibid., pp. 46, 393.

22. With all her historical and dynastic interests, Queen Mary could make mistakes. The portrait which was claimed to represent Queen Charlotte (H. Clifford Smith, *Buckingham Palace* (1930), p. 85) is certainly not of her, but probably of her sister-in-law. She acquired two miniatures by Samuel Cooper, one superb and one very good, as portraits (respectively) of Monmouth and Prince Rupert. Neither identification was correct. Nor were her attitudes entirely scholarly. When informed that the little group of Frederick, Prince of Wales, and his sisters (plate XV) was by Mercier she informed the Surveyor, on 19 June 1933: 'We prefer the picture to remain as by Nollekens'.

23. See Clifford Smith, op. cit., p. 185. To Clifford Smith Queen Mary could do no wrong, and his book is the chief monument to this phase in the history of royal taste. See also, J. Pope-Hennessy, op. cit., pp. 524–6. Queen Mary wrote to the King on 3 July 1930: 'The picture gallery here is finished & all the small pictures are up again, a little crowded, but they look all right' (W.R.A., Geo. V, CC. 8, 340).

One must, in passing, note that one of Queen Mary's sons, Prince George, Duke of Kent, showed a flair for pictures and works of art far more spontaneous than any other member of his family. His splendid collection of pictures was dispersed at Christie's on 14 March 1947. His purchase of the Altieri Claudes, now at Anglesey Abbey, would alone mark him out as the most distinguished royal connoisseur since George IV.

24. K. Clark, *Another Part of the Wood* (1974), pp. 235–8.

25. This phrase occurs in W.R.A., Geo. V, CC. 48/403.

26. Letter from Sir Ellis Waterhouse, 16 January 1976; I am very grateful to Sir Ellis for allowing me to quote from this letter. A pleasant impression of Collins Baker, and a reproduction of a revealing portrait-drawing by Francis Dodd, is to be found in C. J. Holmes, *Self & Partners* (1936).

27. Letter in the Surveyor's office, dated 26 June 1934.

28. '. . . I am afraid I cannot say offhand whom the portrait over the mantelpiece represents. I think it is George II, but I always mix him up with his relations, and I am afraid that the family history of the House of Hanover has never appealed to me as a subject. Unfortunately, my predecessors have never thought of drawing up an inventory of the Royal pictures . . .' (Clark to Sir James Caw, 19 March 1936: hardly fair to Redgrave).

29. A letter (in the Surveyor's office) from Clark gives a nice picture of L/Cpl. Nicolson spending twenty-four hours leave from his Light A.A. Battery at Chatham in July 1940

to ensure the safety of fourteen especially precious pictures at Hampton Court.

30. Unfortunately the equestrian portrait of Henry, Prince of Wales, now at Parham (see above, p. 232), again proved in 1947 too expensive to acquire.

31. Anthony Blunt's achievement in many spheres is lightly touched on by Ellis Waterhouse in his charming Personal Preface to *Studies in Renaissance & Baroque Art*, presented to Anthony Blunt on his 60th birthday (1967). His influence in the area of scholarship which we specially associate with him is indicated in the essays that made up this affectionate volume.

 I was employed to help Ellis Waterhouse in measuring pictures, copying inscriptions and the like, in the summer of 1946 in preparation for the *Catalogue* of the exhibition. I was then a student at the Courtauld Institute. When Anthony Blunt became Director of the Courtauld in the autumn of 1947 I had finished my course and was appointed (1 October) Assistant Surveyor. Ben Nicolson had taken on the editorship of the *Burlington Magazine* in the spring of 1947 and in due course resigned from the Lord Chamberlain's Office. I was appointed Deputy Surveyor in his place on 1 October 1949 and in 1972 succeeded Anthony Blunt, who had been knighted in 1956, as Surveyor.

32. Patrick, Seventh Lord Plunket, Equerry to the Queen and Deputy Master of the Household at the time of his death in 1975, had entered the Household in 1948 as an Equerry to King George VI. He had an unusual flair for interior decoration and a great love of painting.

33. They were part of a set of four companion Stuart portraits by Blanchet, sold from the collection of Lt.-Col. G. H. Hay at Christie's, 25 March 1966 (80–83). They are stated to have belonged in the eighteenth century to William Hay of Edington, a Jacobite.

ACKNOWLEDGEMENTS

The following agencies have supplied photographs:
Bulloz: plates 17, 22, 37, 44, 46
Sport and General Press Agency Ltd: plate 127

INDEX